PHOTOSHOP CS3

Transform your RAW images into works of art

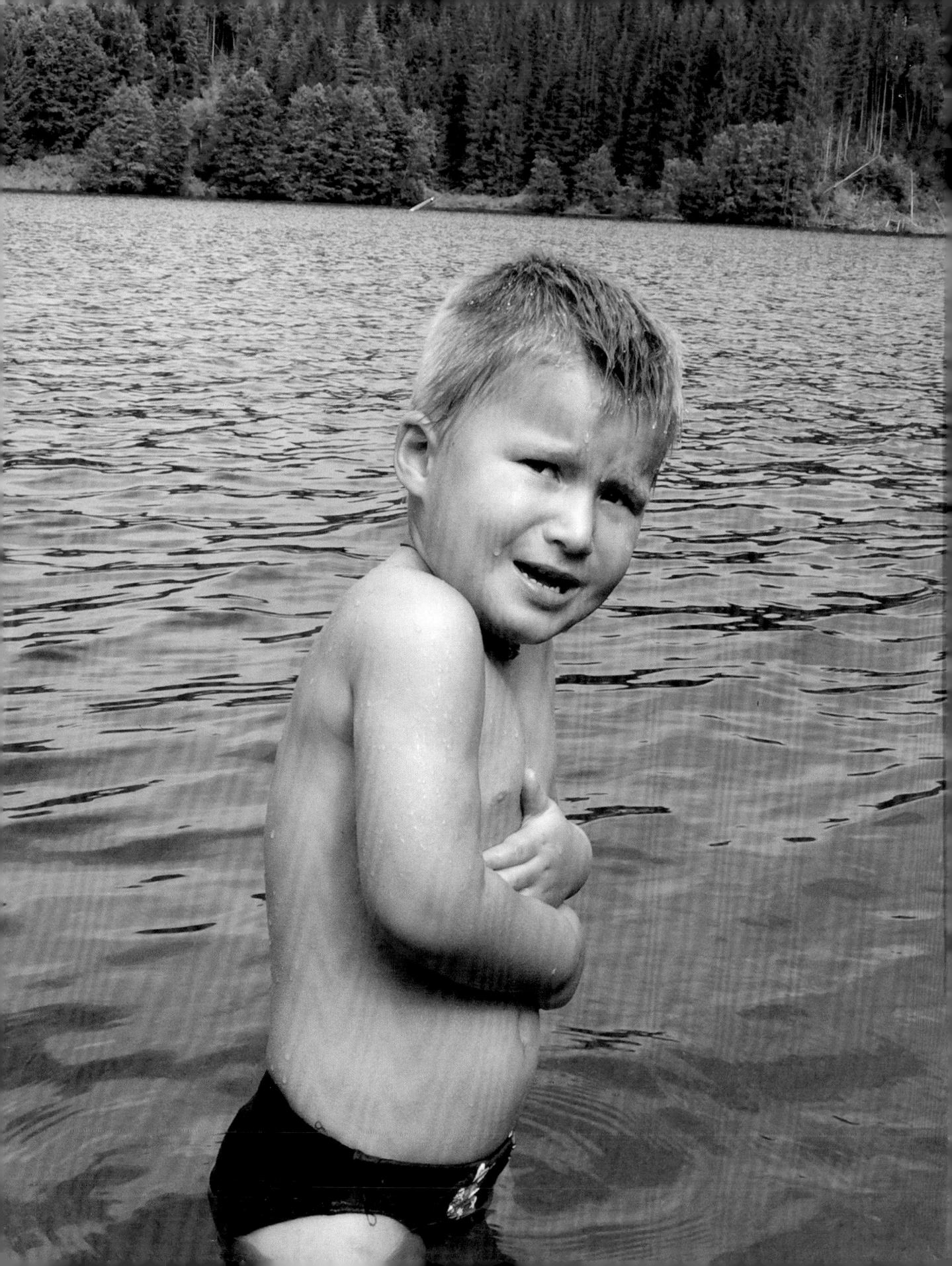

PHOTOSHOP CS3

Transform your RAW images into works of art

Mikkel Aaland

 $\mathsf{O}'\mathsf{REILLY}^{\scriptscriptstyle{\circ}}$

Photoshop CS3 RAW BY MIKKEL AALAND

Editor: Colleen Wheeler

Production Editor: Dennis Fitzgerald

Copyeditor: Phil Dangler

Technical Editor: Doug Nelson

Cover Design: Steve Fehler

Interior Design: Ron Bilodeau, Michael Kavish

Copyright © 2008 Mikkel Aaland. All rights reserved.

Published by O'Reilly Media, Inc., 1005 Gravenstein Highway North, Sebastopol, CA 95472.

O'Reilly books may be purchased for educational, business, or sales promotional use. Online editions are also available for most titles (*safari.oreilly.com*). For more information, contact our corporate/institutional sales department: 800.998.9938 or *corporate@oreilly.com*.

The O'Reilly logo is a registered trademark of O'Reilly Media, Inc. *Photoshop CS3 RAW*, the cover images, and related trade dress are trademarks of O'Reilly Media, Inc.

Many of the designations used by manufacturers and sellers to distinguish their products are claimed as trademarks. Where those designations appear in this book, and O'Reilly Media, Inc. was aware of a trademark claim, the designations have been printed in caps or initial caps. Adobe Photoshop™ is a registered trademark of Adobe Systems, Inc. in the United States and other countries. O'Reilly Media, Inc. is independent of Adobe Systems, Inc.

While every precaution has been taken in the preparation of this book, the publisher and author assume no responsibility for errors or omissions, or for damages resulting from the use of the information contained herein.

Print History: December 2007, First Edition. ISBN-10: 0-596-51052-7 ISBN-13: 978-0-596-51052-7

[F]

Printed in Canada

Acknowledgments

I've been involved with digital photography for over 20 years, and the greatest pleasure has come from working with a community of generous, big-hearted people. For this book, I want to especially thank the following people, who shared their wisdom, knowledge, and work so freely.

From Adobe: Thomas Knoll, Kevin Connor, Tom Hogarty, John Nack, Cris Rys, Jeff Chien, John Peterson, Bryan O'Neil Hughes, Jon Petersen, and John Worthington.

Contributing photographers: Peter Burian, John Carnett, John McDermott, Luis Delgado Qualtrough, Maggie Hallahan, Jack Holm, Peter Krogh, Richard Morgenstein, Michael Reichmann, Mark Richards, Derrick Story, and Martin Sundberg. (On the next page, I've included a photographer's contributor list with contact information. I encourage you to check out the photographers' work and see for yourself why I am so honored to have them associated with this book.)

From O'Reilly, which very patiently supported my efforts: Tim O'Reilly, Mark Brokering, Dan Brodnitz, Laurie Petrycki, Robert Eckstein, Steve Weiss, Betsy Waliszewski, Sara Peyton, Michele Filshie, Ron Bilodeau, and Dennis Fitzgerald. A very special thanks to my editor, Colleen Wheeler, who makes everything happen. The design and layout of this book is groundbreaking and for that, I profusely thank Michael Kavish and Jan Martí, who went way beyond what was expected of them. Lori Barra, of TonBo designs, was also supportive.

Thanks also to Bill Atkinson for his advice and help. We had several lively conversations that informed a lot of the material in this book. Thanks also to Dave Coffin, Eric Hyman, Fred Shippey, Dave Drum, Bruce Yelaska, Cheryl Parker, Jonathan Chester, Rudy Burger, Michael Borek, Andrew Tarnowka, Saurabh Wahi, Mike Haney, Paul Saffo, Leo Laporte, Suzanne Kantra Kirschner, Tom Kunhardt, Martin Evening, Lynne Browne, and Paul Kellogg.

Research assistants Peter Burian and Ed Schwartz both assisted me in various research capacities, and I really enjoyed the collaboration with these fine men. Doug Nelson did an over-the-top job of technical editing, which I really appreciated. Deke McClelland was helpful, as always. Neil Salkind and David Rogelberg of Studio B watched out for my best interests, as usual.

And finally, thanks to my wife, Rebecca, and two daughters, who make all this worthwhile.

Mikkel Aaland San Francisco, 2007

Contributors

Peter Burian is a freelance photographer, editor, and author based in Toronto, Canada. His outdoor, travel, nature, and active lifestyle photographs are available as stock for editorial and advertising use via www.peterburian.com.

John Carnett is Popular Science magazine's award-winning staff photographer of 15 years. See more of John's work at *www.carnettphoto.com*.

Luis Delgado Qualtrough is a photographer whose prints, books, and installations have been shown extensively in the USA, Mexico, and Europe. His work can be seen at www.ladq.com.

Maggie Hallahan Maggie is an accomplished photographer with over twenty years of experience shooting advertising and editorial assignments. Her work has appeared in numerous magazines and can be seen online at www.maggiehallahan.com.

Peter Krogh Peter owns and operates a full-service commercial photography studio in the Washington, DC area. Peter is both an award-winning photographer and the author of the definitive work on digital asset management. His work can be seen at *www.peterkrogh.com*.

John McDermott John is a San Francisco photographer who shoots corporate annual reports, portraits, and sports for editorial and advertising clients. But mostly, he'd rather be wandering the streets of some strange city pretending to be Cartier-Bresson or Jay Maisel. You can see his work at www.mcdfoto.com.

Richard Morgenstein For over twenty years, Richard has photographed people for magazines, corporations, and private clients. The common denominator in Richard's work is his interest in all kinds of people, their passions, and their environments. See his work online at www. richardmorgenstein.com.

Michael Reichmann Michael is a fine-art landscape, nature, and documentary photographer with more than 40 years of experience. He is a well-known photographic educator and author, and the publisher and primary author of The Luminous Landscape web site, www.luminous-landscape.com.

Mark Richards is an award-winning corporate and editorial photographer who specializes in people and lifestyle photography. To see more of his work, visit www.markrichards.com.

Derrick Story Derrick is the digital media evangelist for O'Reilly (http://digitalmedia.oreilly.com). He's the author of Digital Photography Hacks and Digital Photography Pocket Guide. You can listen to his photo podcasts and read his tips at www.thedigitalstory.com.

Martin Sundberg Martin specializes in capturing imagery of people who are passionate about what they do, while they are doing it. By land or by sea, he embraces every opportunity to make pictures that move and inspire. Martin is based in San Francisco. His work can be found at www. martinsundberg.com.

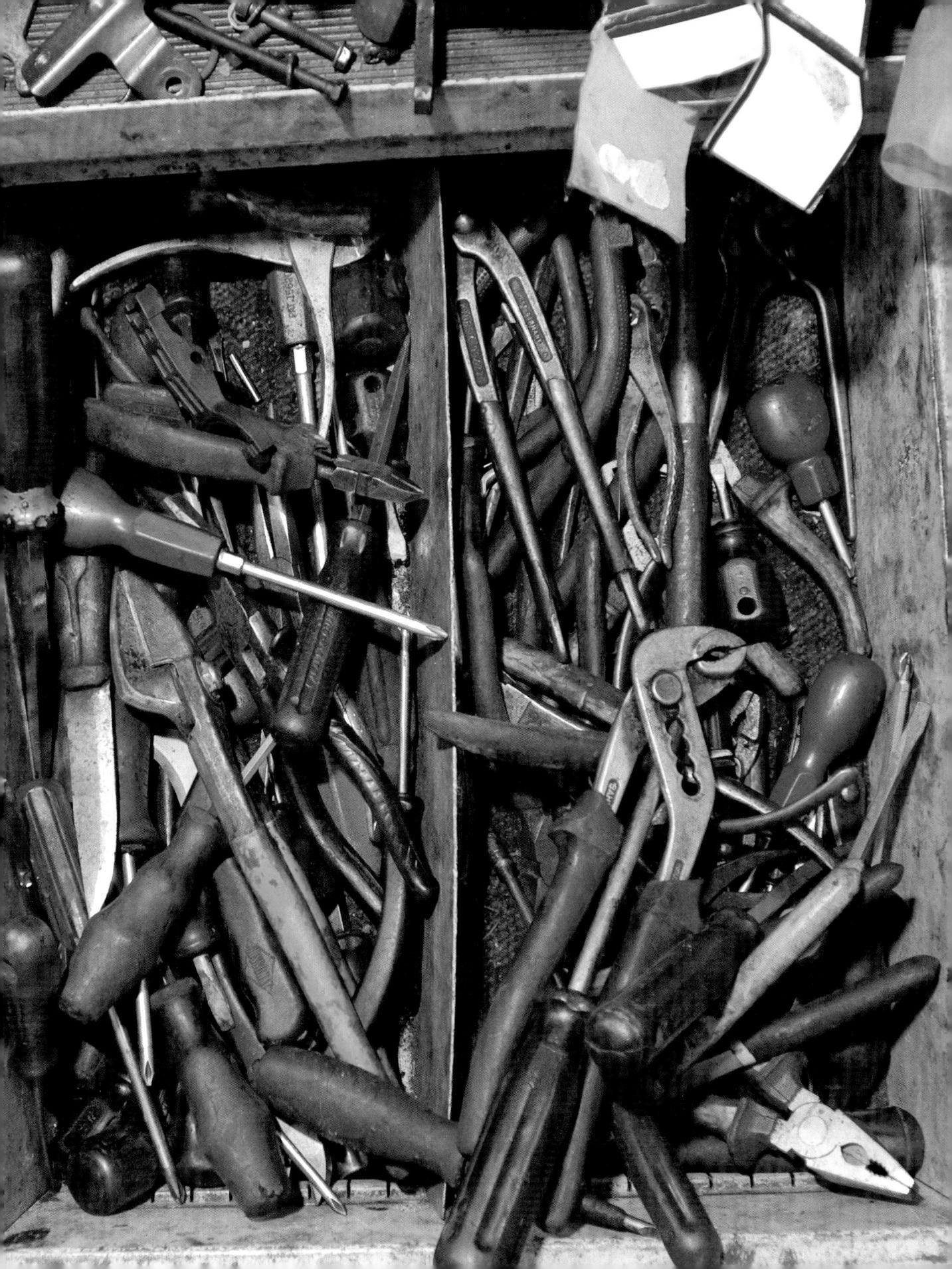

Contents

FOREWORD		xiii	
INTRODUCTI	0 N	xv	
CHAPTER 1	Shooting RAW Why Shoot RAW? When to Shoot RAW	1 2 5	
	Critical Digital Camera Settings Correct Exposure Including a Color Target	10 13 14	
CHAPTER 2	Using Adobe's Photo Downloader Using the Photo Downloader Standard Dialog Useful Features of the Advanced Dialog	17 18 24	
CHAPTER 3	Photo Editing RAW in Bridge Launching Bridge Bridge Revealed Creating a Custom Workspace Editing a Photo Session Renaming Files	27 28 29 39 44 54	
CHAPTER 4	Getting Started with Camera Raw Updating Camera Raw Workflow Options Camera Raw Tools Preview and Analysis in Camera Raw Camera Raw Tabs	57 58 60 62 71 73	80/

CHAPTER 5	Photo Editing with Camera Raw	79
	Preliminary Steps	80
	Editing the Shots	82

CHAPTER 6	Using Camera Raw Basic Tab Controls	89
	Using Camera Raw Auto Tone Adjustments	90
	Customizing the Camera Raw Default Settings	92
	Evaluating an Image in Camera Raw	95
	Manually Adjusting White Balance	104
	Manually Mapping Tone	108
	Adding Clarity	116
	Using Vibrance and Saturation	118
	Finishing Up	121
	Adjustments with Photoshop	121

CHAPTER 7	Advanced Tonal Control	125
	Using Camera Raw Tone Curves for More Control	126
	Using the HSL/Grayscale Tab	132
	Creating Custom Camera Profiles	136
	Advanced Tonal Control with Camera Raw and Photoshop	138
	Part One: Creating Two Versions	139
	Part Two: Blending Two or More Copies in Photoshop	143

CHAPIER 8	Snarpening KAW	14/
	RAW Sharpening 101	148
	Sharpening with Adobe Camera Raw	151
	Using Photoshop's Smart Sharpen	161
	Sharpening High ISO Images with Reduce Noise	167

CHAPTER 9	Reducing Noise, Correcting Chromatic Aberrations, and Controlling Vignetting About Noise Using Camera Raw to Reduce Noise Using Photoshop's Reduce Noise Filter About Chromatic Aberrations Diminishing or Adding Vignetting	169 170 171 175 182 187	
CHAPTER 10	Converting RAW to Black and White, Toning, and Special Effects Using Camera Raw's Grayscale Mix Single Color Toning Getting A Cross-Processing Look with Split Toning Pushing the Boundaries with Special Effects Advanced Localized Control	189 190 196 198 200 202	
CHAPTER 11	Archiving and Working with DNG Archive Strategy: Hedging Your Bets Saving DNG Files Converting to DNG with Camera Raw Using Adobe DNG Converter	205 206 207 213 218	
CHAPTER 12	Converting and Delivering RAW Using Bridge with Image Processor to Convert RAW Files Applying Custom Settings to Multiple RAW Images Using Camera Raw's Save Image Automating Contact Sheets, Packages, and Web Galleries Using Batch and Actions Writing Custom Scripts	221 222 229 232 237 240 245	NG MING
INDEX		246	

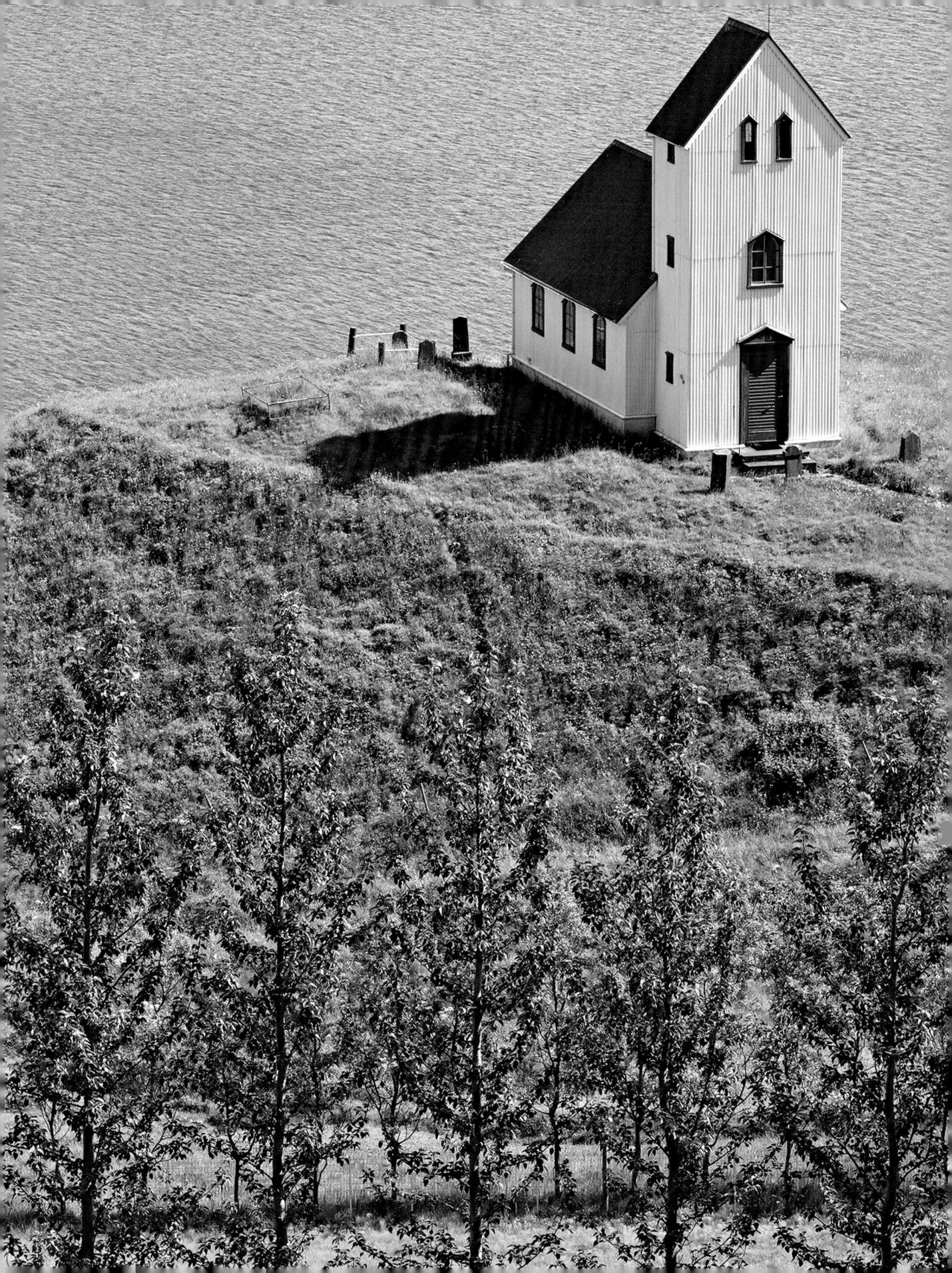

PHOTO CREDIT: Michael Reichmann

Foreword

by Michael Reichmann

The first five years of the twenty-first century have brought with them a revolution in photography. Although film isn't quite dead yet, and likely will remain in use for some years to come, both amateur and professional photographers have embraced digital photography with a vengeance. In this book, Mikkel Aaland has combined a creative photographer's sensitivity with a widely published author's clarity of expression and has produced an eminently readable, in-depth look at the most powerful image processing tools that are currently available to photographers. Mikkel helps us understand not only how these tools work, but also why they do what they do.

The creative control that the chemical darkroom offered had its appeal, but the cost, space requirements, and necessity of working in the dark, in isolation from others, diluted this appeal considerably for many. Dealing with sometimes potentially toxic chemicals also raised concerns. Today, a prosumer-level DSLR, when combined with a contemporary photoquality inkjet printer, can produce images not just equal to, but superior to, those that were possible in the darkroom as little as a decade ago.

But although the tools have changed, from enlargers and chemical trays to computers and desktop printers, the photographer still needs familiarity and skills with the appropriate tools. For most pros, and many serious amateurs, the software tools of choice are Photoshop CS2 and Camera Raw, Photoshop's built-in raw file processing program. When combined with the integrated Adobe Bridge program, photographers have a complete photographic imaging processing studio on their computer.

The arrival of digital image capture brought with it a new concept—that of the RAW file. While JPEG files have their place, and are convenient for snapshots, reportage, and use on the Web, anyone doing digital photography with an eye toward image quality will likely prefer to shoot in RAW mode.

In a RAW file, all of the settings that get "baked" into the image when one sets a camera to shoot a JPEG file are "tagged" to the file, but don't affect it. This gives the photographer great freedom to extract the best possible quality from that file, without having to commit to contrast, saturation, color balance, and sharpening settings at the time of exposure.

The RAW file gives photographers the equivalent of a latent image on film; one that is recorded but as yet unprocessed. The beauty of that file is that one can "develop" it over again any number of times, as one's skills, tools, and needs grow and change. Learning how to get the most from one's raw images is a learning process, and this book will help both newcomers and more experienced users along that path.

Michael Reichmann, photographer and publisher of www.luminous-landscape.com *Toronto, 2006*

Introduction

RAW Power

I get really excited when I talk about the unprocessed RAW data generated by digital cameras. RAW data is the holy grail of digital photography, and you don't need to be a professional photographer to appreciate its potential—you just need a digital camera that saves the RAW data, a computer, Photoshop CS3, and, of course, this book! The fact is, anyone who is serious about digital photography and wants to produce the best possible picture will benefit from shooting and processing RAW.

If you shoot RAW, use Photoshop CS3, and want great images, this book is for you!

RAW is often described as a digital negative. The negative in traditional photography is considered the underlying source from which any number of prints (or interpretations) can be produced. You can take a negative to the corner drugstore and get a decent (but uninspired) print, or you can take the same negative into a darkroom and apply skill and tender loving care to produce something remarkable.

The same holds true for RAW files. You can let your digital camera interpret the RAW data and produce a JPEG or TIFF, or you can do the work yourself.

If you do it yourself, the payoffs are great:

- · Non-destructive and complete control over white balance and color tint
- · Dramatic control over tonal distribution
- Reversible sharpening and detail application
- Full advantage of future improvements in colormetric conversion technology

Having said all this, RAW—and consequently this book—is not for everyone. Not only do you need a digital camera that saves and captures RAW, but you need a powerful computer with lots of storage. Even though you can automate RAW conversion to a certain degree, time is a consideration. The RAW data must be touched, molded, and shaped before it takes form. It takes skill to do this right, and that is where this book comes in.

RAW- and Photoshop CS3-Centric

This book is both RAW- and Photoshop CS3-centric. With some exceptions, I don't discuss working with JPEGs or TIFF files, even though the latest Camera Raw plug-in handles these file formats equally as well as RAW files. (I will show you how to convert your RAW files to these and other formats.) You also won't find reference to other RAW processors such as Adobe Photoshop Lightroom, or DC RAW, or Bibble. There are many such applications devoted to RAW conversion but for this book I've chosen the Photoshop CS3 solution, which, if you own the application, should take you just about anywhere you want to go with your

RAW data .When I say RAW, I'm talking about the unadulterated data that comes from a digital camera. When I say Photoshop CS3, I'm actually talking about three separate working environments: Bridge, Camera Raw, and Photoshop. All three of these components ship under the product name Photoshop CS3.

Bridge is a central organizer for your images, the command center for Adobe's Creative Suite, and a gateway to either Camera Raw or Photoshop.

Camera Raw is the primary RAW processing application that launches from either Bridge or Photoshop.

Photoshop...well, Photoshop is Photoshop, the world-class image editing and processing application. In this familiar environment, you can apply localized editing and processing to your converted RAW images and do whatever else is necessary to take them to their final, perfect form.

What's New in CS3

Once again Adobe has significantly improved an already great application. Very briefly, for photographers shooting RAW, the significant improvements include: A greatly enhanced Bridge with improved editing, sorting, and filtering capabilities. A significantly more feature-laden Camera Raw, with retouching tools, more tonal, color, and black and white controls, ramped up sharpening features, and the ability to open RAW files in Photoshop as Smart Objects and apply Smart Filters. Note: I wrote this book for the Standard version of Photoshop CS3, however all the information is relevant to the more expensive Extended version as well.

Platform Differences

Photoshop CS3 runs equally well on both the Mac and PC platforms. There is very little difference between the two. I work on a Mac, but I've made every possible effort to make this a PC-friendly book as well. When keyboard commands differ between platforms, I've noted the differences. I've also adopted the right-click shortcut to replace the keyboard Ctrl-/click command. This action—which often brings up a contextual menu—is long familiar to PC users, and most new Mac mice now operate similarly.

RAW Files Available for Download

I've made several of the RAW files uses in this book available for download at http://examples.oreilly.com/9780596510527/. These images are copyrighted by me, and can only be used for personal use. Feel free to experiment and test your skills on them, but don't share or publish the work without contacting me and getting permission. They all saved in the DNG file format, and contain all my Camera Raw settings. You can revert to the original default settings in Bridge by selecting Edit Develop Settings Clear Settings, or from within Camera Raw using the Setting menu, Reset Camera Raw Defaults.

Comments and Questions

Please address comments and questions concerning this book to the publisher:

O'Reilly Media, Inc. 1005 Gravenstein Highway North Sebastopol, CA 95472 (800) 998-9938 (in the United States or Canada) (707) 829-0515 (international or local) (707) 829-0104 (fax)

We'll list errata, examples, and any additional information at:

http://www.oreilly.com/catalog/photoshopraw/

To comment or ask technical questions about this book, send email to:

bookquestions@oreilly.com

Digital media artists—from the hobbyist photographer to the graphics designer and digital video producer—can find a wealth of informative and instructional articles, books, guides, and media content at O'Reilly's Digital Media site. For more creative inspiration, visit us at:

http://digitalmedia.oreilly.com/

For more information about our books, conferences, Resource Centers, and the O'Reilly Network, see our main web site at:

http://www.oreilly.com

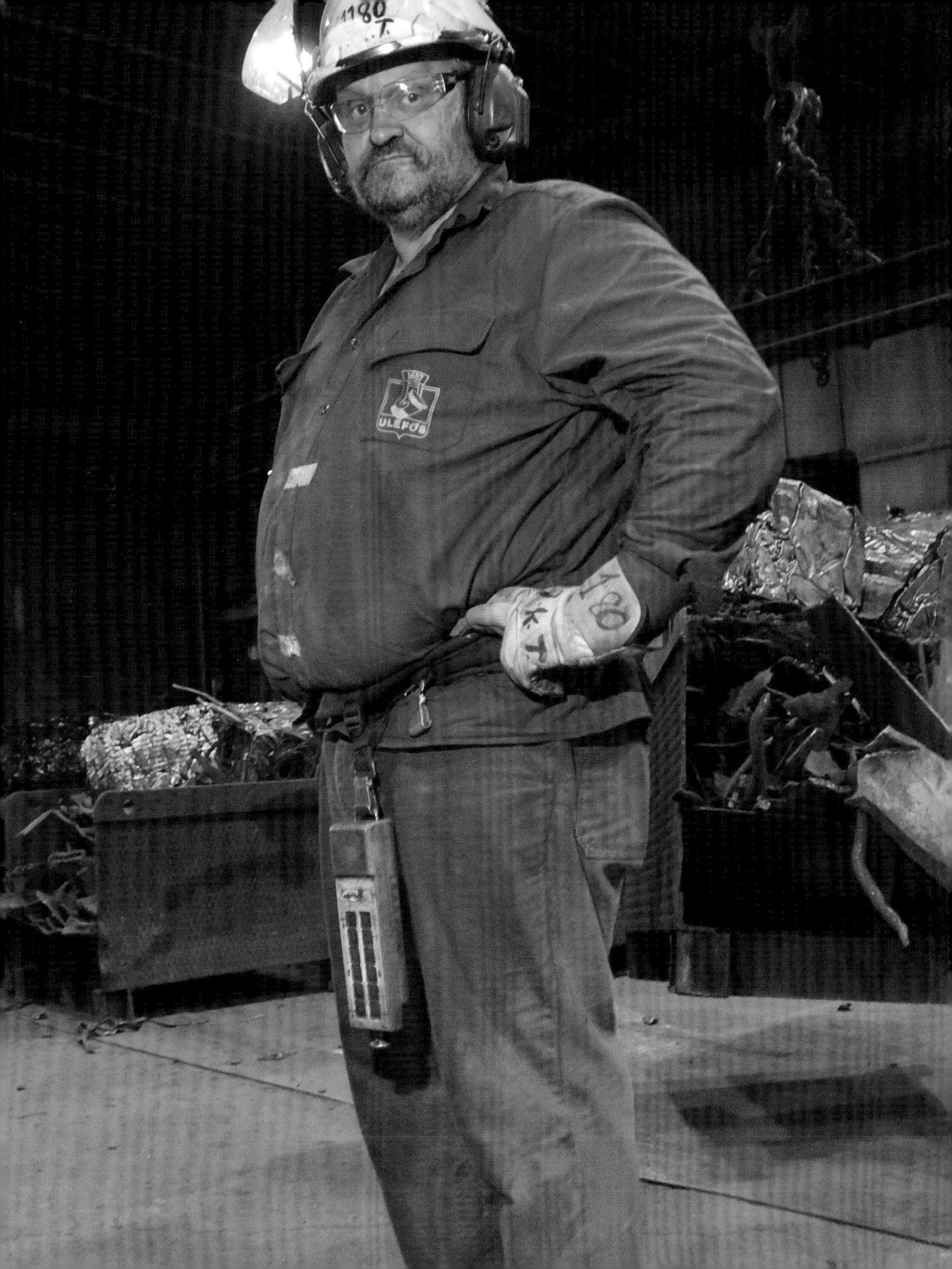

Shooting RAW

Before we look at all the wonderful things you can do to your RAW image files with Photoshop CS3, let's look at the critical (and not so critical) things you need to know when you pick up your digital camera and start shooting RAW. This chapter also summarizes the reasons for shooting RAW, and suggests times when shooting JPEG might be the way to go.

Chapter Contents

Why Shoot RAW?

When to Shoot RAW

Critical Digital Camera Settings

Correct Exposure

Including a Color Target

Why Shoot RAW?

Odds are good, since you are reading this RAW-centric book, you already know the advantages of setting your digital camera to capture RAW data. Just in case there is any doubt, let me briefly explain why shooting RAW is so cool.

I've said this many times: RAW data is the holy grail of digital photography. It contains the basic data produced by your digital camera's sensor. RAW data is also referred to as the "negative" of a digital image, from which the JPEG (or TIFF or PSD) files are derived, much like a print is derived from a negative, Figure 1-1, in traditional photography.

Assembly and Interpretation

RAW data is a mixture of camera sensor data and the camera settings data needed to decode the sensor data into an actual color image. The sensor data is mostly luminance channel pixel values (think lightness and darkness information) and hasn't yet been assembled and interpreted into color as we see it. When you set your camera to save a JPEG file, the camera processes the RAW data from the camera's sensor and saves it in this ready-to-view file format. Then, unless you have set it to do otherwise, your camera dumps the underlying RAW data. When you choose to save the RAW data (Figure 1-2), you'll need to use a computer and imaging software such as Photoshop CS3 to assemble the data into a form ready for viewing and sharing.

Figure 1-1

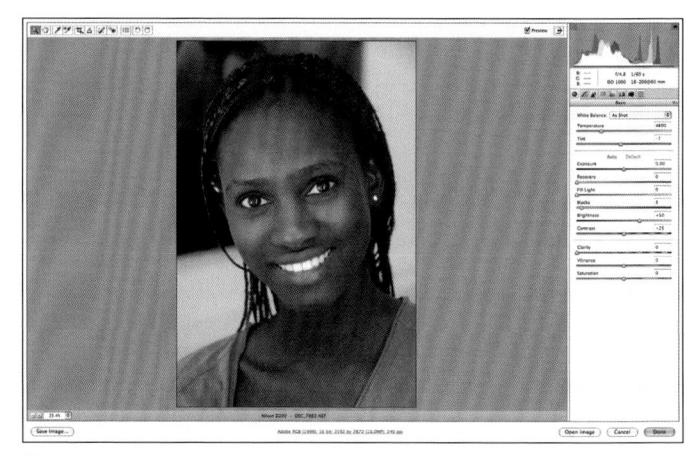

Figure 1-2

Figure 1-3

Figure 1-4

Control

Why do photographers choose to shoot RAW even when it's more work? I should start by saying that most digital cameras do a good job of interpreting and converting the RAW data into a JPEG file. That's why, as I'll explain shortly, there are many times a JPEG is perfectly acceptable. But when you leave the job of converting RAW data to a JPEG to the camera, you always end up with an interpretation of the RAW data that's based on certain camera settings, such as white balance, color space, sharpening, contrast, color, and so forth. All these settings are set by the camera (Figure 1-3).

Flexibility

If you set your camera to save the RAW file, you can later make your own interpretation—or as many interpretations as you wish (see Figure 1-4). It doesn't matter how you've set your camera—which white balance setting you used, or which color space, or how much sharpening you've set, or contrast, or color saturation. Once the RAW file is in the computer, you can change these settings will using software. Saving RAW data, therefore guarantees flexibility.

Quality

With RAW, you get higher quality because you have much more data to work with. RAW files, for example, potentially contain 12 bits of color data per channel or more, as compared to a processed JPEG file that contains only 8 bits. Sometimes the extra color data is irrelevant; however, if you know what you doing with software, often you can "tweak" more quality from

the extra bits or at least distribute the bits to your own liking. Figure 1-5 shows an enlargement of a RAW image converted with the Adobe Camera Raw auto setting. Figure 1-6 shows the same image saved as a JPEG and displayed with the Camera Raw auto settings. Note the difference in the histograms found in the upper right corner of the Camera Raw window. The RAW file displays a much more complete distribution of tonal values, and there is a lot of room to adjust these values. The JPEG file can of course be adjusted, but with less tonal values to work with.

Some photographers find that by carefully mapping the tonal values of a RAW image they can capture much more detail in both shadow and highlight areas than would be possible otherwise.

Benefit from Software Improvements

Finally, when you shoot and save RAW files, you also stand to benefit from improvements in RAW conversion software. As software improves, you can go back to your old RAW files and apply the latest technology to your files, and often reap the benefits from faster, more powerful computers and more sophisticated RAW decoding algorithms. (This also begs the question: will RAW decoders of the future even read older RAW files at all? I'll go over this in depth in Chapter 11.)

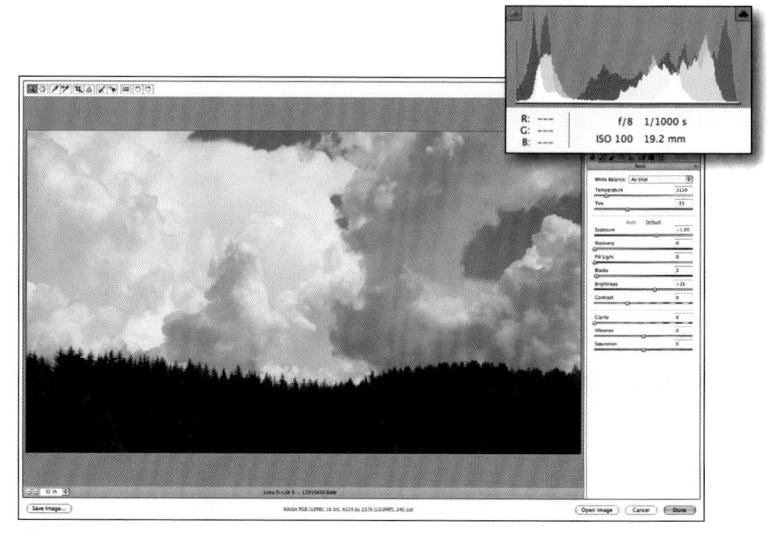

Figure 1-5

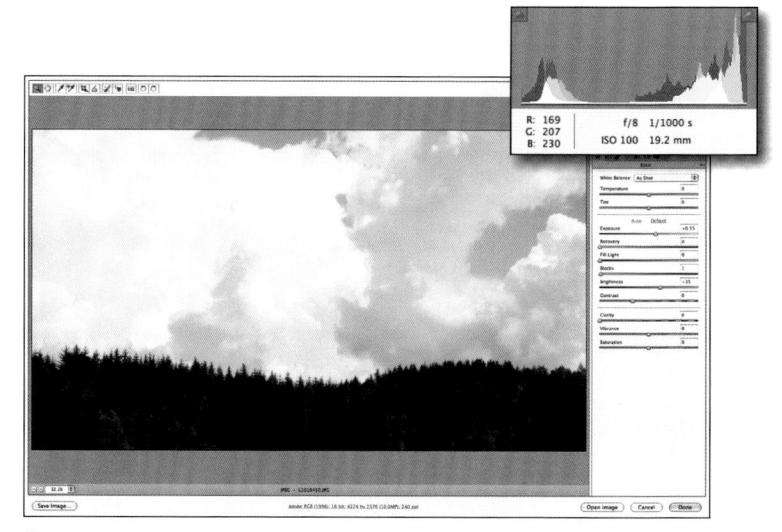

Figure 1-6

Not every shot warrants the flexibility and quality of RAW, especially when you consider storage limitations and the extra work it takes downstream to convert and process the RAW files into formats that can be printed or otherwise shared. When is it appropriate to shoot RAW, and when is it not?

When to Shoot RAW

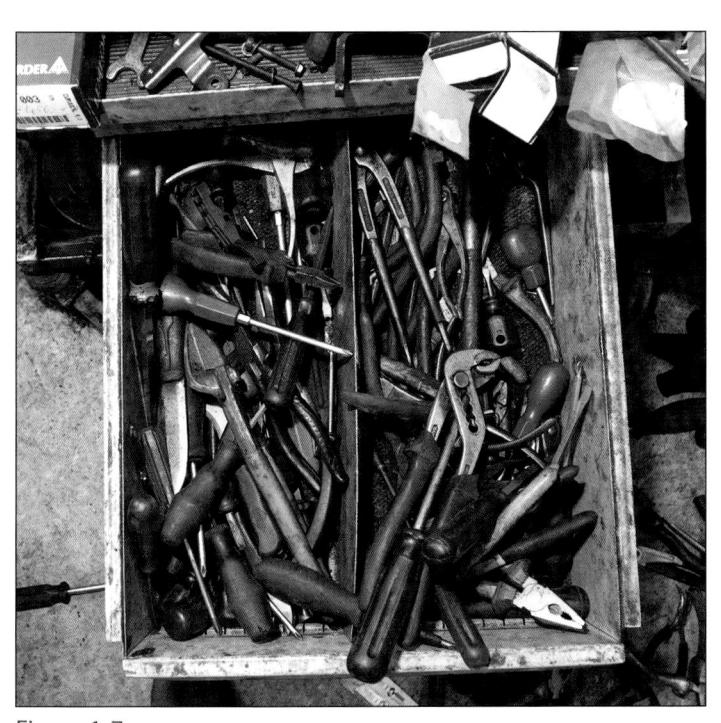

Figure 1-7

Shoot RAW if
Technical quality is critical
Memory is plentiful
Processing time is available

Shoot JPEG if
Capture speed is an issue
Camera memory is limited
Time is of the essence for processing

(Many digital cameras will save only a few RAW files before temporarily "freezing" as RAW data is written to memory.)

In an ideal world—a world fast becoming reality—there will be little or no additional cost associated with the decision to shoot RAW. Digital camera memory will be so cheap that file size won't matter. Digital cameras will easily save both a RAW and a JPEG file—or other file formats of choice. Camera processing time will be reduced significantly so there will be no "backlog" as RAW files are saved to memory. Computer processing power will be so great that it won't take any more effort to manage and process your RAW files than a simple click of the mouse. More applications and operating systems will recognize and display RAW images—much like they universally read and recognize JPEG or TIFF files today. Figure 1-7

This ideal world isn't with us quite yet—even though more and more digital cameras offer a choice of saving both RAW and JPEG (RAW + JPEG).

Since it isn't here yet, I suggest using the guidelines found to the right to determine whether you should be using the RAW format.

(I used to include TIFF as an option, but TIFF is rarely available with digital cameras anymore, so I won't bother with it either.)

A RAW vs. JPEG Example

Here are a couple of examples of RAW versus JPEG choices I made that illustrate some of the decisions you may face. I was in Iceland doing the groundwork for a large photographic project (The Lightroom Adventure) scheduled for a few months in late summer. I brought my wife and daughters with me and mixed work with pleasure. Figure 1-8 is one of several shots of the family enjoying the famous Blue Lagoon, a unique geothermal spa just outside Reykjavik.

These are family mementos, snapshots if you will, meant for the family album. I didn't want to fill my memory card since I was going to have limited opportunities to download photos to my laptop and I had plenty of shooting ahead of me. In this case, I set my camera file preferences to JPEG with the highest quality setting. The saved file size was only 2.5MB and I could shoot to my heart's content without worrying about quickly filling my 1GB memory card.

Later in the day, while strolling around Reykjavik, we came across the church shown in Figure 1-9. With this architecturally complex scene in front of me, my concern for quality and flexibility increased, and I switched my file setting from JPEG to RAW. In the past, I might have used a medium format camera for this kind of shot. The act of changing my file format setting helped put me in a more deliberate mood, and I took time to carefully frame the shot and pay attention to detail. The resulting file size was 15.8MB, considerably larger than a JPEG would have been. For now, changing file formats is a part of my work process, just like changing f-stops and shutter speeds.

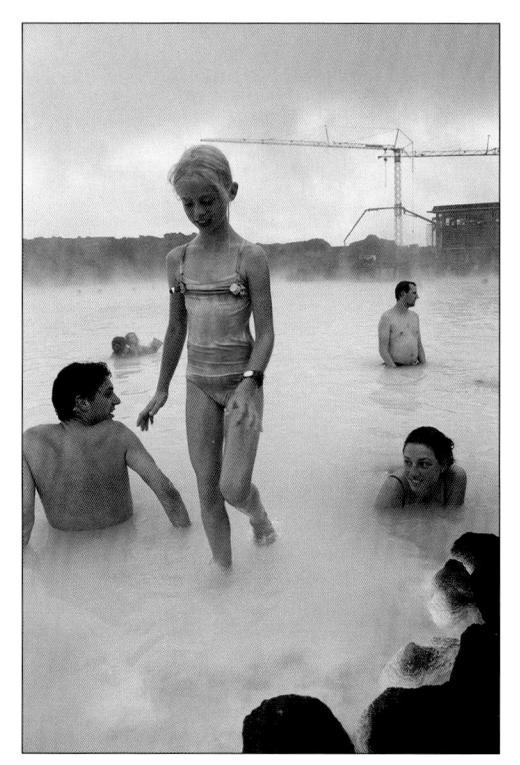

Figure 1-8

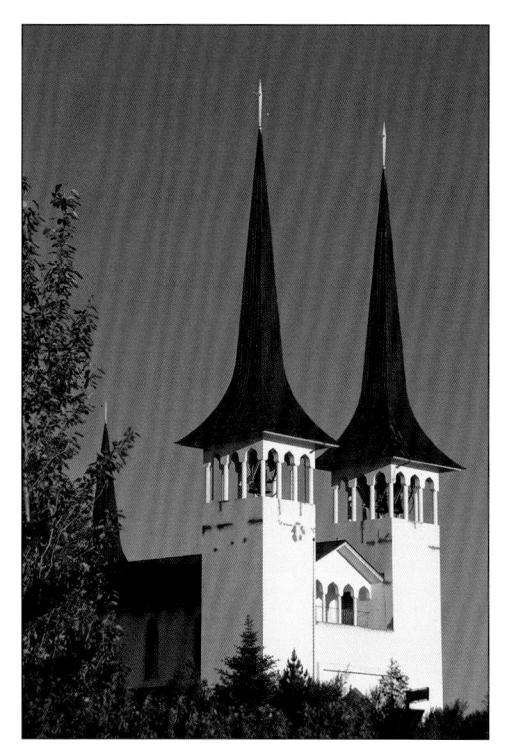

Figure 1-9

Figure 1-10

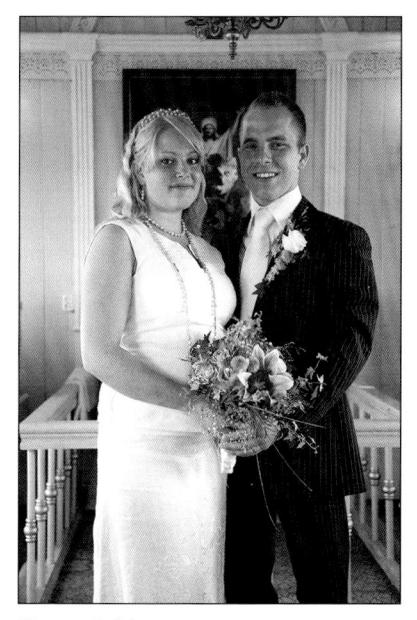

Figure 1-11 © Derrick Story

Figure 1-12

Every photographer will come up with their own criteria and rationale for shooting RAW. I've heard many event photographers say they avoid the RAW format altogether when shooting conventions and other such "grip and grin" situations, as in Figure 1-10. They are perfectly satisfied with the quality of JPEGs, which don't require postprocessing like a RAW file does.

Wedding photographers, on the other hand, tend to shoot and archive RAW files, giving them maximum flexibility for extracting various sizes and quality options later, in order to meet their clients' wishes (Figure 1-11).

Almost every nature photographer I know shoots and archives RAW, which makes sense, since quality is such an important aspect of the kind of shooting seen in Figure 1-12.

Sports photographers I talk to shoot a combination of RAW and JPEG, depending on the capabilities of their equipment and the situation.

I know some photographers are "purists" and believe that shooting RAW all the time is the only way to go. I see their point, but I like to suggest a useful analogy: Compare RAW to FM radio with its higher fidelity. Compare JPEG to AM radio with its lower quality but wider broadcast capabilities. For some things, like classical music, I turn to FM. For others, like the traffic and weather, I turn to AM. There is a place for both.

Actual files found at http://examples.oreilly.com/9780596510527/

This image was shot at the Ulefoss Ironwork in Norway. The factory is a 350 year old factory that produces a variety of iron products, ranging from stoves to manhole covers. In the heat of shooting, I mistakenly changed the white balance from Auto to K 5000. Thank goodness I shot RAW! It was easy to get the colors right, as you can find out for yourself by downloading the original RAW file and opening it in Camera Raw. (For more on adjusting White Balance, see Chapter 6.)

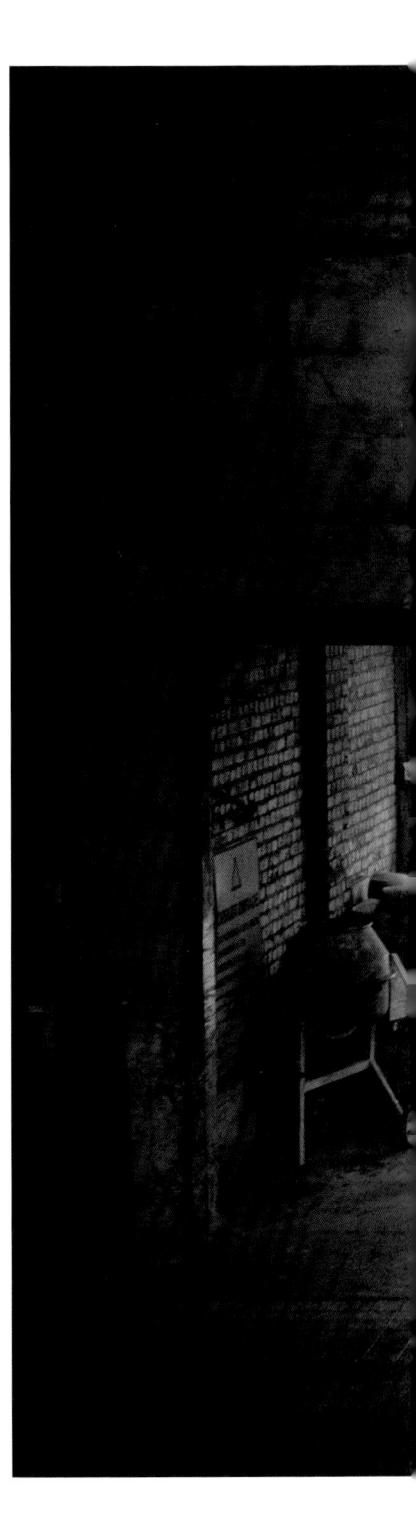

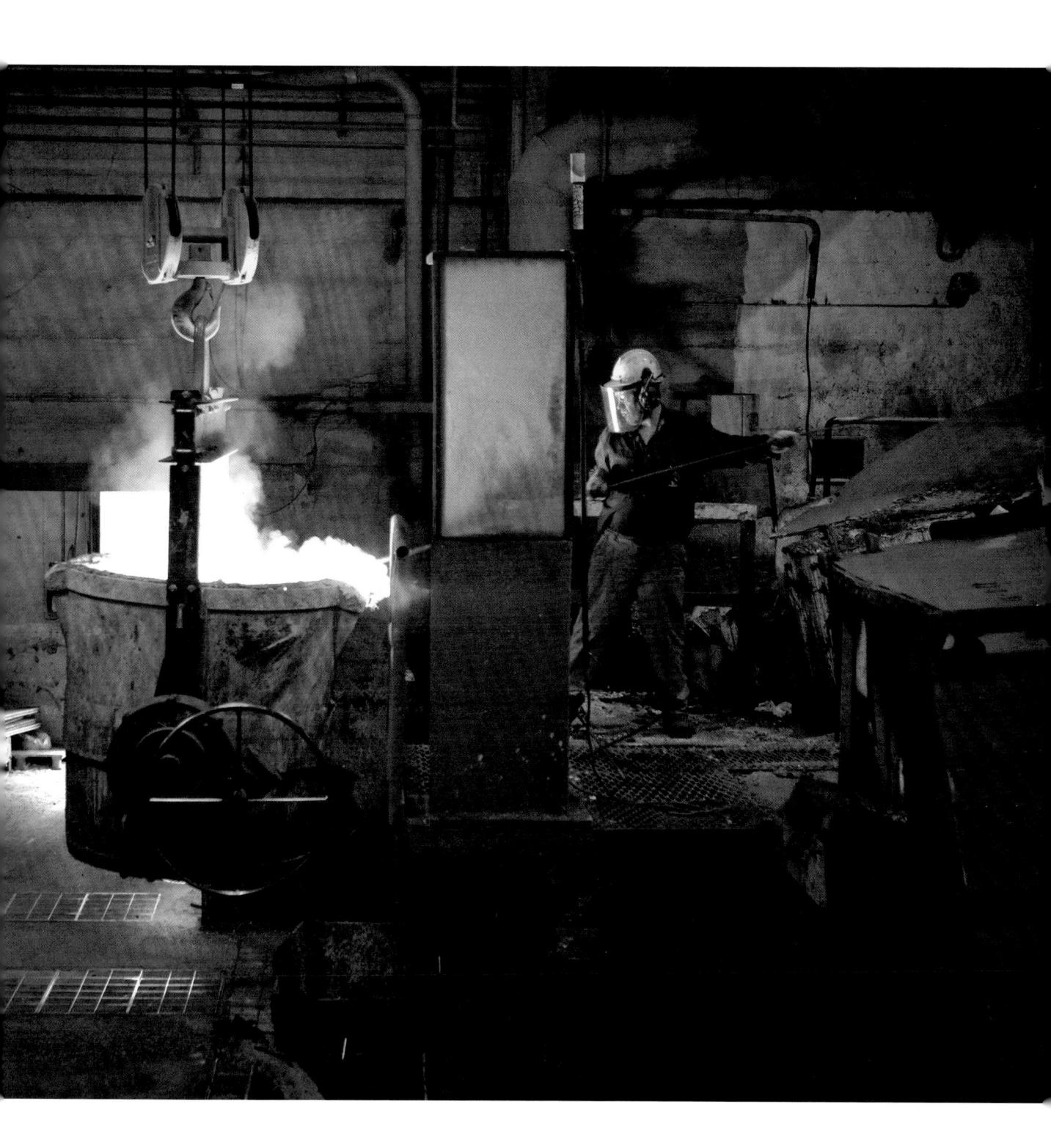

Critical Digital Camera Settings

Shooting RAW adds built-in flexibility from a processing point of view. But the degree of flexibility is dependent on making the right choices as often as possible up front, even before you shoot. In short, some camera settings are critical; others aren't.

What's Critical for RAW

Here are what I consider to be the critical camera settings when you're shooting and saving RAW:

- · File format
- Exposure
- ISO

File Format

This one is obvious; if you don't set your camera to save RAW, as in Figure 1-13, well, you won't get a RAW file with all its benefits.

Exposure

As I'll explain in the following section, there is a common misconception that you don't have to worry about exposure (Figure 1-14) when you shoot RAW. True, you have more margin of error with RAW, but only to a degree. (More on exposure correction later, in Chapter 4.)

150

Just because you shoot RAW doesn't change the fundamental fact that quality is compromised at higher ISOs. The higher the ISO, the more electronic noise. This isn't necessarily bad. You just need to know how ISO settings (shown in Figure 1-15) can make a noticeable difference. (In Chapter 7, I'll explain how to work with high ISOs when processing.)

Figure 1-14

The Not-So-Critical

Here are the issues I don't consider to be quite as important when shooting RAW:

White Balance

I put this in the less-critical category with qualification. Yes, it's true, white balance (Figure 1-16) can be determined later in Adobe Camera Raw with no quantifiable consequences. However, getting a correct white balance setting from the start can streamline the process later.

Sharpening

It doesn't matter how you set your camera sharpening setting, (as shown in Figure 1-17) Camera Raw ignores your settings and applies an optional setting of its own. However, if you shoot RAW+JPEG, your sharpening settings will apply to the JPEG file. Common wisdom is to turn sharpening to its minimum, and leave it as a last step in processing, just before printing. I'll cover process sharpening more fully in Chapter 6.

Color Space

Again, it doesn't matter which color space you set your digital camera to—be it commonly offered Adobe RGB or sRGB (see Figure 1-18). Whatever color space you set can be changed later without consequence in Camera Raw. Color space determines which of the visible colors are available for your image. Some color spaces, like Adobe RGB, are wider and encompass more colors than, say, sRGB, which offers a more limited gamut of color. Keep in mind, if you shoot RAW+JPEG, the camera-selected color space is applied to the JPEG—and can't be changed later without degrading the image.

The Not-at-all Critical

Many digital SLRs (and some digital pointand-shoots) offer sophisticated control over the way black and white images are converted in the camera. Many also offer other kinds of special effects and custom looks. If you use Adobe Camera Raw, or any RAW converter besides the one provided by the camera manufacturer, don't spent a lot of time fiddling with these controls. The settings are often encrypted and unreadable. On first glance in Adobe Bridge, you will probably get a preview that appears to contain your camera settings, such as the shot shown in Figure 1-19. However, once Bridge has created its own preview, the original camera settings are not applied, as shown in Figure 1-20.

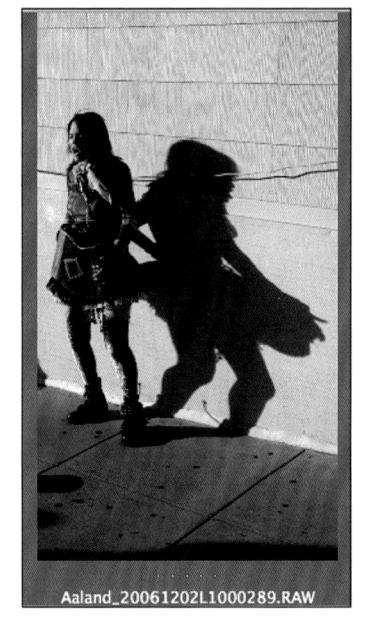

Figure 1-19

Figure 1-20

TIP In most single—light source shooting situations, I rely on my camera's Auto White Balance setting. When lighting sources are mixed—i.e., tungsten and florescent lights—I use the ExpoDisc Digital White Balance filter shown in Figure 1-21, and create a custom white balance setting. You can achieve a custom white balance setting with a simple gray card, but I find the results achieved with the ExpoDisc far superior. It's available for around \$75 at camera stores and online at www. expoimaging.net.

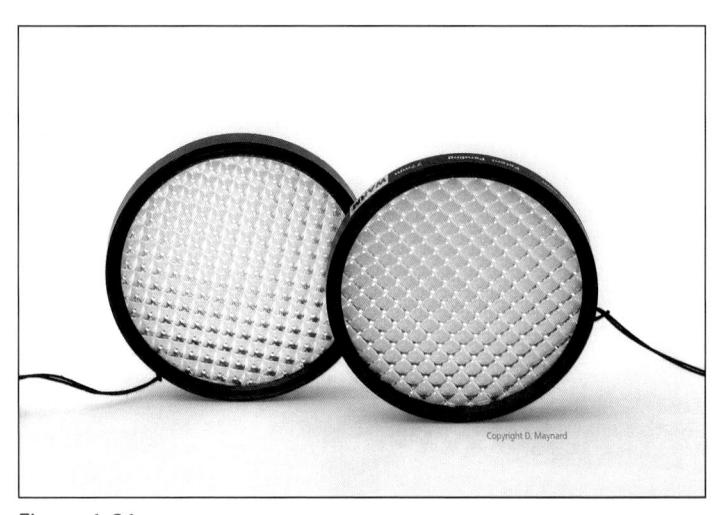

Figure 1-21

It's a common misconception that you don't have to worry about exposure when you shoot RAW. Sure, you have more exposure latitude with RAW, but the further your image is from correct exposure, the more work you'll have to do in Camera Raw or Photoshop to get it right.

Correct Exposure

Figure 1-22

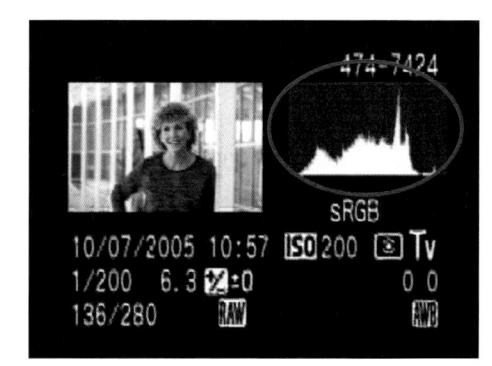

Figure 1-23

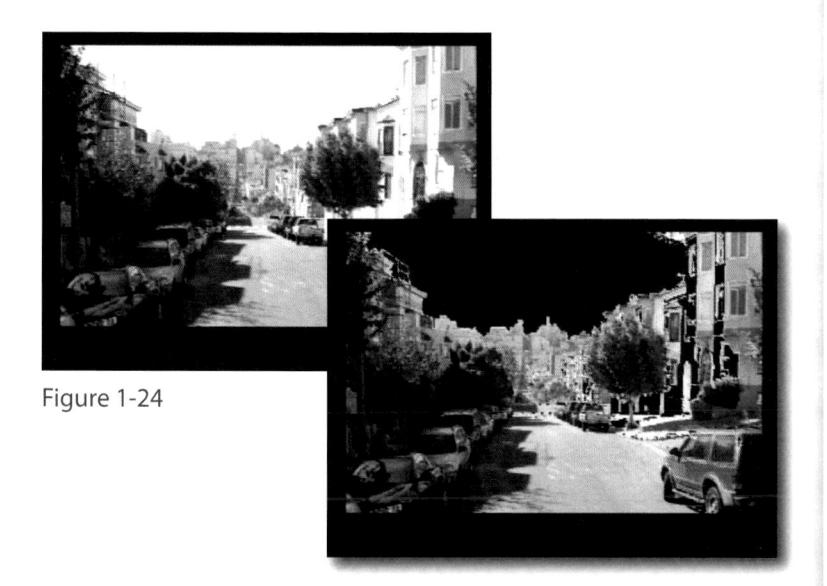

Getting the correct exposure—as most photographers know—can either be very difficult or a piece of cake. It depends on the subject, the light, and the camera's capabilities. Fortunately, almost all digital cameras come with built-in features that help determine whether you are in the ballpark: LCD previews, histograms, and over/ under exposure warnings. If you haven't already, it's good to familiarize yourself with these handy tools and use them wisely. (My book *Shooting Digital* goes into the subject of exposure in great detail.)

LCD Preview The LCD preview, shown in Figure 1-22, will tell you if you got the shot, but it shouldn't be relied on as an indictor of correct exposure.

Histogram Camera histograms, like the one circled in Figure 1-23, are a good indicator of exposure. Properly exposed images will produce a welldistributed histogram, shifted slightly more to the highlights (right side) without clipping.

Over/Under Exposure Warnings Flashing
Over/Under exposure warnings,
(represented in Figure 1-24) are
distracting, but at a glance you'll know
if your highlights are too light or your
shadows are too dark.

Including a Color Target

When it is possible or practical, I find it very useful to include a gray card or a color target—such as the GretagMacbeth color test chart—in at least one representative shot.

You can find color targets at professional camera stores or on the web via a simple search. An X-rite ColorChecker target, like the one shown in Figure 1-25, should cost around \$50.

Gray cards, like the one shown in Figure 1-26, are much less expensive, ranging from \$10–\$20.

Placement of the X-rite ColorChecker target is easy and most effective in a studio environment with controlled lighting. Simply place the target so the studio lights strike it evenly, as in Figure 1-27. Unless you change the type of lighting—i.e., from strobe to tungsten—all you need is one sample shot with the target. Using a target (be it the X-rite ColorChecker target or a gray card) outdoors under varying lighting conditions is trickier. As the light changes, you'll need to reshoot the target to reflect the changes.

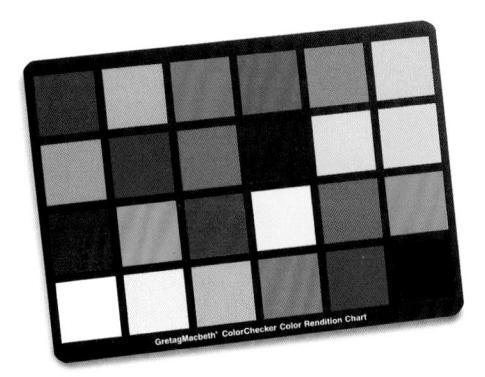

Figure 1-25

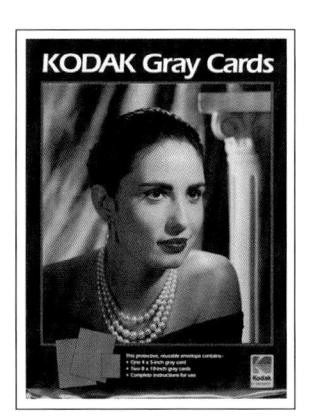

Figure 1-26

Figure 1-27

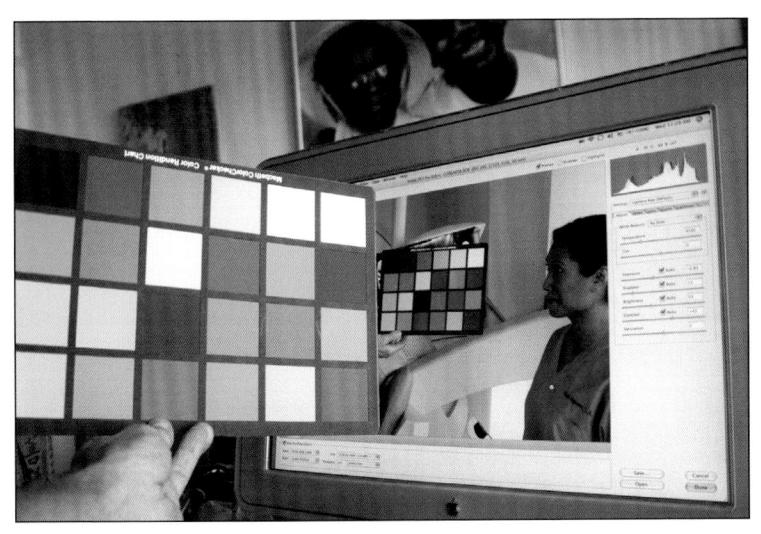

Figure 1-28

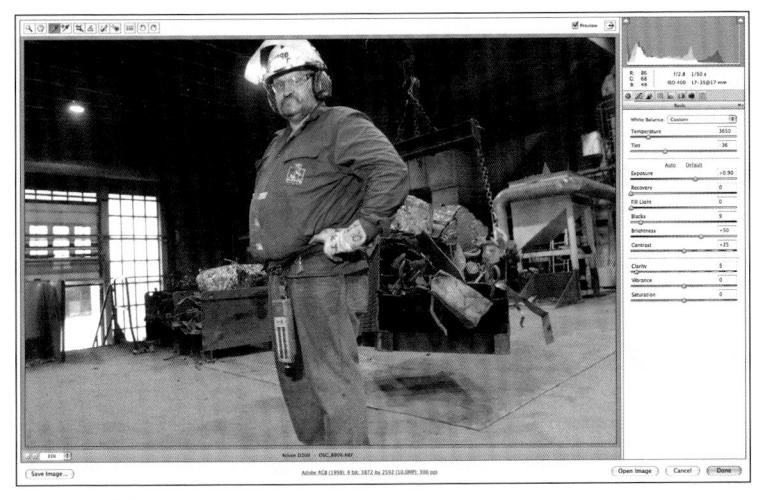

Figure 1-29

Later, when I open my files in Camera Raw, I use targets in either of two ways. If I've included an X-rite ColorChecker card in the shot, I simply hold up the actual color target next to my monitor (Figure 1-28), compare the colors with those on my screen, and manually make adjustments.

This is a very crude and inaccurate method, but sometimes it's all I need.
Other times I simply use a gray card (or one of the neutral colored boxes at the bottom of the X-rite ColorChecker card) as a target for determining correct balance.
I'll discuss this further in Chapter 6.

NOTE Every digital camera produces images with a specific color bias.
Camera Raw compensates for this by referring to color profiles specific to a particular camera.
Depending on your taste and your camera, the default Camera Raw setting may produce satisfactory results. If it doesn't, you can create custom settings for Camera Raw that will help ensure consistent and satisfactory results, as shown in Figure 1-29. I'll show you more on this in Chapter 7.

Using Adobe's Photo Downloader

Adobe Bridge—which is a standalone application that comes with CS3—now includes a gateway to a very useful application called Photo Downloader, which can be used to move files from your digital camera's memory card directly to a storage location of your choice. Photo Downloader vastly improves the performance of the previous Camera Import script and includes some very important features, including the ability to apply metadata templates on import or convert image files to the DNG format.

If your digital camera files have already been transferred to your computer, you might want to go directly to Chapter 3, where I'll describe in detail how to use Adobe Bridge to display these files as well as organize, rate, and sort them.

Chapter Contents

Using the Photo Downloader Standard Dialog
Useful Features of the Advanced Dialog

Using the Photo Downloader Standard Dialog

You can set Photo Downloader to automatically launch when a card reader or external camera source is detected, regardless of whether Bridge or Photoshop are open. Or you can launch Photo Downloader manually from within Bridge.

First we need to open up Adobe Bridge. Do this directly from Photoshop's menu bar by selecting File→Browse, as shown in Figure 2-1.

Or you can also double-click the application icon on your desktop, Figure 2-2, and open Bridge independently from Photoshop.

Setting Preferences

To make Photo Downloader launch on a Mac whenever it detects a card reader or camera source, open Bridge Preferences. (Preferences are found under the Bridge CS3 menu.)

Select When a Camera is Connected, Launch Photo Downloader, circled in Figure 2-3. Deselect this Preference option if you want to launch Photo Downloader manually via the File menu.

In Windows, download preferences are set on a system level, via the Auto Play dialog window Let's start with the Photo Downloader's Standard Dialog mode and see how easy it is to quickly transfer images from your digital camera, rename files, and, if you choose, convert them to DNG. In a subsequent section, I'll show you how to use the Advanced Dialog mode to do even more.

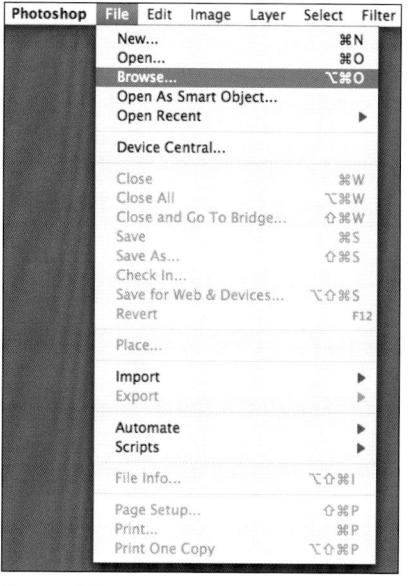

Bridge CS3

Figure 2-1

Figure 2-2

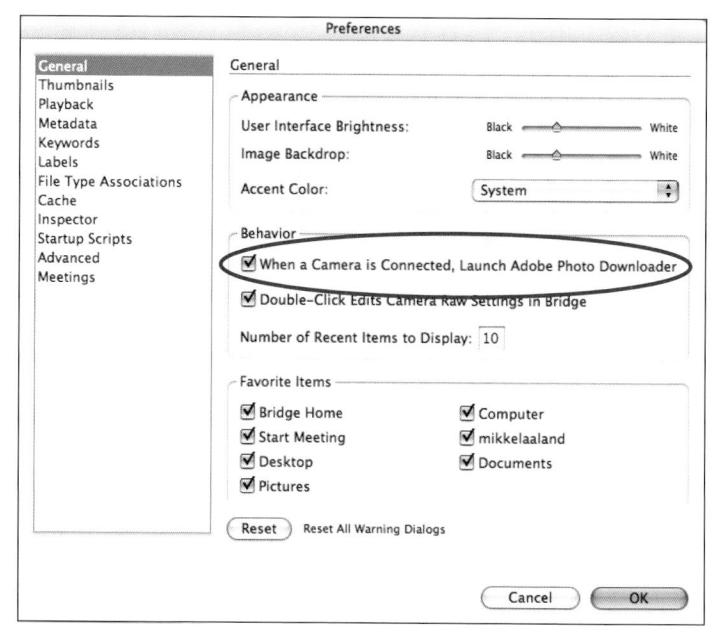

Figure 2-3
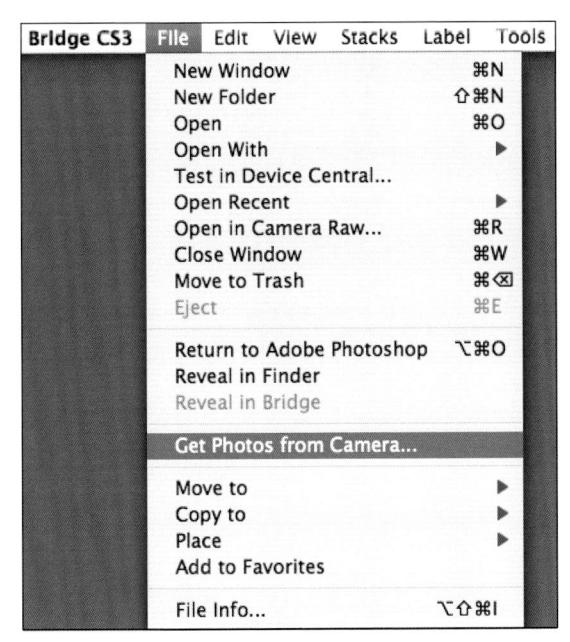

Figure 2-4

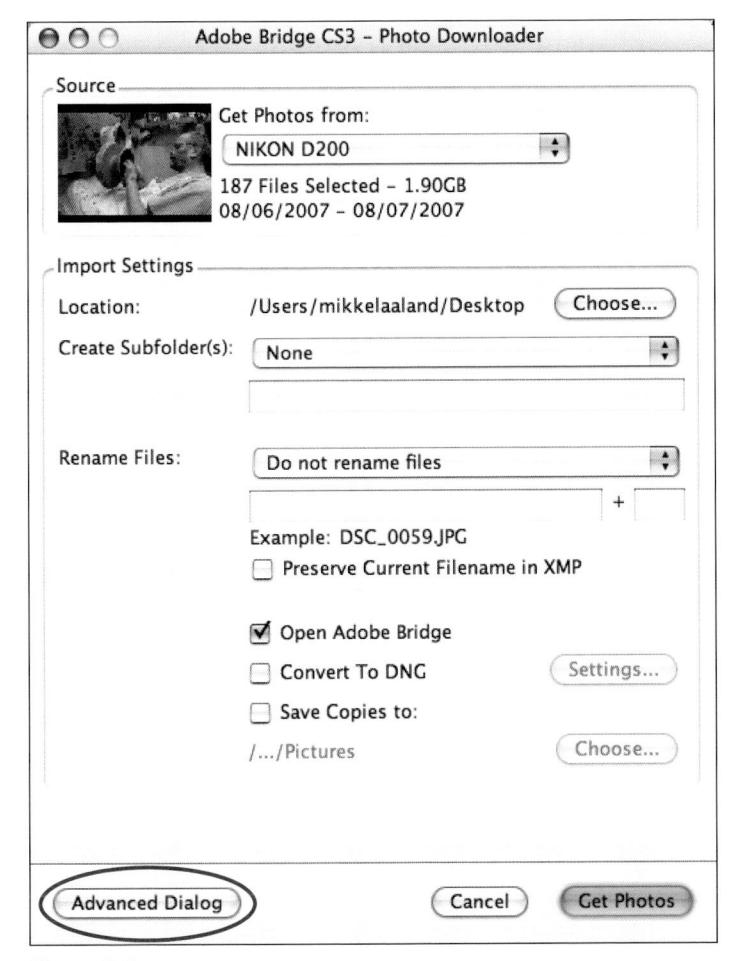

Figure 2-5

Launching Photo Downloader Manually

To launch Photo Downloader manually from Bridge, from the File menu, select Get Photos from Camera, as shown in Figure 2-4.

Choosing Get Photos from Camera brings up the dialog box shown in Figure 2-5. Let's go through the various options starting at the top of the dialog box.

NOTE Clicking on the Advanced Dialog button at the bottom of this dialog box (circled) opens up a new set of options, which I'll cover in the next section.

Get Photos from

If multiple sources are detected, you can select the one you wish to download from the pop-up menu. The number of Files Selected displays under the pop-up menu, as well as the total file size, and a range of dates derived from the files' embedded capture times.

Import Settings

Under Location, choose a place to transfer your files by selecting Choose and navigating to your location of choice.

In the Create Subfolders pop-up menu, you can choose several ways of organizing your files, as shown in Figure 2-6. If you select None, Photoshop Downloader does not create any subfolders and places the images in the Location previously selected. If you select Custom Name, you can name one subfolder. (A text box appears under Custom Name.) If you select Today's Date, Photo Downloader creates a folder and names it with the current date in the year/month/day format.

If you choose Shot Date (and pick from a range of date-naming options), then different subfolders are created containing images meeting the same criteria. You'll know how many subfolders are created by looking next to Location, circled in Figure 2-7.

I usually find it easier to make just one Custom Name folder and place my images from one download in it. That way I don't have to navigate through several subfolders to find the image I'm looking for.

Rename files

If you want, you can have Photo Downloader rename the files generated by your digital camera. A variety of custom sequences are available via the pop-up menu, shown in Figure 2-8.

Since camera file names are nondescriptive, renaming them is sometimes desirable. It also prevents the possibility of accidently overwriting camera files with the same file name. I like to include my last name, the date, and the unique camera file number. This provides a lot of useful information at a glance without having to open or otherwise view the file.

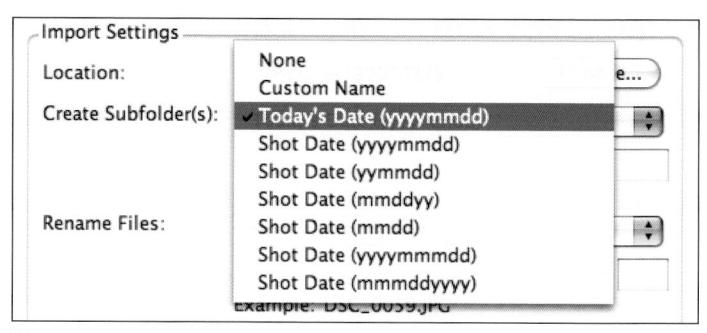

Figure 2-6

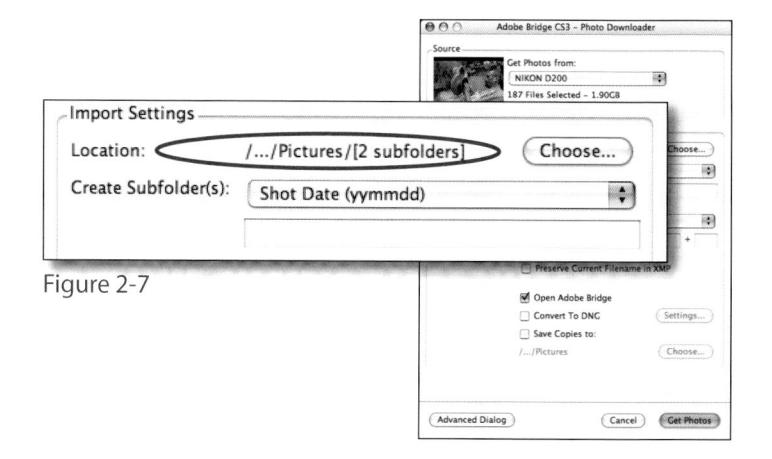

Figure 2-8

NOTE You can always rename your files later, after transferring them from your digital camera. To do this in Bridge, select the files you wish to rename and then select Tools—Batch Rename. Using this method provides even more naming options and may be the desirable way to go for some. For more on using Batch Rename, refer to Chapter 3.

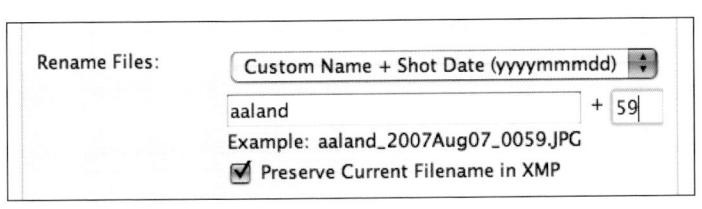

Figure 2-9

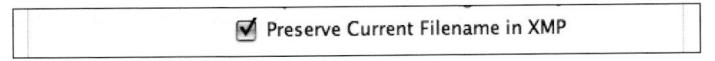

Figure 2-10

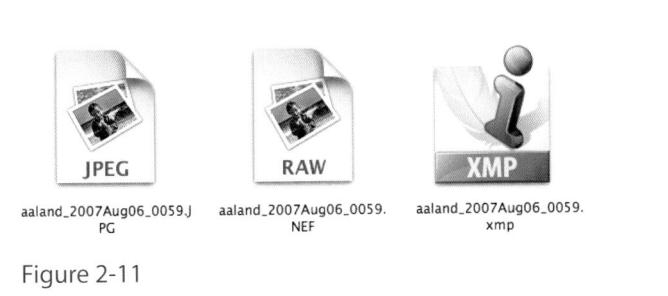

✓ Open Adobe Bridge

Convert To DNG

Settings...

Figure 2-12

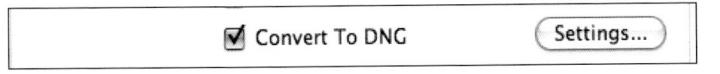

Figure 2-13

Figure 2-14

In order to create this particular sequence, select Custom Name + Shot Date from the pop-up menu (Figure 2-9). Type your name in the text field and insert a sequence number. (I start my sequence based on the first number of my first shot.) An example always appears so you can see what a file name will look like.

Preserve Current Filename in XMP

Regardless of what file name you choose, you can have Photo Downloader maintain a record of the original file name as XMP data by selecting Preserve Current Filename in XMP, as shown in Figure 2-10.

With JPEG files, the XMP data is written directly into the image file. For native RAW files, it is written to an XMP sidecar that exists independently of the original RAW file (Figure 2-11). If you use a renaming nomenclature that doesn't include the original file name, it's a good idea to preserve the current file name this way. You never know when a unique camera-naming sequence might come in handy when searching for a file.

Open Adobe Bridge

If you select this option (Figure 2-12), Bridge displays your downloaded images in the preview window upon completion of your download.

Convert to DNG

Convert your JPEG or RAW files into the Digital Negative file format (DNG) by selecting the DNG option (Figure 2-13). DNG is covered in Chapter 11.

Save Copies to

Automatically back up your files at another location by choosing a destination (Figure 2-14). This slows the download time a little because an exact duplicate of your files is created.

GRUNDIG

Working RAW

Actual files found at http://examples.oreilly.com/9780596510527

Once again, this is my Citroen car mechanic, Tor Tinholt, in Ulefoss, Norway. His grease-encrusted hands can also be found elsewhere in this book. If you download the RAW file and compare the original with what I have done, you'll see it took some work to get the tonal values right. I used the Recovery slider to bring out detail in the window area and boosted the Black slider. I also used Fill Flash to open up the values in Tor's face and finished off by adding a vignette to the edges.

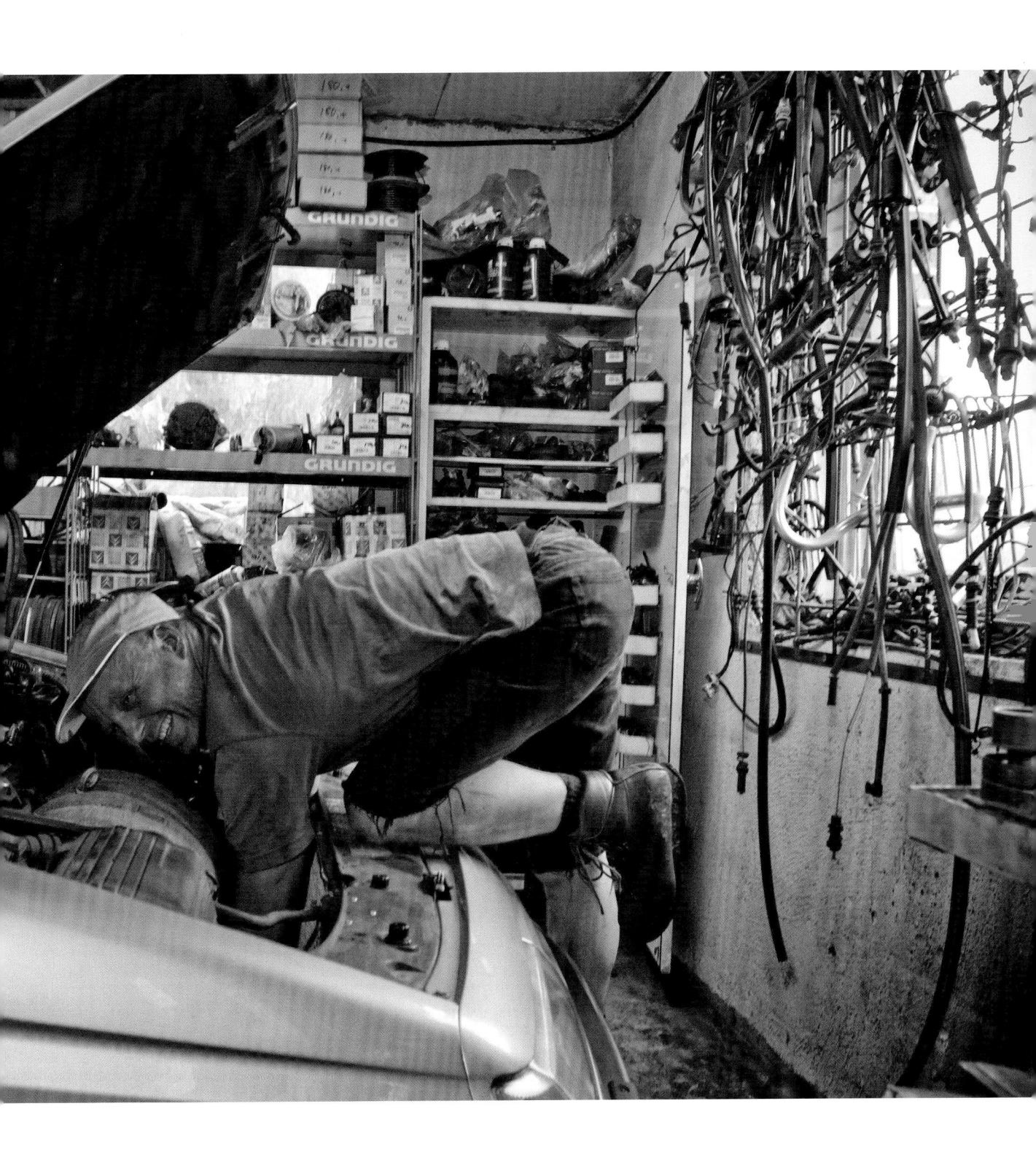

Useful Features of the Advanced Dialog

To get to the Advanced Dialog mode, simply select Advanced Dialog at the bottom of the Photo Downloader dialog box. You will see something similar to the dialog box shown in Figure 2-15. The difference with Advanced mode is that you can make a selection of specific images rather than import all of them at once, and you can apply useful metadata to every image file directly on import.

Selecting Images

By default, all the images in the preview window are selected. You can deselect images individually by checking the box in the upper right of a thumbnail. You can also select Check All at the bottom of the box and add images one by one by checking the box on individual thumbnails. Use the scroll bar on the right to view images that don't fit in the small viewing area.

Right-click on an image and you get the contextual menu shown in Figure 2-16.

The theory here is the more you do to your images on import, the less work later. When you select Advanced Dialog, you can not only select which images are imported from a thumbnail display, but you can also add the all-important metadata that publicly asserts your copyright and other rights to an image.

Figure 2-15

Figure 2-16

Figure 2-17

Figure 2-18

Figure 2-19

Adding Metadata

This is one of the most useful of all the new features of Photo Downloader.
You can add metadata such as name, copyright, contact information, usage rights, etc., on import. Photo Downloader automatically adds this data directly to your image files. You have two basic choices

Basic Metadata

When you select this option from the pop-up menu (Figure 2-17) you have only two choices: Author and Copyright, which may be all you need, for now. (You can always go in later, in Bridge, and add more data fields and keywords as well.)

Presets

If you have created a metadata preset in Bridge, it appears as an option in the popup menu as well, as in Figure 2-18.

After You Are Done

Once you are finished, select Get
Photos from the bottom of the Photo
Downloader dialog box. The download
time depends on the number of images,
the speed of your computer system,
and your settings. You can stop the
transfer at any time by hitting Stop in
the downloading dialog box circled in
Figure 2-19. I would caution you against
immediately erasing your camera
memory card until you have opened a few
files from your computer storage just to
make sure the transfer was accurate.

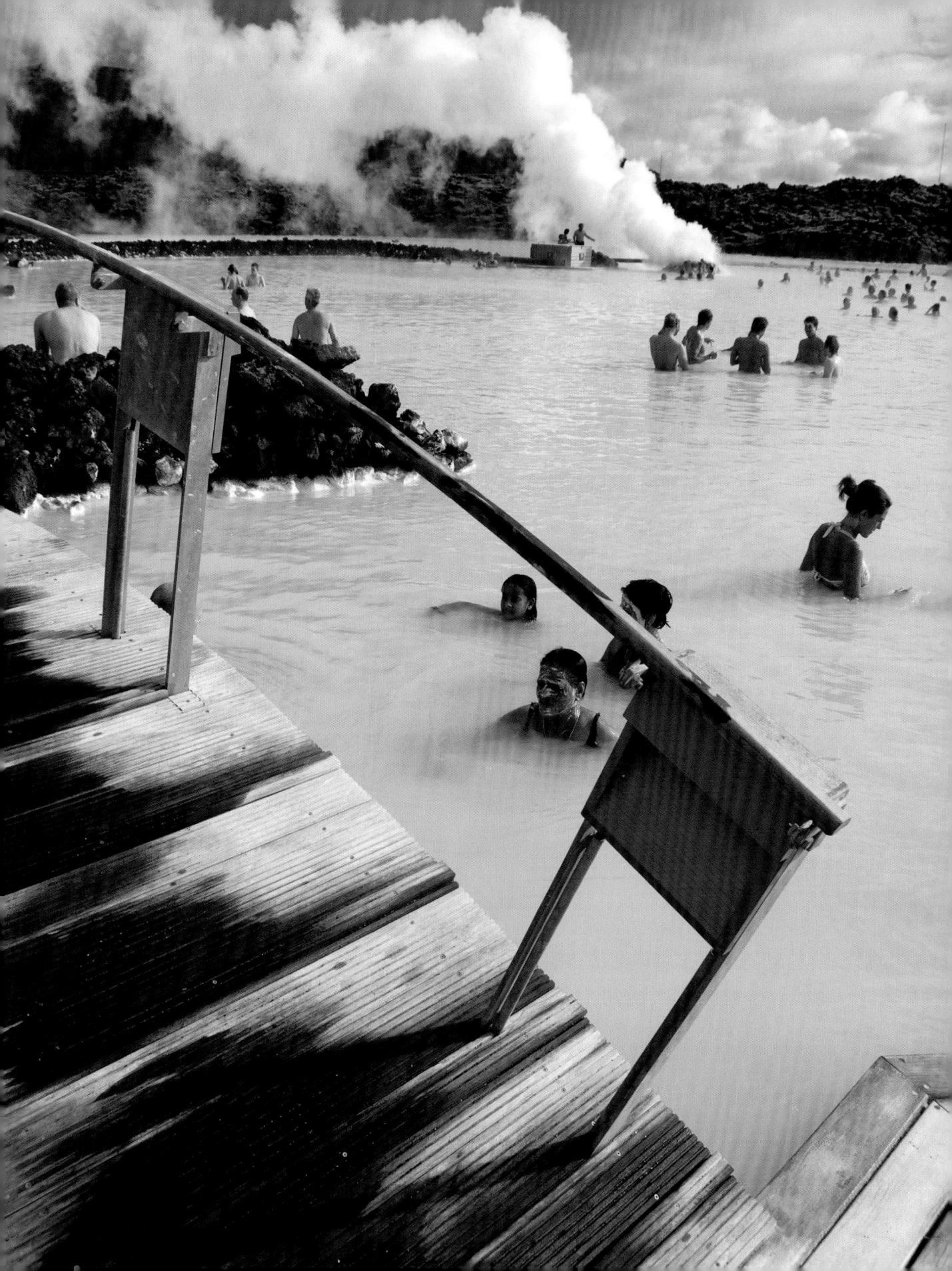

Photo Editing RAW in Bridge

Adobe Bridge is roughly analogous to a traditional light table, and is therefore the perfect environment for photo editing your RAW files. Bridge 2.0 (bundled with Photoshop CS3) features several improvements and features, such as the Loupe tool for close-up viewing, a stacking feature that makes it easier than ever to edit your RAW files, and Filter panel for quickly culling your shots based on several criteria. Its also been optimized to generate thumbnails and previews faster and for better overall performance. Let's take a look at how to use Bridge for photo editing, and then, in subsequent chapters, we'll delve more deeply into the actual processing of RAW data using the two other distinct environments: Photoshop and Camera Raw.

Chapter Contents
Launching Bridge
Bridge Revealed
Creating a Custom Workspace
Editing a Photo Session
Renaming Files

Launching Bridge

Bridge is a standalone application that launches separately from Photoshop CS3. It shares many of the attributes of the File Browser found in earlier versions of Photoshop, but it has more features and is designed to act as a central hub not only for Photoshop, but also for all of Adobe's Creative Suite products.

To open Bridge from within Photoshop:

- 1. Open Photoshop.
- 2. Select File→Browse.

You can also open Bridge from within Photoshop by clicking on the Bridge icon found in the Options bar, circled in Figure 3-1.

If you want Bridge to launch automatically whenever you launch Photoshop, you must change Photoshop's default preferences. To do this:

- Open Photoshop
 Preferences. On a Mac, choose
 Photoshop→Preferences→General; in Windows, choose Edit→Preferences.
 Or use the shortcut: #+K (Ctrl-K).
- 2. Check the box next to "Automatically Launch Bridge" (circled in Figure 3-2).

The next time you launch Photoshop, Bridge will launch as well.

NOTE Since Bridge is an independent application, it can also be launched at any time directly from your desktop or Start menu (Figure 3-3).

Figure 3-1

Figure 3-2

Figure 3-3

Bridge offers several customizable workspaces that make editing and working with RAW files a snap. First, I'll show you the default workspace and its relevant components. In subsequent sections, I'll show you how to customize a workspace and then I'll walk you through a real-word photo editing session.

Bridge Revealed

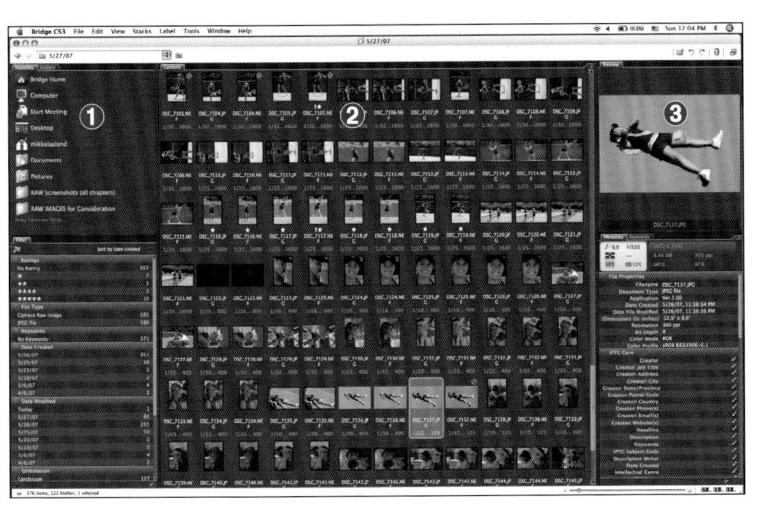

Figure 3-4

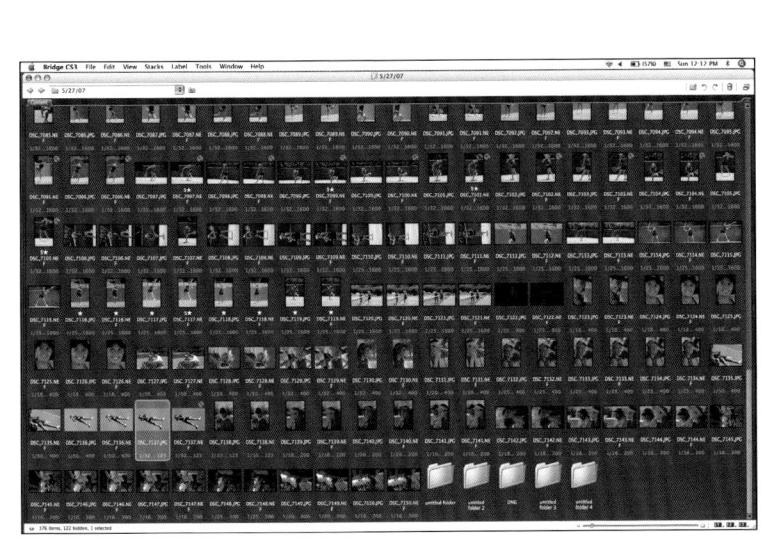

Figure 3-5

When you open Bridge for the first time you should see something like what is shown in Figure 3-4. This is the default workspace, and I'll use it to point out the various key elements of Bridge. The default workspace is a perfectly good place to start editing, sorting, and rating your images.

As you can see, Bridge consists of several panels, each of which can be placed in the left, middle, or right column. Panels can be placed in the upper or lower half of a column as well as stacked on top of each other. The middle column is generally reserved for displaying content thumbnail previews.

You can easily remove all the panels from view and leave only the middle column by hitting the Tab key. Your window ends up looking like the one in Figure 3-5.

Content Panel

The Content panel—shown in the middle column of the default workspace—is reserved for displaying content as scalable thumbnails. Bridge recognizes just about every image file format imaginable, including the commonly used JPEG, TIFF, and RAW files, as well as .mov or .mpeg or other video formats generated by many digital cameras. If Bridge encounters a file format it cannot read (such as an unsupported RAW file), it will generate a thumbnail such as the one shown in Figure 3-6.

Content Thumbnail Size

You can increase or decrease the size of the thumbnails displayed in the default workspace content panel incrementally by using the slider found at the bottom right of the window (shown enlarged in Figure 3-7). Larger sizes will increase the time required to view them.

Content Thumbnail Metadata

The thumbnails in the content panel can display very useful information related to your image, such as file name, file size, and camera exposure data (circled in Figure 3-8). By default, only the file name is displayed, but you can change this in the Bridge Preferences, under Thumbnails → Details.

NOTE To properly orient images, use the right and left arrows (circled in Figure 3-9) at the top-right of the Bridge window, or right-click to use the contextual menu and choose the appropriate rotate command. The new orientation will also show up in Camera Raw, but not necessarily other applications.

Figure 3-6

Figure 3-7

Figure 3-8

Figure 3-9

Figure 3-10

Figure 3-12

Figure 3-11

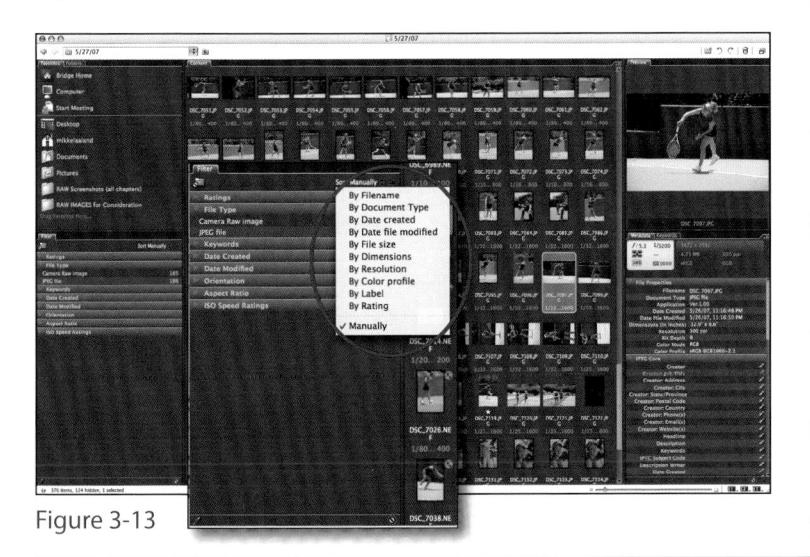

Favorites and Folders Panel

At the top of the upper left column in the default workspace, there are two panels stacked on top of each other, the Favorites and Folders panels (Figure 3-10). These panels provide two ways to navigate to your images. The Favorites panel includes folders specified by you. To add an item to the Favorites panel, select the item in the Folders panel, then either right-click the folder and choose Add to Favorites from the contextual menu, or chose File→Add to Favorites from the menu bar. To remove a folder from the Favorites panel, select the folder and then choose File→Remove from Favorites.

The Folders panel, shown in Figure 3-11, contains a hierarchical listing of all the content on your computer or connected media. You have to physically navigate to the desired folder of images, which are then displayed as thumbnails in the content panel.

Another way to navigate to content is to use the Look-In pop-up window located at the top of the Bridge window which lists recently viewed folders, as you can see in Figure 3-12. A forward and backward arrow next to the Look-In menu will step you incrementally through previously viewed folders.

Filter Panel

When you select a folder of images, Bridge automatically sorts all the thumbnails in the Content panel by filename. You can control the order in which it appears via the Filter panel. Sort order criteria is selected via the pop-up menu at the top of the Filter panel, circled in Figure 3-13. You can also control what shows up in the Content panel via the Filter panel. I use this feature all the time! For example, my image folders often contain JPEG and RAW files of the same shot because I frequently set my camera to shoot RAW+JPEG. To avoid duplicates, I go to the File Type criteria and click on Camera Raw image, as in Figure 3-14. Now only my RAW files from a selected folder will appear in the Content panel. You can also filter according other associated metadata such as Keyword, Date Created, Date Modified, Orientation, Aspect Ratio, ISO Speed, Serial Number, and Copyright Notice.

Normally the filter resets to default when you move between folders. However, if you set up a filter and want it to apply to other folders, click on the pushpin icon at the bottom left of the panel circled on the left in Figure 3-15. Now when you browse to another folder, the same filtering criteria will apply. To clear the filter, select the cancel icon (circled on the right).

Preview Panel

In the upper right of Bridge in the default workspace is the Preview panel, enlarged in Figure 3-16. Nothing is previewed unless you select a thumbnail in the content panel. You can select multiple thumbnails and they will be displayed in the Preview Panel, but each one will be very small.

You can use the Loupe tool to help you make critical editing decisions based on sharpness. Just click anywhere on the preview and the Loupe tool will appear, showing the area next to the point at 100% as in Figure 3-17. Zoom in with the + key, and zoom out with the - key. If you

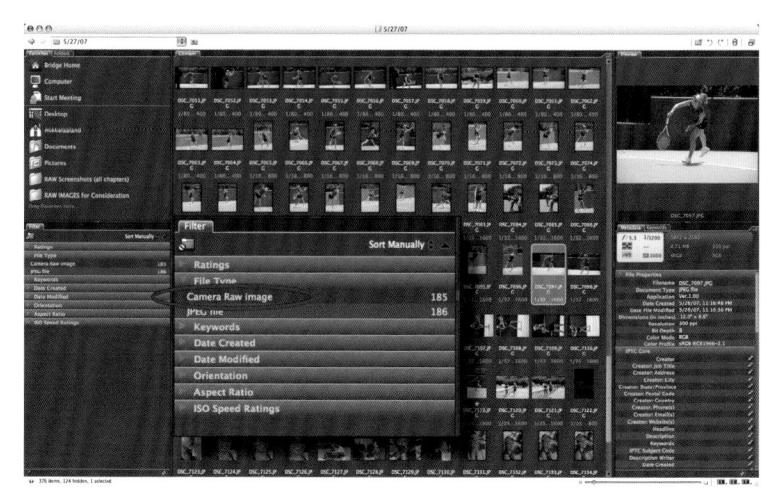

Figure 3-14

Figure 3-15

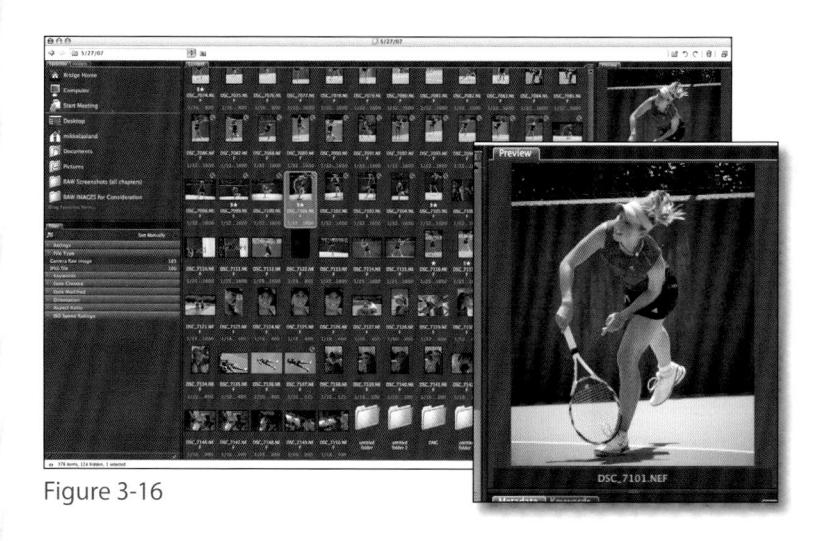

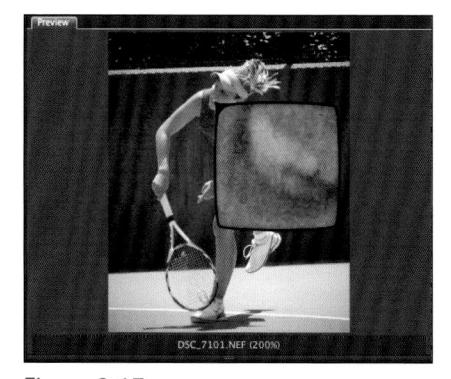

Figure 3-17

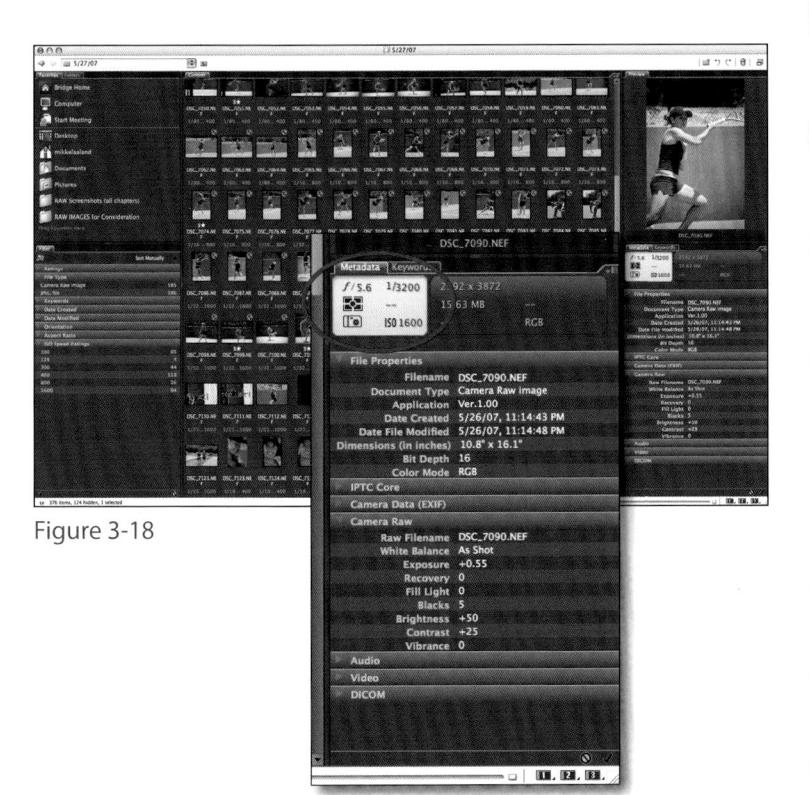

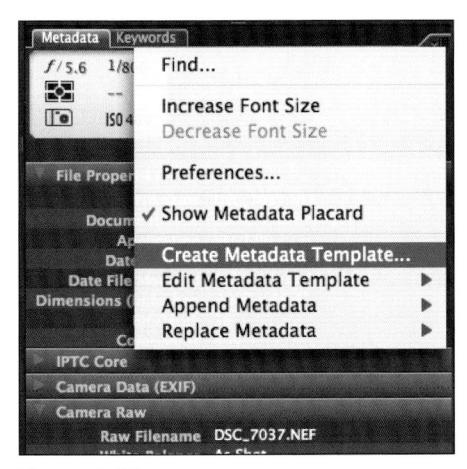

Figure 3-19

have multiple images displayed in the Preview window you can open a separate Loupe tool for each. Remove the Loupe tool from sight by clicking anywhere within its boundaries.

Metadata Panel

Under the Navigator and stacked with the Keywords panel in the default workspace, is the Metadata panel, shown in Figure 3-18. This panel contains a lot of useful information available at a glance. (See the "Understanding Metadata" sidebar on the next page.)

When you select a RAW image thumbnail in the Content panel, metadata associated with that image will appear in the metadata panel. The metadata placard, for instance (circled), contains a summary of important camera EXIF data, such as ISO, shutter speed, f-stop, and white balance.

Some of the metadata is associated with your camera settings and is relatively fixed. (You can change creation dates, for example but not shutter speeds.) Other information such as captions, creator, and copyright information is fully editable.

Metadata Template

It's easy, and very useful, to create a metadata template containing commonly applied information such as contact info and copyright status. Do this by filling in the appropriate fields in the Metadata panel, and then, in the Metadata panel pop-up menu (shown in Figure 3-19), select Create Metadata Template. You can also select and edit existing templates from this pop-up menu.

Understanding Metadata

Metadata is any data embedded in an image file that has been generated by you, your camera, or an application. EXIF metadata, for example, is data generated by a digital camera that contains such information as camera manufacturer, camera exposure time, f-stop, shutter speed, ISO, etc. EXIF data, like that shown in Figure 3-20, can be viewed in the Bridge Metadata panel or via File → File Info, Camera Data 1.

IPTC Core and XMP data, on the other hand, contain a wide range of contextual information, such as copyright and/or image description. You can also access this information using File→File Info and selecting the IPTC Contact (Figure 3-21), or in Bridge's Metadata panel, which is described in the previous pages.

While you can easily use Bridge to add IPTC and XMP data to an image file and even create custom templates, EXIF data is generated by your camera and is generally not editable using Bridge.

A typical RAW file contains EXIF data; and you can add other metadata via the Metadata and Keyword panels, or via File → File Info. However, it's important to remember that once you convert your RAW file to another file format or try to read IPTC or XMP metadata created in Bridge in another application, the metadata may or may not survive the conversion or transition. I will address this potential problem later in Chapter 11.

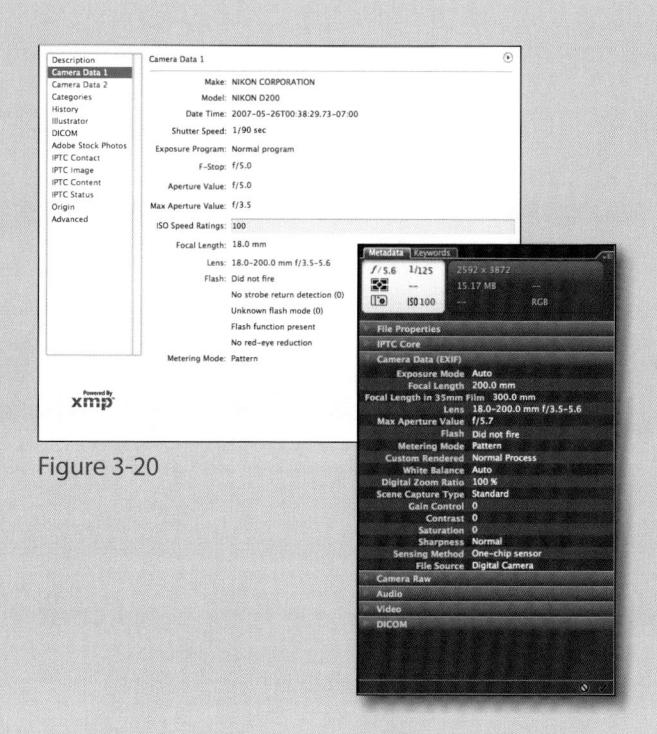

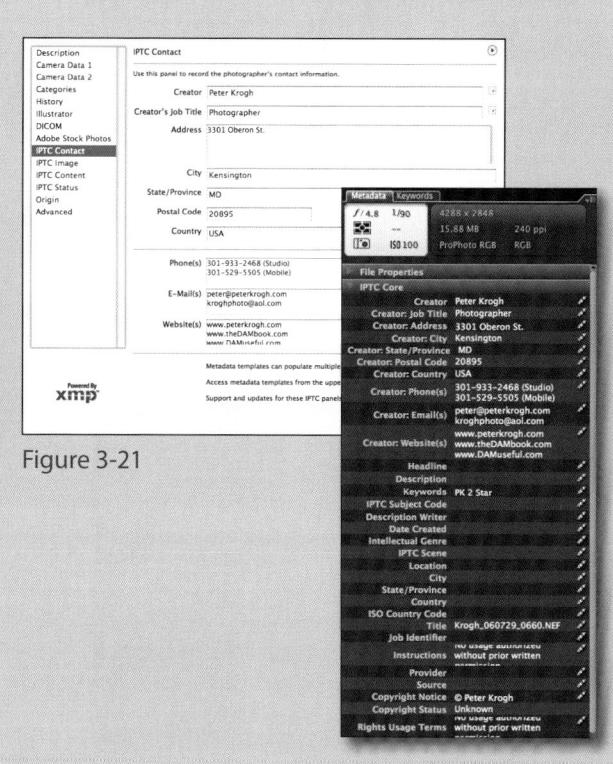

Figure 3-22

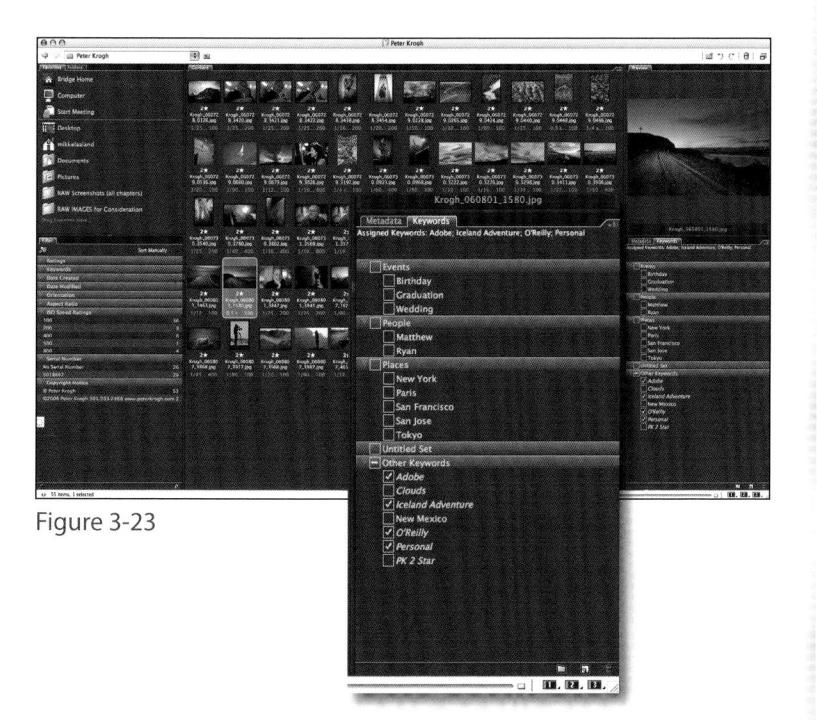

Figure 3-24

To apply an existing template to one or many images, select the appropriate thumbnail in the Content panel. From the Metadata panel pop-up menu, select Replace Metadata and the appropriate template. Be sure to click the apply icon at the bottom of the Metadata panel (circled in Figure 3-22) when you are finished, otherwise your changes won't be applied.

Keywords

Stacked under the Metadata panel is the Keywords panel. Keywords are another way of identifying your images for retrieval at a later date, and with the Keyword panel you can both add keywords (or keyword sets) and search your collection of images based on specific words. The icons at the bottom of the Keywords panel, shown in Figure 3-23, are used to create keyword sets, keywords, or to remove specific words or sets.

Native RAW file keywords entered via the Keywords panel are written into the .xmp sidecar file that accompanies the RAW file. DNG, JPEG ,TIFF, and PSD files have the keywords written directly into the image files as XMP data, which can be read by other image editing applications.

Slideshows

Bridge can quickly transform into a very useful slideshow for viewing and editing your images (Figure 3-24). The slideshow begins when you type the keyboard shortcut #-L (Ctrl-L). Exit the slideshow with the Esc key. Hit the spacebar to pause the show. Clicking the mouse enlarges the images to 100% and pauses the show until you click on the mouse again and hit the spacebar. Use the + or -

keys to zoom in or out. The slideshow will display selected images. If no images are selected, the slideshow will display all the images in a folder.

You can control display characteristics and edit directly from within the slideshow with keyboard commands. Pressing the H key brings up these commands, as shown in Figure 3-25. To hide the displayed commands, press the H key again. To guit the slideshow, wait until the last slide is displayed, or hit the Esc key at any time. If you want to avoid looking at non-graphic files or duplicate JPEG + RAW files in your slideshow, set the Filter panel appropriately. To control transitions, display, and speed, choose View→Slideshow Options from the menu bar, which brings up the dialog box in Figure 3-26.

Changing the Background Brightness

The default neutral gray background is advisable for viewing most images—whether they are color or black and white. You can darken or lighten the area around the Content or Preview panels background in the Bridge preferences via the Image Backdrop slider. You can also darken or lighten the area around other panels separately via the User Interface Brightness slider, circled in Figure 3-27. The slideshow background remains the same neutral gray, regardless of how you set the Appearance brightness.

Display Performance Issues

What happens if thumbnails for your RAW files don't appear, or appear slowly? The thumbnails are actually generated by the Camera Raw plug-in so the problem may be

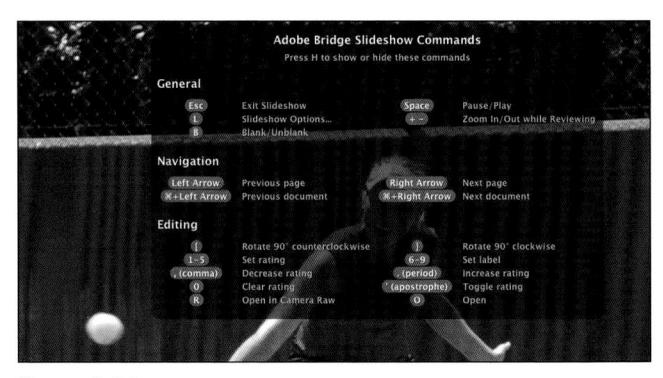

Figure 3-25

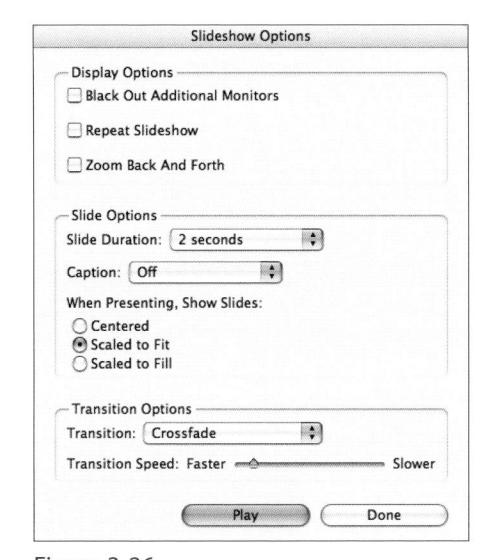

Figure 3-26

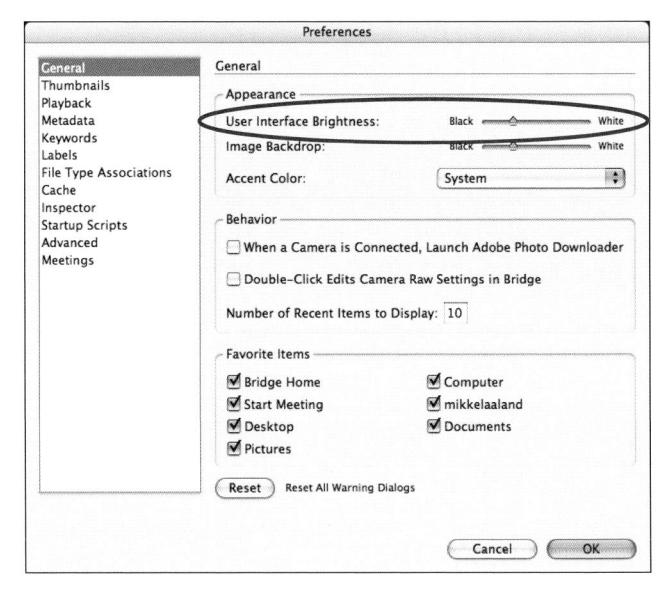

Figure 3-27

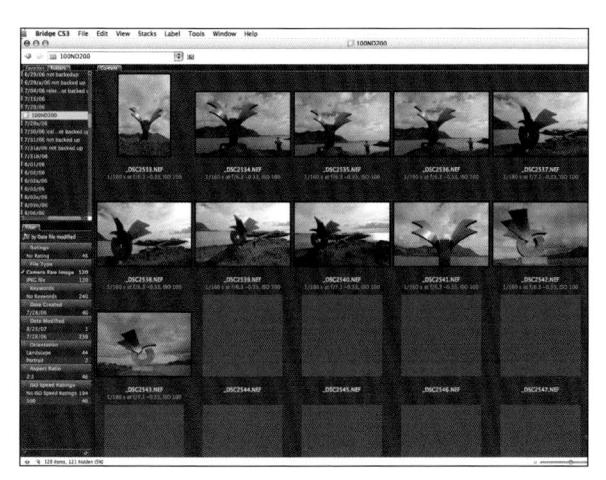

Figure 3-28

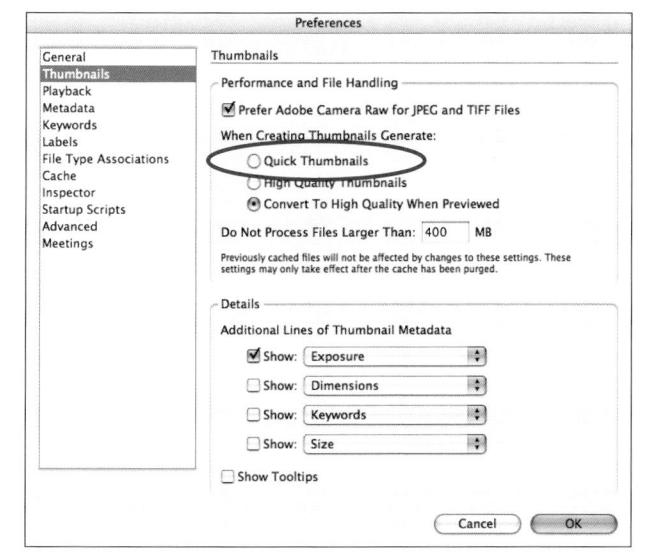

Figure 3-29

Figure 3-30

that your version of Camera Raw does not support your RAW files. You can periodically check the Adobe web site to make sure you are using the latest version of Camera Raw. Or, updates are now possible using the Adobe Updater. Select Help→Updates and click on the Preferences button to select Adobe Camera Raw.

You may notice that when Camera Raw is open and hosted by Bridge, Bridge stops generating new file thumbnails, as in Figure 3-28. You can get around this by having Photoshop host Camera Raw instead. That way, even though you can continue working in Camera Raw, Bridge thumbnails will be generated in the background. To understand what I'm talking about when I say "hosted," see the sidebar later in this chapter titled: "Who Is the Host?"

NOTE You can speed up thumbnail display in Bridge for CS3 by telling Bridge to use the low-resolution thumbnails embedded in the original camera file. Do this by selecting Quick Thumbnails in Bridge's Preferences, under Thumbnails, circled in Figure 3-29. Personally, I select, Convert to High Quality When Previewed, as a happy compromise.

Even though CS3's Bridge is faster than earlier versions, don't be surprised if RAW file thumbnails take time to appear, especially when viewing them for the first time. A lot of processing is happening in the background, and even the fastest computer may seem slow. You can check the status of thumbnail generation at the bottom left of the Bridge window, circled in Figure 3-30. Once the thumbnails are created and cached, the next time you

open the folder, they will appear quickly. (When Camera Raw creates a thumbnail, it caches the small image separately from the original file.) If you click on a RAW file whose thumbnail hasn't yet been generated, Bridge stops generating the other thumbnails and prioritizes that file. When the thumbnail has been generated, it resumes where it left off (Figure 3-31).

Purging the Cache

In rare cases, thumbnail files can become corrupted and won't display. In this case, you have no choice but to purge the thumbnail cache and have Camera Raw start over by building new thumbnails. To do this, select Tools→Cache and select Purge Cache for Folder [name] (Figure 3-32). To purge the entire central cache, go to the Bridge Preferences and under Cache, choose Purge Cache from near the bottom of the dialog box (circled in Figure 3-33). Either of these actions affect only the Bridge cache, not the Camera Raw XMP or database data, nor does it purge the Camera Raw cache, which can be done via Camera Raw preferences.

A warning: purging a Bridge cache can also purge labels and ratings, which are cached along with the thumbnails.

TIP The Bridge cache stores thumbnails, previews, and metadata for all file types. Bridge automatically uses a centralized cache file, and you can choose the location of this file in the Bridge Preferences Cache section. If you want to make sure the metadata and thumbnails travel with image folders that are offline, go to the Bridge Preferences Cache section and select Automatically Export Caches to Folders when Possible.

Figure 3-31

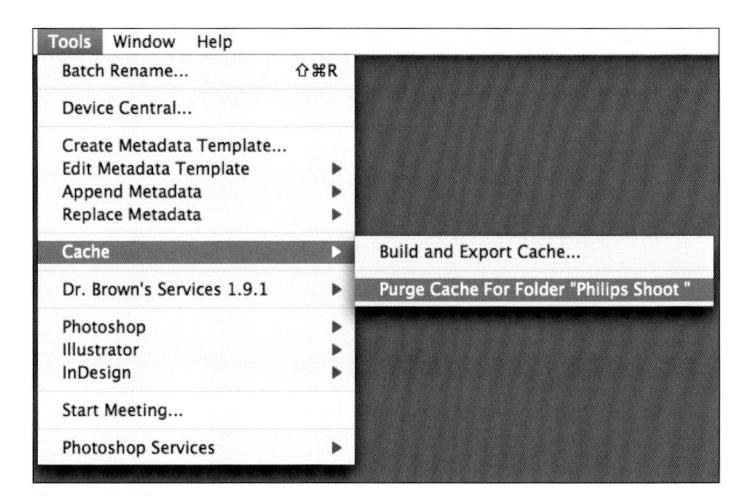

Figure 3-32

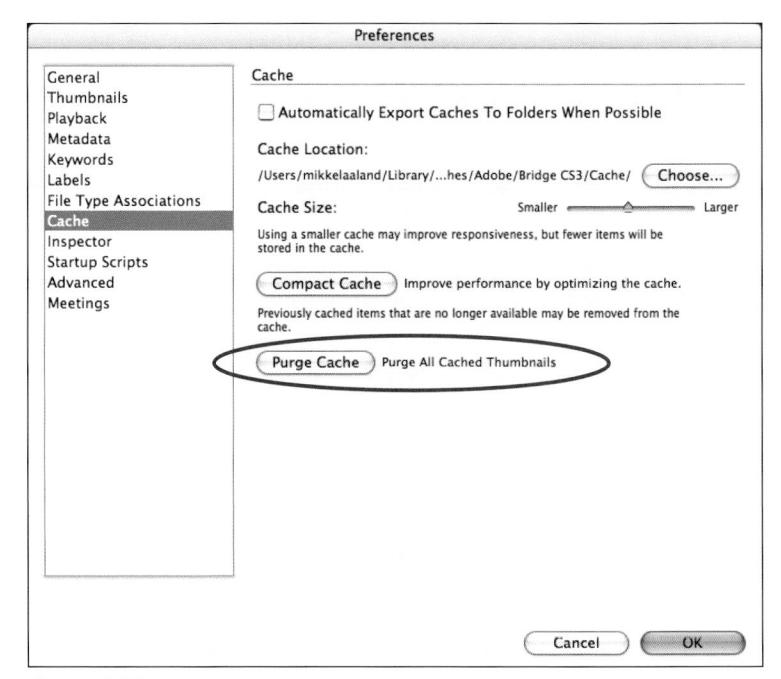

Figure 3-33

Earlier I showed you Bridge's default workspace. Now let's see how to select another Bridge preset workspace, and modify it slightly to make it more suited to editing, rating, and sorting RAW images.

Creating a Custom Workspace

W Help New Synchronized Window NXX Save Workspace.. Delete Workspace Folders Panel Favorites Panel Reset to Default Workspace ✓ Metadata Panel √ Keywords Pane Light Table ₩F2 / Filter Panel File Navigator ₩F3 Preview Panel Metadata Focus ₩F4 Inspector Panel Horizontal Filmstrip ₩F5 жм Minimize Vertical Filmstrip ₩F6 Bring All To Front Workspace 2 ₩F7 My Workspace Kodak/Philips_2 Compact Adobe Stock Photos Adobe Photographers Directory

Figure 3-34

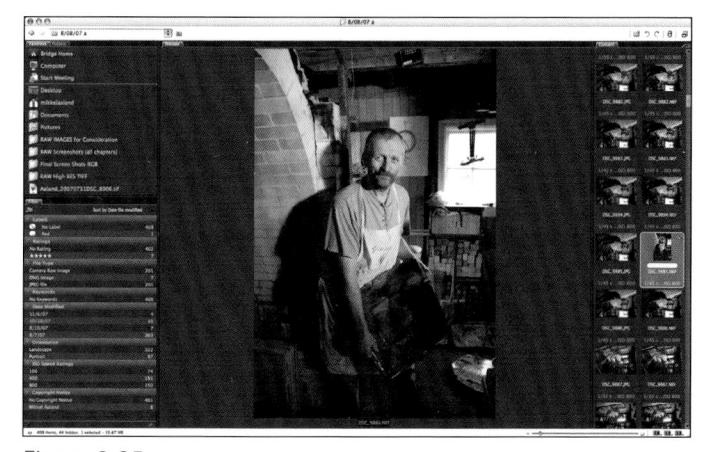

Figure 3-35

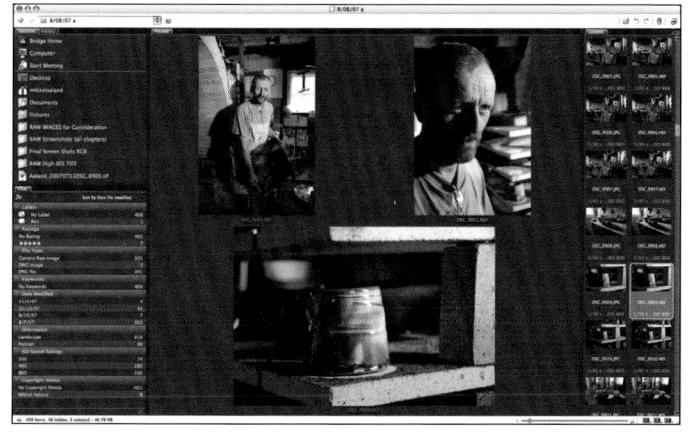

Figure 3-36

Bridge offers several preset workspaces, found under Window→Workspace (Figure 3-34). I mostly use the Default workspace (as mentioned earlier) and one of the Filmstrip workspaces with a slight modification.

The Horizontal and Vertical Filmstrip

In the Horizontal and Vertical Filmstrip workspaces, the Preview panel occupies the center column (Figure 3-35) and the content panel runs horizontally or vertically to the side.

What makes these workspaces so special for photographers is the size of the preview. If you hit the Tab key, the side panels disappear for an even better view of a selected image. In this workspace, you can also use the Loupe tool to magnify areas of your image up to 800%. I'll show you how to use the Loupe tool in the next section.

In either Filmstrip workspace, you can also select more than one image for comparison. Hold the Shift key and click on thumbnails to select them sequentially. Hold the Command key to select images nonsequentially. You can add as many images as you like and use synchronized Loupe tools on all of them (Figure 3-36).

Customizing the Workspace

Here's how I tweaked the out-of-the box Vertical Filmstrip workspace to better fit my work procedure, changing the emphasis from the Favorites to the Folder panel and adding a Metadata Panel, which provides useful information about my images that I take into account when I'm editing. To do this:

- Select the Vertical Filmstrip workspace (Figure 3-37) by choosing Window→ Workspace→Vertical Workspace. You can also click on the tiny arrow near the #2 icon at the bottom right of the Bridge window and pick the Vertical Workspace from the pop-up menu.
- 2. Select the Folder panel. (I find the Folder panel more useful than Favorites in most cases.)
- Add the Metadata panel to the workspace by choosing Window→ Metadata Panel. The panel will appear in the right column, on top of the Content Panel (Figure 3-38).
- 4. Move the Metadata Panel to the left column, nested under the Filter Panel, by clicking on the Metadata tab and dragging the panel into position. (Or ignore step 3, right-click the Filter panel tab, and select Metadata Panel from the contextual menu. It will then appear in place under the Filter panel.)

When done, you can click and hold on the triangle near the #2 icon at the bottom right of the Bridge window, as shown in Figure 3-39. From the pop-up menu, select Save Workspace and name the arrangement "My Workspace". Now I can toggle between the Default workspace and My Workspace by clicking on the icons #1 and #2, respectively.

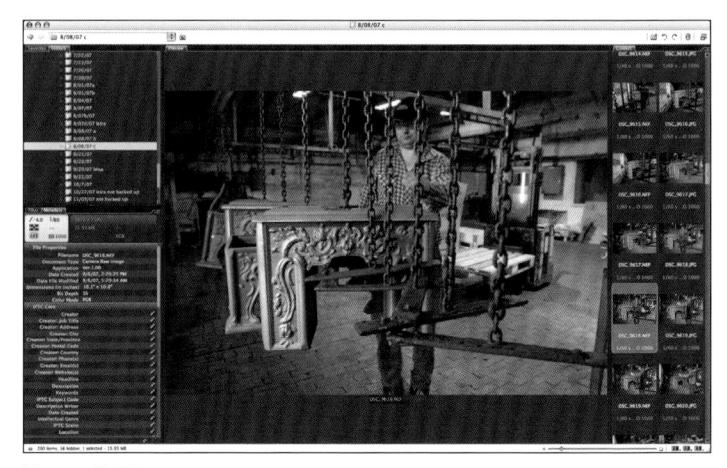

Figure 3-37

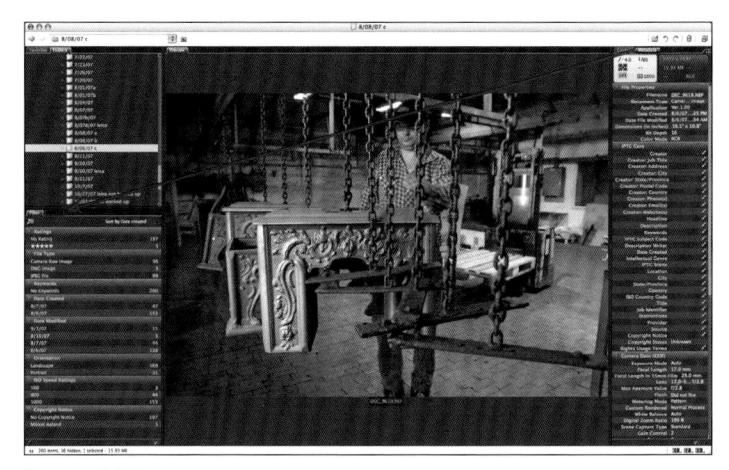

Figure 3-38

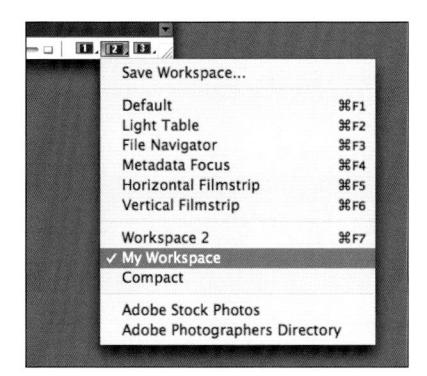

Figure 3-39

NOTE You can also resize the side columns by placing your cursor on the dividing boarder, clicking and dragging to the desired size. For my custom workspace, I leave them at their default size.

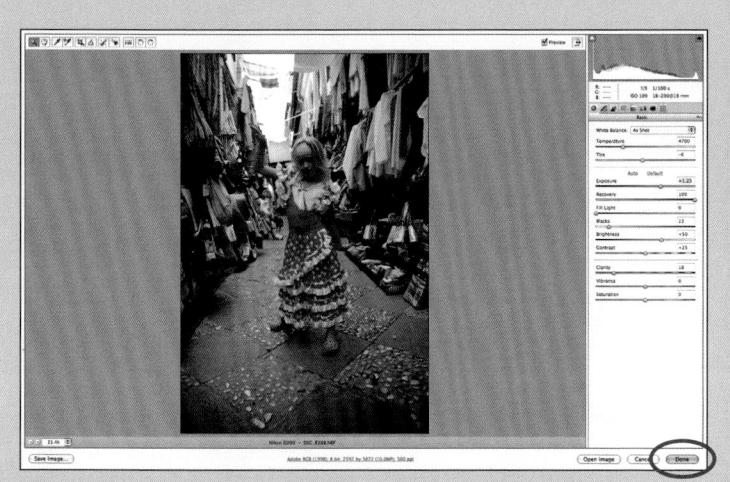

Figure 3-40

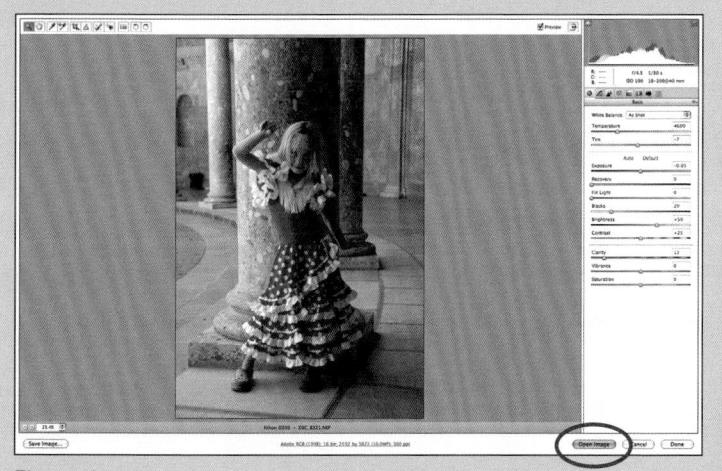

Figure 3-41

Who Is the Host?

When you open a RAW file from Bridge, you can choose the host. Your choice can make a difference in performance. If you select a RAW file, then select ૠ-R (Ctrl-R), or File→ Open in Camera Raw, the Camera Raw host is Bridge. If you select a RAW file, then select ૠ-O, or File→Open With→Adobe Photoshop CS3, the Camera Raw host becomes Photoshop. You can actually have two Camera Raw windows open at the same time, one hosted by Bridge, the other by Photoshop.

How can you tell who's the host just by looking? If the Done button is the active selection, as circled in Figure 3-40, it tells you Bridge is the host. If Open Image is the active selection, as circled in Figure 3-41, it tells you Photoshop is the host.

When Bridge hosts Camera Raw, thumbnail production in Bridge stops until you close Camera Raw. However, as you will see in Chapter 11, when Bridge hosts Camera Raw and you convert a batch of RAW files to the Adobe DNG format using Camera Raw Save Options, you can close Camera RAW while the conversion occurs completely in the background and Bridge remains operable. If Photoshop hosts Camera Raw, you convert RAW files to Adobe DNG, and close Camera Raw before the conversion is finished, Photoshop becomes inoperative during the conversion. In short, most of the time, it's best to host Camera Raw from Bridge. This will keep the work area of Photoshop operational and, for the most part, it won't affect Bridge functionality.

Working RAW

Actual files found at http://examples.oreilly.com/9780596510527/

The RAW file for this image is included on the O'Reilly site for you to download so you can experience the full value of having a GretagMacbeth color chart in an image. When you open the RAW file in Camera Raw, I suggest you select Reset Camera Raw defaults from the Camera Raw Settings pop-up menu. Then you will see a huge color shift as the white balance goes from Custom to As shot. Next, take the white balance tool from the toolbar and click on the third gray box from the right at the top of the chart. Voila! Correct white balance. (For more details on this, see Chapter 5.) By the way, the man in the shot is one of my excellent assistants, Matt Stevens.

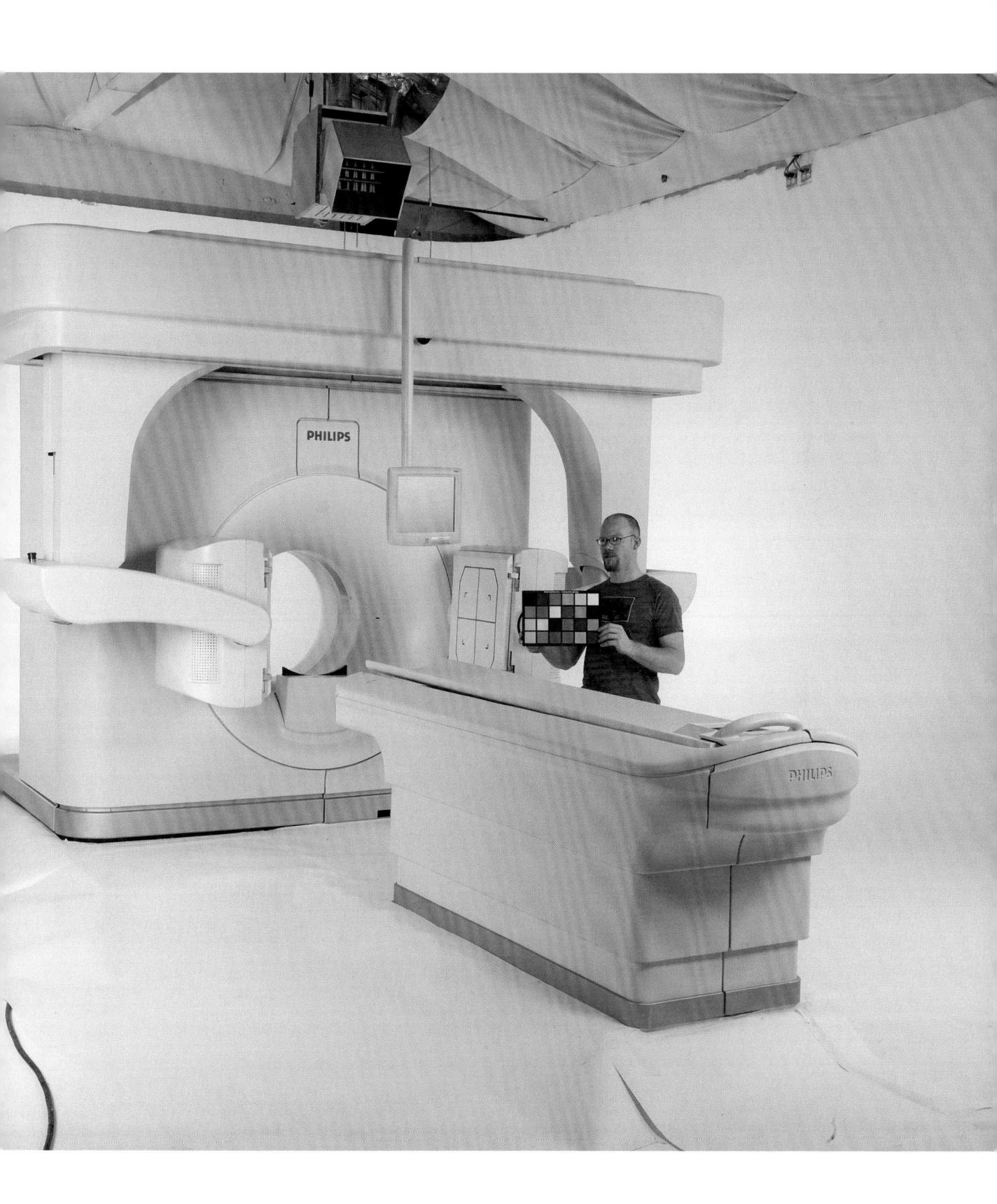

Editing a Photo Session

Once you transfer your images from your digital camera to your computer, and then navigate to that folder and select it from Bridge's Folder panel, you'll get something that looks like Figure 3-42. I use Bridge's default workspace for the first phase of my editing because I can quickly see at a glance the obviously bad shots. When I'm finished with this phase, I'll often switch to the customized workspace mentioned earlier to check for focus and other image qualities that require larger magnification. Rating and adding keywords can be done in either workspace.

Deleting Images

OK, the shot at the top left of the screen (Figure 3-43) containing my wayward assistant is an example of an obviously bad shot.

To delete images like this from Bridge and your hard drive:

- Select the unwanted image. To select multiple images, shift-click all images.
 Select non-adjacent images by \$\mathscr{c}\$-clicking on a Mac or Ctrl-clicking in Windows.
- Click the trashcan icon found in the upper-right corner of the Bridge window, shown in Figure 3-44.
 Alternatively you can hit the Delete key.

Getting from point A (a folder filled with RAW images stored on your hard drive) to point B (a finished image) requires several incremental steps. To illustrate how to use Bridge to do this, I'll use images I took on assignment for Philips Medical system.

Figure 3-42

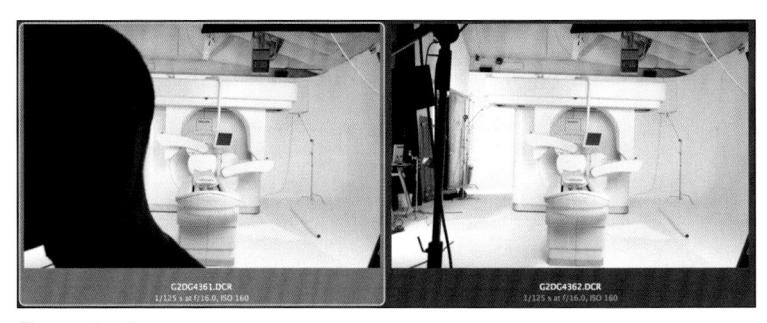

Figure 3-43

Figure 3-44

Figure 3-45

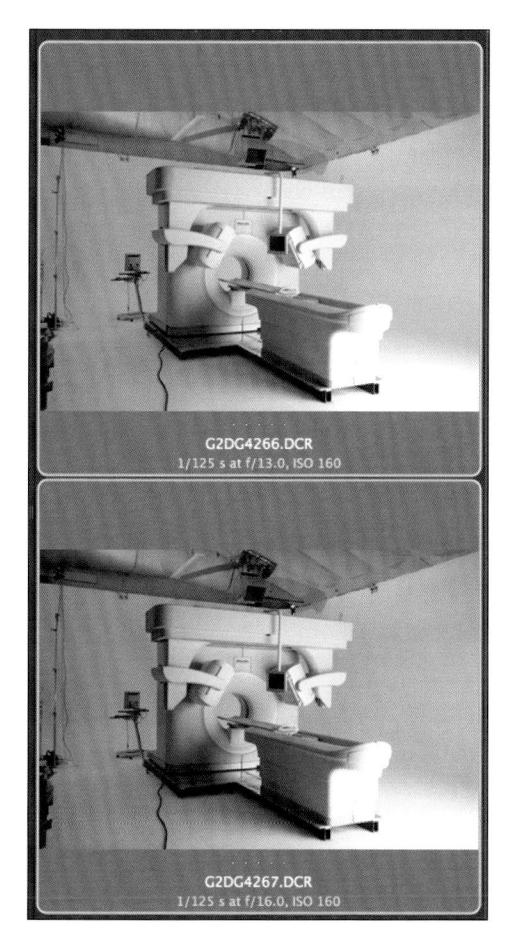

Figure 3-46

You can also delete images via a contextual menu. Select an image or images, right-click, and select Move to Trash, as in Figure 3-45. (In Windows, select Delete). You can retrieve a trashed image from the Trash or Recycle Bin as long as it hasn't been emptied.

Checking Exposure

Images that are radically under- or overexposed can also be deleted. Bridge doesn't offer a histogram or other exposure checking tools, so you will need to rely on purely visual clues for this initial sorting. In order to check exposure from within Bridge, be sure your Camera Raw settings are set properly. For instance, look at the two shots shown in Figure 3-46.

These images look as if they were shot using the same exposure. But they weren't. As you can see by the EXIF data, the top image was shot at f/13 and the bottom image was shot at f/16. The images appear the same because one of the Camera Raw Defaults was set to automatically adjust and correct exposure. The Bridge thumbnail—which is generated in the background by the Camera Raw plug-in—is based on that auto adjustment rather than the actual exposure.

To make sure the Camera Raw Default setting produces thumbnails that reflect different exposures:

Open Camera Raw Preferences
either from Bridge or from within the
Camera Raw window. You get to the
Preferences from within Camera Raw
by selecting the Open Preferences
dialog icon in the toolbar, or with the
keyboard shortcut #-K (Ctrl-K).

- Under Default Image Settings, make sure Apply auto tone adjustments is deselected (Figure 3-47).
- Select OK and return to Camera Raw or Bridge.

Here are the same two images after making sure auto tone adjustments is deselected; you can now see in Figure 3-48 that the images look different, allowing you to make an informed decision based on their different exposures.

If Camera Raw was originally set to Apply auto tone adjustments when all your thumbnails were first generated and you changed your Camera Raw Defaults setting as outlined above, you will want to purge your Bridge thumbnail cache. In Bridge, select Tools→Cache→Purge Cache for [Folder Name]. Now all the new thumbnails will reflect the original camera settings. Use this method judiciously, as it will also purge some ratings and labels.

Checking for Image Sharpness

Next I'll check for image sharpness. If possible, it's always best to cull out unacceptable images early on in the editing process, before anyone gets too attached to the image and chooses it above other sharper ones.

Sometimes out-of-focus shots are blatantly obvious; other times the unsharpness is a result of subtle camera or subject movement and doesn't show up easily in Bridge's default workspace viewing options, like in Figure 3-49. It's not always easy to tell if an image is adequately sharp. You'll need to enlarge the image (or part of the image) in question to its greatest magnification.

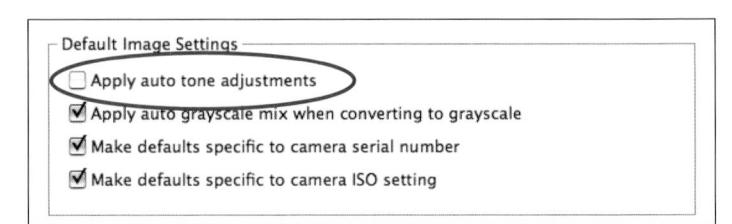

Figure 3-47

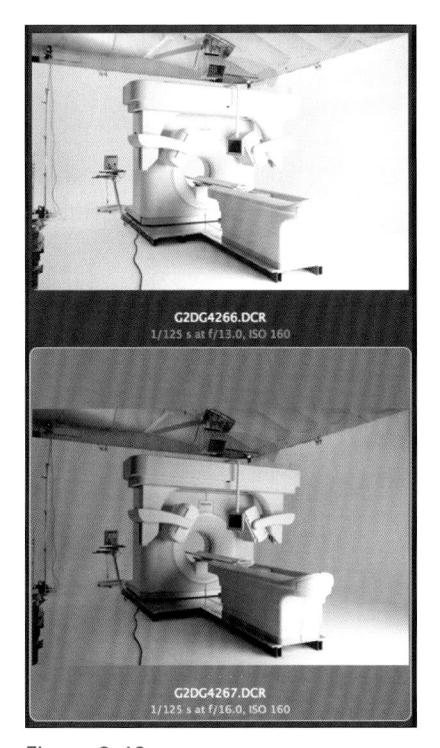

Figure 3-48

Figure 3-49

Figure 3-50

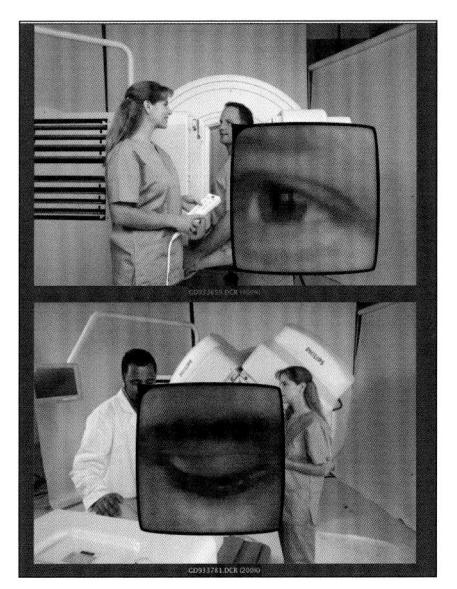

Figure 3-51

NOTE It's one thing to make unilateral editing decisions, and quite another when others are involved in the decision-making. It's not practical to provide RAW files to clients. (Most people wouldn't appreciate such large files that require special software anyway.) One of the easiest ways to share files for editing purposes is to create some sort of shared contact sheet. However, you can use various Bridge and Photoshop automation tools to create a Web Photo Gallery, a printable Contact Sheet, or a PDF file that contains contact sheets. I'll show you a few ways to do this in Chapter 12.

To do this:

- Using one of the Filmstrip workspaces, select an image by clicking on it with your mouse.
- 2. A enlarged Preview will appear in the Preview panel
- 3. Click anywhere on the image to bring up the Loupe tool, as in Figure 3-50.

Using the Loupe Tool

The Loupe tool magnifies a specific area of the image by 100%. You can increase or decrease magnification by using the mouse scroll wheel or by pressing the + or - keys.

Move your cursor and the Loupe tool moves, magnifying the area at the arrow point, not what the loupe is over.

You can open multiple images in the Preview window by \Re -clicking (Ctrl-clicking) on thumbnails in the Content panel. Multiple Loupe tools can also be used on the displayed images by clicking on each image in the Preview panel, as shown in Figure 3-51. To synchronize the Loupe tools, hold the \Re (Ctrl) key and drag. Hold the \Re (Ctrl) key and hit the = or - keys and the magnification is also synchronized between Loupe windows.

To hide the Loupe tool, click inside the tool itself. (Clicking outside the tool only moves the tool, to the frustration of many users.)

Editing Based on Metadata

Most of the time editing decisions are based on visual considerations, but sometimes EXIF and other metadata can also inform your decision. Is there enough resolution, for example? What kind of file is it? What kind of camera was used? What ISO was used? And so on. When you view thumbnails in Bridge, some (but not all) of this data is viewable on the thumbnail, as you can see in Figure 3-52.

You can customize which metadata is displayed on a thumbnail this way, up to a point. To change what is displayed, open Bridge preferences, select the Thumbnails category (Figure 3-53), and in the Details section, choose the Additional Lines of Thumbnail Metadata to display from the four pop-up menus. Each list has the same choices—basically, you get to pick four. You may note that ISO is not an option. However, if you select Exposure, ISO will be included along with f-stop and shutter speeds. You can always view other Metadata by scrolling through the Metadata panel, selecting File→File Info, or simply looking at the Metadata panel.

Figure 3-52

Thumbnail Icons Revealed

You can tell the status of your RAW file by looking at its thumbnail in Bridge. Figure 3-54 shows a RAW file thumbnail revealed.

- Indicates Camera Raw cropping.
- Indicates Camera Raw settings have been applied.

Double clicking an icon will open the RAW file in Camera Raw.

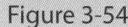

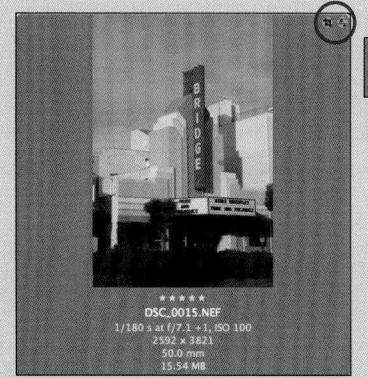

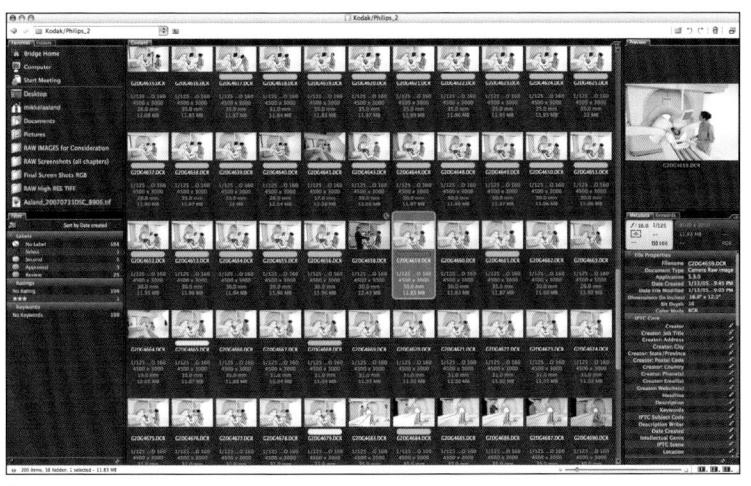

Figure 3-55

Label	Tools	Window	Help	
Ratin	g			
No Rating		₩0)	
Reject		77	S 7	
*		% 1		
**		₩2		
✓ ★★	*	#3		
**	****			
**	****			
Dec	Decrease Rating		100	
Incr	Increase Rating			
Label				
✓ No	Label			
Sele	Select			
Sec	Second			
App	Approved			
Rev	Review			
Tol	Do .			

Figure 3-56

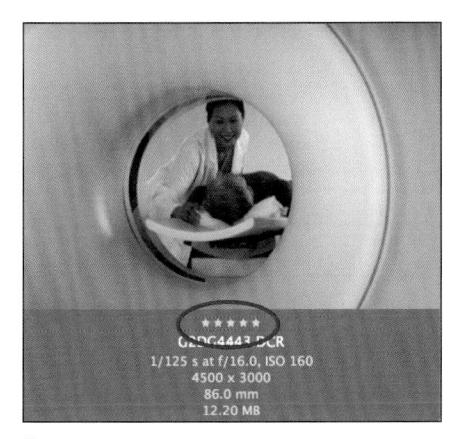

Figure 3-57

Labeling, Rating, and Adding Keywords

Another step in my editing process is to label and/or rate the images according to importance or category.

Adobe has turned to a traditional workflow for inspiration, using stars and colors to differentiate one image from another. You can assign, for example, five stars to an image that is a definite "keeper," four to a lesser one, and so on. You can also "group" images by color, as I've done in Figure 3-55.

To assign stars to an image or images:

- Select the image. Select multiple images by holding the # (Ctrl) key while clicking. Pressing #-A (Ctrl-A) selects all the images in a folder.
- Assign a star value via the Label menu shown in Figure 3-56. Or use a keyboard command (shown in the Label menu). Use Label → Decrease (#-, or Ctrl-,) or Label Increase (#-, or Ctrl-.) to incrementally change the rating. Or assign stars via the Filter panel.

You can also assign stars directly under the thumbnail by clicking on the dots, circled in Figure 3-57. All the selected thumbnails will be similarly rated. Remove individual stars by clicking on them. Remove all stars by clicking to the left of the first star. This is all too easy to do accidentally, so beware.

Color Labels are also added via the Label menu (with corresponding keyboard commands) or via the Filter panel.
Color Labels can be used to flag files to be trashed or otherwise categorized.
Color Labels are named Select, Second, Approved, Review, and To Do by default,

but you can change the names in Bridge preferences under Labels, as shown in Figure 3-58. Once you have created a star rating or color label, you can sort or view your images accordingly via the Filter panel.

Keywords

It's also very easy to add a keyword from Bridge while you are editing. Keywords are embedded in the image file as metadata and add another layer of flexibility to image searches and accessibility.

To add a keyword in Bridge:

- Select the Keywords panel, shown in Figure 3-59. (It's visible under the Metadata panel.)
- 2. Select the image or images you wish to add keywords to.
- Several keyword sets and keywords are already available in the Keywords panel. If you want to use any of the default sets or words, simply click in the box next to the name. Click again to deselect.
- 4. You can add you own keywords or sets by clicking on the icons at the bottom of the panel. Type the name in the resulting field. To remove a set or keyword, select it and then click on the trash icon at the bottom of the panel (circled in Figure 3-60.)

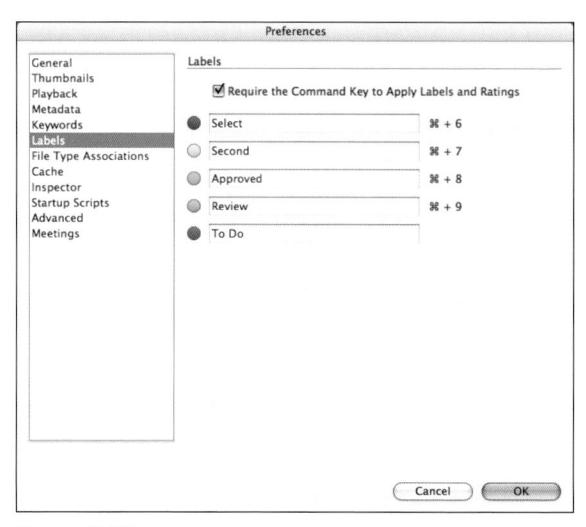

Figure 3-58

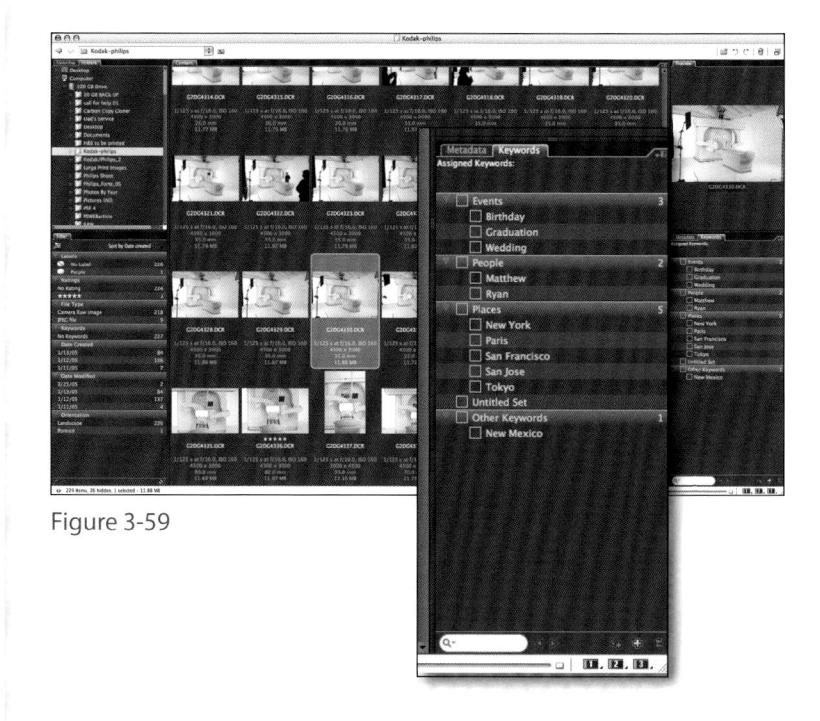

Figure 3-60

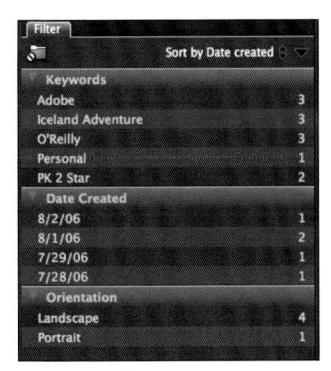

Figure 3-61

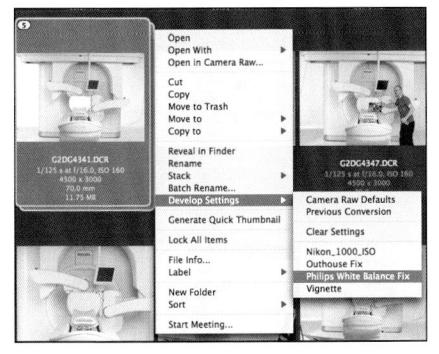

Figure 3-62

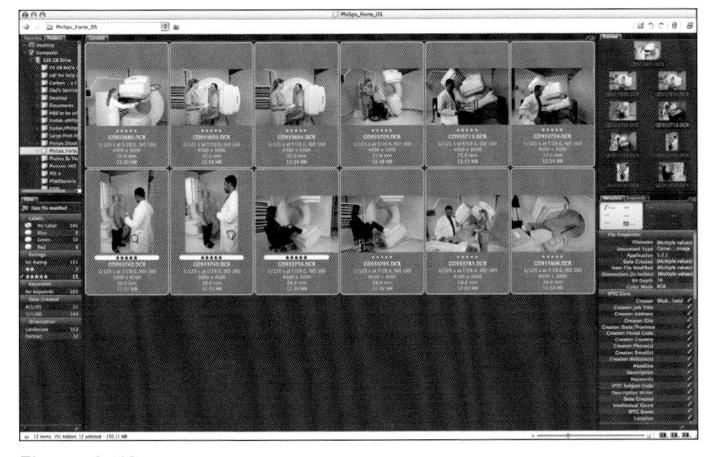

Figure 3-63

Figure 3-64

To search by keyword, go to the Filter panel/Keywords tab (Figure 3-61). All the keywords associated with the images in the open folder will be listed. Click on the keyword you wish to search by. Only images with those keywords will be displayed.

Stacking

New to Bridge in CS3 is the Stacks feature, which is a great way to group like-minded images. Not only is this a good way to clean up your Content work area, but commands that apply to a single file can be applied to a stack with a single click. For example, say you want to apply a Camera Raw white balance preset to a batch of stacked images. All you do is select the entire Stack by clicking on its outside border and right-clicking. Select Develop Settings from the contextual menu (Figure 3-62), chose your develop preset, and you are done.

If you have more than 10 images in a stack, you can also preview the images in place at a specified frame rate, essentially creating a slideshow on the fly. (I show you how to do this shortly.)

Creating a Stack

Select a group of images. For this example, as you can see in Figure 3-63, I'll use the Filter panel to filter my top picks, those with the 5-star ratings. Select Stacks—Group as Stack from the menu bar.

When I deselect the filter ratings, my stack is nicely nestled in with all my other images, ready to expand. Note in Figure 3-64, the number of stacked images is displayed in the upper left corner or the stack.

Here are some general tips for working with Stacks:

To expand a stack

Click the number in the upper left of the stack (circled in Figure 3-65) or select Stacks \rightarrow Open Stack to expand a stack. You can also use the keyboard shortcut \Re - \rightarrow (Ctrl- \rightarrow).

To collapse a stack click the number in the upper left corner again (as circled in Figure 3-66), or select Stack \rightarrow Close Stack, or use the keyboard shortcut \Re - \leftarrow (Ctrl- \leftarrow).

To promote an image to the top

To change the top image in a stack, expand the stack, right-click on the image you want on top, and choose Stack→Promote to Top of Stack from the contextual menu (Figure 3-67). (The default sort order is set by the sort order for the folder containing the stack.)

Figure 3-65

Figure 3-66

Figure 3-67

Figure 3-68

Figure 3-69

Figure 3-70

To scrub the thumbnails

When you have 10 or more images in a stack you can "scrub" the stack and preview the images sequentially like a mini slideshow within the stack itself. It's a quick way to see what you have without expanding the stack. All you need to do is hold your mouse over the top thumbnail and a slider appears, as in Figure 3-68. Click play or drag the slider and the images toggle one after another.

Control the Stack Playback Frame Rate in Bridge preferences under Playback/ Stacks (Figure 3-69).

For better viewing, I suggest you enlarge the thumbnail stack with the thumbnail slider at the bottom of the Bridge window to a viewable size.

You can also enable "onion skinning" by right-clicking on the stack and selecting Stack → Enable Onion Skinning from the contextual menu. As shown in Figure 3-70, this turns preceding and succeeding frames into semitransparent overlays on the current frame.

Renaming Files

There are many reasons to rename an image file. Digital cameras produce seemingly obscure strings of sequential numbers that have no relationship to the content of an image. Some photographers prefer adding some sort of descriptor to a particular set of images, which is very easy to do from within Bridge.

To rename a batch of image files from within Bridge, follow these steps:

- From the Tools menu, select Batch → Rename (Figure 3-71).
- 2. In the Batch Rename dialog, shown in Figure 3-72, under New Filenames, pick your criteria. For example, as you can see in here, I selected "Text" from the pop-up menu. In the text field, I typed in "Philips". Then, in the next criteria field, I selected "Sequence Number" from the pop-up menu. (There will be a next field only if you click the "+" icon.) I left "1" as my starting point and selected "Three Digits" from the adjacent pop-up menu. You can preview the changes at the bottom of the Batch Rename window.

In Chapter 2, I showed you how to rename files on import using the File→Get Photos from Camera command. You can also rename files at any time directly from within Bridge. Let's see why you might want to rename files and how to do it.

NOTE I generally prefer to use a custom file-naming nomenclature recommended by Peter Krogh which starts with the photographers name, then the date (YYYYMMDD) and then the filename. For example, Aaland_20070901_DSC3766.NEF.

Figure 3-71

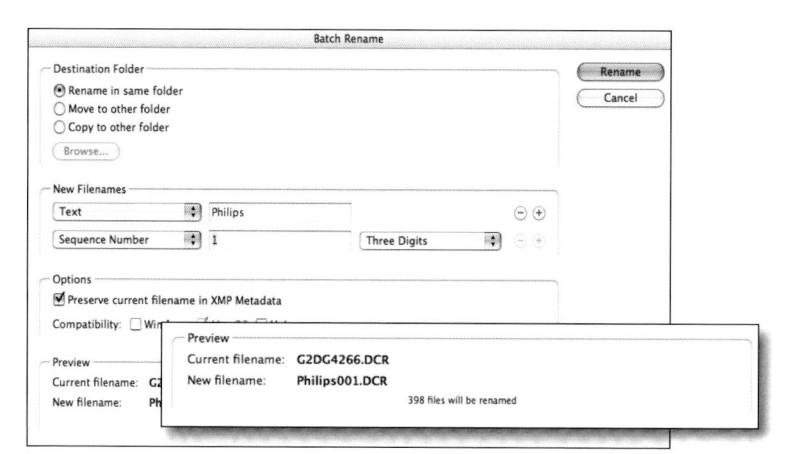

Figure 3-72
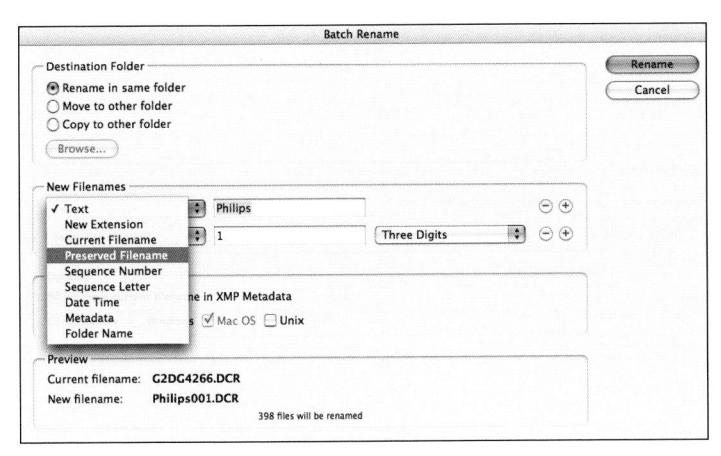

Figure 3-73

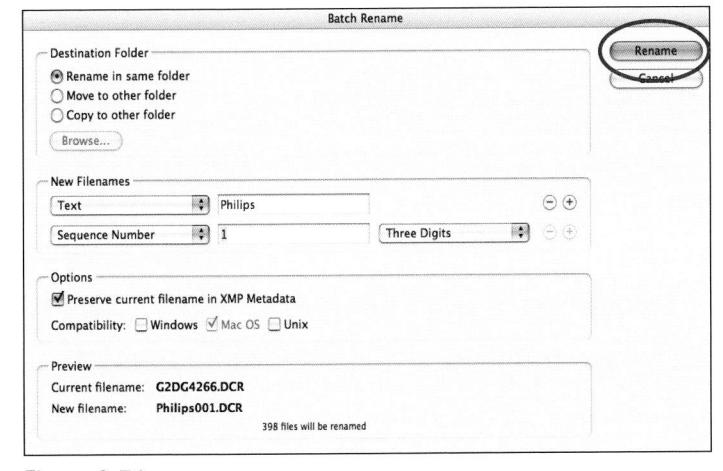

Figure 3-74

- 3. If you want to retain a record of the original file name, in the Options area, select "Preserve current file name in XMP Metadata". If you do this, you can always retrieve the data later by selecting "Preserved Filename" (Figure 3-73) in the criteria pop-up window. If you want to use camera EXIF data—such as exposure time or focal length—as part of the file name, simply select EXIF Metadata from the criteria pop-up window and then select your choice in the adjacent popup window. Again, you can preview the results in the Preview section of the Batch Rename window.
- 4. When you are done, select Rename (circled in Figure 3-74). The time it takes for renaming depends on the number of files selected and whether you selected Copy to other folder, which makes a copy of the original and renames the copy. Copying obviously adds time to the process.

WARNING Although it may seem like one at times, Bridge isn't technically an image asset manager on par with programs such as Extensis Portfolio, Canto Cumulus, ACDSee, Microsoft Expression Media, etc. Bridge doesn't create a separate image database and is therefore only capable of searching, organizing, and handling online image files. For more on handling your images with an asset management program, see The DAM Book: Digital Asset Management for Photographers by Peter Krogh (O'Reilly, 2005).

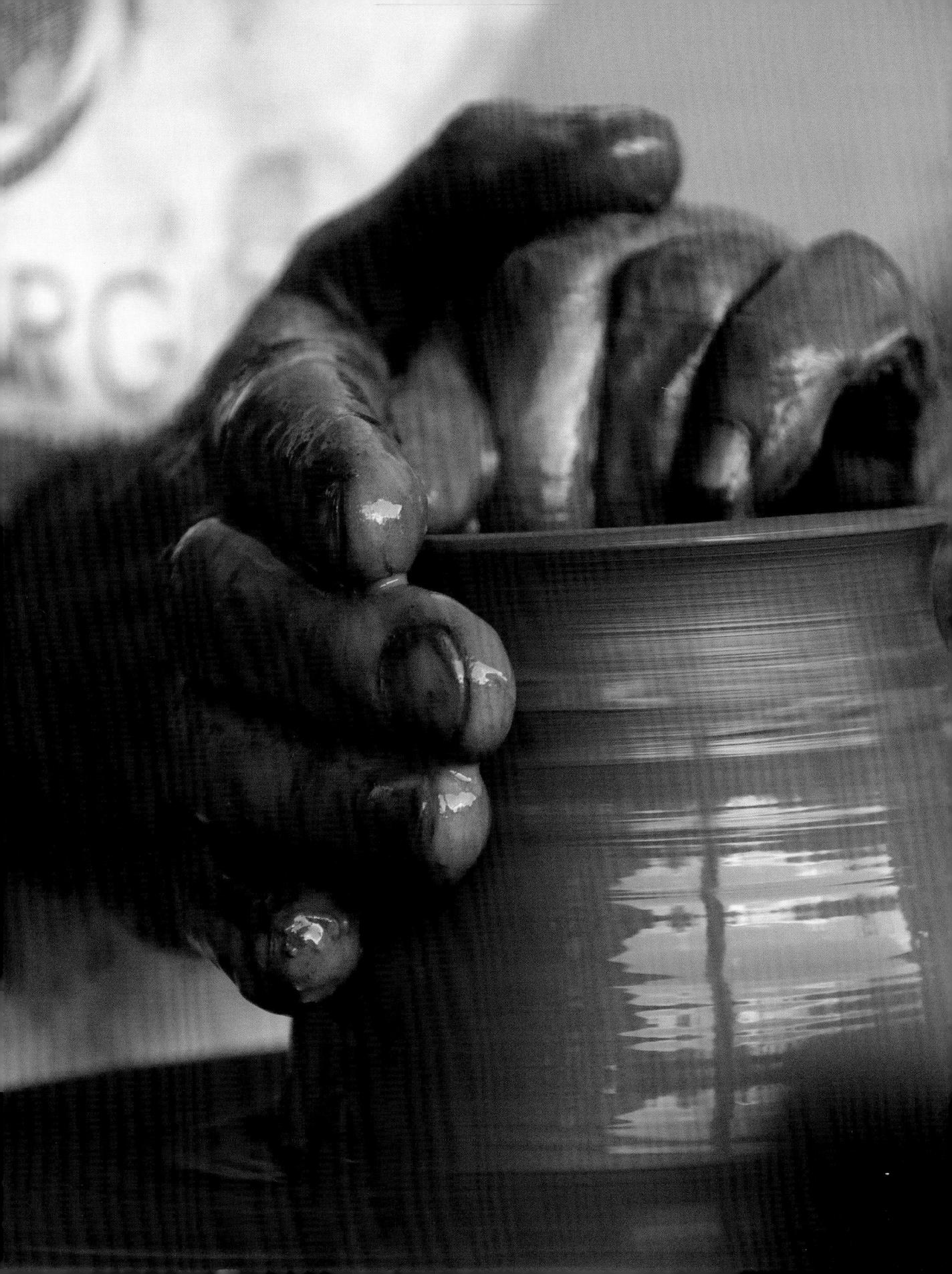

Getting Started with Camera Raw

The heart of CS3's RAW processing is the Adobe Camera RAW plug-in, developed and constantly updated by the eminent Thomas Knoll, one of the original creators of Photoshop. Camera Raw has come a long way in a relatively short time and has become the RAW processing tool for many photographers. This chapter gives you a general overview of the basic controls and features of Camera Raw. Subsequent chapters expand into more detail on such subjects as editing with Camera Raw, tone mapping, white balance, sharpening, and reducing noise.

Chapter Contents
Updating Camera Raw
Workflow Options
Camera Raw Tools
Preview and Analysis in Camera Raw
Camera Raw Tabs

Updating Camera Raw

You can update to the latest version of Adobe Camera Raw by going to www.adobe.com/support/downloads/ (Figure 4-1) or by using the Adobe Update Manager (Help→Updates) from within Photoshop or Bridge. I've had mixed results with the Update Manager, so I suggest you check out the Adobe site from time to time. The update is available through other sites as well, which you can find by Googling the words "Camera Raw Updates."

Which Version?

You can tell which version of Camera Raw you are using by selecting Photoshop→ About Plug-In→Camera Raw... from the main Photoshop menu. In Windows, the "About Plug-In" location is under the Help menu. The dialog box containing the version number (circled in Figure 4-2) will appear.

From the main menu bar in Bridge, you can find the Camera Raw version number by selecting Bridge →Camera Raw Preferences. (With Windows, Camera Raw Preferences are under the Edit menu.) The version number is at the top of the Preferences dialog box, as shown in Figure 4-3.

Before you do anything, you'll want to have the most recent version of Camera Raw. Every few months or so, it is updated to support new digital cameras. Occasionally, minor behind-the-scenes improvements are also made. It's therefore best to periodically download the latest version. It's free.

Figure 4-1

Figure 4-2

	Camera Raw Preferences (Version 4.3)	
General		ОК
Save image settings in:	Sidecar ".xmp" files	Cancel
Apply sharpening to:	All images 🗼	-
Default Image Settings -		-
Apply auto tone adju	stments mix when converting to grayscale c to camera serial number	

Figure 4-3

Figure 4-4

Figure 4-5

Figure 4-6

From Camera Raw you can find the version number by selecting the open preferences dialog box icon located in the toolbar (circled in Figure 4-4). The version number appears in parentheses at the top of the dialog box (also circled).

After You Download

After you download the Camera Raw plug-in file from the Adobe site, do the following:

- 1. Close Photoshop and Bridge.
- On a Mac, go to the Finder; in Windows, open My Computer and double-click Local Disk (C).
- 3. On a Mac, navigate to Library/
 Application Support/Adobe/Plug-Ins/
 CS3/File Formats. (Figure 4-5). In
 Windows, navigate to Program Files\
 Common Files\Adobe\Plug-Ins\CS3\File
 Formats. (Vista doesn't use the "My"
 grammar, but the path is the same, as
 you can see in Figure 4-6.)
- Move the existing plug-in to another location or simply rename the file.
 Keep this version in case you need to revert to your original version.
- Place the Camera Raw plug-in from the download into the same folder as in Step 3.

The next time you fire up Photoshop or Bridge, the new version will become available. It's not necessary—or desirable—to replace or throw away any Camera Raw cache folders. Just replace the plug-in itself.

Workflow Options

At the bottom of the Camera Raw workspace is a link (Figure 4-7). Click on it and the Workflow Options dialog box appears as shown in Figure 4-8. Here you will see options for Space, Depth, Size, and Resolution. The most recent settings will be selected. Let's take a look at each option and see how it relates to your overall workflow.

Space Here you can choose from a variety of color spaces, including the ones you see in Figure 4-9. In Chapter 6, I'll go over the arguments for choosing each; for now, just keep in mind that since we are working with RAW files, you can apply any color space of choice (at any time) without actually changing the underlying image data.

Depth In Camera Raw, you can choose between two depths: 8 Bits/
Channel and 16 Bits/Channel (Figure 4-10). Most digital cameras save approximately 12 Bits/Channel of color data. To get the most out of the RAW data when it is opened from Camera Raw into Photoshop, I work with 16 Bits/Channel for as long as possible, even though it results in larger file sizes. (As you will see in Chapter 12, if you are working on multiple RAW images, there may be times when 8 Bits/Channel is more efficient.)

Let's start our overview of Camera Raw with the Workflow Options dialog box, which offers important choices that are key to getting the most out of your RAW images. (Open the Camera Raw plug-in from either Bridge or from Photoshop's Open command.)

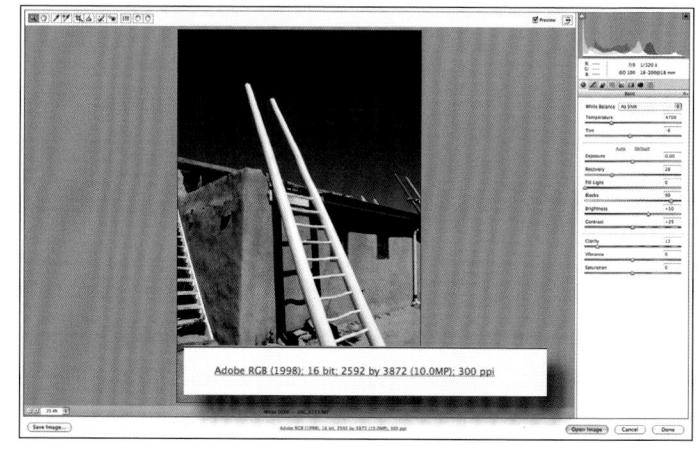

Figure 4-7

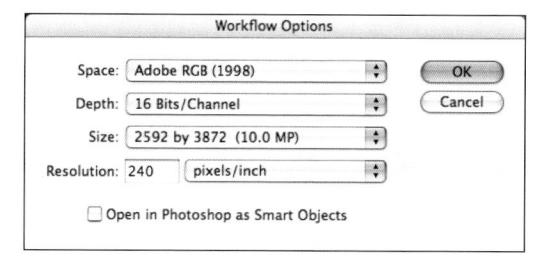

Figure 4-8

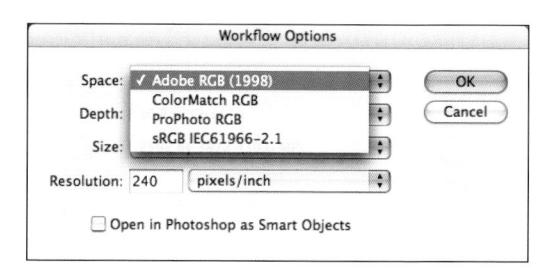

Figure 4-9

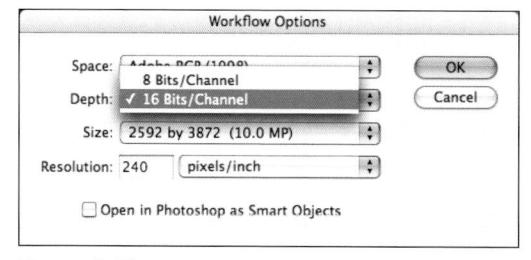

Figure 4-10

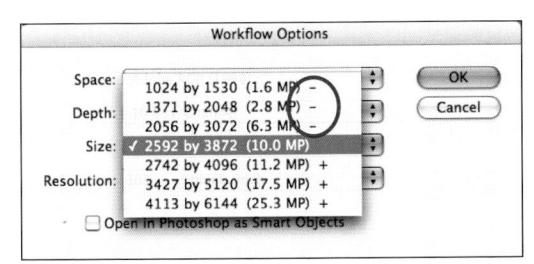

Figure 4-11

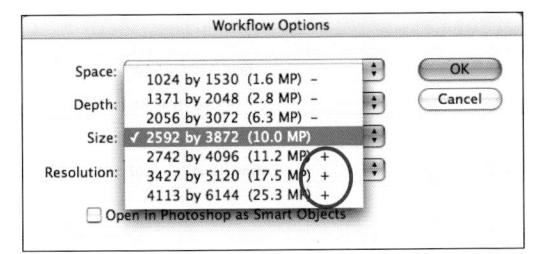

Figure 4-12

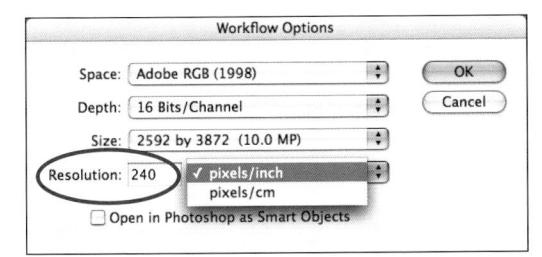

Figure 4-13

NOTE At the bottom of the Workflow Options dialog box is an option to Open in Photoshop as Smart Objects. When this is selected the Camera Raw Open Image button changes to Open Object. Smart Objects are Photoshop layers which enable you to work non-destructively on image content, much like you do in Camera Raw. You can't paint, dodge, burn, or clone Smart Objects unless you rasterize them first, but many other Photoshop functions such as masks and filters can be applied without changing the original characteristics of the image. You can also reopen a Smart Object into Camera Raw and make non-destructive changes there.

Size Your digital camera is capable of a specific maximum image size. You can either reduce that size via camera settings or better vet, do it later in Camera Raw and Photoshop. As you can see in Figure 4-11, any size under the actual size set by your camera is marked with a minus sign at the end. Any size over the actual size is marked with a plus sign at the end (Figure 4-12). The actual size of your camera has no markings at the end. When should you go over or under the native size set by your camera? The fact is, this setting doesn't actually "resize" the RAW file. It only tells Photoshop how to size the RAW file when it's opened. I'll get into more detail about resizing in Chapter 12, but, in short, I generally recommend resizing in Photoshop when quality is an issue, and using Camera Raw size settings when appropriate and a speedy workflow is the main concern.

Resolution The resolution value is relevant only when it's time to print your image. It's a value used by a printer driver to determine how many pixels to print per inch/centimeter (Figure 4-13). The default of 240 pixels/ inch is generally considered a suitable number for most desktop printers. Changing these settings doesn't change the number of total pixels in your image, only the distribution of those pixels when it comes time to print. Again, I want to emphasize that changing these workflow settings doesn't do anything to the actual RAW file. It only creates a Camera Raw setting that is applied when the RAW file is opened in Photoshop; the settings can be changed at any time.

Camera Raw Tools

The Camera Raw toolbar is located at the upper left corner of the work area, enlarged in Figure 4-14. Clicking on the tool icon selects that tool, but for most of

the tools, there are keyboard commands

Navigation Tools

as well.

Some processing decisions—such as color and exposure corrections—are more easily made when the entire image is visible in the viewing area. Other tasks, such as sharpening and noise reduction, benefit from enlarging or magnifying an image so details are readily discernible. Get the view you want via the Zoom and Hand navigation tools, which are found both in the toolbar and in the lower-left corner of the Camera Raw window.

Zoom Tool

To select the zoom level in Camera Raw:

- 1. Click on the pop-up window on the lower-left side of the viewing area, as shown in Figure 4-15.
- 2. Choose Fit in View to make the entire image visible in the viewing area. (The Fit in View option will set different files to different zoom amounts, depending on the original file size.) Double-clicking on the Hand tool (found in the toolbar at the top of the viewing area) also makes the entire image visible in the viewing area. The

Many Camera Raw tools will seem familiar to seasoned Photoshop users. There are navigation tools, zoom tools, color sample tools, cropping tools, and retouching tools, to name a few. In this section, we'll take a look at all of them.

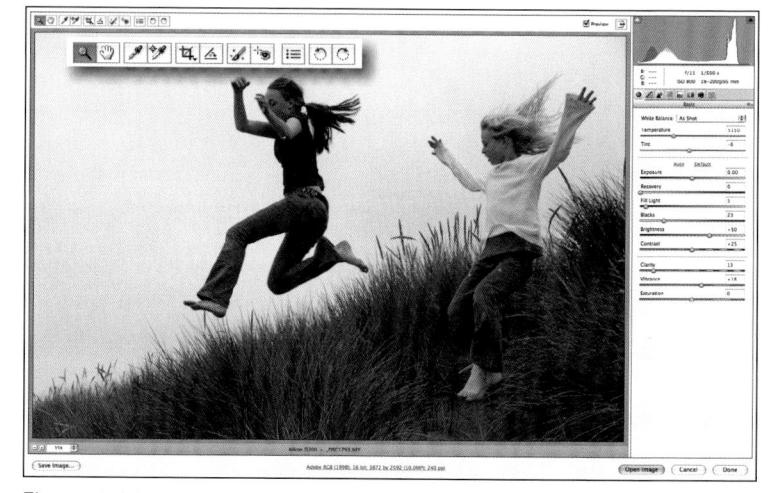

Figure 4-14

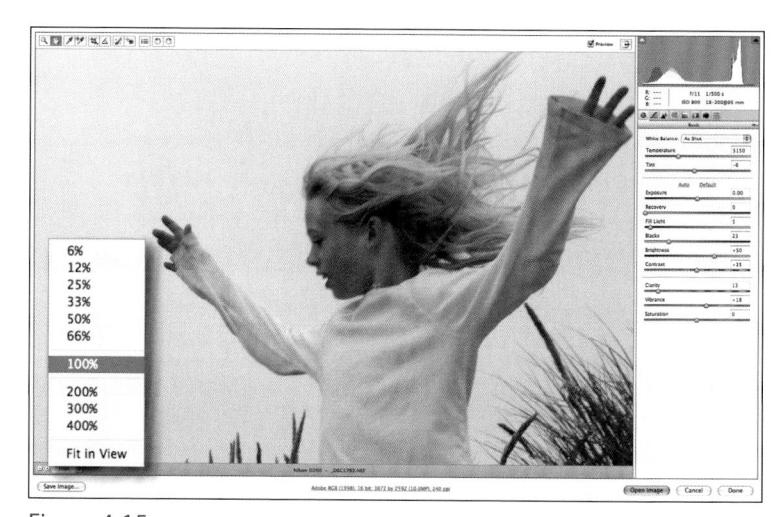

Figure 4-15

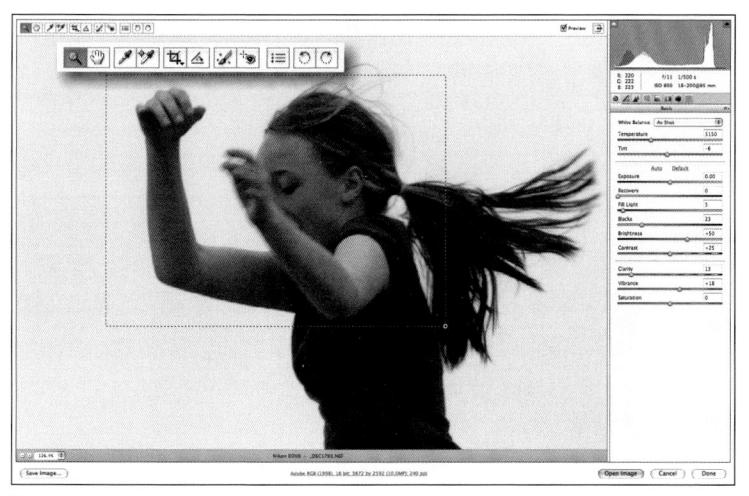

Figure 4-16

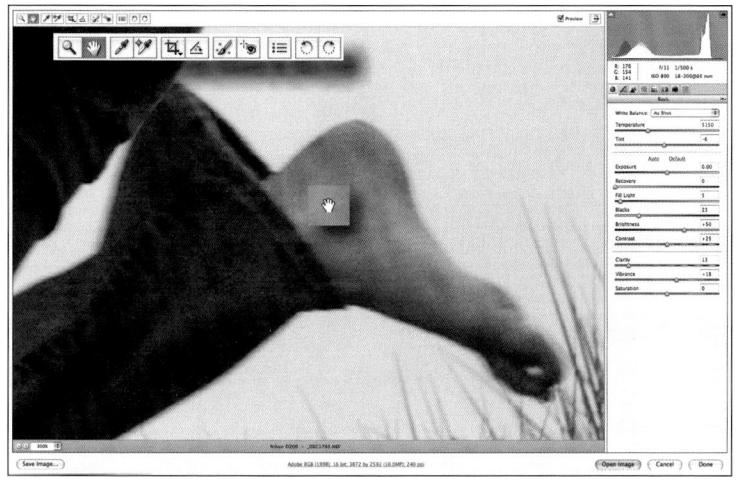

Figure 4-17

keyboard shortcut #-0 (Ctrl-0) will also set the image to Fit in Window size. Use higher magnification percentages to zoom in. You can also use the #-[+] (Ctrl-[+]) and #-[-] (Ctrl-[-]) keystrokes to zoom in or out. Plus and Minus buttons are also found in the lower-left corner of the Camera Raw viewing window. Standard Photoshop magnifying keyboard commands also work. Place your cursor over the area you wish to be centered and then use #-click (Ctrl-click) to zoom in, or #-Option-click (Ctrl-Alt-click) to zoom out.

3. You can also use the toolbox Zoom tool. Select it by clicking on the icon or using the keystroke Z. Hold your cursor over the area you wish to zoom in or zoom out. Use Option-click (Alt-click) to zoom out, or just click if you want to zoom in. You can also simply drag the cursor over the area of interest and release to zoom in, as shown in Figure 4-16.

The Hand Tool

To navigate a zoomed image with the Hand tool:

- Click the Hand tool icon (found at the top of the viewing area, enlarged in Figure 4-17) or use the keystroke H.
- Place your cursor over the image area and click and drag the image into position. The open hand becomes a clenched fist until your release your mouse.
- 3. Select the Hand tool at any time by holding the space bar. Your cursor will change to a hand.

White Balance Tool

The White Balance tool, located in the toolbar next to the Hand tool (Figure 4-18), can be used to automatically set the white balance based on a selected area of your image. (You can also set white balance manually using the Temperature and Tint Sliders in the Basic tab.) I'll get into more detail on using this tool in Chapter 6, but it's very easy to use: Simply select the tool and click on an area of your image that should be neutral gray. Then view the results. Double-clicking on the tool icon resets the white balance to As Shot.

Color Sampler Tool

The Color Sampler tool is also located in the toolbar, (enlarged in Figure 4-19) next to the White Balance tool. (The Keystroke command is S.) You can use the tool to take up to nine static color samples from the preview image. These sample points will update in real time to reflect any color or tonal adjustments. The values appear as RGB values above the preview image, as you can see in Figure 4-19. Values can be cleared by clicking Clear Samplers.

You can also get a real-time RGB readout by moving the Zoom tool, Hand tool, White Balance tool, Color Sampler tool, Crop tool, or Straighten tool anywhere over the preview image. The RGB values of the areas under the cursor will appear in the left corner of the dialog box under the histogram, as you can see enlarged in Figure 4-20.

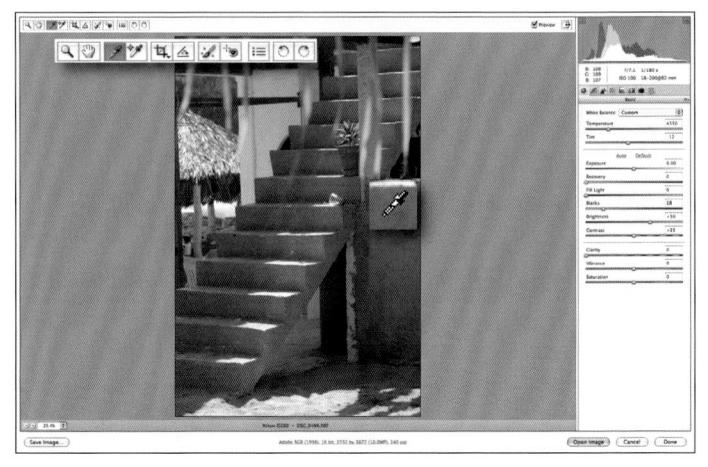

Figure 4-18

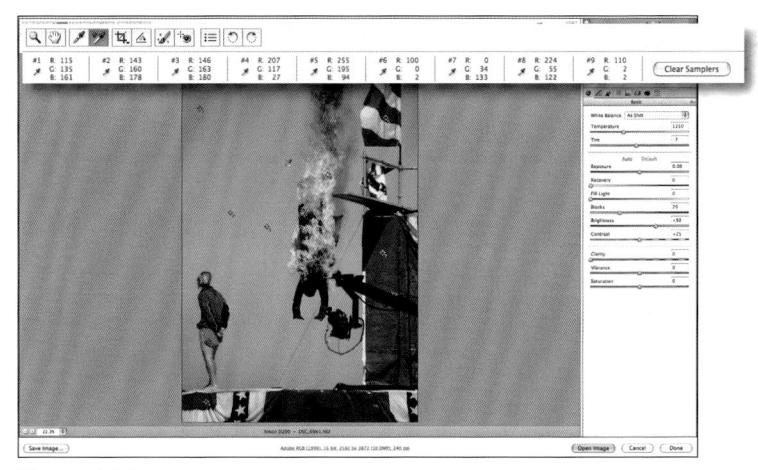

Figure 4-19

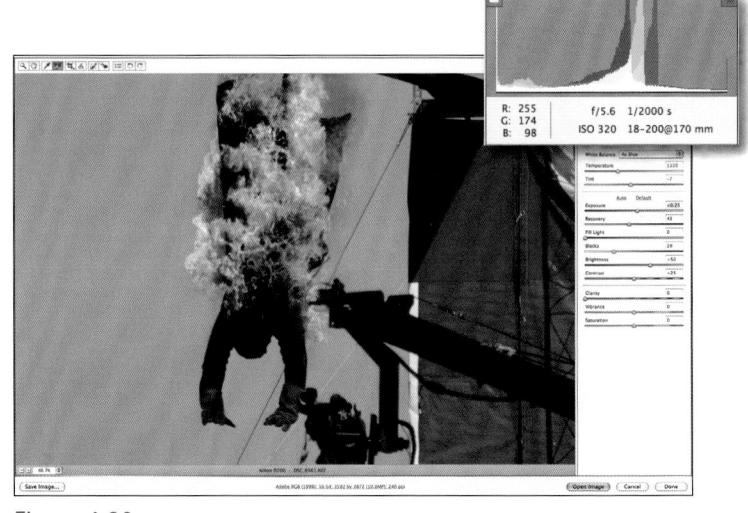

Figure 4-20

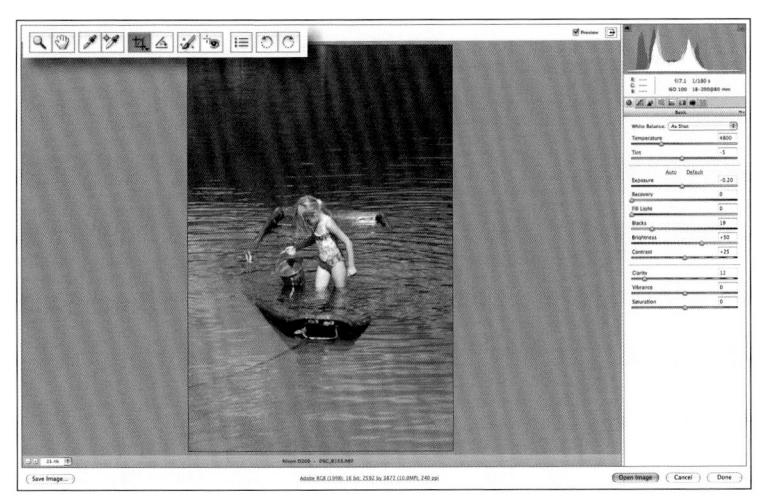

Figure 4-21

Figure 4-22

Figure 4-23

Crop Tool

Cropping is used to remove unwanted objects, to create a specific aspect ratio for printing, and to improve composition. Camera Raw's Crop tool is located in the toolbar, enlarged in Figure 4-21.

Camera Raw's crop tool works in much the same way as the one in Photoshop. Either select the Crop icon in the toolbar or use the keystroke C. Click on the image window and drag it to the desired size. Once you release the mouse, a rectangular box with bounding bars at the edges appears, as you can see on the left in Figure 4-22. You can adjust the size of the crop at any time or click inside and drag the crop into place. If you have multiple images open in Camera Raw, click the Select All button to apply a similar crop to all the images. You can also apply a previously made crop to other RAW files by selecting those files. You can even rotate the crop to any angle you wish. To do this, place the cursor slightly outside one of the bounding boxes, as I've done on the right in Figure 4-22. The cursor will turn into a curved arrow. Click to rotate it to the desired angle.

To clear a crop, use the contextual menu (shown in Figure 4-23) that appears when you click and hold the Crop tool, or simply use the Esc key. When you are finished cropping and close Camera Raw, you don't really crop or throw away any data. When you reopen the RAW file in Camera Raw, the crop mark remains, however, it will be completely changeable or removable. When you open the file from Camera Raw into Photoshop, you are no longer working on the original RAW file, so the crop is applied and data is thrown away, unless you open the file as a Smart Object.

When you use the Crop tool in Camera Raw, all you see is a grayed-out area designating the area to be cropped as shown in Figure 4-24. You have to use your imagination a little to visualize the final cropped image. You can get around this by opening multiple images. When you do this, the thumbnail version reflects the actual crop or rotation. (The Bridge thumbnail will also contain a crop icon, indicting a crop has been made.) You can also double-click the crop icon and the Crop tool will zoom into the cropped area.

Camera Raw also includes useful presets and customizable crop settings. Click and hold the Crop icon's arrow and a drop-down menu appears. If you select Custom, you will get the dialog box shown in Figure 4-25.

And, if you click on the Crop pop-up menu, you get the options shown in Figure 4-26. Choose Ratio and you can type in custom ratio values. Choose Pixels, Inches, or cm, and select an exact crop dimension, much like you can in Photoshop's Crop option bar.

Creating a Panorama with Custom Crop

The Crop Custom settings can be very useful. For example, photographer Martin Sundberg (featured in Chapter 5 using Camera Raw to edit his photo shoots) discovered a clever way of quickly turning a normal image into a ready-to-print panorama.

This is what to do:

- 1. Select the Crop tool.
- Select Custom from the drop-down menu. Martin Sundberg chooses Ratio, and types in a 6 to 17 ratio, as shown in Figure 4-27.

Figure 4-24

Figure 4-25

Figure 4-26

Figure 4-27

Figure 4-28

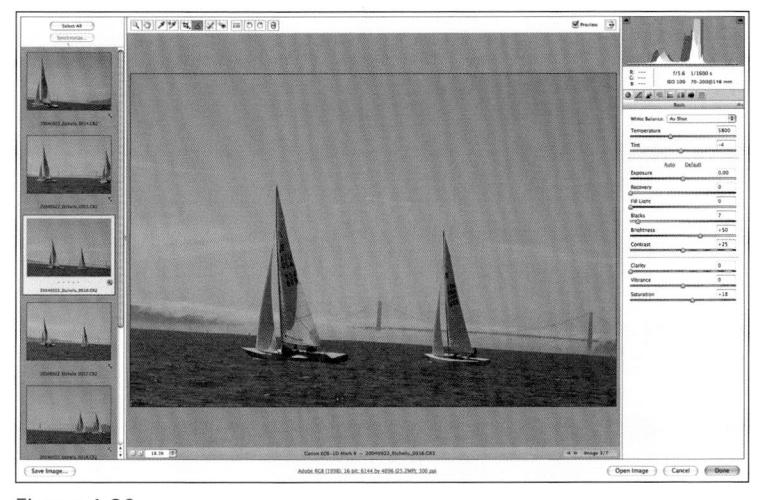

Figure 4-29

Figure 4-30

Figure 4-31

- 3. Click and drag the custom shape into place, as shown in Figure 4-28.
- 4. Next, in the Workflow Options window, select the crop size. Martin chooses a Crop Size of 6144 by 2168 (13.3MP). Now when he opens the file in Photoshop, it will automatically interpolate up to a printable size worthy of the panorama. Note:

 Cropping changes the size options.

Straighten Tool

Sometimes you just want things to be perfect, even if they aren't shot that way. Take Martin's example shown in Figure 4-29. Martin specializes in fast-moving action, and it's not always possible for him to frame a shot perfectly. In this shot, Martin wanted to straighten the horizon. With Camera Raw's Straighten tool, it's easy to get shots like this one right.

Here is what to do to fix a shot like this in Camera Raw:

- Select the Straighten tool (Figure 4-29) in the toolbar at the top of the Camera Raw window. (You can simply type A to select the tool.)
- 2. Click/drag and follow the slant of the horizon line, as shown in Figure 4-30.
- 3. That's all. When you release the mouse, Camera Raw does the rest, calculating the correct angle and adjusting the image to make up the difference. You can see the results in the viewing window shown in Figure 4-31, with crop marks. The area that won't be deleted is grayed out. When you select Open Image and open the file in Photoshop, it will be cropped and straight. Clear straightening with Clear Crop from the Crop tool pop-up menu.

If you find it hard to visualize what the final image will look like in Camera Raw without opening the image in Photoshop or looking at it in Bridge, there is a workaround. You'll need to start by opening at least two RAW files in Camera Raw, including the one you wish to fix. Because Camera Raw creates thumbnails of the multiple images (Figure 4-32), you can actually see the effects of the Straighten tool on the thumbnail. It's not a perfect solution, but it works.

Retouching and Red Eye Removal Tools

Camera Raw doesn't have anywhere near the retouching capabilities of Photoshop, but the Retouching tools (Healing and Clone) and Red Eye Removal tool—all new to Camera Raw—are great for simple tasks such as removing artifacts caused by dust on a sensor or red eye caused by on-camera strobes. The tools are non-destructive and always redoable.

Retouch Tool

The Retouch tool is located in the toolbar. When you select the tool, the options become Radius, which controls the size of the selection, and Type: Clone or Heal (enlarged in Figure 4-33). The Heal tool blends the target and the source, while the Clone tool takes a copy of the source area, pastes it over the target area, and blends the edges.

I mostly use the Heal tool to remove small spots and blemishes located in areas of continuous tone, such as the facial skin shown in Figure 4-34. I actually don't use the Clone tool much in Camera Raw. If an image requires cloning, I prefer to do the work in Photoshop, where I have more options and control.

Figure 4-32

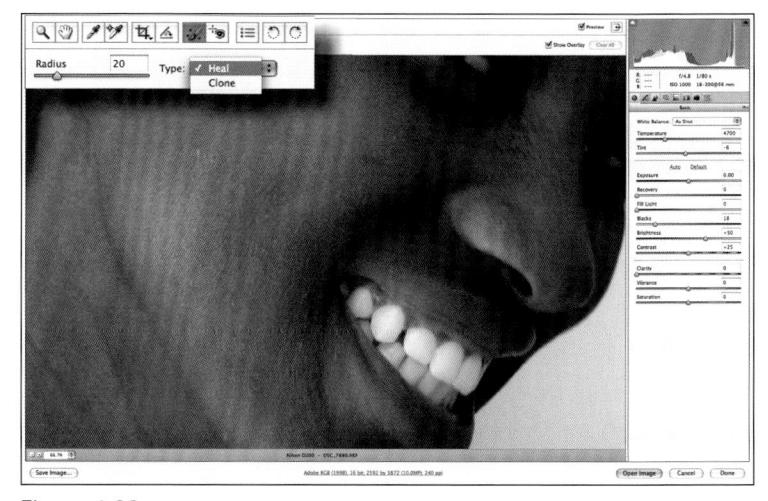

Figure 4-33

Figure 4-34

Figure 4-35

Figure 4-36

Figure 4-37

NOTE If you have multiple images open in Camera Raw and you Select All, your Retouch tool work applies automatically to all the images. If you select Synchronize, you can apply your Retouch tool work selectively to specific images. This is useful if your images contain a common artifact caused by, say, dust on the camera sensor.

Here's how to remove a spot. I'll use the Heal tool, but the procedure is the same for the Clone tool.

- 1. Choose the Retouch tool from the toolbar by selecting Type: Heal.
- 2. Place your cursor over the spot and adjust the red/white dashed circle size by dragging, or adjust the size with the Radius slider. Adjust the size until it's about 25% larger than the spot to be removed, as shown in Figure 4-35. (The bracket keys also enlarge or shrink the spot size.)
- 3. A second circle in green/white dashes, shown in Figure 4-36, will appear near your initial selection. If you make your circle too big, it may take a while to appear. This is the source for the healing tool and if you click inside the circle and drag, you can move the source to different positions while keeping the red target circle fixed.

The entire procedure can be repeated as many times as necessary on the same image until all the spots are removed. At any time, you can go back and relocate either the target or the source (Figure 4-37). Deselect unwanted selections by placing your cursor over the circle and using the Delete key. Selecting Clear All from the top right of the preview window will do just that.

You can toggle the visibility of the circles with the V key, or by selecting and deselecting the Show Overlay check box in the top right of the preview window area.

Red Eye Removal Tool

To use the Red Eye Removal tool:

- 1. Select the tool from the toolbar by clicking the eye icon.
- 2. Place the cursor over the red eye with the crosshair positioned slightly outside of the pupil. Click and drag until the rectangle is larger than the eye, as shown in Figure 4-38. Release your cursor and the red should disappear (Figure 4-39). You can adjust the effect by resizing the rectangle or by using the sliders. The Pupil Size slider will increase or decrease the size of the pupil, the Darken slider affects the opacity of the pupil.
- Repeat this process as many times as necessary. Select Clear All from the top right of the preview window to start over.
 Select Show Overlay to turn visibility of the rectangle on and off or use the V key.

NOTE You cannot make a Camera Raw preset that contains your Retouching or Red Eye Removal settings. However, with multiple images open in Camera Raw, click Select All and Synchronize (circled, Figure 4-40), and then select Spot Removal in the Synchronize dialog box settings and the same settings will apply to multiple images.

Image Orientation buttons

Camera Raw offers a couple of ways to rotate images to their proper orientation:

- Click on an appropriate arrow key from the toolbar, circled in Figure 4-41.
- Use the keystroke R to rotate right (clockwise) or Shift-R (clockwise) and L (or Shift-L) to rotate left.

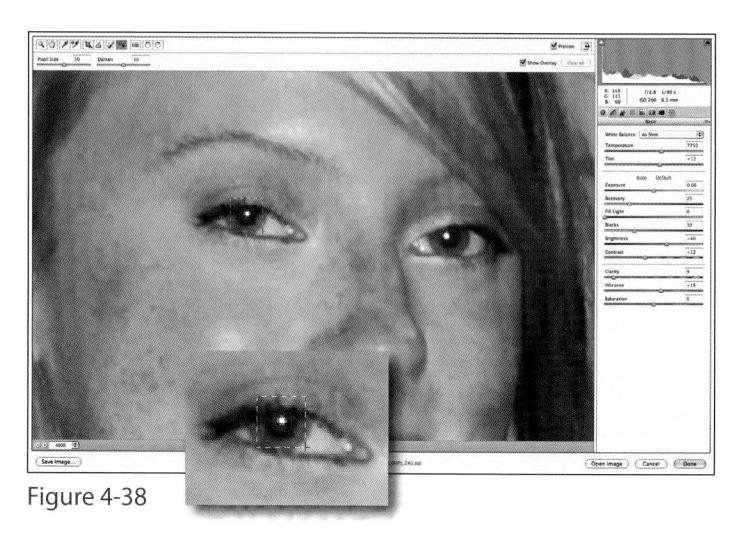

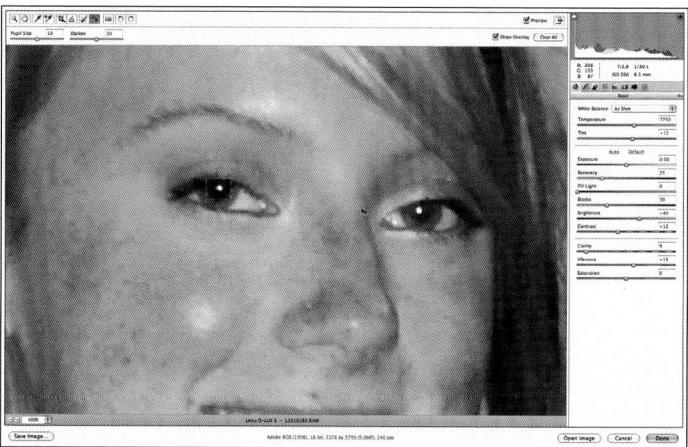

Figure 4-39

Figure 4-40

Figure 4-41

Before working on a RAW image, it's a good idea to analyze what needs to be done. First, Camera Raw generates a large preview reflecting the current settings. It also provides other ways to analyze an image, including a histogram and Shadow/ Highlights warnings. Let's take a look at these features.

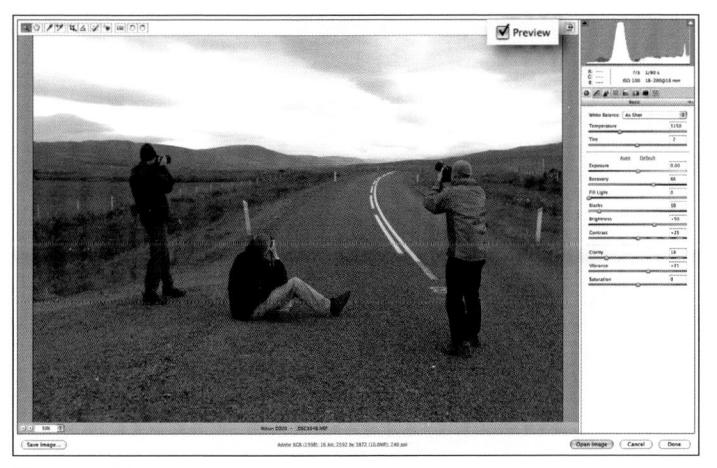

Figure 4-42

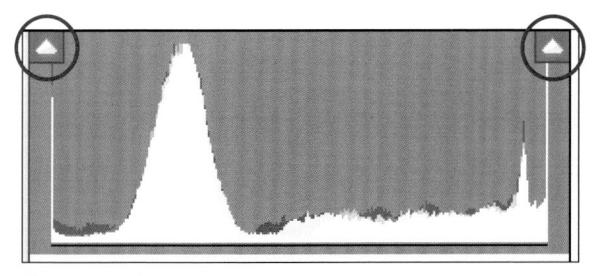

Figure 4-43

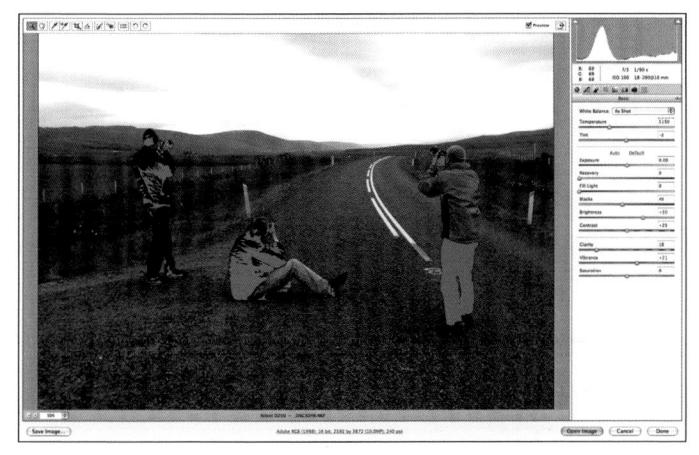

Figure 4-44

Preview and Analysis in Camera Raw

Preview Option

At the top of the Camera Raw window is a Preview checkbox, enlarged in Figure 4-42. Use this to toggle between the current settings and the Camera Raw settings applied when you opened the file in Camera Raw. Unchecked means you are viewing your image at Camera Raw settings applied when you opened the image; checked means you are viewing the image with current settings. (Toggle the P key for checked and unchecked.) Any Crop or Straighten adjustments remain, regardless of whether or not the Preview checkbox is selected.

If you haven't touched any of the Camera Raw controls, the Preview checked version will look exactly like the Preview unchecked version.

Shadow/Highlight Clipping Warnings

At the top of the Camera Raw histogram are two triangles, as shown in Figure 4-43. They will change colors to indicate which channel is clipping. If you click on the triangle to the left, anything that falls below the range of 0, or pure black, is shown in purple, as indicated in Figure 4-44. You can also use the keystroke U.

If you click on the triangle to the right, anything that falls beyond the range of 255, or pure white, is shown in red in Figure 4-45. You can also use the keystroke O. If either warning is active, it will have a white outline around the arrow; a black outline means it's inactive. Shadow and Highlight clipping warnings take any tonal or color adjustments you make in Camera Raw into consideration, so the RAW file itself might be fine, but may show clipping warnings after an adjustment. In Chapter 6, I'll get into more on using the Shadow and Highlight clipping warnings.

Color Histogram

The histogram found in the top right of the Camera Raw window, shown in Figure 4-46, displays red, green, and blue values visually. As you change tonal and color settings, the histogram adjusts accordingly. Under the histogram, there is an at-a-glance accounting of such camera data as ISO, focal length, f-stop, and shutter speed. I explain use of the histogram in greater detail in Chapter 6.

Other Analyzing Controls

There are other "hidden" controls that help you analyze and make decisions about your images. When you hold the Option (Alt) key and slide the Exposure, Recovery, or Blacks sliders in the Basic tab (Figure 4-47), your preview will reflect clipping information based on color channels. Also, in the Detail tab, when you hold the Option (Alt) key and slide any of the Sharpening sliders, you'll get real-time visual information as well. (This requires 100% view mode or higher.) I'll go into more detail on these tools in Chapter 6.

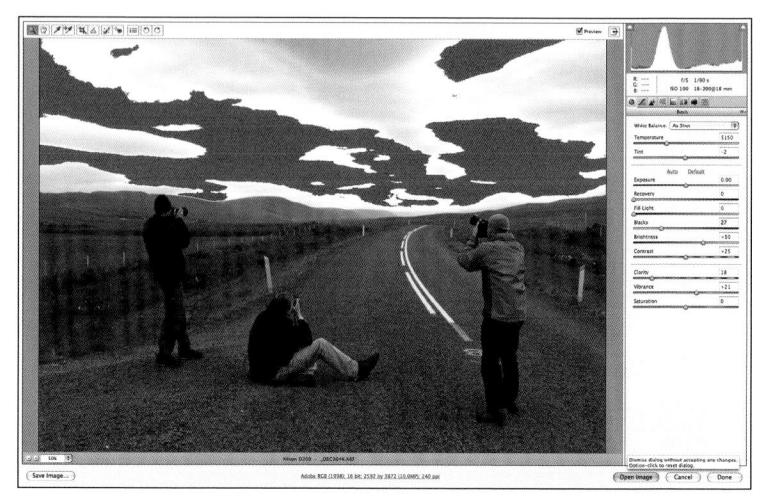

Figure 4-45

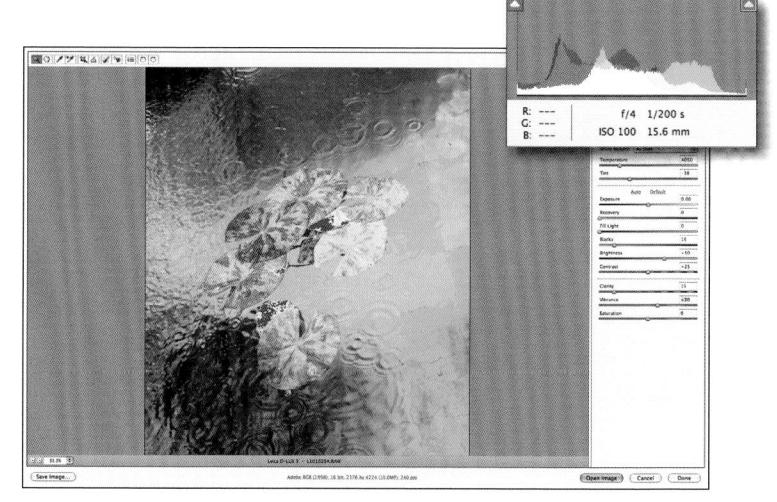

Figure 4-46

Figure 4-47

Camera Raw has eight tabs, and each tab is a gateway to controlling the look and feel of your RAW image. Let's look at the tabs, one by one.

Camera Raw Tabs

Figure 4-48

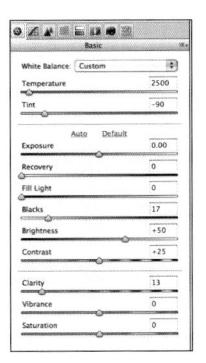

Figure 4-49

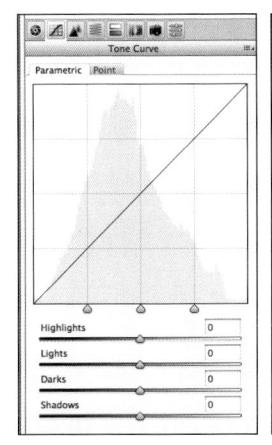

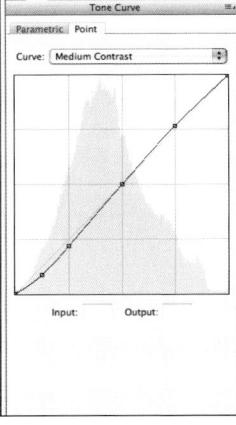

Figure 4-50

The different tabs are represented graphically on the right side of the Camera Raw window (Figure 4-48). If you hold your mouse over each icon, a balloon appears naming the function of each tab.

Basic Tab

Under the Basic tab shown in Figure 4-49, you'll find settings for White Balance, Temperature, Tint, Exposure, Recovery, Fill Light, Blacks, Brightness, Contrast, Clarity, Vibrance, and Saturation. I'll get into the proper use of the Basic tab controls in Chapter 6.

Tone Curve Tab

Like Exposure in the Basic tab, Tone
Curve controls let you adjust the entire
tonal range of an image. You have two
curves to choose from: Parametric, and
Point, shown in Figure 4-50. With the
Parametric curve you adjust tonal values
with four sliders: Highlights, Lights, Darks,
and Shadows. With the Point curve,
you can adjust up to 14 different points
throughout an image's tonal range (from
shadows to highlights). You can save Tone
Curve settings for use in another image.
I'll get into using Tone Curve controls in
more detail in Chapter 6.

Detail Tab

Detail controls, found under the Detail tab shown in Figure 4-51, control Sharpening (Amount, Radius, Detail, Masking) and Noise Reduction Luminance and Sharpening controls. I discuss how to use the Noise Reduction controls in Chapter 9.

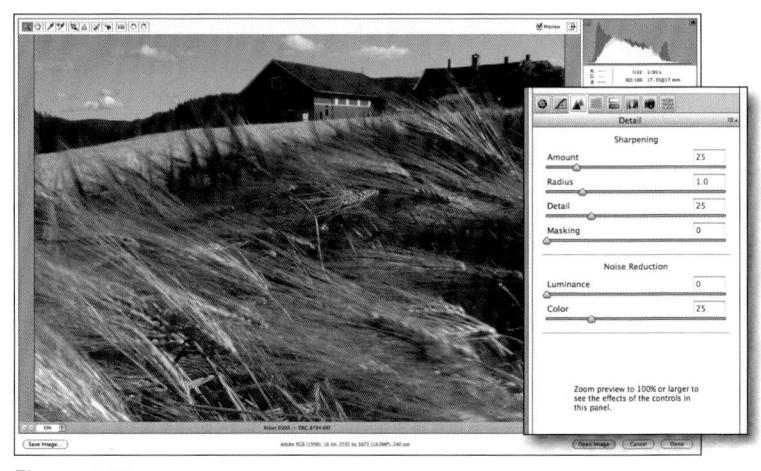

Figure 4-51

HSL/Grayscale

Under the HSL/Grayscale tab, you'll find very useful color and black and white controls. HSL stands for Hue, Saturation, and Luminance. Camera Raw uses a method of defining and working with color based on these three values, shown in Figure 4-52. Many of you will find working with color this way intuitive, easy, and even fun!

When you select the Convert to Grayscale box, as shown in Figure 4-53, grayscale conversion is as simple or complex as you like. You can quickly convert an image to black and white with good results by using the Auto setting, which is the default setting. Or you can use the Grayscale Mix controls and come up with a custom conversion of your own. I'll go into more detail on using the HSL controls in Chapter 7 and the Grayscale controls in Chapter 10.

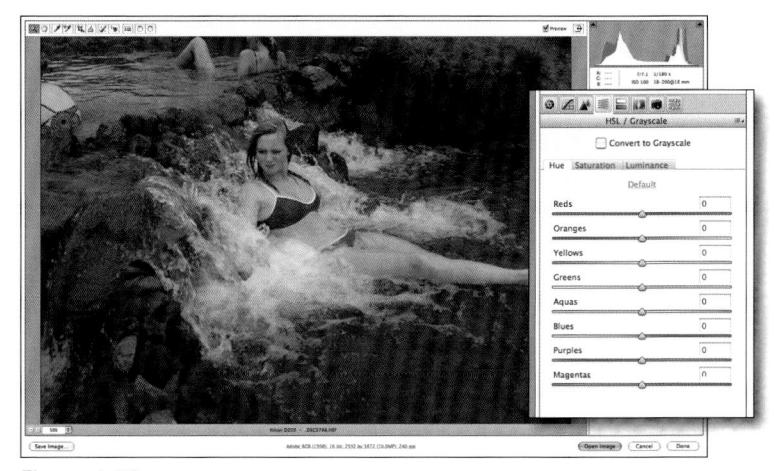

Figure 4-52

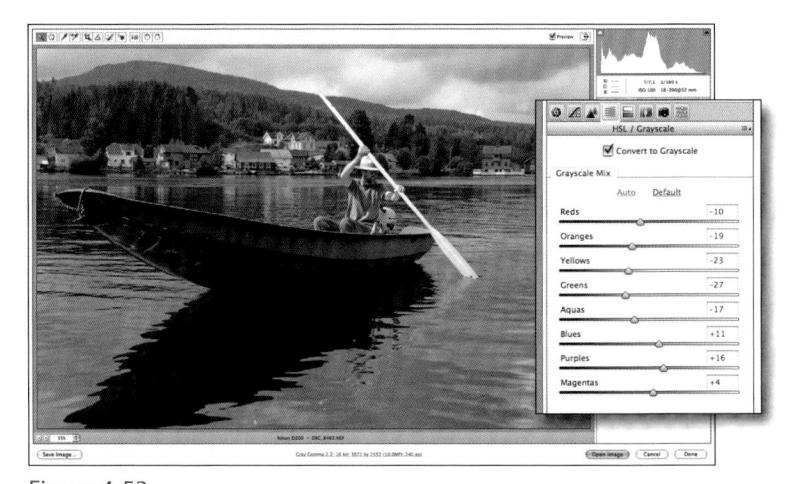

Figure 4-53

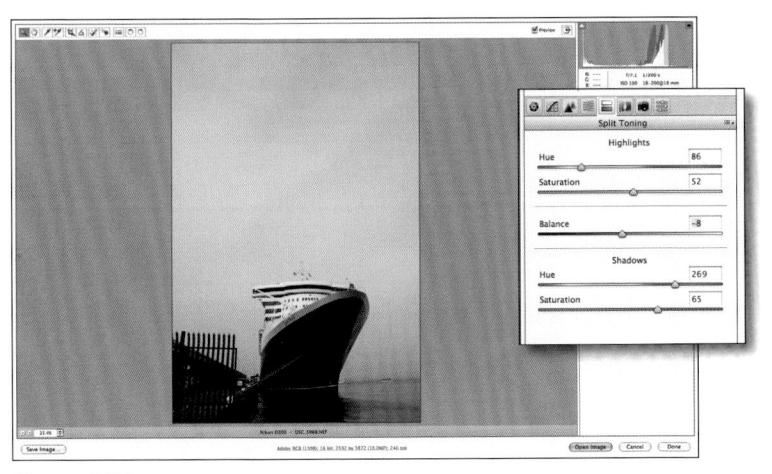

Figure 4-54

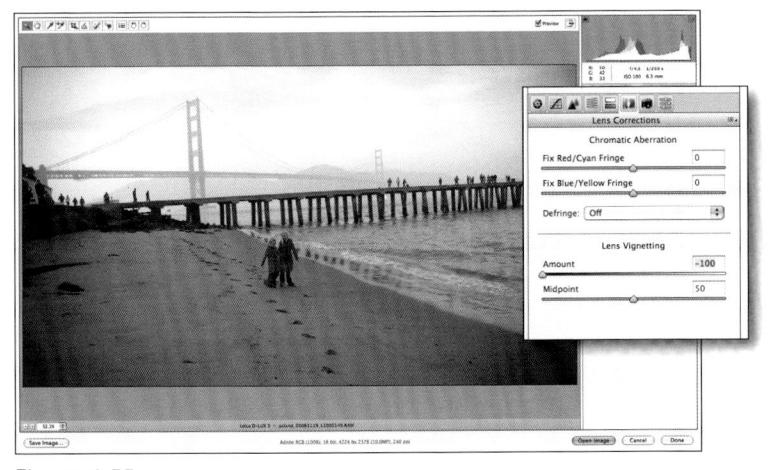

Figure 4-55

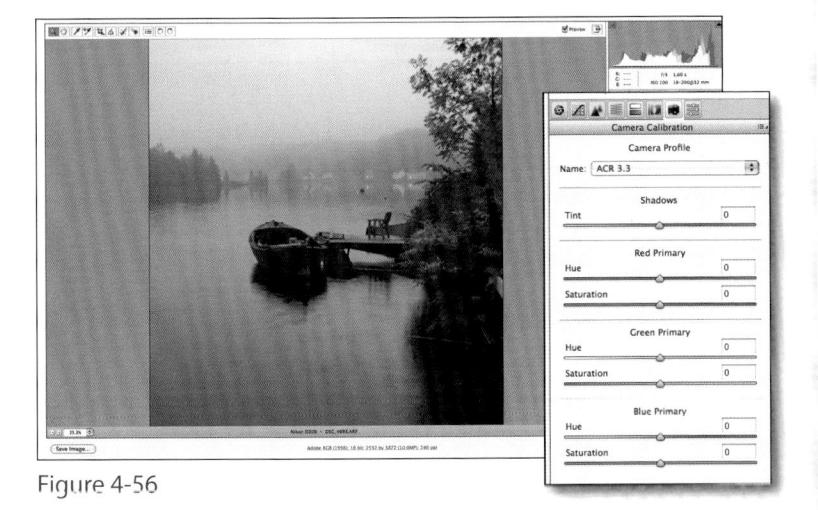

Split Toning Tab

Under the Split Toning tab, shown in Figure 4-54, you can control the tint and saturation of a tint applied to the highlight areas of any image separately from that applied to the shadow areas. The Balance slider in the middle controls the range of each. These controls can be applied to a black and white or a color image. I'll go into more detail on using these controls in Chapter 10.

Lens Corrections Tab

Under the Lens Corrections tab (Figure 4-55) are tools to overcome Chromatic Aberration and Vignetting. I go into great detail on this subject in Chapter 9.

Camera Calibration Tab

You can use the Camera Calibration controls, shown in Figure 4-56, to improve the color accuracy of your RAW files. You can also use these controls to create special effects and grayscale images from RGB. I go into the use of Camera Calibration for fine-tuning the behavior of Camera Raw's built-in camera profiles in Chapter 6. I cover using the Camera Calibration controls for special effects and the creation of grayscale images in Chapter 10.

Presets Tab

Under the Presets tab, pictured in Figure 4-57, you can view previously made Camera Raw presets and apply them to selected images. You can also create new presets based on current Camera Raw settings by clicking on the Create New Preset icon located at the bottom of the Camera Raw window (circled). To delete a preset, select it and then click the trash icon that's also found at the bottom of the Camera Raw window.

Figure 4-57

What to Do When You Mess Up?

There are a couple ways to undo unwanted operations in Camera Raw. Of course, there is the standard Undo command, %-Z (Ctrl-Z), which undoes the last action you took. You can also hold the Option (Alt) key and Cancel changes to Reset, circled in Figure 4-58. Click Reset and your image will remain open in Camera Raw, but it reverts to the settings that were applied when the image first opened in Camera Raw.

If you want to clear all Camera Raw settings and revert to the original settings, select Reset Camera Raw Defaults from the Setting pop-up menu, shown in Figure 4-59. (From Bridge you can do this on one or more selected thumbnails by selecting Edit→Develop Settings→Clear Settings.)

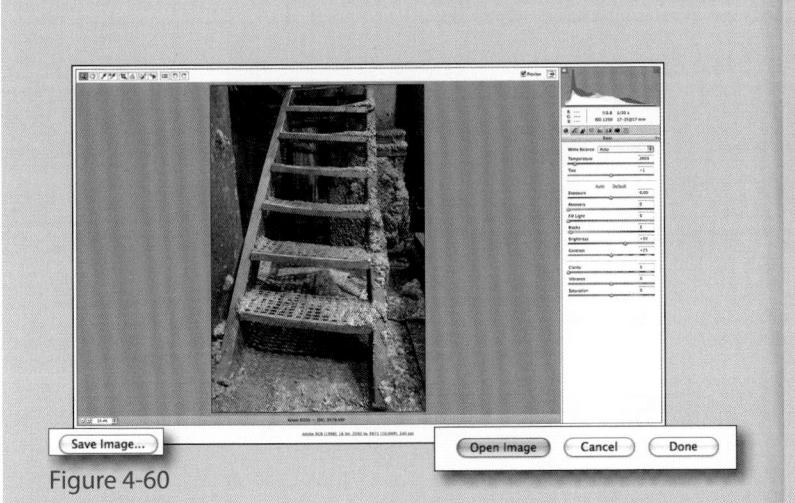

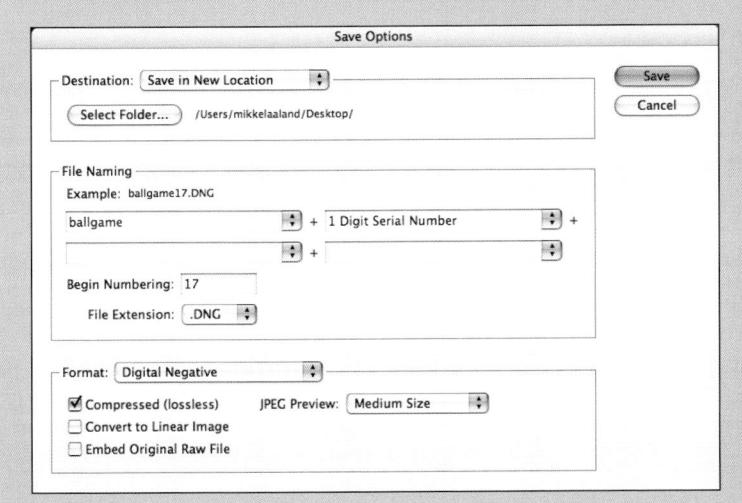

Figure 4-61

What to Do When You Are Done?

You have several options when you are finished adjusting and working on your image in Camera Raw (Figure 4-60), represented by four buttons across the bottom of the Camera Raw interface:

- Save Image when you want to convert your RAW file (or files) into a TIFF, JPEG, PSD, or DNG file. When you select Save Image, you get the dialog box shown in Figure 4-61.
- Open Image when you want to open your RAW file as-is in Photoshop. If you selected Open in Photoshop as Smart Objects in the Workflow Options dialog box, Open Image will be replaced with Open Object.
- Cancel if you want to exit Camera Raw with no new settings applied.
- Done to apply your current settings, exit
 Camera Raw, and return to Bridge or
 Photoshop (depending on which application is host to Camera Raw) without opening the file.

Photo Editing with Camera Raw

In Chapter 3, we saw how to edit, trash, and rate RAW files in Adobe Bridge. In this chapter, we will see how Camera Raw can be used as a viable alternative to photo editing and rating in Bridge. There are compelling reasons to do this. Not only can you open multiple images in Camera Raw, but you can also have analytical tools like the histogram available at a glance to help you make editing decisions. You can also easily set a magnification level in Camera Raw that enlarges the entire image rather than a small portion of the image (i.e., Bridge's Loupe tool). You can also synchronize and apply any of your image settings—including retouching settings—to a batch of images. And, of course, you can trash images directly from Camera Raw and rate them as well. Let's see how.

Chapter ContentsPreliminary Steps
Editing the Shots

Preliminary Steps

Martin is best known as a photographer specializing in extreme outdoor sports. His subjects often move fast—very fast and Martin often shoots several frames per second to maximize the chances of getting the perfect frame. However, shooting this way also increases the chances of an image being out of focus or blurred from camera or subject movement. One frame may be perfectly sharp and the next soft. Even correct exposure is hit and miss. Examining for sharpness and exposure is therefore a critical component in Martin's editing process. In this section, we'll join Martin as he imports and edits a freestyle biking shoot using Bridge (Figure 5-1) and Camera Raw.

Before ending up in Camera Raw, Martin performs some preliminary steps which include importing and renaming files in Bridge. Here's how he does that, step-bystep:

- Import the RAW files from the memory card into Bridge. Here Martin imports the shots from his Canon 1D Mark II.
- 2. Next, select all the images in Bridge by using the keyboard shortcut ૠ-A (Ctrl-A). (If no images are selected, Bridge assumes all visible images are to be renamed.) Then apply a Batch Rename using Tools→Batch Rename from the menu bar. In the Batch Rename dialog box, Figure 5-2, Martin creates a starting numerical identifier and the descriptive text: bike_ramp.

Let's look at the the workflow of photographer Martin Sundberg, who often uses Camera Raw to edit his photo shoots. As you'll see, Martin actually uses a combination of Bridge and Camera Raw—but his workflow should open you to using Camera Raw in ways you may not have thought of before.

Figure 5-1

		Ba	tch Rename			
Destination Folder						Renan
Rename in same folde	er					Cance
Move to other folder						-
Copy to other folder						
Browse						
New Filenames		p				
Text	*	20050620_			$\odot \odot$	
Text	*)	bike_ramp_			$\Theta \oplus$	
Sequence Number	•	1	Four Digits	*	$\odot \odot$	
Options						
Preserve current filen	ame ir	XMP Metadata				
Compatibility: Windo	ws V	Mac OS 🗹 Unix				
Preview						
Current filename: _F6D	8229	CR2				
New filename: 2005	0620	_bike_ramp_0001.CR2				
		18 files will be ren	amed			

Figure 5-2

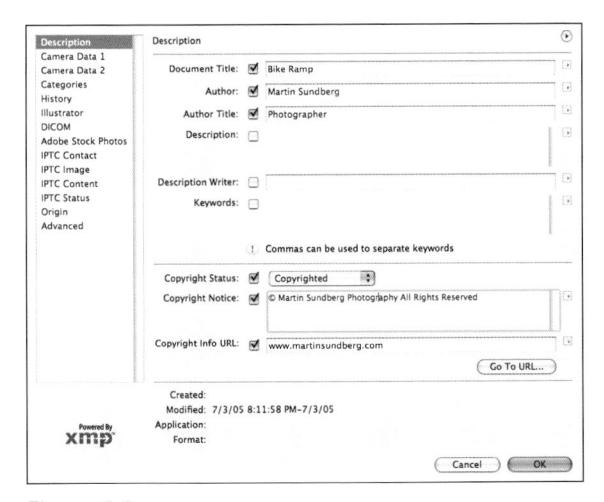

Figure 5-3

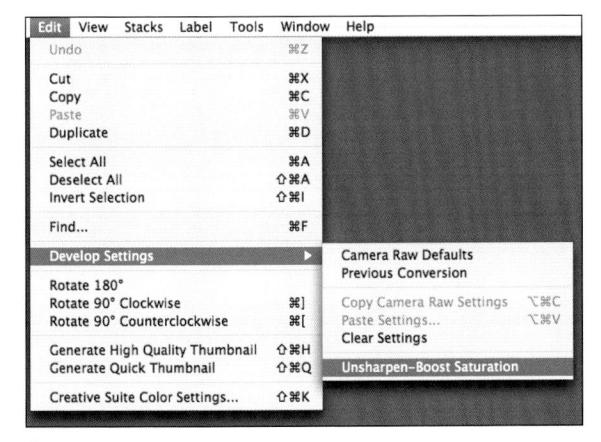

Figure 5-4

Figure 5-5

- After batch renaming, select all the files again. Then use the Metadata panel or Info (File→File Info, to bring up the dialog box in Figure 5-3) to apply a copyright notice, author, and URL. The data entered in the Metadata panel or File Info will apply to all the selected images.
- 4. At this point, in Bridge, select all your files. Then you can apply a custom Camera Raw setting to all the images. Martin has created a setting he calls Unsharpen-Boost Saturation. Because he has the preset saved, he can use Edit→Develop Settings→Unsharpen-Boost Saturation from the file menu (Figure 5-4). Right-clicking on an image brings up these options as well. Martin's custom setting turns off sharpening in Camera Raw and boosts saturation by about 30 percent.

We'll go over creating and using custom Camera Raw settings in Chapter 12, but for now, just take note that this is a point where changes can be made to the whole collection of RAW files at once from within Bridge (Figure 5-5). Whew! So much to do before actually editing! But everything Martin has done up to now is an integral part of any good workflow. Tagging images for copyright and ownership is critical for maintaining image integrity, and renaming files gives Martin hands-on control over critical image information. After all this, it's on to editing.

Editing the Shots

Most photographers think of Camera Raw as a RAW file converter. But here you'll see that its capabilities extend beyond image processing and it can also be used to examine, analyze, cull, and rate images as well.

Let's do some actual editing of multiple images in Camera Raw:

- 1. From Bridge, open the selected files by placing your cursor over one of the selected thumbnails and double-clicking. After a while, the images appear in the Camera Raw window and look like Figure 5-6. Note the image in the main window opens at 34.4 percent, or some other percentage dictated by a camera's native resolution. Not a good size for determining sharpness. Also note the icon in the lower right corner of each file's thumbnail. This signifies Camera Raw settings have been applied. Remember, in Martin's case, he applied the custom Camera Raw settings earlier, in Bridge.
- Before magnifying the image to
 a desirable 100 percent, choose
 Select All from the top of the image
 window. Next, use the Zoom tools to
 magnify the image to 100 percent.
 The keyboard shortcut #-Option-0
 (Ctrl-Alt-0) also sets an image to 100
 percent (Figure 5-7). Now all the
 images will appear at 100 percent, and
 you don't have to stop and change the
 zoom level each time.
- Cycle through the images using the keyboard arrow keys. At 100 percent magnification, Martin quickly sees which images are sharp and which aren't.

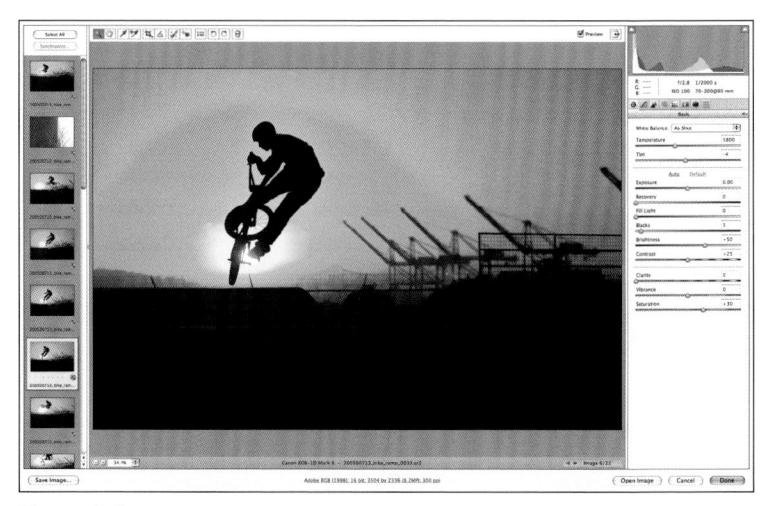

Figure 5-6

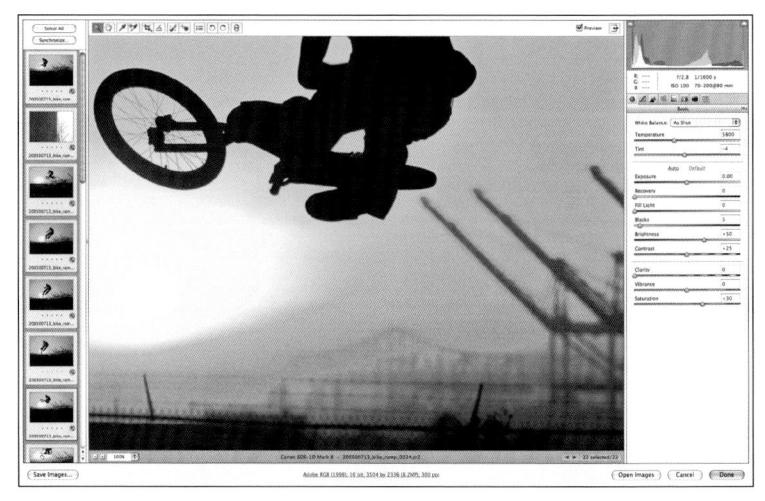

Figure 5-7

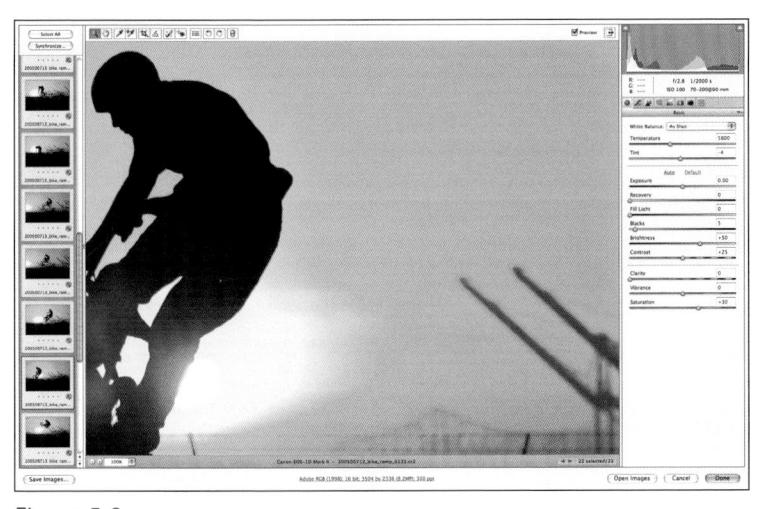

Figure 5-8

Figure 5-9

Figure 5-10

4. Use the histogram on the top right to observe the distribution of tonal values (Figure 5-8). Look for clipping in the highlights or shadow areas. The histogram will change with each image. Select one thumbnail at a time and make needed Exposure adjustments. Make sure the exclamation mark in the upper right of the image is clear before making any decisions.

Deleting in Camera Raw

Like in Bridge, you can trash and prioritize images in Camera Raw but with the advantage of being able to enlarge and analyze individual images more fully than you could in Bridge. To delete an image, select the image and click the Trashcan in the toolbar at the top of the Camera Raw window, circled in Figure 5-9. To deselect images marked for deletion, simply click the trash icon again. You can also delete/ undelete by using the delete keyboard command. (The trash icon will appear in Camera Raw only when multiple RAW files are open.) A reminder will appear in the image window. In the filmstrip view, the image icon will have a reminder as well, in the form of an X. When you exit Camera Raw, the images marked for deletion are automatically moved to the trash or recycle bin.

Assigning Ratings in Camera Raw

You can also assign your ratings here by clicking directly on the filmstrip thumbnails (just below the image), or by selecting a thumbnail and using %-Numbers 1–5 (Ctrl-Num 1–5). Figure 5-10 shows what Martin's thumbnails look like in Camera Raw after he assigns ratings.

Camera Raw can't sort images by priority, so Martin waits to do this last, in Bridge.

Synchronizing in Camera Raw

In this example, Martin applied a Camera Raw preset to his images while in Bridge. He could have also waited and applied the preset in Camera Raw, or used the Camera Raw Synchronize feature. Synchronize is great when you want to apply image settings selectively, for example, when you want to apply a custom Retouch setting to a batch of images, and none of the other settings.

Let's say you have a spot caused by sensor dust which is found in the same location on every image. To remove the spot on all the images simply select a representative image from the filmstrip, then:

- Select the Retouch tool from the Camera Raw toolbar, circled in Figure 5-11. Select Heal from the Style popup menu.
- Click on the spot with your cursor and draw a circle approximately 25% larger than the spot.
- Select the other images to which you want to apply the spot removal.
 Use #-click (Ctrl-click) for individual images. Click Select All to select all the images in the filmstrip.
- Click Synchronize from the top of the filmstrip. In the resulting dialog box, select Spot Removal from the Synchronize pop-up menu, as shown in Figure 5-12.
- 5. Click OK. You are done.

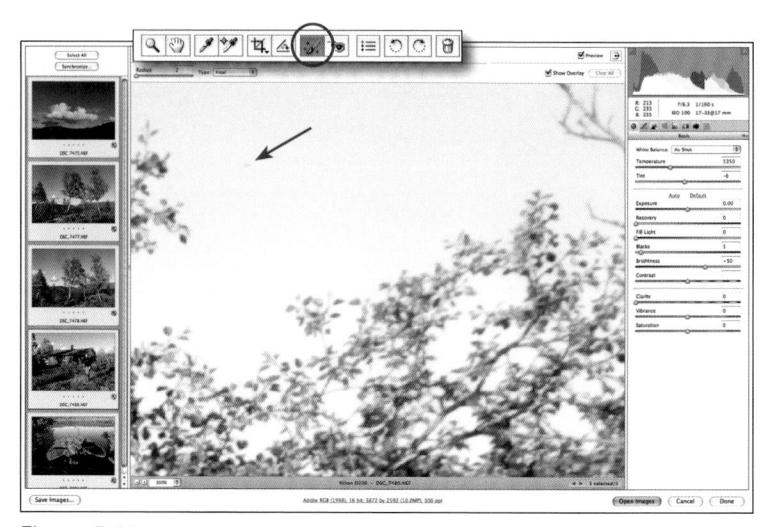

Figure 5-11

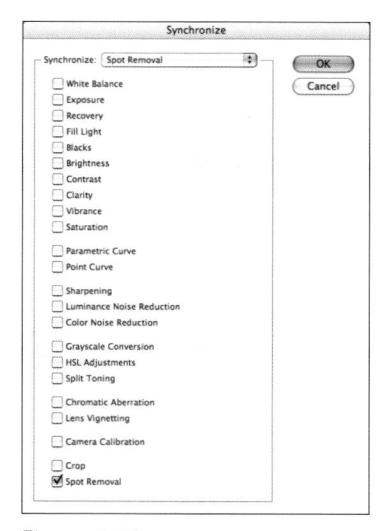

Figure 5-12

NOTE After editing and tagging (and other image processing and retouching) your images, click Done. This doesn't open the images in Photoshop. That's not what you want—at least not at this time. Selecting Done closes the Camera Raw window and assigns a XMP sidecar file to each image that contains the tagging information. (Or, depending on how Camera Raw Preferences are set, it saves the information in a Camera Raw database.) Later, in Bridge, as a final editing step, you can sort your images according to rating and make a new folder to hold the cream of the crop (View→Sort→By Rating).

Figure 5-13

NOTE RapidFixer is downloadable for CS3 from DAM Useful (http://damuseful.com/pages/rapidfixer. html) and can be purchased for \$49.95.

RapidFixer: Bringing Camera Raw Controls into Bridge

For many photographers, seeing a full screen of thumbnail images—as you can in Bridge—makes it easier to edit. But wouldn't it be great if you could quickly apply individual Camera Raw adjustments to your Bridge images without going into the Camera Raw work environment?

Well, for an extra \$49.95 and a plug-in called RapidFixer, you can. Look at Figure 5-13. You'll see the familiar Bridge workspace but because Rapid Fixer is installed, you'll see some very handy controls at the top and bottom of the screen. Here you'll find most of Camera Raw's tonal controls, including Temperature and Tint, Split Toning, Vibrance, HSL Controls, and even Vignetting controls. When you apply your settings in Bridge, you'll see the thumbnail previews update to reflect the new settings in realtime. You can apply settings to one or many images. You can also cut and paste settings between images—without leaving the Bridge environment.

RapidFixer is especially great if you have a batch of images that require relative exposure changes. For example, if you start with one image that is overexposed 1 stop and another that is 1.5 stops over, you can increase the Exposure value starting point for the first image to 1 stop over and the staring point for the other to 1.5. If you do this in Camera Raw, you are applying exactly the same settings in a non-relative way.

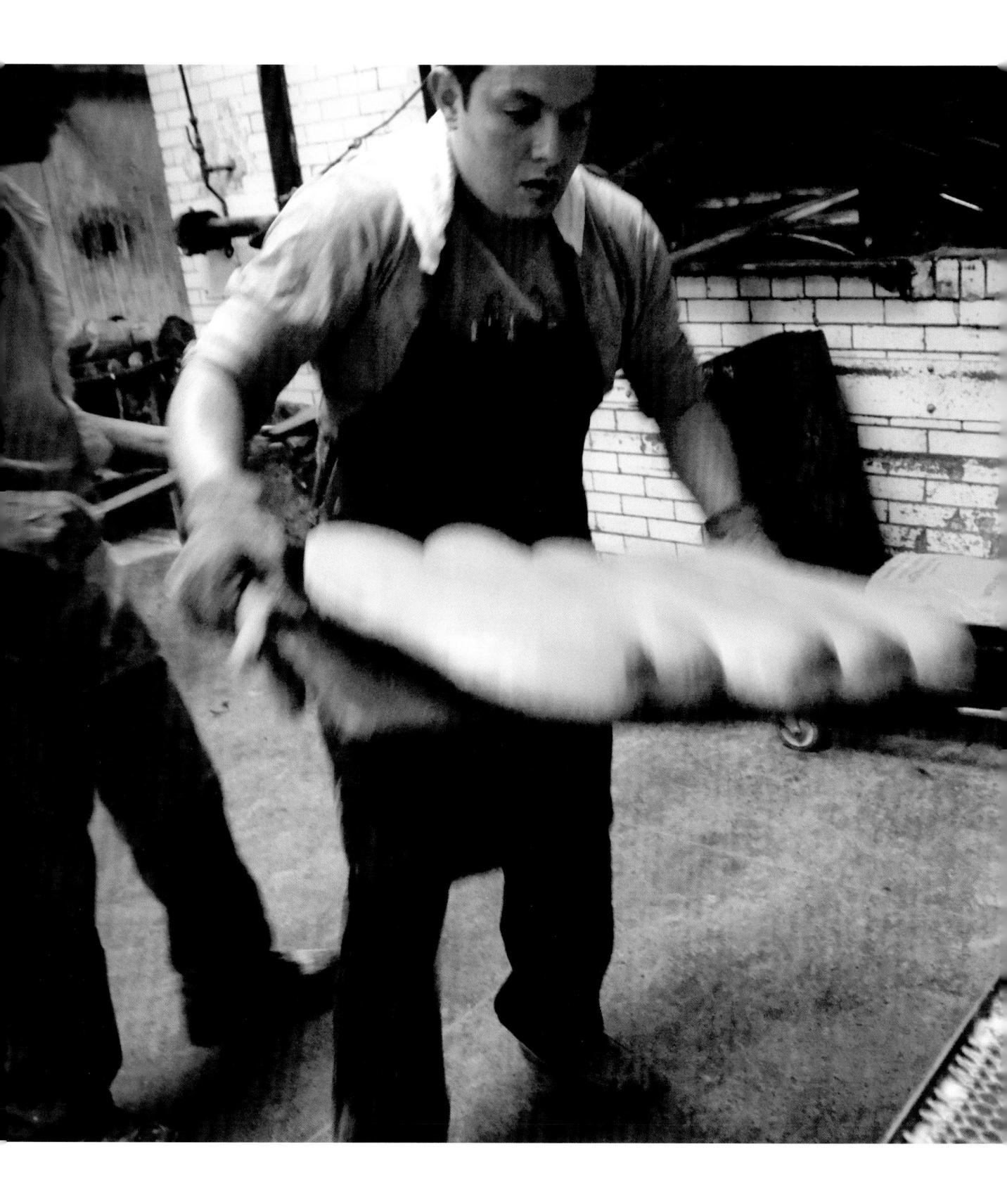

Working RAW

Actual files found at http://examples.oreilly.com/9780596510527/

Download this RAW file, open it in Camera Raw, reset it to the original Camera Raw default via the Settings pop-up menu, and you'll see there is a lot of noise in this image, shot at 1600 ISO. The first thing I did was use Camera Raw's Noise Reduction controls. Then I adjusted the white balance to give it a warmer tint. I adjusted the exposure values slightly, but left the other Basic tab settings alone. By the way, this shot was taken at the American Italian French Baking Company on Grant Avenue in San Francisco. It's my local bakery.

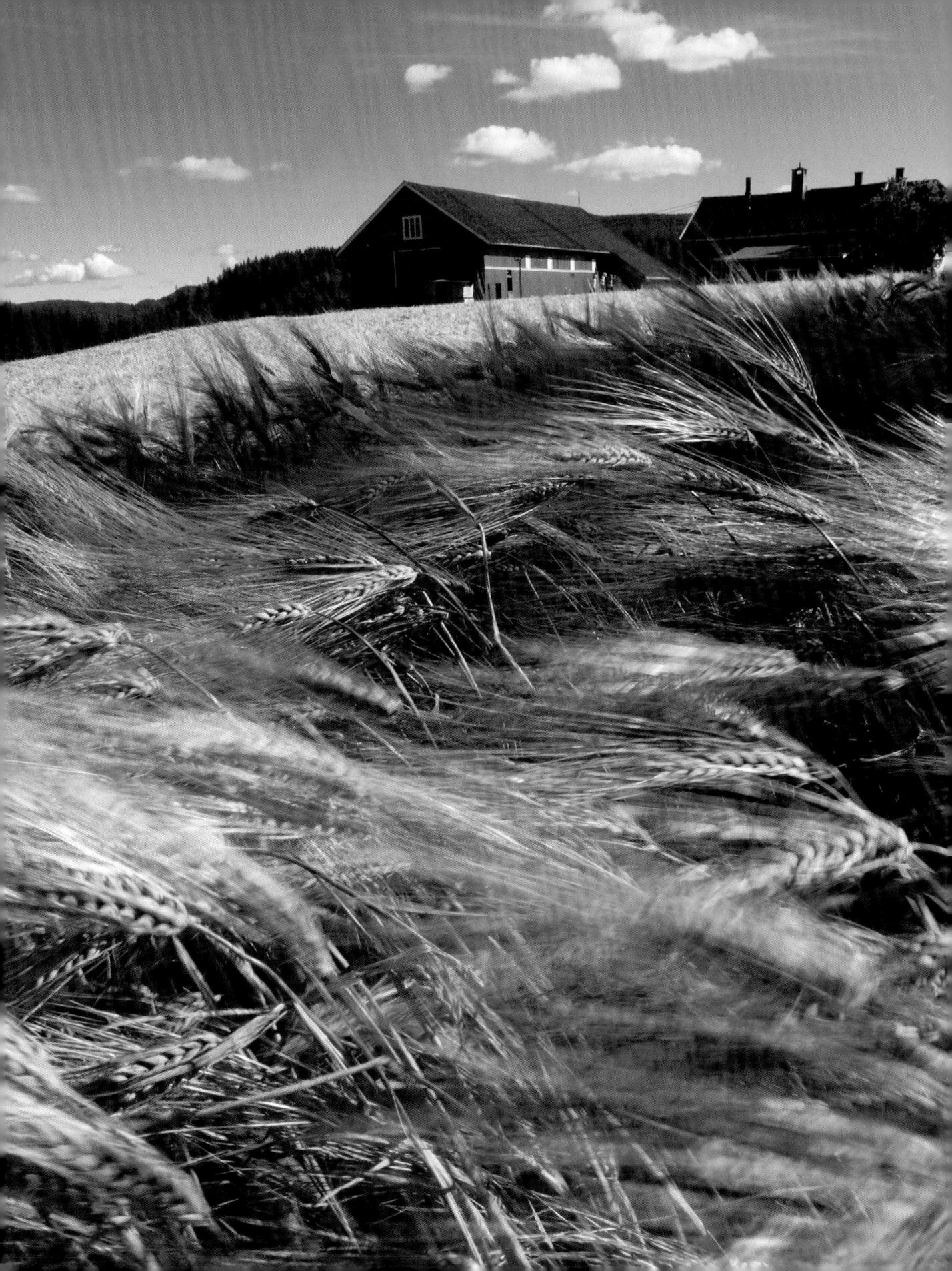

Using Camera Raw Basic Tab Controls

All RAW files require extensive processing to produce an image pleasing to the eye. Adobe Camera Raw does most of the computational work to assemble a RAW file in the background, but it also provides many tools to make an image look the way you want it to. In this chapter, we'll see how to use the controls found under the Basic tab to automatically redistribute the tonal values of a particular image. Or, if you prefer, you can manually change the white balance or redistribute tonal values with the Exposure, Recovery, Fill Light, Blacks, Brightness, or Contrast sliders. You can use the Clarity, Vibrance, or Saturation sliders to control color saturation or give an image more pop. In the next chapter, I'll show you how you can get more advanced control over color and tone using the Tone Curve and HSL/ Grayscale tabs.

Chapter Contents

Using Camera Raw Auto Tone Adjustments
Customizing the Camera Raw Default Settings
Evaluating an Image in Camera Raw
Manually Adjusting White Balance
Manually Mapping Tone
Adding Clarity
Using Vibrance & Saturation
Finishing Up
Adjustments with Photoshop

Using Camera Raw Auto Tone Adjustments

With auto tone adjustments, Camera Raw applies a made-toorder tone map based on the individual characteristics of a particular image. This often produces satisfactory results, and it's a good place to start.

There are two distinct ways to apply auto tone adjustments in Camera Raw. You can set Camera Raw preferences to apply auto tone adjustments automatically to every image you open in Camera Raw, as shown circled and enlarged in Figure 6-1.

Or, you can apply auto tone adjustments on an image-by-image basis by selecting Auto in the Basic tab, shown circled and enlarged in Figure 6-2. The keyboard shortcut for Auto is #-U (Ctrl-U). Using #-R (Ctrl-R) reverts to the default settings.

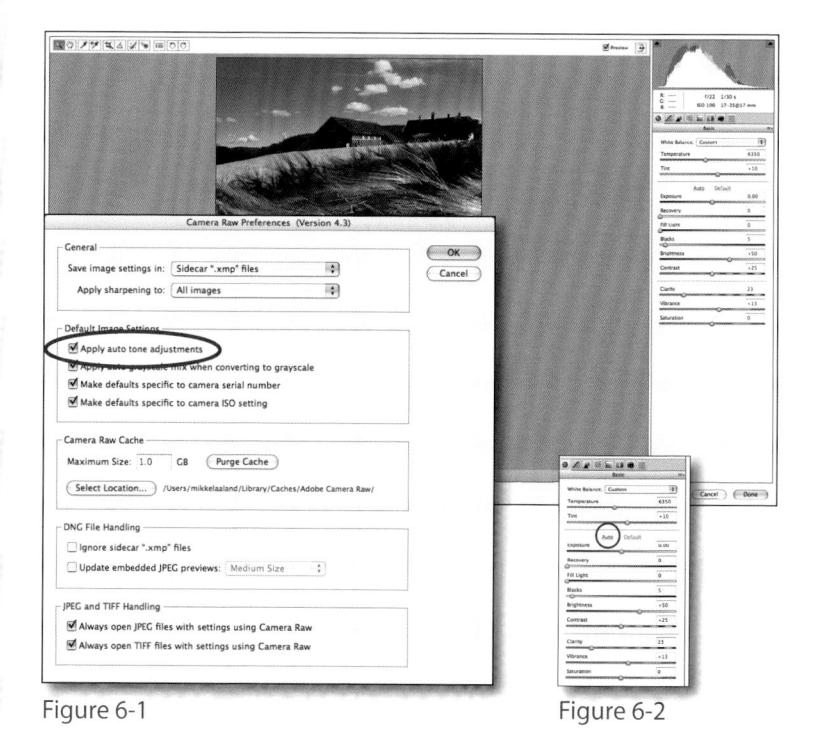

When you don't apply auto tone adjustments, the preview window shows a behind-the-scene interpretation of the RAW data determined by image data, camera model, and camera white balance settings, without any attempt to "optimize" the tonal map, as shown in Figure 6-3.

Many times applying auto tone adjustments will improve an image, as it does in Figure 6-4.

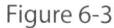

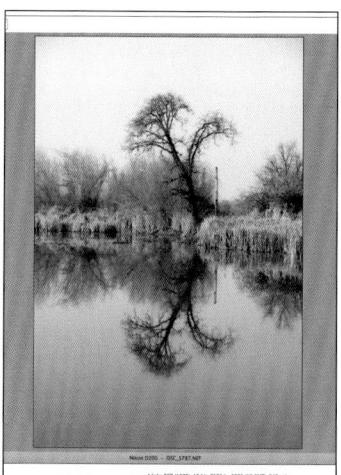

Figure 6-4
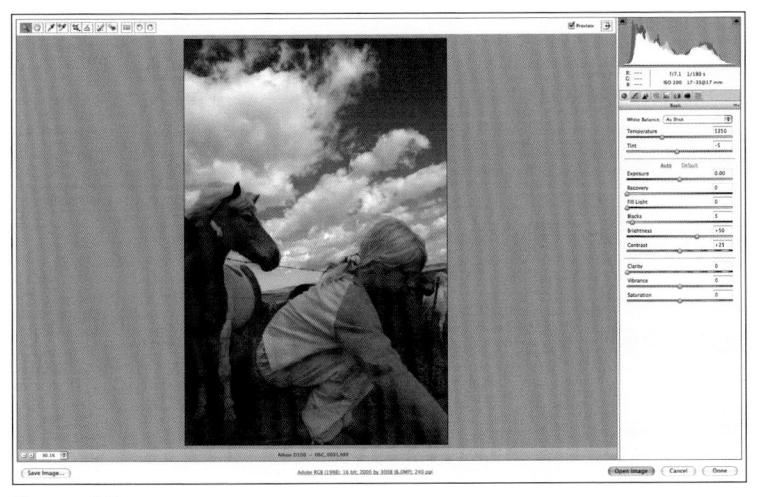

Figure 6-5

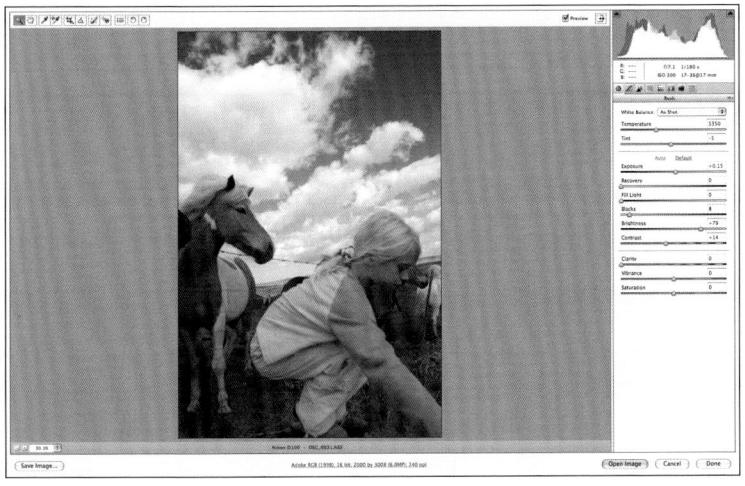

Figure 6-6

The auto tone adjustments work well for many images, but not all. The earlier photo in Figure 6-3, for example, was shot under even lighting conditions and the auto tone adjustments worked very well. The example in Figure 6-5, however, shows an image shot under strong backlit conditions. Here it is with auto tone adjustments not selected.

In Figure 6-6, you can see that auto tone adjustments improved things slightly, but didn't go far enough to open the darker areas in the foreground.

Actually, this image is a perfect candidate for manual tweaking of the Basic tonal controls, which I'll get into shortly.

NOTE As I said in Chapter 3, selecting the Apply auto tone adjustments option in Camera Raw Preferences can cause confusion when you use Bridge to view and edit images. Say you shot one image frame at f/5.6 and another of the same scene at f/8 using the same shutter speed. Clearly there should be tonal differences between the two shots, and these differences should be reflected in Bridge's thumbnails. However, if Apply auto tone adjustments is selected in Camera Raw, the two Bridge thumbnails will likely look the same because Camera Raw generates the thumbnails and auto adjustments make each thumbnail look the same—or at least very similar.

Customizing the Camera Raw Default Settings

The Camera Raw default setting is always applied when you open a RAW image for the first time in Camera Raw. To change the Camera Raw default to make your images, say, more saturated and "Fujichrome film-like:"

- 1. Open a RAW file in Camera Raw.
- 2. In the Basic tab (Figure 6-7), slightly increase the saturation values with the Saturation slider, to taste.
- 3. Select Save New Camera Raw Defaults from the Settings pop-up menu, shown in Figure 6-8.

NOTE If you make any changes to an image in Camera Raw, and then select Open Image or Done from the bottom of the Camera Raw window. the next time you open the RAW file, the Settings pop-up menu will show a check by the words Image Settings (Figure 6-9). The saved settings will be applied. The settings are also reflected in the Bridge thumbnails. You can always revert to the factory Camera Raw default in the Settings pop-up menu by selecting Reset Camera Raw Defaults, Select Done or Open Image; the next time you open your image in Camera Raw, Camera Raw Defaults will be checked in the Settings pop-up menu.

If you consistently don't like the way the Camera Raw Default setting makes your images look when you open them in Camera Raw, you can easily customize the default setting. You can also create a custom preset which can be applied on an image-byimage basis from within Camera Raw or from within Bridge.

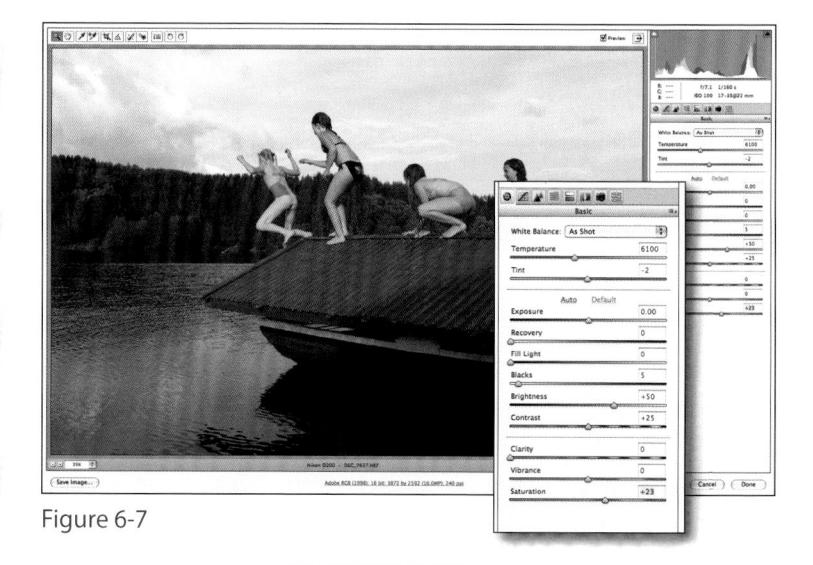

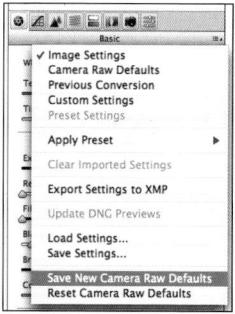

Figure 6-8

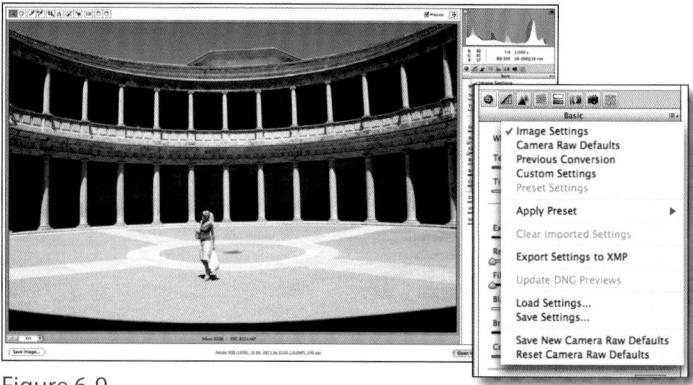

Figure 6-9

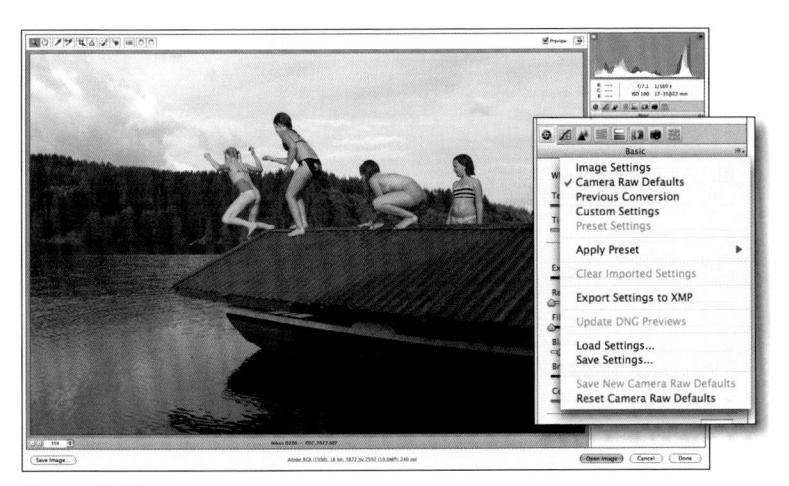

Figure 6-10

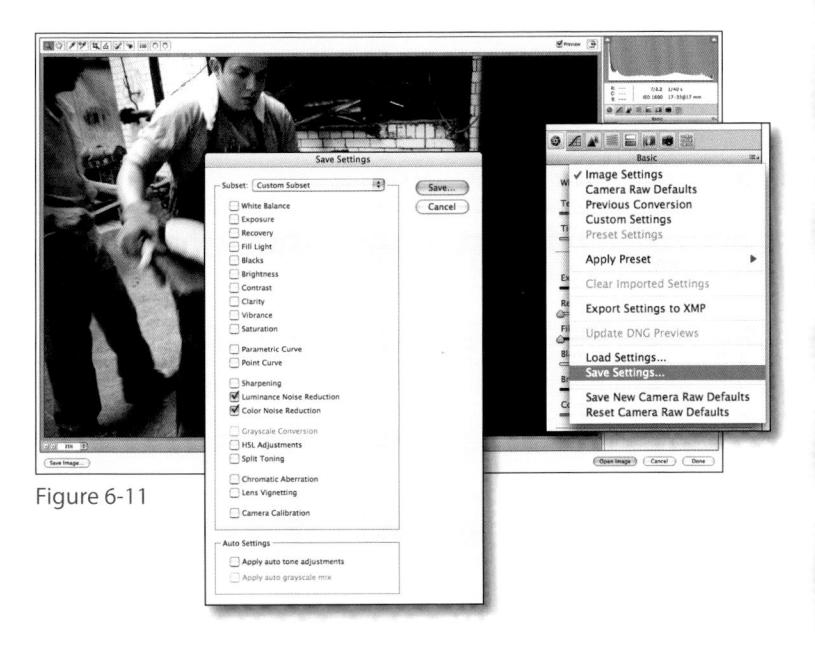

Figure 6-12

The next time you open an image in Camera Raw, the altered default settings will apply. You'll know you are using the default settings by looking at the Settings pop-up menu and seeing a check by the words Camera Raw Defaults, as you can see in Figure 6-10.

Of course, this is a very simple example of what you can do. In fact, you can use any of Camera Raw's controls to create a quite different Camera Raw Default.

Creating a Custom Preset

In many cases, it might be more useful to simply make a user-defined custom setting instead of changing your Camera Raw default. For example, you might make a custom preset that applies only to files from one particular type of digital camera, or one that applies to indoor images shot with a high ISO, or to backlit images, etc.

You do this by:

- Making the appropriate Camera Raw adjustments.
- Selecting Save Settings from the settings pop-up menu instead of selecting Save New Camera Raw Defaults.
- 3. Selecting which settings to apply in the Save Settings dialog box, shown in Figure 6-11. (In the Subset popup menu you will find ready-made selections that may or may not be appropriate.)
- 4. Naming your new setting, as I've done in Figure 6-12.

Your custom-named setting will now appear in the settings pop-up menu, under Apply Preset (Figure 6-13), where it can be selected.

The setting will also appear as an option in the Bridge menu (e.g., Edit→Develop Settings→[Preset Name Here], as seen in Figure 6-14) so you can apply the custom setting to one or multiple images without leaving Bridge and opening Camera Raw.

For the ultimate fine-tuning of your Camera Raw Default setting, you might consider the very comprehensive, but labor intensive, calibration controls found under Camera Raw's Camera Calibration tab. I'll cover this in the next chapter.

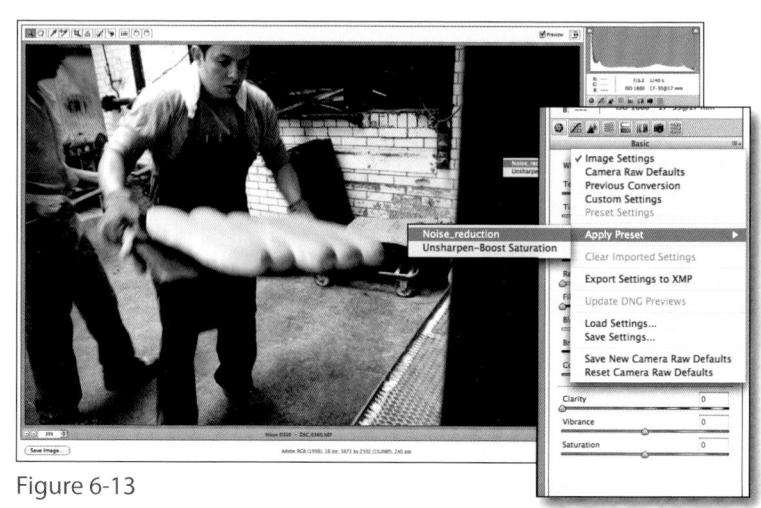

Figure 6-14

This is Why You Shoot RAW

This discussion on changing the Camera Raw default and creating custom settings emphasizes one of the more compelling reasons to shoot RAW. In the past, you'd have to switch films to get this kind of user control over the look and feel of your images. Kodachrome was known for one kind of look, and Ektachrome or Fujichrome were known for another (Figure 6-15). Photographers would pick the appropriate film based on personal taste, shooting conditions, and subject matter. Now you can create a look and feel on an image-by-image basis, and change your mind again with no permanent consequences.

Just looking at Camera Raw's preview window can be deceptive, even if your monitor is perfectly calibrated. What may look good onscreen may, in fact, have serious technical shortfalls that become evident later, especially when you go to print. Let's look at various non-subjective ways to evaluate your images.

Evaluating an Image in Camera Raw

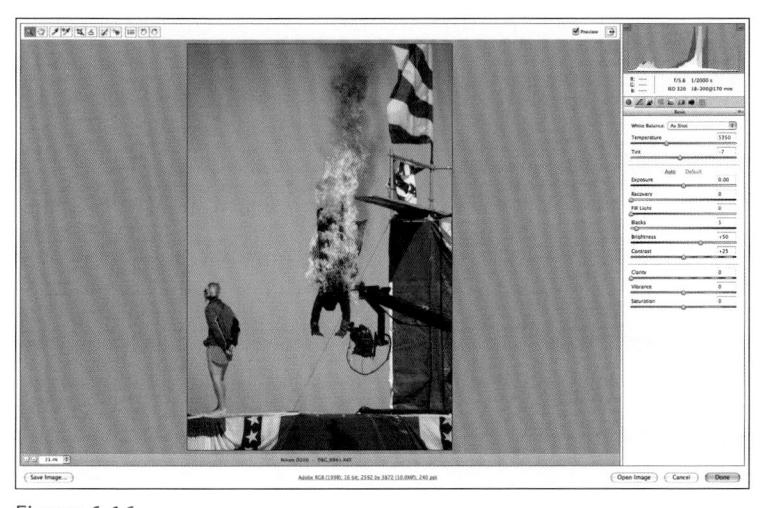

Figure 6-16

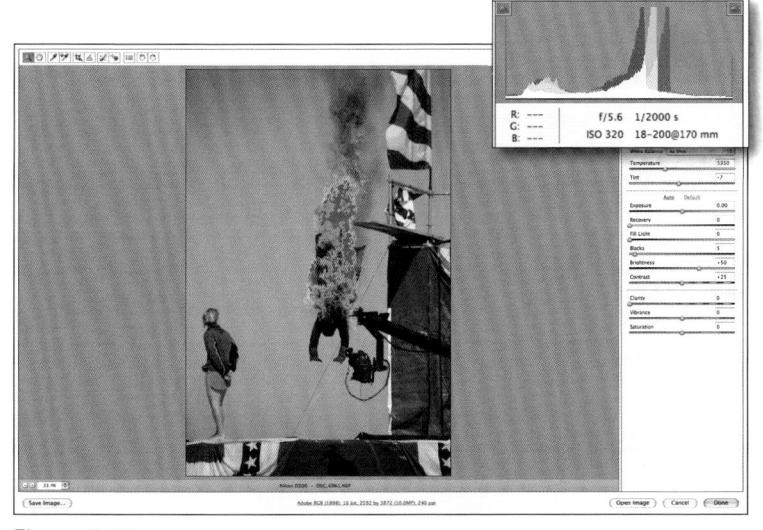

Figure 6-17

Figure 6-18

But first, here's an example of what I mean by monitor deception. Look at the image in Figure 6-16. This image may look fine at first glance. But click on the arrows at the top of the histogram window (enlarged in Figure 6-17) to activate Camera Raw's Shadows and Highlights warnings, and you'll see several highlight areas lacking in detail. Those areas are represented in red. Shadow areas lacking detail are represented in blue, which you can't see very well with this particular image.

Normally, it's not useful to rely on just one or even two tools or methods when evaluating an image. For example, the Shadows and Highlights warnings in the previous image can be confirmed by looking at the histogram or by using Camera Raw's Exposure and Blacks clipping display. I'll explain both in more detail shortly.

NOTE While an image preview is being generated, a yellow caution icon, shown in Figure 6-18, appears in the preview window. Wait until the caution is gone before evaluating the image.

Here is an evaluation procedure

that'll highlight most of Camera Raw's evaluation tools and give you a good grip on the state of a particular image, such as the one shown in Figure 6-19.

Once you've determined what needs to be done—if indeed anything needs to be done at all—you can then proceed to apply the necessary changes using Camera Raw's Basic, Tone Curves, or HSL/Grayscale tab controls. (The procedure, as written, may seem laborious, but stretching it out this way gives me a chance to delve into Camera Raw features that are useful for you to know.)

Think of the evaluation procedure like the process of selecting fruit from a farmer's market. Pick up the fruit, examine it, touch it, squeeze it gently, and smell it. Take everything into account before you buy and eat it. OK, let's start:

- Open the RAW file. Note whether
 Auto tone adjustments in the Basic
 tab (circled in Figure 6-20) has been
 selected. As mentioned earlier, out of-the box Camera Raw settings have
 Apply auto tone adjustments turned
 off but this setting may have been
 changed in Camera Raw preferences.
 It's helpful to know what's been done
 to your image before you go any
 further.
- To open Workflow Options, click on the hyperlink (shown in Figure 6-21) at the bottom of the Camera Raw window. You can choose your color space from this dialog, as shown in Figure 6-22. The relevant settings depend on the final destination of your image. (See the sidebar "Choosing a Color Space.")

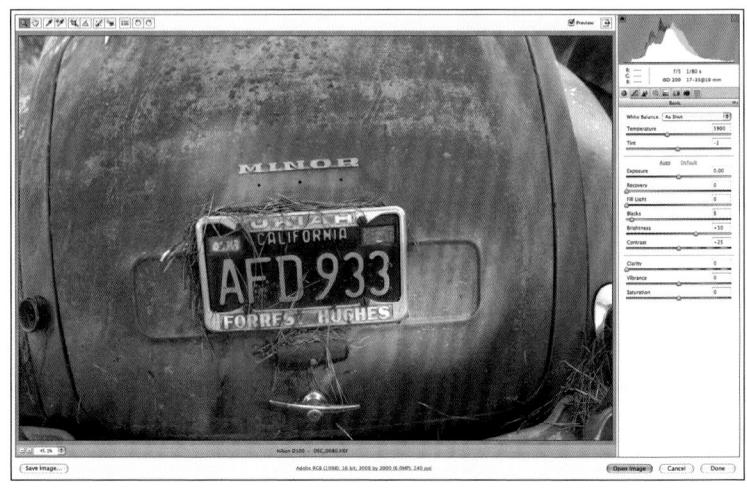

Figure 6-19

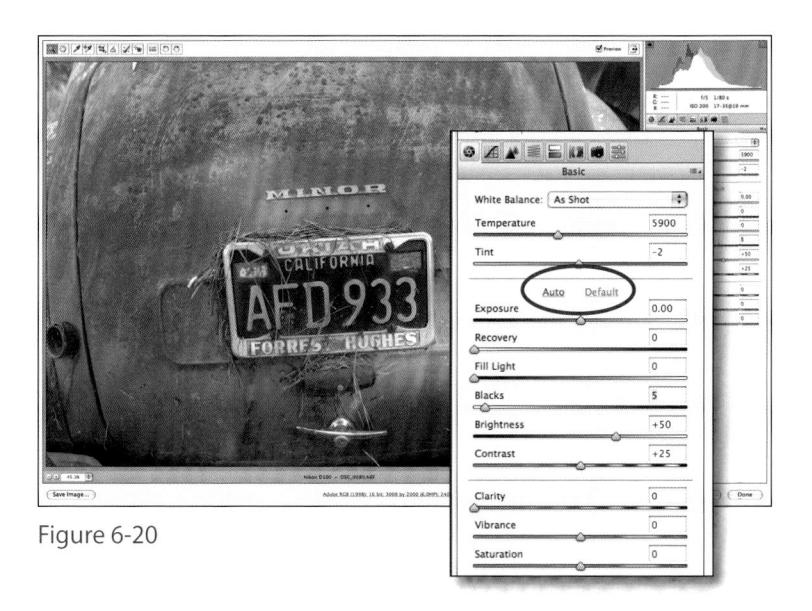

Adobe RGB (1998); 16 bit; 3008 by 2000 (6.0MP); 240 ppi

Figure 6-21

	Workflow Options	5	
Space:	Adobe RGB (1998)	*	Ок
Depth:	16 Bits/Channel	*	Cancel
Size:	3008 by 2000 (6.0 MP)	•	
Resolution:	240 pixels/inch	•)	
□Ор	en in Photoshop as Smart Obje	cts	

Figure 6-22

Figure 6-23

Figure 6-24

Figure 6-25

Choosing a Color Space

Color space mathematically defines the boundaries of color. Think of color space in terms of relative size. A small color space limits colors to a relatively small space—or technically, a smaller gamut. A large color space creates a large room capable of holding more colors, i.e., a larger gamut. sRGB is often described as smaller color space. Adobe RGB is larger. (ColorMatch RGB is a slight variation on Adobe RGB.) The largest color space available in Camera Raw is ProPhoto RGB.

You can get an idea of what I'm talking about by looking at Camera Raw's histogram as you change color spaces. The example in Figure 6-23 shows the histogram for my image using sRGB. Note the clipping on both the shadow and highlight sides of the histogram, as indicated by the abrupt vertical lines on either end of the graph. Figure 6-24 shows the same image using Adobe RGB. There's still some clipping. Finally, you see the image using ProPhoto RGB in Figure 6-25. Note that all clipping is gone.

Which space you use depends on your goal and what's familiar. If you have no plans to further process your image outside of Camera Raw, and your destination is a monitor or low-end desktop printer, sRGB may be your best option. If you plan on editing your images further in Photoshop, use the color space with the widest possible gamut. (Keep in mind that ProPhoto is a less supported color space than Adobe RGB, and ProPhoto images can look bad if viewed in a non-color managed application.)

3. Set your preview to Fit in View (Figure 6-26). You'll want to magnify your image when it comes time to evaluate sharpness, luminance smoothing, color noise reduction, vignetting, and chromatic aberrations, but when it comes to checking white balance and tonal distribution, it's best to have the whole picture in view. The exception to this, as you'll see, is when you use the Exposure or Blacks clipping display when 100% or higher magnification makes the warnings more discernible.

Figure 6-26

Using the Color Sampler Tool

Camera Raw provides a couple of ways to precisely measure color. One way is to simply move your cursor—be it the Zoom tool, Hand tool, White Balance tool, Color Sampler tool, Crop tool, or Straighten tool—over the preview image, and the RGB values of the area below the cursor will appear below the histogram (Figure 6-27).

Or, you can select the Color Sampler tool, and place up to nine color samplers in the preview image as shown in Figure 6-28. Clear the color samplers by clicking Clear Samplers.

Color sampling is particularly useful if you have included a quantifiable color target in your image, or if you can find an area in your image that should be close to neutral. In that case, you can determine color cast by comparing the R, G, and B values.

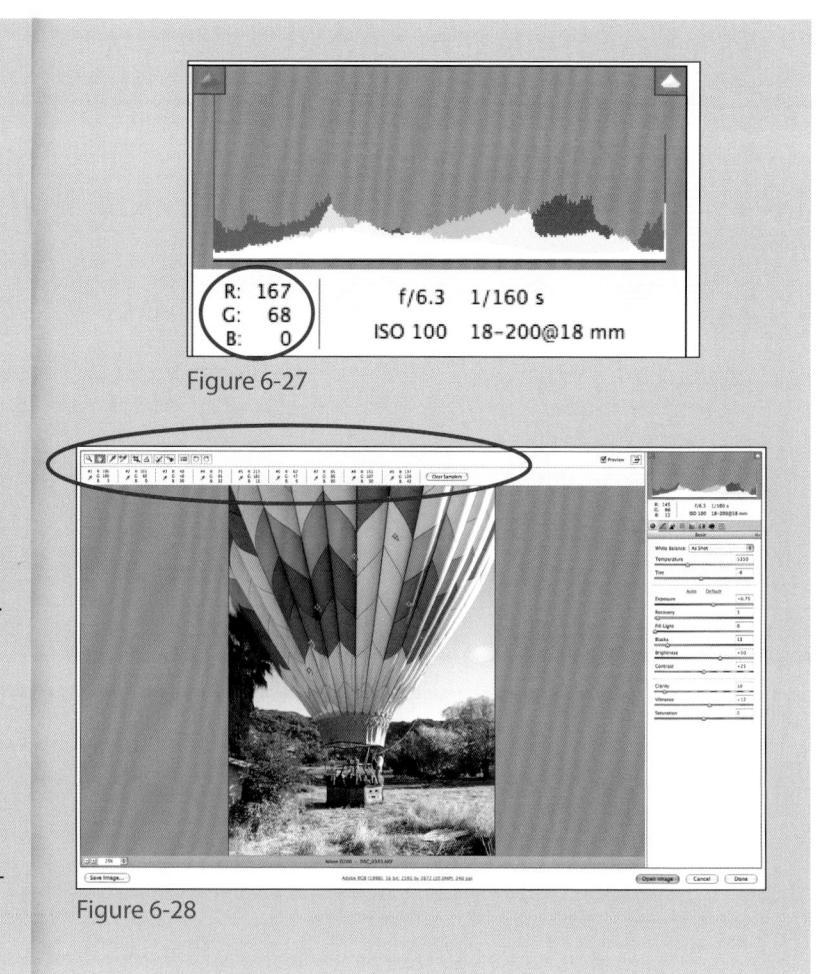

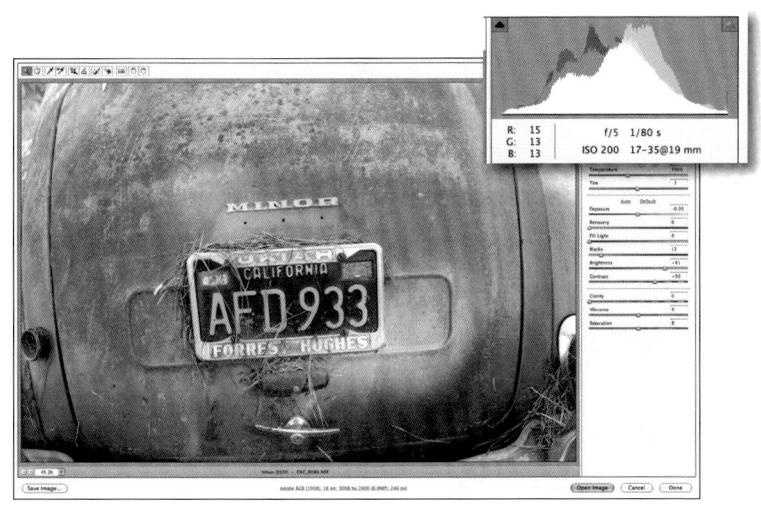

Figure 6-29

Figure 6-30

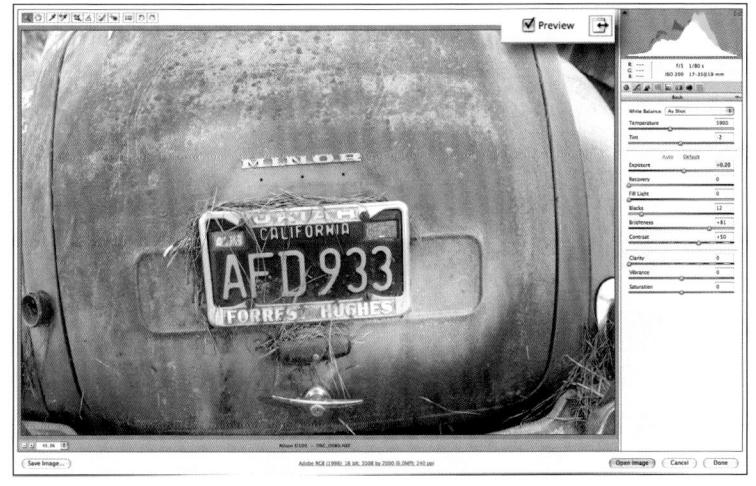

Figure 6-31

4. Study the histogram (enlarged in Figure 6-29). This is your road map to proper distribution of tonal values. (See the sidebar "Interpreting the Histogram" for more information.)

- 5. Check the white balance. At this preliminary stage, I switch between As Shot and the other presets listed in the pop-up menu shown in Figure 6-30, and I observe the effects. I leave finetuning via Camera Raw's Temperature and Tint sliders for later, when I'm actually doing the work on the image. (If you really need to know precisely what is going on with the color, you can use the Color Sampler tool. See the sidebar, "Using the Color Sampler Tool.")
- 6. Toggle the Auto setting off and on and observe changes. Do this by using the keyboard shortucts **x**-U (Ctrl-U) and #-R (Ctrl-R) or by clicking on Auto and Default in the Basic tab. You can also toggle the Preview checkbox at the top of the Camera Raw window, enlarged in Figure 6-31. When selected, the Preview reflects any setting changes made in the current tab, along with settings in the hidden tabs. Deselecting the Preview checkbox displays the image with the original settings when you first opened the image. (You can create a side-by-side image comparison environment. See the sidebar later in this chapter, "Side-by-Side Comparisons".)

Interpreting the Histogram

Camera Raw's histogram graphically displays the 8-bit Red, Green, and Blue (RGB) values of your image (Figure 6-32). The histogram is not a reflection of the actual RAW data (which is grayscale and linear), but a reflection of the processed RGB data with non-linear tone mapping applied. The histogram updates in real time to reflect changes you make in color space, white balance, or tone mapping. The Camera Raw histogram is much more accurate than the one associated with your digital camera, so don't be surprised to see a difference.

Note the colors in this histogram in Figure 6-33. It's fairly intuitive to figure out what they represent. White represents tones in all three channels: red, green, and blue. Red represents red tones, green represents green tones, and blue represents blue tones. Cyan represents tones in both the green and blue channels. Magenta represents tones in both the red and blue channels. Yellow represents tones in the red and green channels. The sharp lines on either end of the histogram indicate the degree of clipping: Higher lines represent more clipping, while lower lines indicate less clipping. White lines represent clipping in all three color channels. The color of the line tells you which color is actually clipped, and, in this example, you can see highlight clipping in the red channel, and shadow clipping in the blue channel.

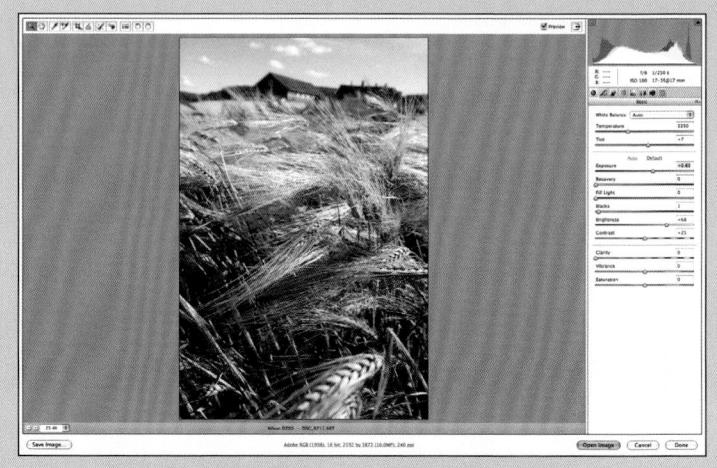

Figure 6-32

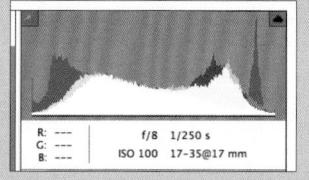

Figure 6-33

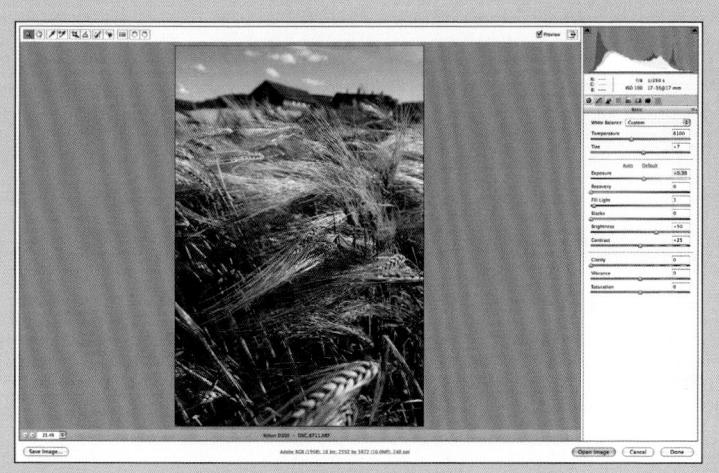

Figure 6-34

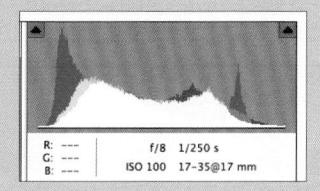

Figure 6-35

The histogram in Figure 6-34 displays the tonal values of the same image, but with different Basic tab settings. (I'll show you exactly how to adjust an image in the section titled "Manually Mapping Tone".) The clipping is gone and the values are distributed over a narrower space. The resulting image, in my opinion, has the appearance of more depth, and is more pleasing to the eye. Note the close-up of the histogram in Figure 6-35 indicates that the opposite of clipping has occurred: There are zero white (or near-white) pixels, and zero black (or near-black) pixels. This may or may not be desirable, depending on what is done later with this image.

Every image—and every tonal or color change to that image—will produce a different histogram. As you'll see in subsequent sections, the goal is to produce a distribution of tonal values based on both subjective response and quantifiable criteria (such as highlight or shadow clipping). The histogram is not the final judge, but it's an indispensable tool for getting you the image you want or need.

- 7. Observe the Exposure—or more accurately, highlight—clipping display. Do this by holding down the Option (Alt) key while clicking on the Exposure slider. (As you change the values by moving the slider, the clipping display updates in real time.) It's best to view the results at 100% or higher zoom levels. In Figure 6-36, black represents unclipped pixels, red represents red channel clipping, green represents green channel clipping, and blue represents blue channel clipping. Yellow represents clipping in red and green channels, magenta represents clipping in red and blue channels, and cyan represents clipping in the green and blue channels. White represents all three RGB channels clipped.
- 8. Observe the Blacks clipping display. Do this by holding down the Option (Alt) key while clicking on the Blacks slider. (As you change the values by sliding, the clipping display updates in real time.) Again, the display is best viewed at 100% or higher zoom levels. In Figure 6-37, white represents unclipped pixels. Red pixels display clipping in the red channels, while green displays clipping in the green channels. Blue displays clipping in the blue channels. Yellow represents clipping in red and green channels, magenta represents clipping in red and blue channels, and cyan represents clipping in the green and blue channels.
- Finally, if I have the luxury of time,
 I turn my attention away from the
 image. Even a few minutes away from
 the image is helpful. That way, I come
 back to work on it with fresh eyes.

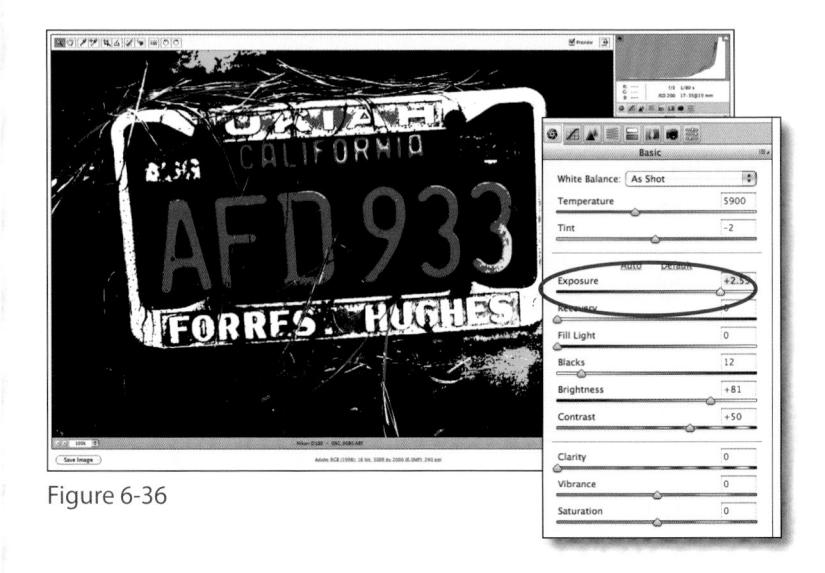

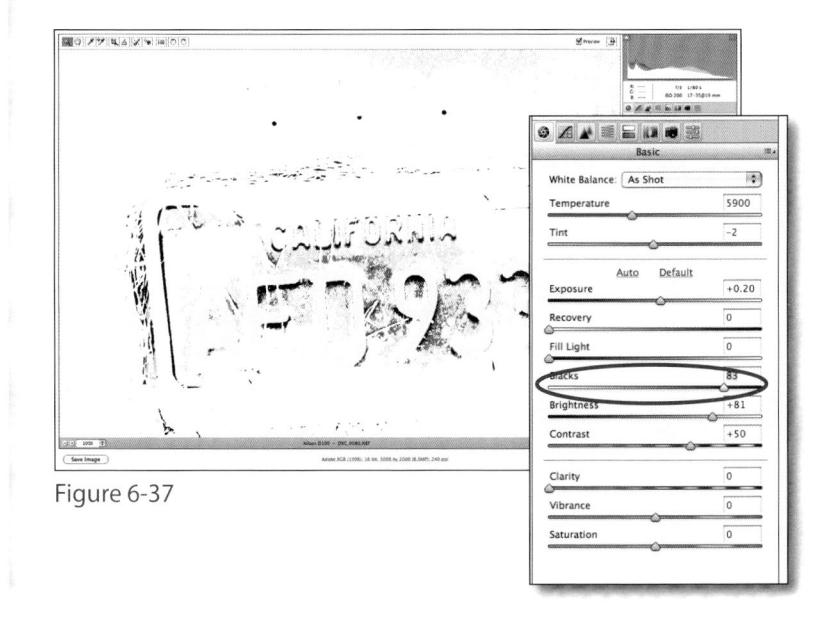

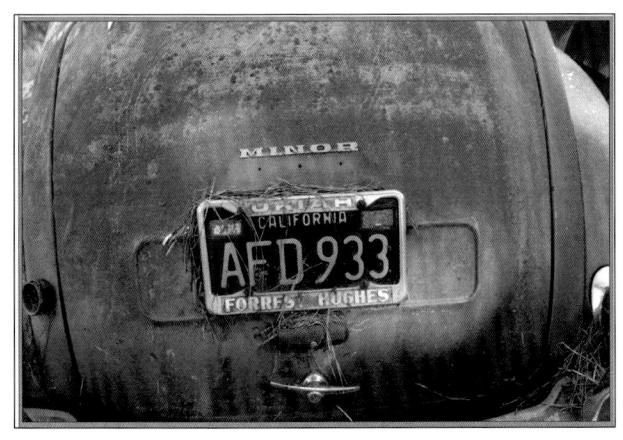

Figure 6-38

Of course, I also have to emphasize the best photograph is not always the one that is technically perfect (Figure 6-38). A successful image can be taken apart and criticized for not containing enough detail in the highlights or for having shadows that are blocked up. The colors may not be exactly as the scene warranted. However, any evaluation of an image should take the emotional content into consideration.

| Ten | Ten

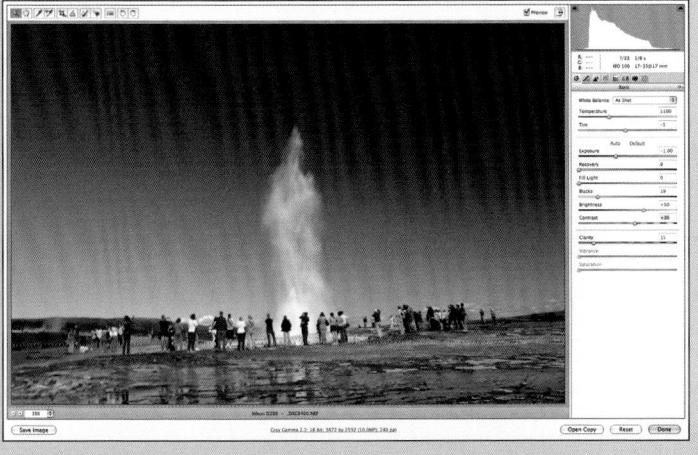

Figure 6-39

Side-by-Side Comparisons

Side-by-side image comparisons are handy when you want to quickly evaluate changes to an image against the original. There is no simple way to do this in Camera Raw, but there is a roundabout way. It requires you to first open your RAW file in Camera Raw with Photoshop as Camera Raw's host, and then, back in Bridge, open the same RAW file with Bridge as Camera Raw's host. (You need to start with Photoshop as host or you won't be able to get back to Bridge and open the second screen.)

You'll end up with two Camera Raw windows (Figure 6-39). If you have enough screen space (or two monitors), position them to make side-by-side image comparisons. To open a RAW file with Photoshop as host (assuming Bridge preferences are set to default), select a Bridge thumbnail, and then press %-0 (Ctrl-0). To open a Raw file with Bridge as host, select a Bridge thumbnail and then use %-R (Ctrl-R). When Bridge is host, Done is highlighted. When Photoshop is host, Open Image is highlighted.

Manually Adjusting White Balance

When working on a RAW image in Camera Raw, in the White Balance pop-up menu (Figure 6-40), you have the following choices: As Shot, Auto, Daylight, Cloudy, Shade, Tungsten, Fluorescent, Flash, and Custom. (If you open a JPEG or TIFF in Camera Raw, you only get As Shot, Auto, and Custom choices.) You also have a Temperature and Tint slider for finetuning.

If you select As Shot, Camera Raw will apply the white balance setting that was recorded at the time of exposure. In my experience, when lighting conditions are simple—i.e., light comes from a single light source—I am generally happy with the As Shot preset (Figure 6-41).

This assumes that the camera does a good job determining white balance in the first place, and nowadays most prosumer cameras do. It also assumes Camera Raw is capable of reading the camera white balance data, which is sometimes encrypted. If Camera Raw can't read the camera white balance setting, then As Shot will not appear (but the Auto option will).

In situations where the light comes from multiple sources, correct white balance becomes more problematic. For example, in the shot in Figure 6-42, the light comes from both natural light and an incandescent bulb. In this case, there is a strong magenta tint.

I begin working on an image by first setting white balance. Other writers suggest performing tonal corrections first, but both affect each other. Regardless of which you do first, you may want to go back and fine-tune either adjustment. I use a couple approaches to manually adjusting white balance.

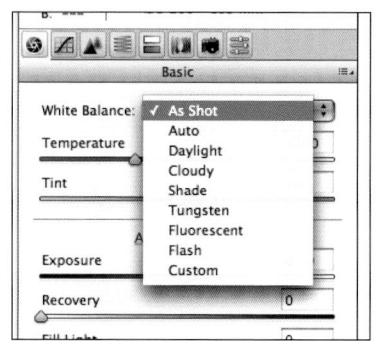

Figure 6-40

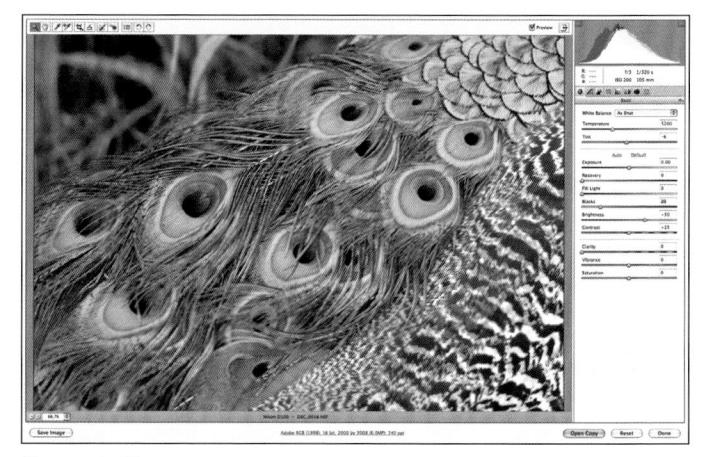

Figure 6-41

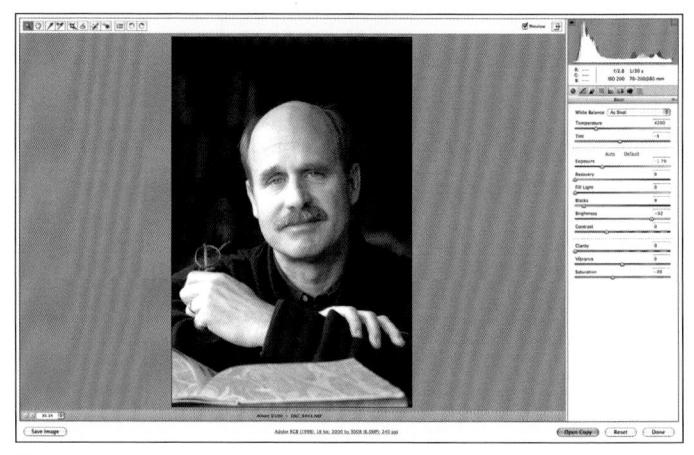

Figure 6-42

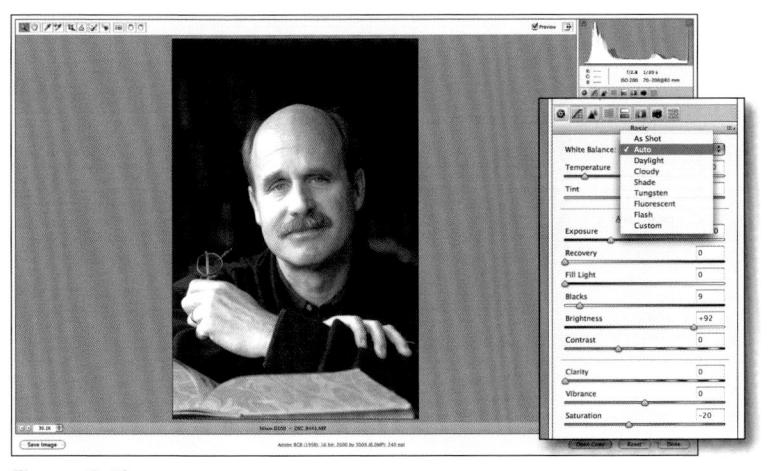

Figure 6-43

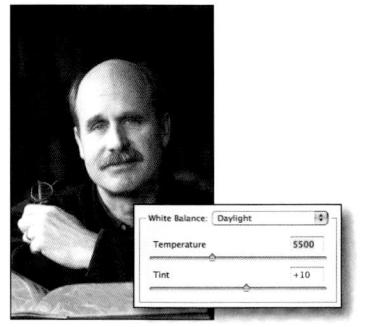

Figure 6-44

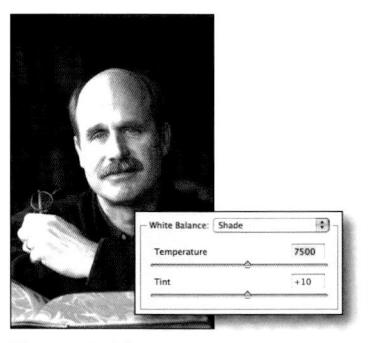

Figure 6-46

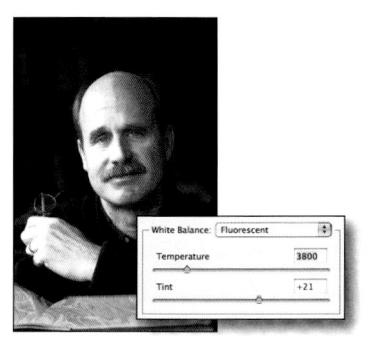

Figure 6-48

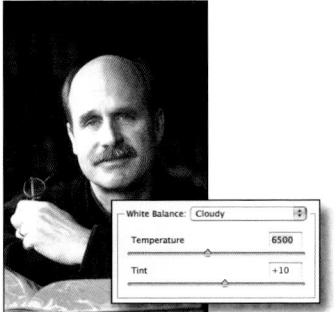

Figure 6-45

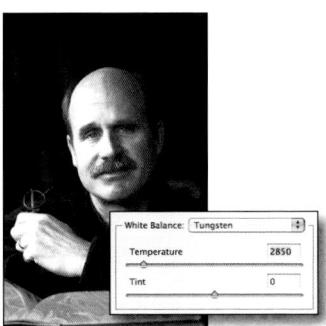

Figure 6-47

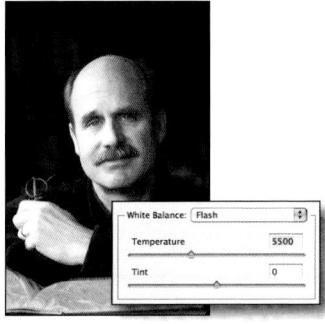

Figure 6-49

White Balance Presets

If you are not satisfied with the As Shot setting, you can try the other settings from the pop-up menu. Start with Auto. Camera Raw reads the image data and automatically attempts to adjust the white balance. Auto often works fine. However, as you can see in Figure 6-43, Auto gives our example image a bluish cast.

Select the other presets and observe the changes in your image. Shown are the effects of the various presets on my sample image. As you can see, none of the presets do the trick:

- · Daylight Figure 6-44
- · Cloudy Figure 6-45
- Shade Figure 6-46
- Tungsten Figure 6-47
- Fluorescent Figure 6-48
- Flash Figure 6-49

TIP The presets are also available by selecting the White Balance tool from the menu bar, placing your cursor over the image area, and right-clicking (control-click for one-button Mac users).

White Balance Tool

You can also select and use the White Balance tool from the Camera Raw toolbar to set white balance. (Alternatively, you can hold the Shift key and the cursor becomes the White Balance tool.) With the tool, click in an area of the image that should be gray, neutral, or white. The White Balance tool then attempts to make the color exactly neutral. The changes are reflected in the Temperature and Tint sliders. You'll also notice a change in the histogram. Sometimes this works, sometimes it doesn't. I tried using the White Balance tool in our sample image, but had no luck. First, I got the warning you can see in Figure 6-50. Then I poked around more, but never found a satisfactory target from which to take a reading.

Temperature and Tint Controls

Below the White Balance pop-up menu are two sliders, Temperature and Tint, that can be used to fine-tune the white balance or produce creative effects. If you move the Temperature slider to the left, colors will appear bluer (or cooler). Move the slider to the right, and the colors appear more yellow (warmer). If you move the Tint slider to the left (negative values), you'll add green to your image. Move it to the right (positive values) and you'll add magenta. (Moving either slider will change the White Balance pop-up menu setting to Custom.) By using the Tint slider and moving it -35 to the left (Figure 6-51), I finally removed the magenta tint and achieved a satisfactory result.

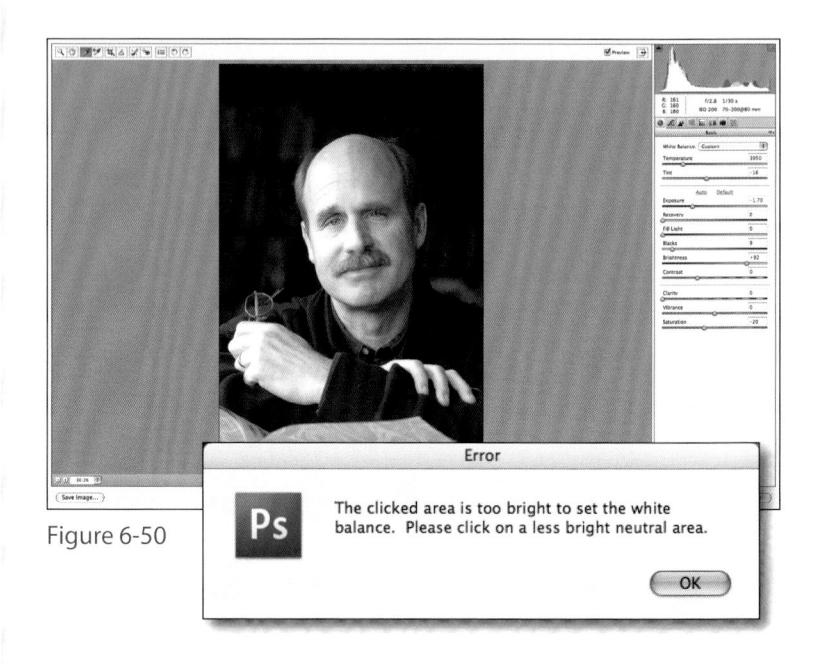

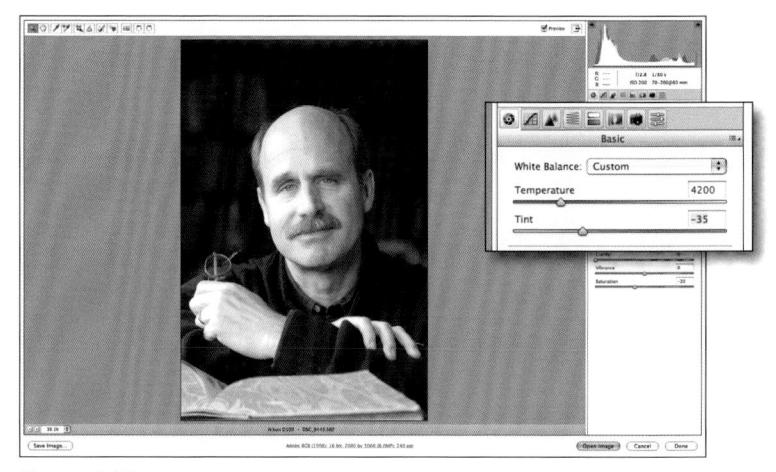

Figure 6-51

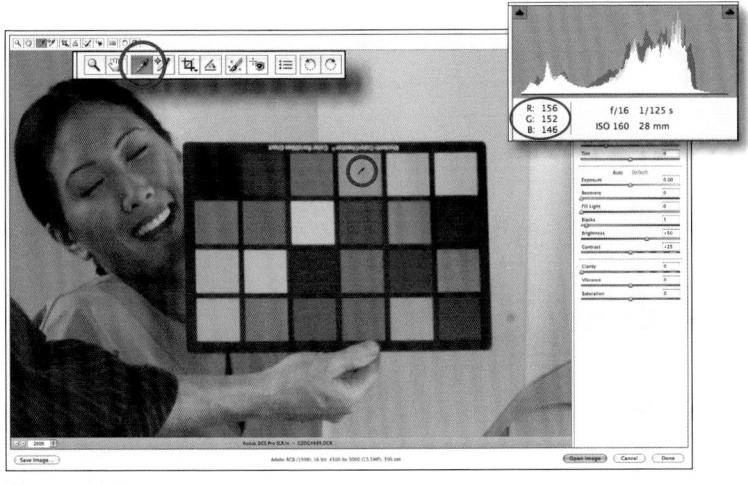

Figure 6-52

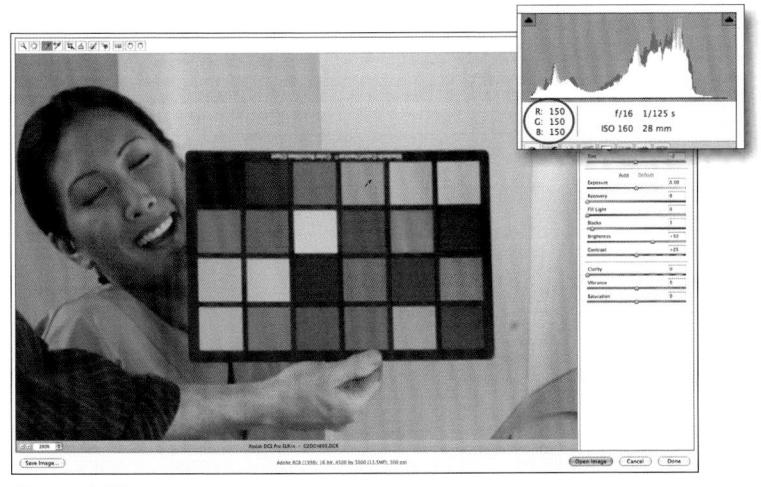

Figure 6-53

Determining White Balance from a Target

Unless you include a quantifiable target in your shot, it's difficult, if not impossible, to know if your white balance is perfectly correct. Whenever possible, I find it very useful to include a GretagMacbeth color test chart, like the one in Figure 6-52, in a shot. (A common, less-expensive, 18% gray card also works fine, but I like the added bonus of the reference colors.) Then I simply select and position my White Balance tool over the target (a neutral square in this example) in the Camera Raw preview window. If my exposure is in the ballpark, the R, G, and B numbers over the histogram should be close, but not necessarily the same.

I then click on the target and the numbers become exactly the same, or neutral, and the changes in the white balance are reflected in the image and in the histogram, as you can see in Figure 6-53. I use this setting as a basis for all the shots taken with the same lighting conditions. (I go into the details on how to do this in Chapter 12.)

Manually Mapping Tone

Briefly, in as non-technical terms as I can get for a very technical subject, I'll describe what the various tonal control sliders, shown in Figure 6-54, do.

Exposure Positive values (over 0) brighten an image and set a white clipping point. Negative values darken an image, while attempting to maintain detail in the highlight areas. The default non-auto setting is 0.

NOTE Setting a white point establishes a cut-off point from which pixels with lighter values are clipped, or, in other words, set to pure white. Other pixel values are adjusted relative to the new highlight values.

Recovery Attempts to recover details in the highlight areas that might otherwise be missing. It does this by looking individually at the Red, Green, and Blue channels, finding data in one channel, and then reconstructing the data across the three channels. It has the effect of darkening the highlights slightly without affecting the darker areas. A before and after example is shown in Figure 6-55. Note in the before image how clipping in the highlights, as indicated by the solid line at the far right of the histogram, is gone in the after image. The default setting for Recovery is 0.

If the auto or default settings aren't producing the image you want, try manually adjusting the Basic tab settings. Generally do this after setting white balance and before using the Tone Curve tab controls. Changing tonal distribution affects white balance settings, so this rule can be argued both ways.

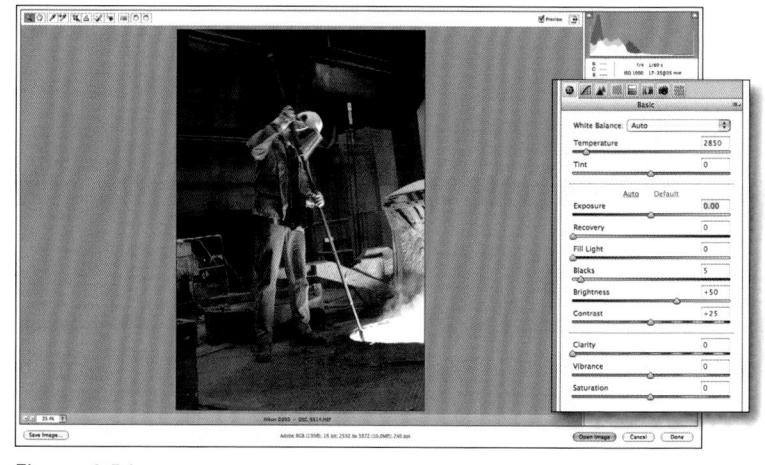

Figure 6-54

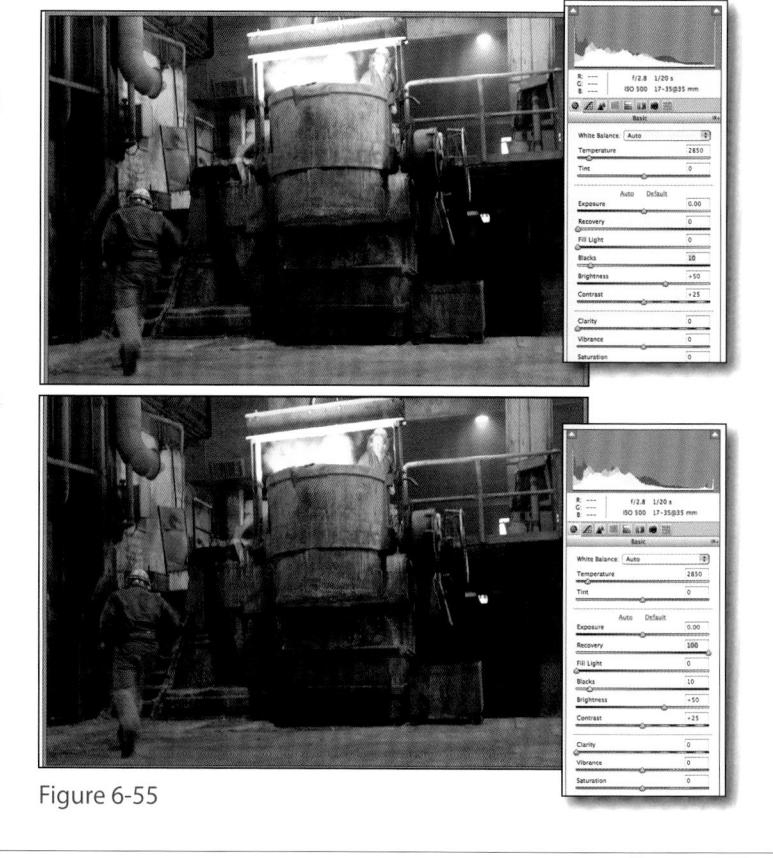

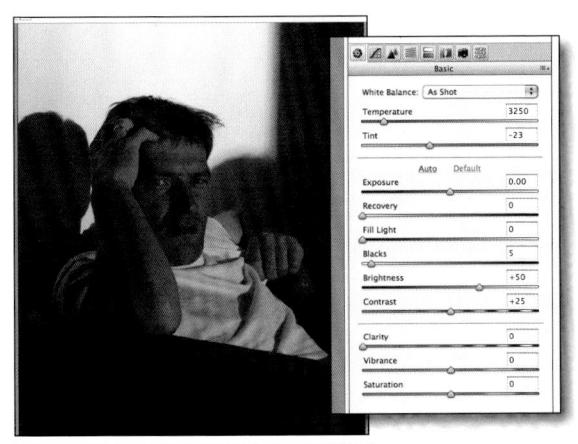

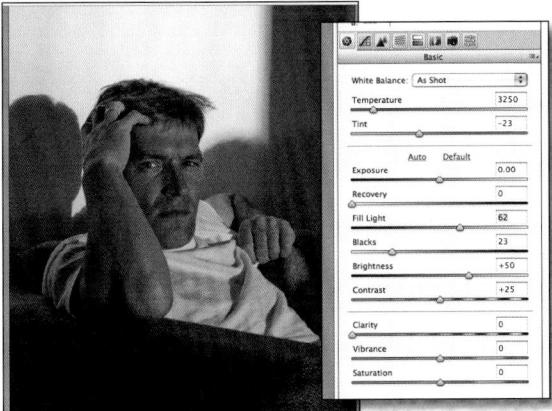

Figure 6-56

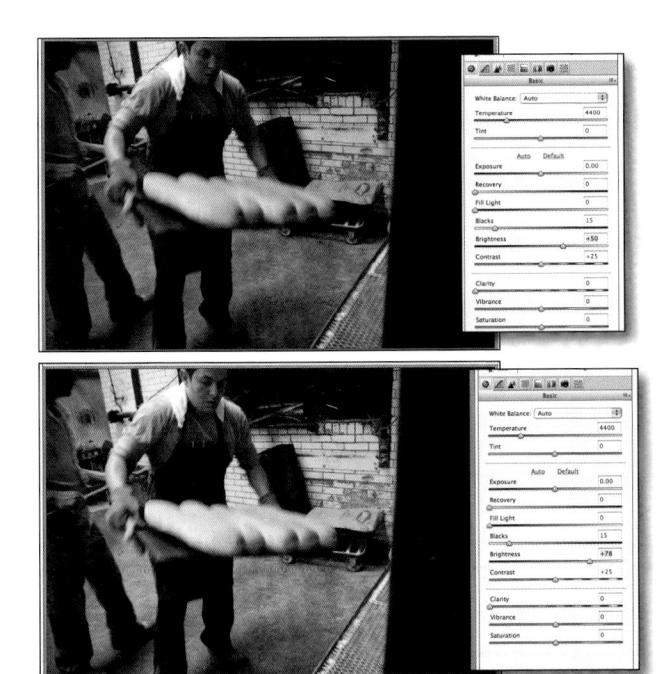

Figure 6-57

Fill Light Opens up the shadow areas without affecting the highlights (to a point). Care should be taken to not push the slider too far, as shadow noise is often enhanced as well. Figure 6-56 shows a before and after example. The default setting for Fill Light is 0.

Blacks Darkens the darkest part of the image (sets a black clipping point), while mostly leaving the rest of the image alone. The default non-auto setting is 5.

NOTE Setting a black point establishes a cut-off point from which pixels with darker values are clipped or set to pure black. Other pixel values are adjusted relative to the new shadow values.

Brightness Is similar to Exposure, but redistributes the tonal values in a linear adjustment. While positive Exposure settings often clip highlights, moving the Brightness slider to the right doesn't result in highlight clipping. It compresses the highlights and opens up the shadow areas. Conversely, moving the slider to the left darkens an image by compressing the shadow areas and opening up the highlights. (In Figure 6-57, I moved the Brightness slider to the right in the after view.) The default non-auto setting is 50.

Contrast Works in conjunction with the Brightness setting, applying an S-curve that results in either increased or decreased contrast, while leaving the extremes alone. (Again, you can easily observe this by watching the histogram as you move the Contrast slider.) The default non-auto setting is +25.

Clarity Produces local contrast
enhancements to add punch or pop
to your image. It basically works like
Photoshop's Unsharp Mask filter to make
hazy photos clearer and dull images
shine. It also enhances the appearance
of depth. (I'll show examples later in the
chapter.) The default setting is 0.

Vibrance Saturates (or desaturates) areas of primary colors while leaving areas of secondary shades, such as skin tones, alone. (I'll show examples of Vibrance and Saturation later in the chapter.) The default setting is 0.

Saturation Increases or decreases the strength of all colors. (In the histogram you'll see individual colors become more pronounced.) The default setting is 0.

Simplifying the Toning Process

I'll try and simplify the process of using most of these controls as much as possible, and give you a semblance of procedure you can follow that will be useful for many images. I'll leave the more advanced Tone Curve discussion for the next chapter.

Let's start with the work of photographer Derrick Story. Derrick's original image with default settings is shown in Figure 6-58. (I'll follow up with a couple other step-by-step examples using some of my own images that should further convey my point about how tonal controls are interrelated.)

Derrick begins by following an evaluation procedure much like the one I outlined earlier. He toggles auto tone adjustments on and off using #-U (Ctrl-U) and then #-R (Ctrl-R), observing the difference. Figure 6-59 shows his image with Auto selected.

NOTE Looking at these tonal controls—or reading about them—may make some photographers feel like they just slipped into the cockpit of a 747. Fortunately, if you select the wrong controls or sequence, you won't crash. However, there are consequences to blindly sliding any of the controls, and you can easily make a moderately problematic image worse.

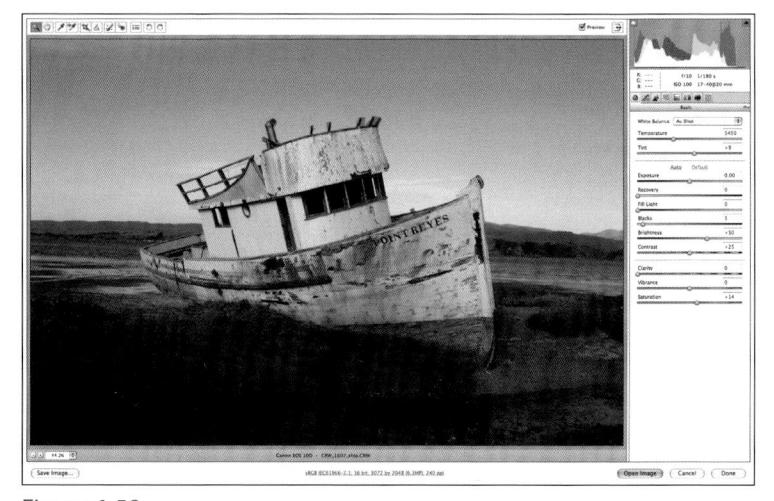

Figure 6-58

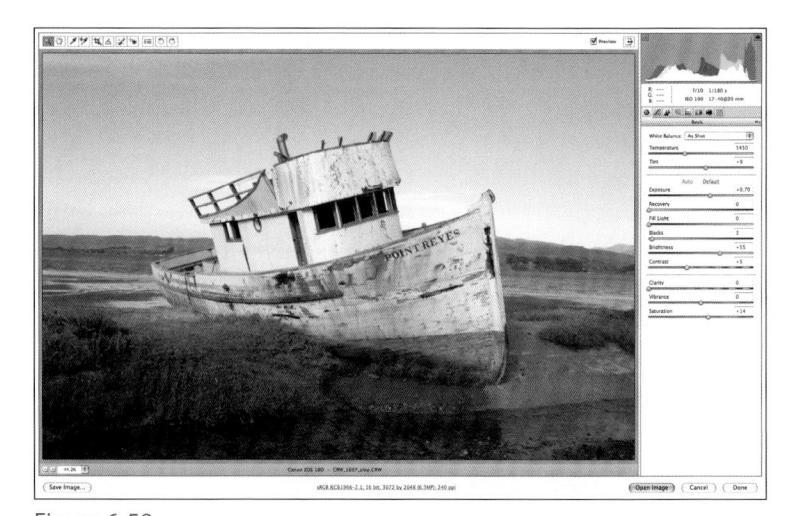

Figure 6-59

Figure 6-60

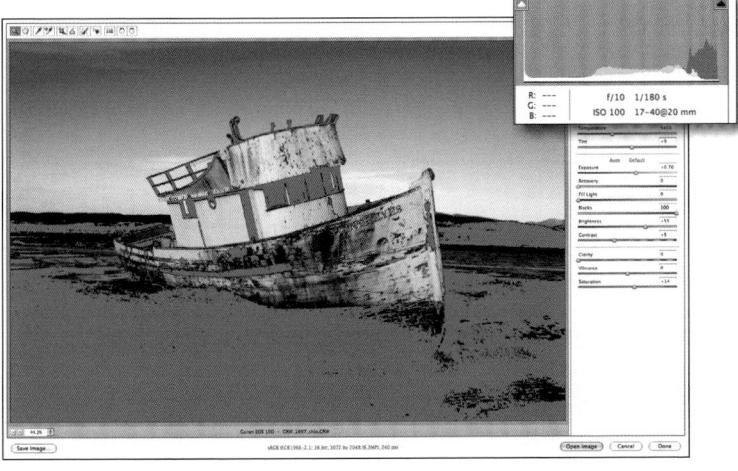

Figure 6-62

Figure 6-63

He selects the Shadows and Highlights warnings in the histogram, but as you'll see, he considers the warnings only as rough guides. He always keeps a close eye on the histogram throughout his editing process.

With regard to workflow options (Figure 6-60), note that Derrick works in the sRGB color space. This is a very conscious and deliberate decision on his part.

Derrick's images often end up on the Web, and he has set up his whole workflow based on that color space. Like most photographers, he sets his depth to 16

Bits/Channel, and drops down to 8 Bits/
Channel later (in Photoshop), after he has confirmed a final destination.

Let's follow the next steps of Derrick's workflow:

- Observing that the auto tone adjustments are in the ballpark, Derrick leaves Auto selected.
- 2. Note in his histogram, Figure 6-61, that the tonal values are shifted dominantly to the right, toward the lighter values. This lets Derrick know he has room to work with, using the Blacks slider. He slides the Blacks slider completely to the right, to a value of 100 (Figure 6-62). In Derrick's image, his shadows clipping warning shows blue just about everywhere, and the histogram confirms shadows clipping.
- Next, he holds the Alt (Option) key while clicking on the Blacks slider arrow to bring up the Shadows Clipping display shown in Figure 6-63. This gives a color-by-color clue to the clipping.

- 4. Sliding the Blacks value back to 0 is too much the other way. As you can see in Figure 6-64, the shadow clipping is mostly gone, but the image looks a bit flat without solid blacks.
- 5. Finally, sliding the Blacks to 10 produces some clipping in the dark areas and gives the image more depth, as you can see in Figure 6-65. Increasing the Contrast slider slightly (to a value of +14) helps too. (Because of the relationship between the Contrast control and the Exposure. Blacks, and Brightness tonal controls. it's generally best to adjust the Contrast setting last.)

国の / 7 4 4 / / W IE 0

Figure 6-65

f/7.1 1/200 s ISO 200 17-35@20

Figure 6-66

Procedural Variation

Here is another example, one my own, which we saw previously. With all the auto tone adjustments selected, the image in Figure 6-66 looks a little punchy—or bright—for my taste, and there is obvious clipping in the highlights and shadow areas.

Figure 6-67

Figure 6-68

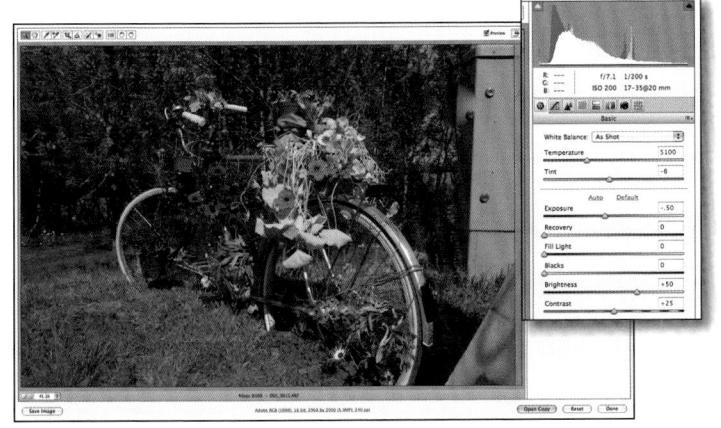

Figure 6-69

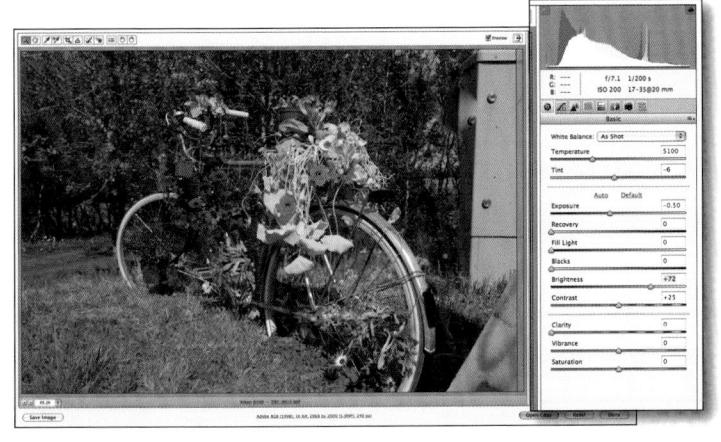

Figure 6-70

With the auto tone adjustments off, it looks like Figure 6-67. As you can see—and as is confirmed by the histogram shift to the left—the image is now darker. Too dark for my taste.

Here is what I did to this image, which loosely follows what I do to other problematic images.

- 1. Turn auto tone adjustments off using #-R (Ctrl-R) or click on Default, as shown in Figure 6-68.
- Start with the Exposure slider. Because there is clipping in the highlights, I decreased the setting to about -50, which made the image look too dark. I will brighten it up later with the Brightness slider.
- 3. Next, I turn to the Blacks. Even when I set the Blacks to 0, the clipping remains as shown in Figure 6-69.
- 4. To brighten the image, move the histogram to the right, and open up the shadows. I slid the Brightness slider to 72, which shifted the histogram nicely to the right. The results are shown in Figure 6-70.

I could have completely removed the shadow clipping by changing from Adobe RGB color space to ProPhoto RGB color space, but since I'm set up for Adobe RGB, I was satisfied to stop here. As a last example, let's look at another one of my previously used images in Figure 6-71. It's the one from the beginning of the chapter, where auto tone adjustments helped a bit, but were not wholly effective.

This time, I'll manually adjust some of the Adjust tone controls to fine tune it. As you will see, tweaking it helps, but to get the final image, I need to bring it into Photoshop and apply localized adjustments with an adjustment layer. (I'll get into how I do that at the end of the chapter.)

To tweak the auto tone adjusted image:

- 5. Open up the highlights with the Exposure control, pushing the histogram as far to the right as possible without clipping the highlights (Figure 6-72). Remember, it's always best to start your adjustments with the Exposure control.
- 6. Adjust the Blacks slider slightly to open the shadow areas, as I've done in Figure 6-73.

The background now appears too light, but as you'll see later, I was able to work Photoshop magic and get things right because there is still detail in the highlights. I did try using the Camera Raw curve control—which I'll cover in the next chapter—but it was too extreme.

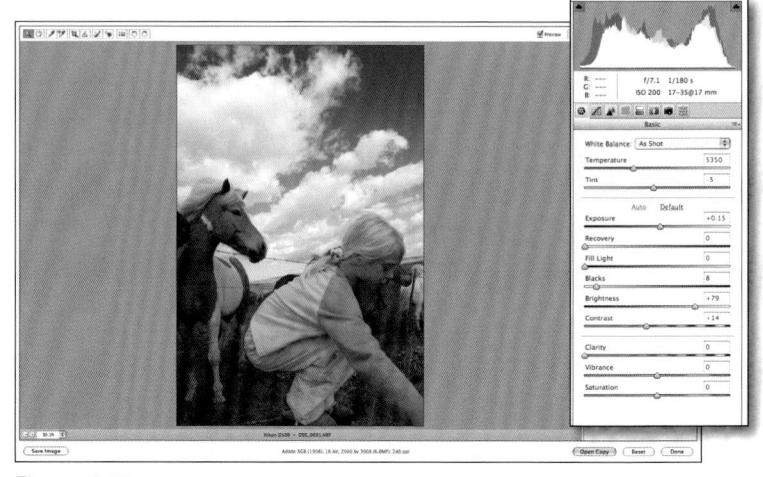

Figure 6-71

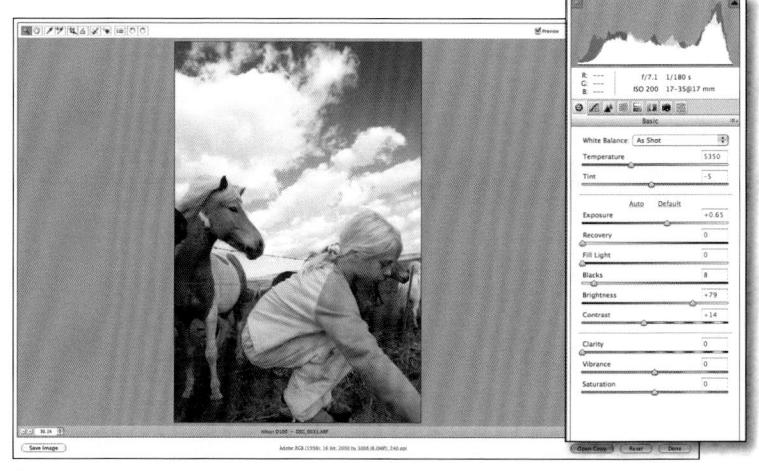

Figure 6-72

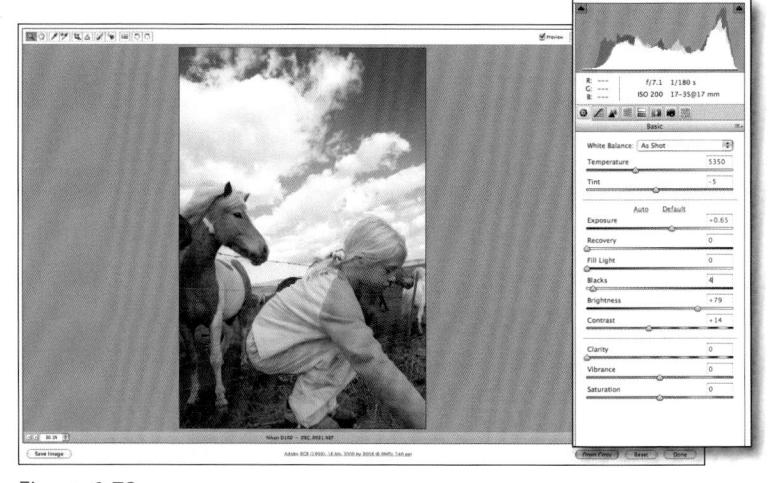

Figure 6-73

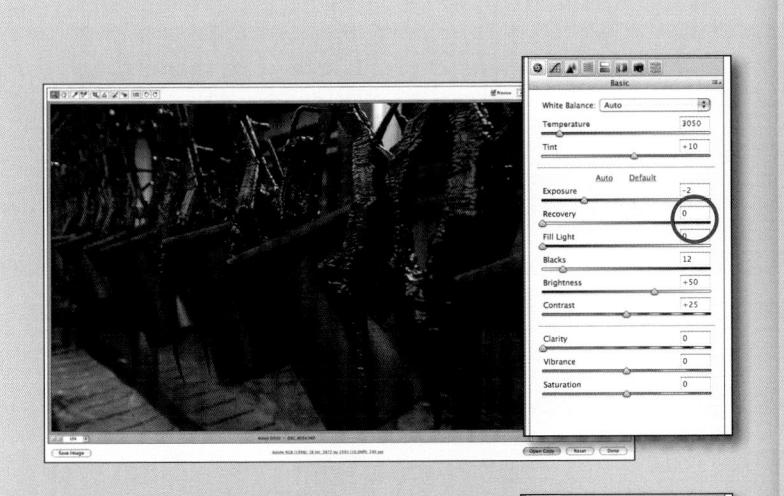

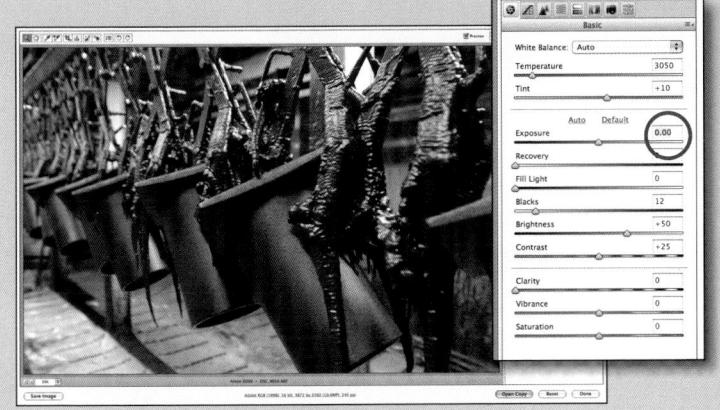

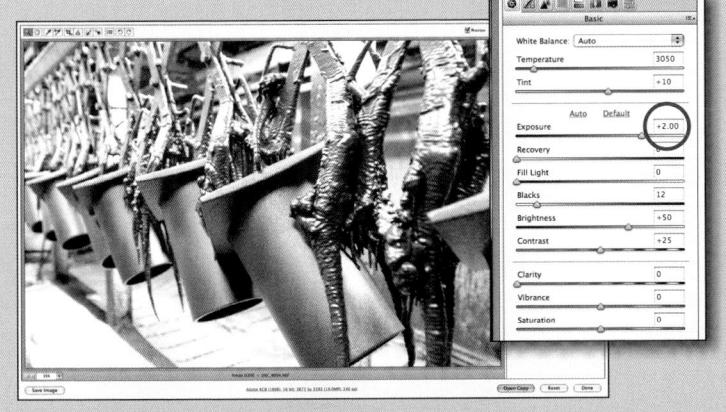

Figure 6-74

Camera Raw Exposure Settings: Same as f-stops?

Camera Raw Exposure values—which can be typed directly into the numerical field with a [+] or{-] prefix—are often compared to lens f-stops, where each f-stop lets in twice (or half) as much light as the next.
Figure 6-74

If this analogy helps you figure out the relationship between Camera Raw Exposure settings and the actual effect on your image, great. However, for some, using f-stops as analogy can be confusing, especially when the results have very little to do with the results you'd get if you changed stops on a camera—via aperture, shutter speed, or ISO controls.

F-stops and shutter speeds control the amount of light striking a sensor. ISO determines the sensitivity of a sensor to light. If you change an f-stop, you also change the depth-of-field. If you change shutter speeds, you can add or stop motion. F-stops and shutter speeds work together to determine the quantity of light striking a sensor. When you use the Exposure setting in Camera Raw on a RAW file, the tonal information is either there or it's not. You don't add new information. You change the emphasis of the information by changing its distribution.

Adding Clarity

An easy way to add punch to your images is with the Clarity slider found in the Basic tab. Used in a small dose, like a sprinkle of salt, it will act like a secret sauce and give the colors in your images pop.

Power Photoshop users have long known the value of using the Unsharp Mask filter to apply local contrast enhancement. By setting the filter Amount to 20%, Radius to 50, and Threshold to 0, hazy photos become clear, dull images shine, and appearance of depth is enhanced, as in Figure 6-75.

The technique works by selectively applying an increase in contrast to small regions of an image and leaving larger regions relatively alone. This prevents a loss of detail in shadow/highlight areas and gives an image more clarity, or "punch."

Figure 6-75

Camera Raw's Clarity

Camera Raw has incorporated the fundamentals of this technique into the Clarity slider, found in the Basic tab (Figure 6-76). There is just one control that affects the intensity of the effect; everything else is done in the background.

Clarity works great on many types of images, as long as the amount is not overdone. Even though the effect may appear subtle on a monitor, when you go to print, it will likely seem more pronounced.

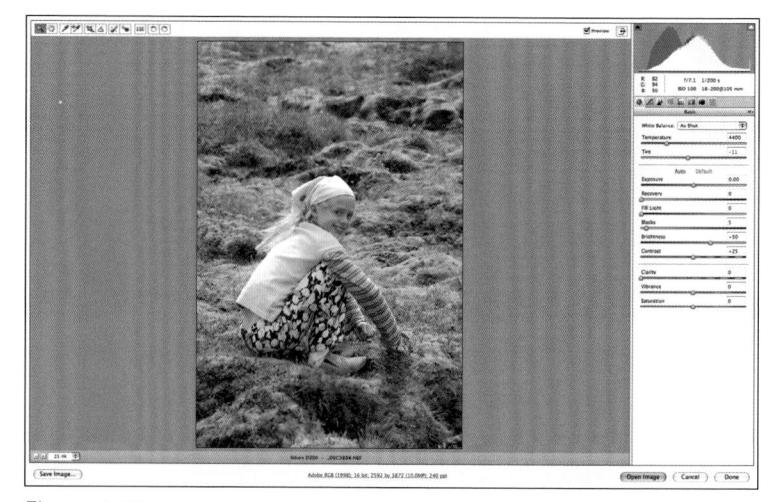

Figure 6-76

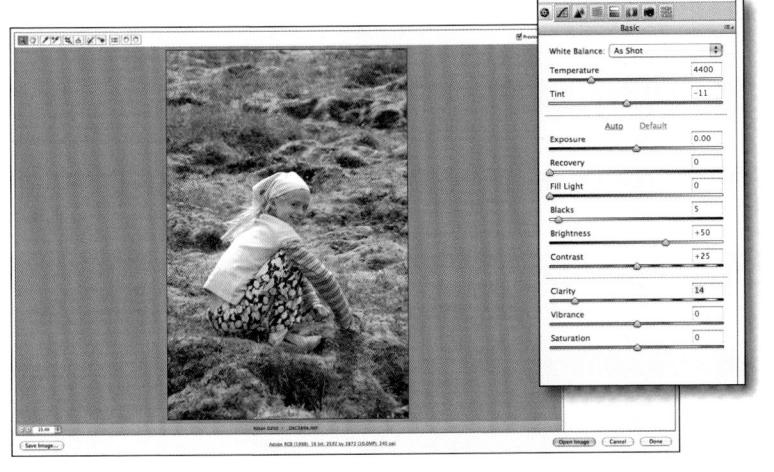

Figure 6-78

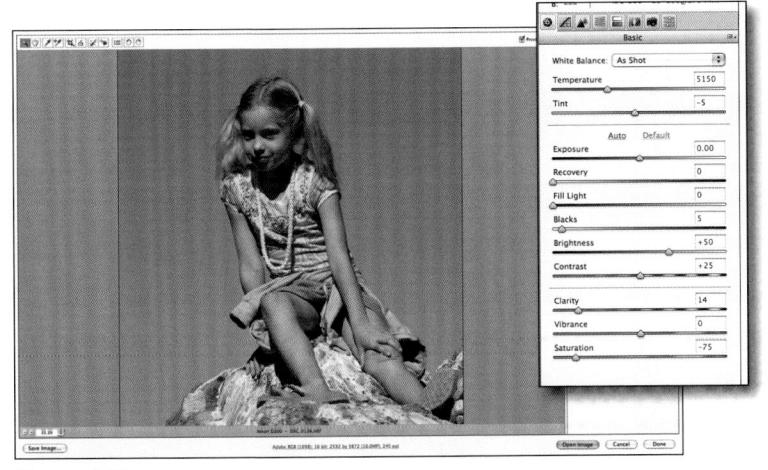

Figure 6-79

Clarity Overdone

Let me show you what I mean about using this slider judiciously. In the example in Figure 6-77, I cranked up the Clarity setting to 100. I also enlarged the image by 200% and included the before and after versions so you can see the effect better. Look at the transitions between the ladder and the sky and you can see what I mean when I say Clarity applies local contrast enhancement. In this case, the higher values don't improve the image.

Clarity Just Right

In Figure 6-78, I applied a Clarity setting of 14, which nicely sets the foreground off from the background and gives the overall image a nice punch. If you look closely, you'll see that the skin tones are still smooth.

Which Images Work Best?

Clarity should be used discriminatingly. I've found Clarity to be especially useful on low-contrast images caused by shooting through a dirty window or shooting with an inherently low-contrast lens. Images with lens flare also make good candidates for Clarity.

I urge you to use caution when using Clarity on close-up portraits. It's very easy to overdo the effect, which results in blotchy-looking skin. On the other hand, using Clarity in conjunction with a desaturated look, such as the one shown in Figure 6-79, can be very effective.

Using Vibrance and Saturation

Both the Vibrance and Saturation sliders (found in the Basic tab) increase or decrease color intensity, but they do it in very different ways. Let's see how to use them.

Vibrance versus Saturation

Vibrance is especially useful when you are working on images that contain areas of primary colors you wish to saturate or desaturate, while leaving areas of secondary shades—such as skin tones—alone. Saturation globally increases or decreases color intensity. As you will see, each slider has its appropriate use.

Look at the before and after shots shown in Figure 6-80. I left the Vibrance slider alone and increased the color Saturation to a value of 66. Note the increased saturation in the red bathing suit, which I wanted. However, also note the unpleasant shift in skin tones, which I didn't want.

Now I will reset the Saturation slider to 0, and instead use the Vibrance slider. Note in the before/after shot shown in Figure 6-81, the red bathing suit is more vivid, but the skin tones have remained pretty much untouched.

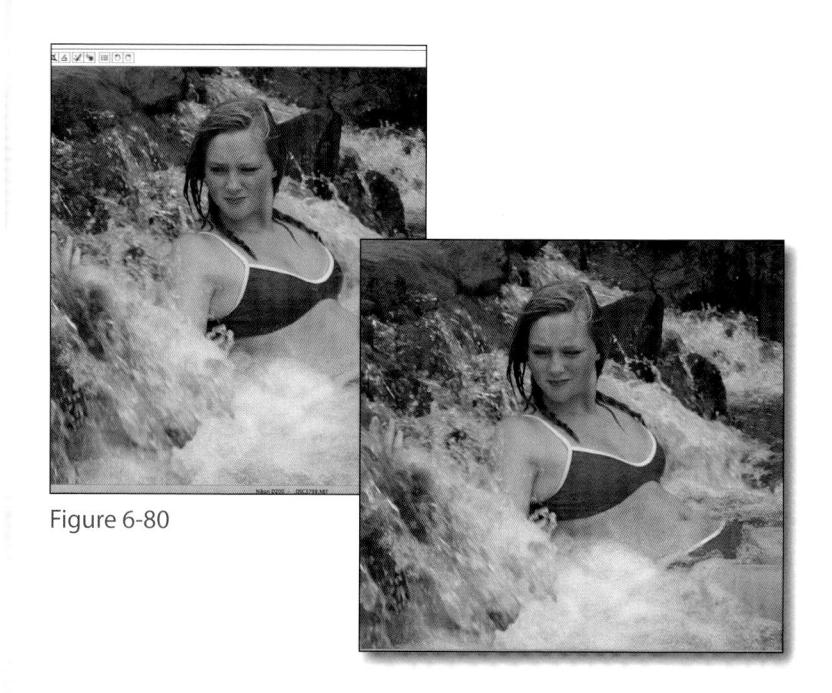

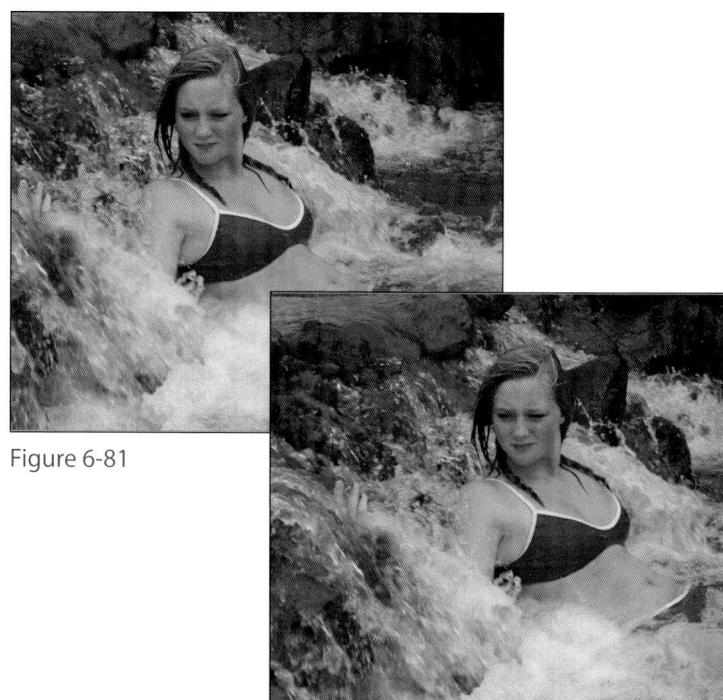

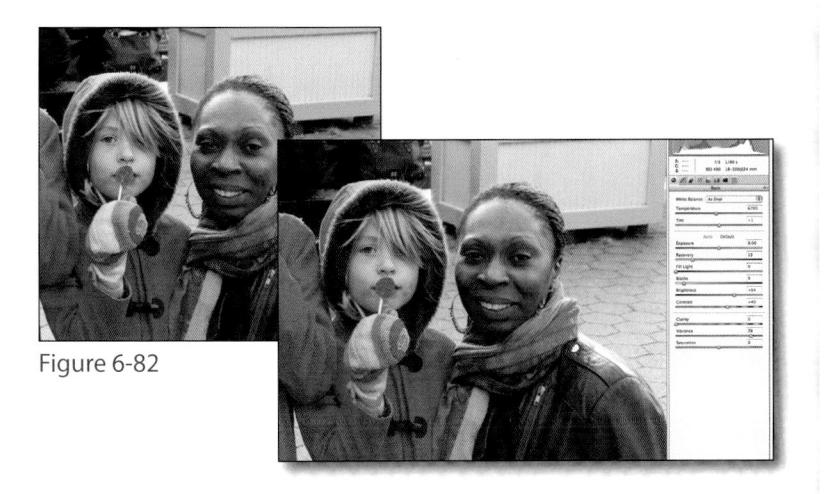

Figure 6-83

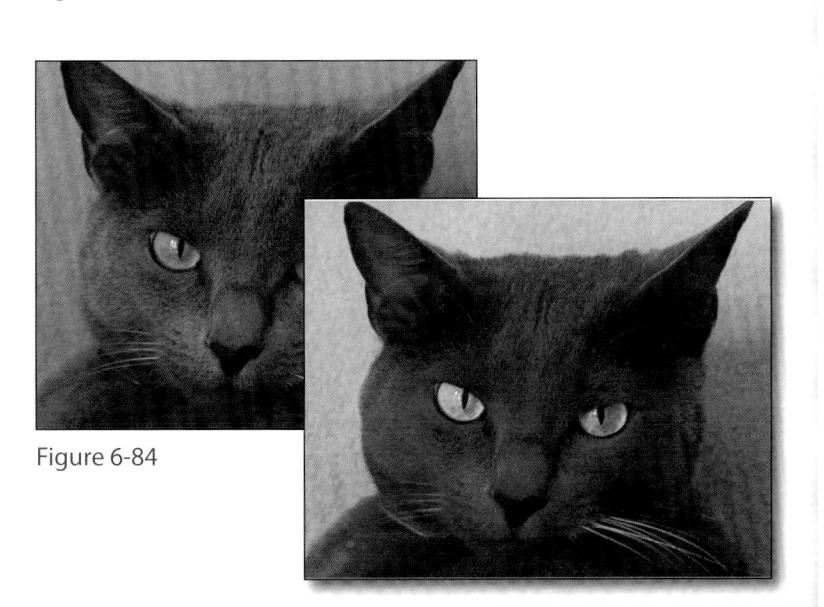

Using Vibrance

I find the Vibrance slider very useful when I'm working with portraits. Since skin tones are not primary colors, the Vibrance slider leaves pretty much all skin tones alone, regardless of color, as you can see in Figure 6-82. But the Vibrance slider isn't only for portraits. It can also be used for other types of images when you want to enhance one part of the image, while leaving other parts alone.

Using Saturation

The Saturation slider works globally on all the colors of an image. This can be desirable, especially with images such as the one shown in the before/after view in Figure 6-83. When I used Vibrance on photographer Richard Morgenstein's image, it left the turquoise (or non-primary colored) rope alone, which wasn't what I wanted. Saturation, however, at a setting of +41, boosted all the colors.

Using Both Vibrance and Saturation

This falls under the heading of special effects. But crank up the values of both Vibrance and Saturation and you can end up with some wild results, like the ones in Figure 6-84.

Reverting and Undoing

There are a couple ways to revert to the Camera Raw default settings or undo what you have done in Camera Raw.

To revert to the original Camera Raw default:

- Select Camera Raw Defaults from the Settings pop-up menu.
- Hold the Option/Alt key and Cancel changes to Reset (circled in Figure 6-85). This resets Camera Raw to the settings used when you opened your file, which may or may not be the original Camera Raw default settings.

You can undo one step by typing \Re -Z (Ctrl-Z). Typing \Re -Z (Ctrl-Z) again brings you back to the previous step.

You can also reset many sliders by doubleclicking on a slider's triangle indicator (circled in Figure 6-86) to reset that specific slider.

To view the original Camera Raw default settings (or the settings applied when you first opened a RAW file in Camera Raw), deselect the Preview checkbox (Figure 6-87) at the top of the display window.

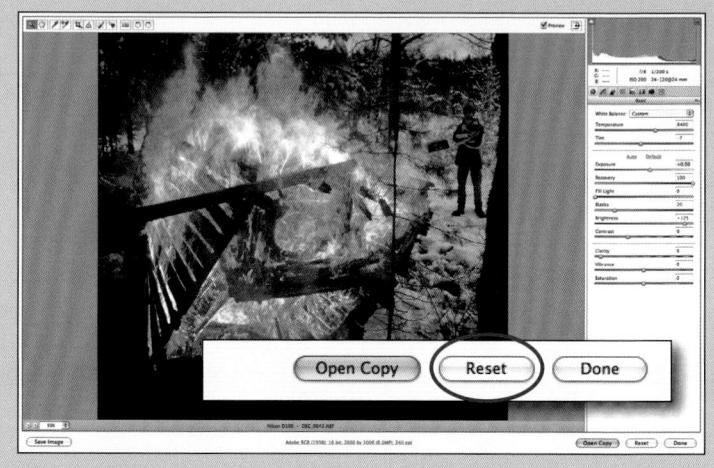

Figure 6-85

Figure 6-86

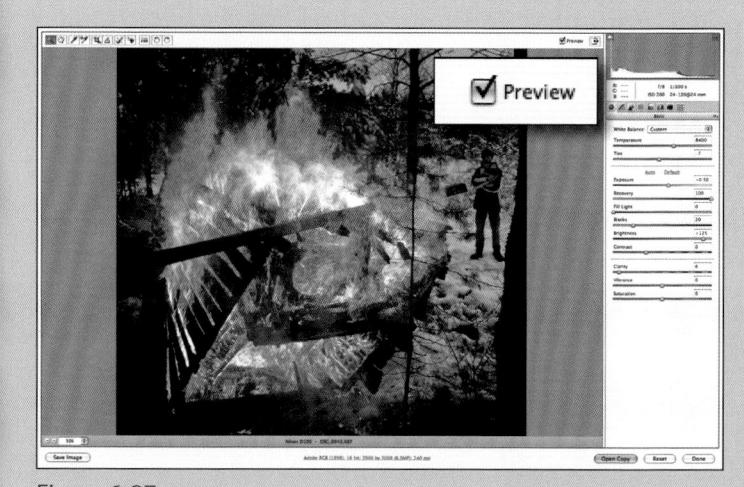

Figure 6-87

Camera Raw applies adjustments globally to the entire image. If you want specific control over specific parts of an image, you'll need to convert your RAW file with Camera Raw and open it in Photoshop. In this section, I'll show you a simple Photoshop procedure for applying localized control.

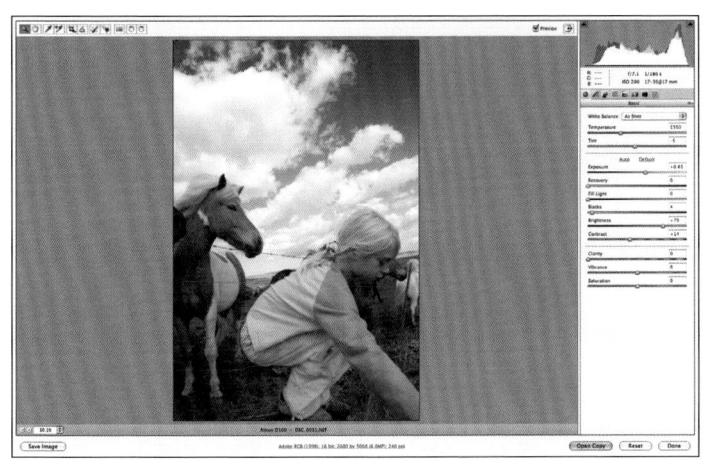

Figure 6-88

Figure 6-89

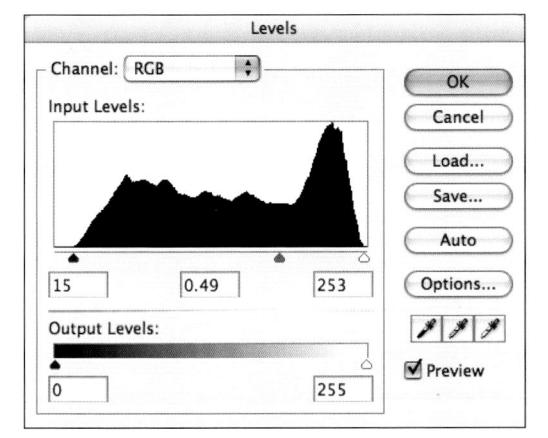

Figure 6-90

Finishing Up Adjustments with Photoshop

Once you take your image from Camera Raw in Photoshop, you'll have a wide range of tools to work with—including masks and adjustment layers—that will allow you to apply tonal corrections to some areas of an image and not others.

Let me illustrate this by returning once again to an earlier image, shown in Figure 6-88. In Camera Raw, I was able to improve the foreground, but only at the cost of making the background look washed out in the preview window. However, the Camera Raw histogram indicated no clipping in the highlights, so I was fairly confident that detail remained. Here is a relatively simple way to use Photoshop to improve images like this one:

- Open the image from Camera Raw into Photoshop. (From the bottom right of Camera Raw, select Open Image.)
- Create a Levels (or, if you prefer, Curves) adjustment layer (Layer→New Adjustment Layer→Levels). Or click on the adjustments layer icon, circled in Figure 6-89, at the bottom of the layer palette.
- Apply your Levels adjustment until the background is correct (Figure 6-90).
 The foreground is now too dark, but we'll fix it shortly.

4. Even though the clouds originally looked blown out on my monitor, I knew from Camera Raw's histogram that there was no highlight clipping. This was confirmed when I was able to successfully use the Levels to correct the background, as you can see in Figure 6-91.

NOTE I want to emphasize an earlier point: If you plan on doing any editing in Photoshop, bring in as much data as you can. Use the appropriate color space—usually Adobe RGB or ProPhoto—and start with 16-bit depth. Also, get your white balance, or color, as close as possible in Camera Raw. You may have more control over specific colors in Photoshop, but you will always pay a price in the form of image degradation, unless, of course, you are working on Smart Objects, which are fully editable.

- 5. Choose the Adjustment layer (Figure 6-92) and select the Brush tool from the toolbar. Make sure the foreground swatch at the bottom of the toolbar is set to black. (The keystroke X will switch the background and foreground colors alternately. The Keystroke D will make sure default colors are selected.)
- 6. With the brush tool and an appropriate-size brush with a soft edge, "paint" or "mask" the foreground area of the image, leaving the effect of the Levels adjustment only on the background (Figure 6-93, thumbnail). (Use the bracket keys to increase or decrease the size of the brush.

Figure 6-91

Figure 6-92

Figure 6-93

Figure 6-94

The final image is shown in Figure 6-94.

NOTE The RAW file for this image, along with the other Working RAW files, can be found at http://examples.oreilly.com/9780596510527.

There are other Photoshop techniques similar to this one that will apply specific corrections to specific parts of an image. In the next chapter, I will go into more detail, but this is a subject for a book unto itself—and several good books offer good techniques on this subject. I especially recommend Martin Evening's *Photoshop CS3 for Digital Photographers*.

Figure 6-95

Monitor Calibration

If a monitor is too contrasty, too bright, or if the colors are off, there is no way to predict what an image will look like when it is printed. A monitor can be calibrated using software alone, but hardware calibration is more accurate.

For a few hundred dollars or less, you can buy a product that attaches to your monitor and physically measures the colors and brightness, which creates a color profile that can be used to produce consistent results.

The Eye-One Display 2 (Figure 6-95) costs about \$249 (www.gretagmacbeth.com). Software calibration comes with Mac OS X. It's called the Display Calibrator Assistant; you can find it in the Utilities folder. Windows users must rely on third-party solutions.

Advanced Tonal Control

In the previous chapter, we used the color and tonal controls found under Camera Raw's Basic tab. In this chapter, we'll learn more advanced control using the Tone Curve and HSL/Grayscale tabs. I'll also show you how to use the Camera Calibration tab to create a custom look based on your camera model. Finally, you'll learn a technique that takes a bit more work but often produces dramatic results: using Camera Raw to create two or more versions of the same image with different distribution of tonal values, then merging those two versions in Photoshop into one that displays or prints an amazingly wide range of shadow and highlight detail.

Chapter Contents

Using Camera Raw Tone Curves for More Control

Using the HSL/Grayscale Tab

Creating Custom Camera Profiles

Advanced Tonal Control with Camera Raw and Photoshop

Part One: Creating Two Versions

Part Two: Blending Two or More Copies in Photoshop

Using Camera Raw Tone Curves for More Control

It's generally recommended that you first do your major editing in the Basic tab, then use either the Parametric or Point tone curves for fine tuning. You get to the tone curves by clicking on the Tone Curve icon (circled in Figure 7-1).

You'll see two tabs: Parametric and Point. Let's start with the Parametric tone curve.

Using the Parametric Tone Curve

Just as with Photoshop's Curves, the horizontal axis represents the original intensity values of the pixels, and the vertical axis represents the new tonal values.

With the Parametric tone curve, you basically work with four set points: Highlights, Lights, Darks, and Shadows. Instead of placing a multitude of points on the curve and dragging the curve to a desired position, like you do with the Point tone curve, you control the tonal values with the sliders found under the graph. What's lacking in detailed control is more than made up for in ease of use. In Figure 7-2, I've adjusted the sliders to produce a wide range of tonal values.

Further control is found with the Split points; three triangles at the bottom of the Parametric tone curve graph (as circled in Figure 7-3). Drag the triangles horizontally left or right to control the width of the given tonal range. Double-clicking on a triangle will reset that specific region.

The tonal controls of Camera Raw's Basic tab redistribute linear RAW data produced by digital cameras into a form pleasing to the eye. You can get even more control over how this data is mapped with the Camera Raw tone curves. You have two tone curves to choose from: Parametric and Point. Let's see how they work.

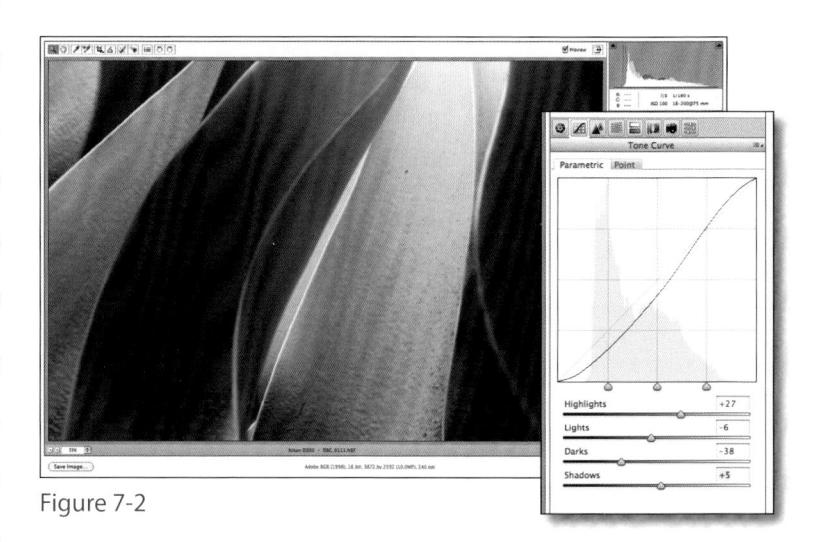

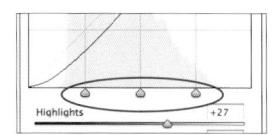

Figure 7-3
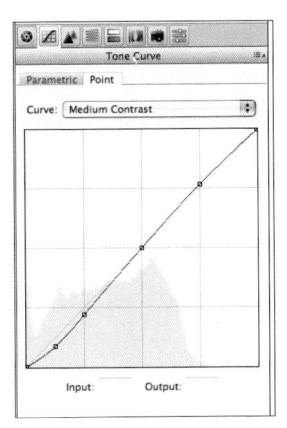

Figure 7-4

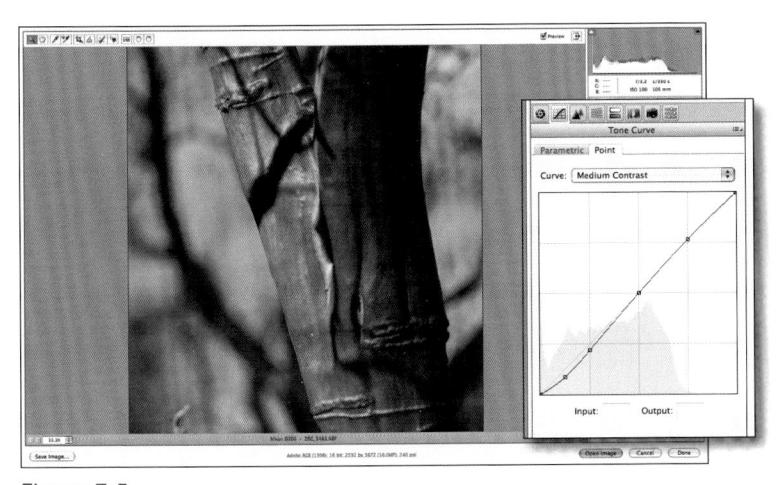

Figure 7-5

Using the Point Tone Curve

For photographers familiar with using Photoshop Curves, the graph that appears when you select the Camera Raw Point tone curve (shown in Figure 7-4) will seem very familiar. You can adjust up to 14 different points throughout an image's tonal range, which is represented by a diagonal line. (With Basic tab controls, you effectively control only 5 points on a tone curve.) Many of the methods for applying and manipulating these points are the same as those in the familiar Photoshop Curves dialog box. Custom curves can be saved and applied to other images.

Some photographers may find the added control offered by Camera Raw's Point tone curve daunting. For these photographers, the easy-to-use Parametric tone curve described earlier might be a better choice, or using the easy-to-apply Point tone curve presets might suffice. Let's first go over these Point tone curve presets—which are found in the pop-up menu at the top of the Point tone curve—first, then move on to actually working on the Point tone curve itself.

Point Tone Curve Presets

The default Point tone curve preset is Medium Contrast. As you can see in Figure 7-5, four points have been added to the diagonal line and input/output levels were adjusted to slightly increase contrast. It may not be so obvious here, in print, but slight variations in the out-of the-box presets illustrates how even very slight changes in the tonal curve can appreciably affect an image. The Linear preset (shown in Figure 7-6) creates a perfectly straight diagonal line in the tonal curve graph. This results in an image with no change from input to output,

effectively ceding all control to the Basic tab tonal settings. The Strong Contrast preset creates the Curve shown in Figure 7-7. Four points are set and manipulated to increase contrast. Again, the manipulation is very slight, but effective.

Creating a Custom Curve

To create a custom point tonal curve, start with the Linear Tone Curve Setting. Add a point along the straight diagonal line by either clicking directly on the line or Camera Raw image preview window. Hold the

key (Ctrl key) without clicking, and you'll see a preview of where the point will appear on the curve when you click.

You can add up to 16 control points to the curve. To remove a point from the tonal curve, do one of the following:

- Drag it off the graph.
- Select it and press Delete.
- #-click (Ctrl-click) the control point.

There is no way I can go into all the details required to fully explain how to use curves—and still have room for the other subjects in this book! However, from a very basic point of view, changing the shape of the curve alters the tonal distribution. Bowing the curve upward or downward will cause the image to lighten or darken. (In Figure 7-8, I've lightened the image by placing a single point in the middle and bowing the curve upwards.)

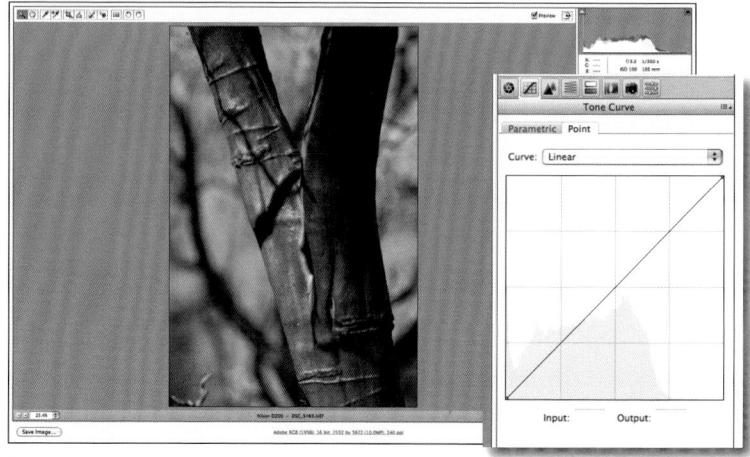

Figure 7-6

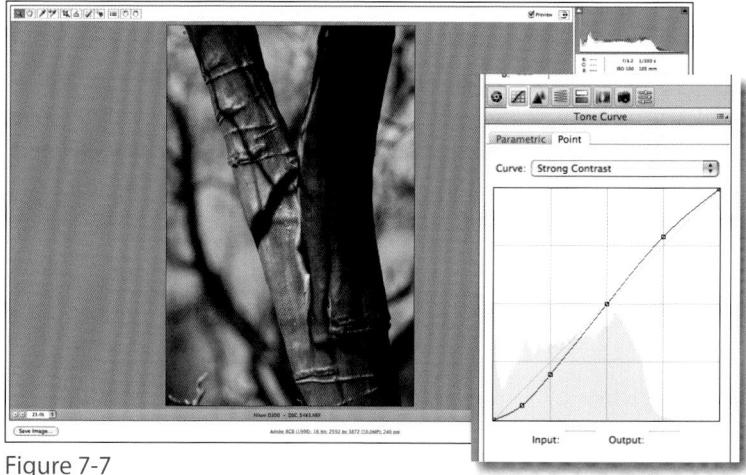

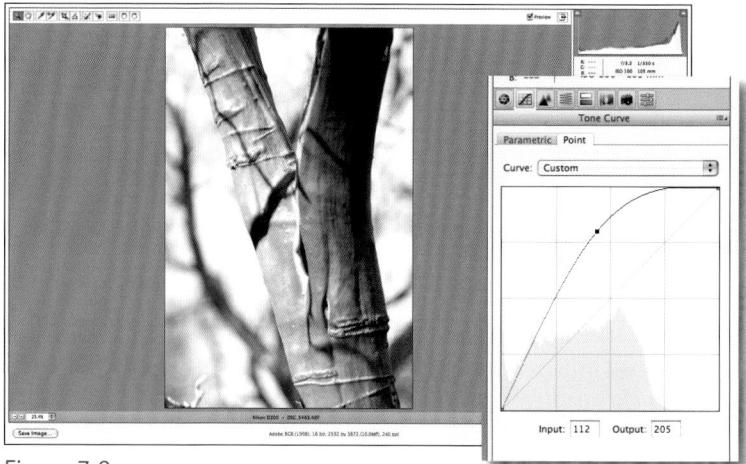

Figure 7-8

Figure 7-9

Figure 7-10

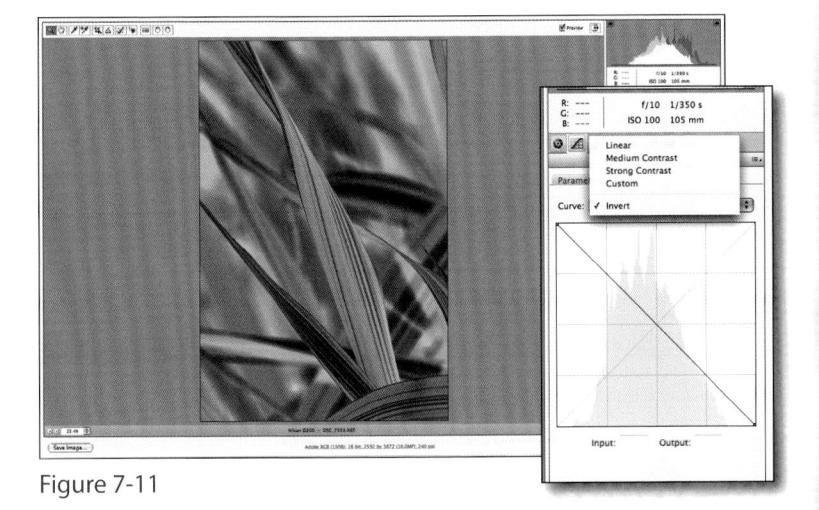

Steeper sections of the tonal curve represent areas of more contrast; flatter sections of the tonal curve represent areas of lower contrast. Any points you placed on the curve will remain anchored and you can make an adjustment in one tonal area while other areas remain relatively unaffected.

The Custom selection appears in the Tone Curve pop-up window whenever you manually manipulate the tonal curve. If you save a custom setting properly, it will also appear in the Curve Settings pop-up menu.

Creating Custom Presets

Create a custom Point tone curve by selecting Save Setting from the Settings menu, as shown in Figure 7-9. In the Save Settings dialog box, select Point Curve from the Subset pop-up menu, as shown in Figure 7-10. Select Save and name the setting appropriately. Be sure it goes into the Camera Raw Curves folder, a subfolder under Camera Raw; otherwise, it won't appear in the Point curve tone Curve pop-up menu. In this image. I've turned the image in Figure 7-11 into a negative by inverting the histogram and saved it as a custom setting called Invert.

TIP If you press the Delete key without selecting a point on the curve, Camera Raw assumes you want to trash your current file and a warning will appear. If this occurs, simply press the Delete key again and the warning will disappear.

Real-world custom curve example

Here's a real-world example of using Camera Raw Point tonal curve to get an effect that wasn't possible with the Basic controls alone. The photo in Figure 7-12 was shot by photographer and author Peter Krogh. As you can see in the histogram, the shadow areas are clipped.

Peter did what he could using the Basic tab tonal controls, but he finally resorted to using the Camera Raw Point curve tonal control. He's found the Point curve tone controls very useful for adding contrast in the darks, without blowing out the highlights. Look at Peter's tonal curve, and you'll see the simple adjustment made by adding two points on the curve and extending the shadow "toe." This method is simple but effective. Why did he end up in black and white, as shown in Figure 7-13? Peter just liked how it worked for this particular image. He simply set the Adjust tab Saturation setting to 0.

NOTE To delete custom settings from the Point tone curve pop-up menu, you'll need to go to the Camera Raw → Curves folder on your hard drive. (Location of this folder varies between platforms. It's best to search with the word "Curves" to determine the exact location.) Here you will find .xmp files. Select the ones you want to delete and drag them to the trash. The next time you open Camera Raw, they will not appear.

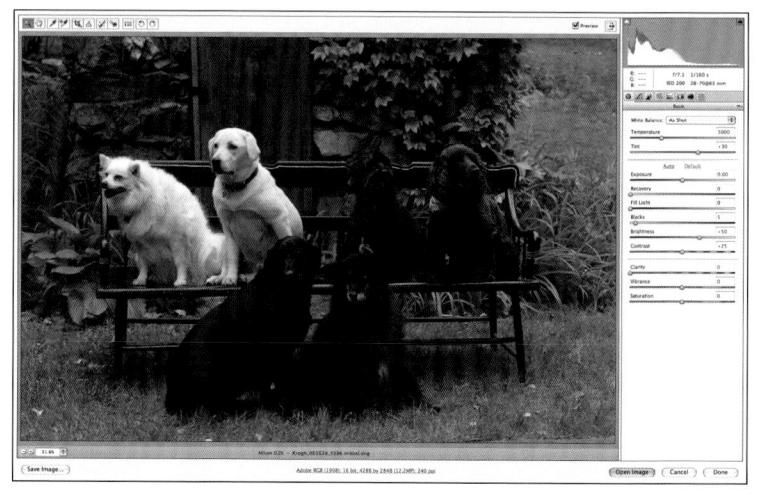

Figure 7-12

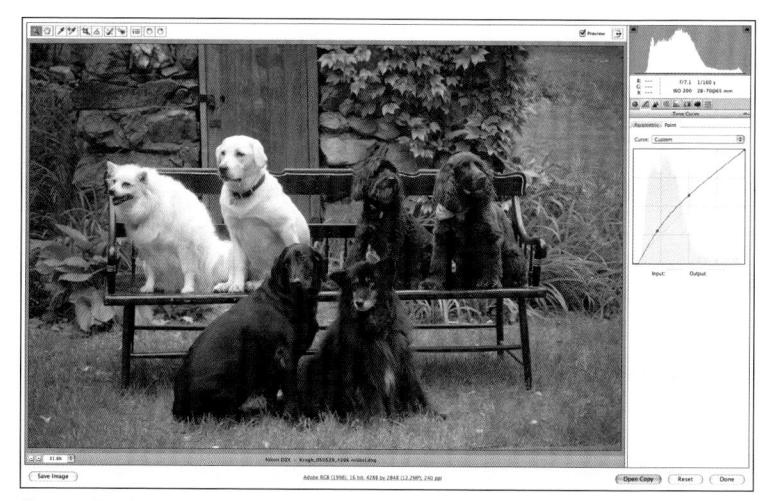

Figure 7-13

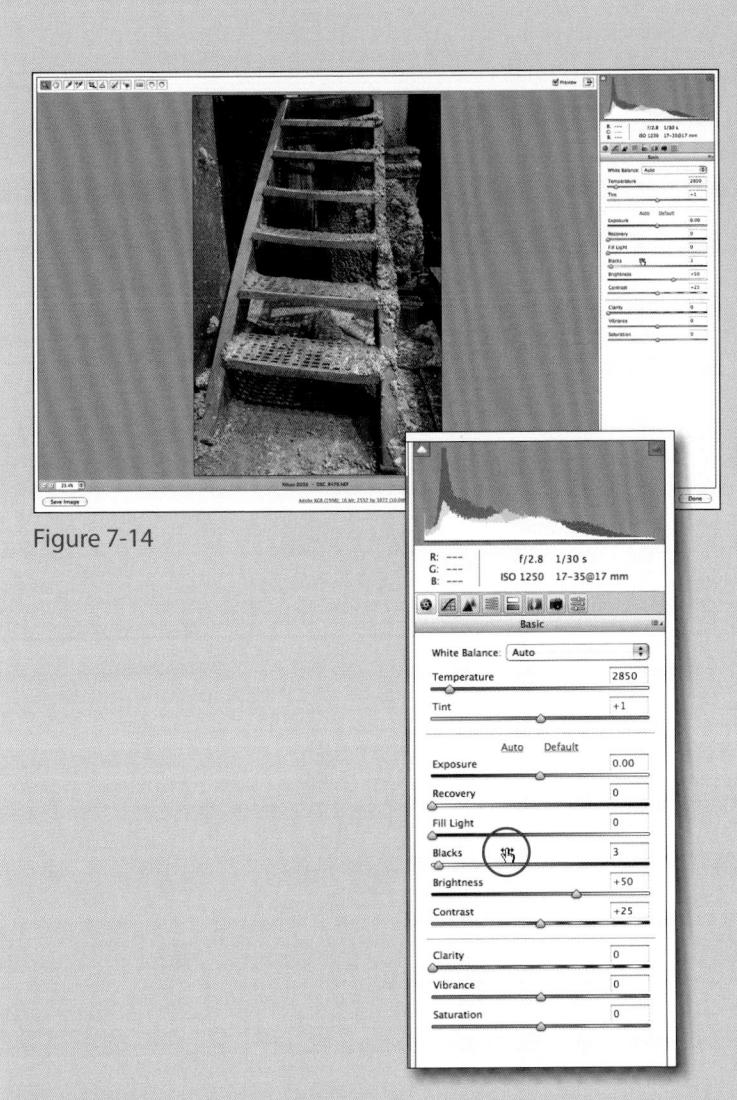

Useful Keyboard

Here is a sampling of general keyboard commands you can use to streamline your work in the Basic and Tone Curve tabs. (I've already mentioned some of them.)

- In the Basic tab, 第-U (Ctrl-U) applies auto tone adjustments. The keystroke 第-R (Ctrl- R) reverts to Default settings.
- **Tab** cycles through the Basic tab Adjust controls.
- \mathcal{H}-0 (Ctrl+0) automatically reverts the preview window to Fit in View. \mathcal{H}-0p-tion-0 (Alt -Ctrl-0) reverts the preview window to show actual pixels (100%).
- Down/Up Arrow keys move the Basic tab adjust values incrementally. Shift+Down/Up Arrow keys increase the incremental values.
- Esc is for when you are totally frustrated and want to get out of Camera Raw as fast as possible. None of your changes are saved.

In addition to the keyboard key shortcuts, Camera Raw uses scrubbers, like the one circled in Figure 7-14. To use scrubbers, place your cursor over one of the sliders. The cursor should change to a double-ended arrow such as the one shown here. If you click and drag to the left, the numeric entry will decrease; if you drag to the right, it will increase. Double-clicking on a slider's triangle will revert it to the default setting.

Using the HSL/Grayscale Tab

Let's take the HSL part of the HSL/ Grayscale tab (Figure 7-15) apart. Right away, you will see several choices: Hue, Saturation, Luminance

Hue sliders change the specified color.

For example, change only the reds in your image to another color by sliding the Reds slider left or right.

Saturation changes the color vividness or purity of the specified color. You can desaturate a specific color, say green, by sliding the Greens slider to the left. You can saturate, say, only the reds in your images by sliding the Reds slider to the right.

Luminance changes the brightness of a specified color.

Default reverts all the sliders to their default, which is zero. Only the sliders in the selected sub-tab will be affected. (Double-clicking on an individual slider's triangle will revert just that slider.)

Red Coat Example

Let's walk through some specific examples of how to use the HSL/ Grayscale tab, starting with changing the color of my daughters' coats (Figure 7-16) and then changing the Saturation and Luminance values. The challenge here is to match the targeted colors with the appropriate sliders, which isn't always easy.

Camera Raw's HSL/Grayscale tab is where you'll get even more color and tone control. HSL stands for Hue, Saturation, and Luminance. Many people will find working with tone and color this way intuitively easy, and fun! (The Grayscale part of this tab is covered in Chapter 10).

Figure 7-16

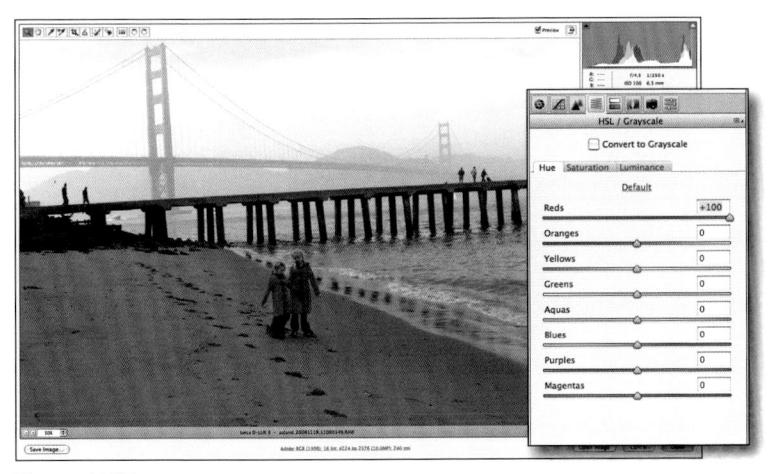

Figure 7-17

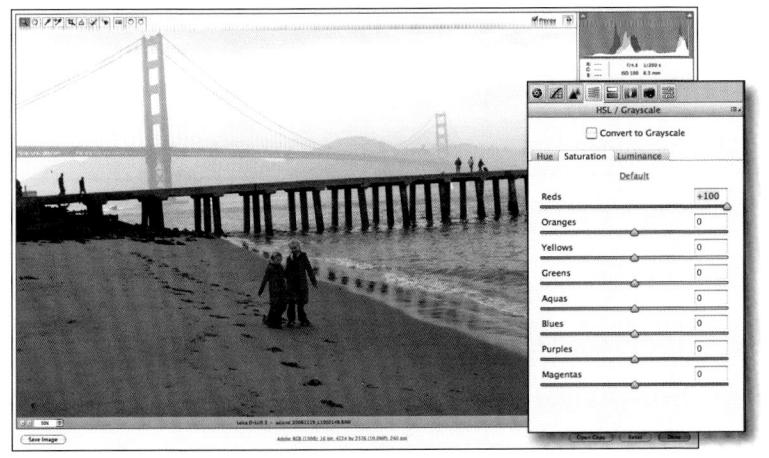

Figure 7-18

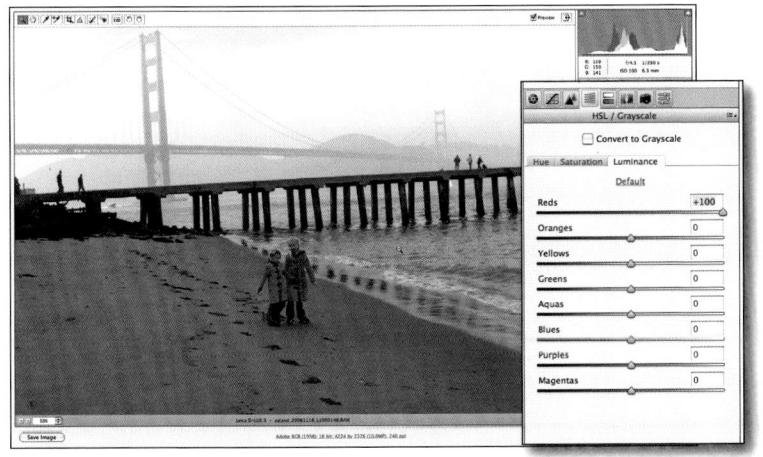

Figure 7-19

Changing Hue

In Figure 7-17, I moved the Reds slider to +100, which changed all the reds in the image to orange. (You'll quickly see the range of hue is limited. Red goes to orange or purple, but the purple cannot go to blue.) Sometimes an area may contain a mix of colors, in which case you'll have to move more than one slider to get the changes in color you want. Remember these are global changes, and in the case of this particular example, any reds elsewhere in the image will change as well.

Changing Saturation

To increase the saturation of the red coats, I clicked on Saturation in the HSL/Grayscale tab and slid the Reds slider to +100. Again, this is a global effect and all the reds in Figure 7-18 are affected.

Changing Luminance

To change the Luminance, I clicked Luminance in the HSL/Grayscale tab. I selected the Reds slider and increased it to +100. You can see how this affected the Luminance values of only the reds in Figure 7-19.

Create a Dramatic-Looking Sky

Figure 7-20 shows an example of using a combination of Saturation and Luminance controls to turn this ordinary-looking sky into a more dramatic one.

I started by selecting Saturation in the HSL/Grayscale tab. I moved the Blues slider to +61. Next I clicked on Luminance in the HSL/Grayscale tab. I set the Blues slider to -61. This darkened my rich blue sky and gave it even more distinction from the white clouds (Figure 7-21).

A Tanned Beach Look

Next, I'll use the Saturation sub-tab to make a subtle shift in the facial tones of the image without affecting the other parts of the image. I'll also use the Luminance sub-tab to darken the green foliage in the background. The before image is shown in Figure 7-22.

I used a Saturation Oranges slider setting of +70 and a Luminance Greens slider setting of-100. The after image is shown in Figure 7-23.

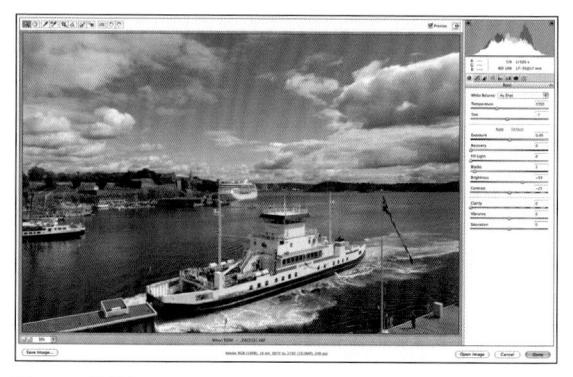

Figure 7-20

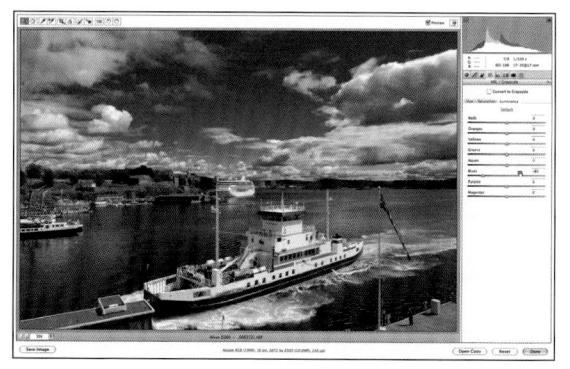

Figure 7-21

Figure 7-22

Figure 7-23

Figure 7-24

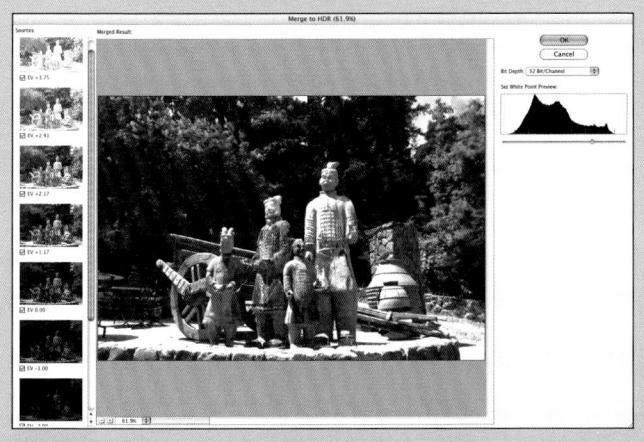

Figure 7-25

Figure 7-26

Photoshop's Merge to HDR

A relatively recent addition to Photoshop is Merge to HDR (High Dynamic Range). Merge to HDR allows you to blend or merge three or more files taken of the same scene with different exposures and create a new file capable of storing an almost infinite number of tonal values. Merge to HDR is available in Photoshop via the File—Automate menu command shown in Figure 7-24. Merge to HDR is available in Bridge via the Tools—Photoshop menu command.

The advantage of using Merge to HDR is obvious: by using different multiple shots at different exposures, you can extend your dynamic range much farther than is possible with a single shot, like the one in the preview of Figure 7-25. Few displays—and no printers—are capable of utilizing all this data. You'll need to rely on another Photoshop feature, HDR Conversion. HDR Conversion automatically appears when you change modes to a lower bit-rate, and provides a variety of ways to squeeze the dynamic data into a useable form, as shown in Figure 7-26.

There are obvious limitations to the multiple shooting technique, often referred to as "bracketing." First, it's most effective with static scenes. Second, it works best if you carefully frame each shot, preferably using a tripod. Third, it uses up more memory both in the camera and on the hard drive. It also takes some effort to properly use HDR Conversion and achieve optimal results. For a step-by-step instruction on using Photoshop's Merge to HDR, please go to my web site, www. shooting-digital.com.

Creating Custom Camera Profiles

You can use any image to calibrate, but an image containing a color chart like the one in Figure 7-27 and shot under controlled lighting, will produce more predictable results.

The Calibration Process

Open your image in Camera Raw. In the Camera Calibration tab (shown in Figure 7-28), select a Profile set from the Camera profile pop-up menu. ACR (which stands for Adobe Camera Raw) 3.0 or higher are the new and improved camera profiles. Often ACR 2.4 is listed, which means your camera didn't require the updated ACR profile. If both 2.4 and a higher ACR profile are listed you can choose either one. However, Adobe recommends choosing 2.4, which they say assures consistent behavior with older photos. If an image is in the TIFF, JPEG, PSD, or DNG format, and not RAW, a profile of Embedded will appear.

Next, use the sliders to create the look you are after. Start by moving the Shadows slider to correct for any green or magenta tint in the shadow areas. Then use the Red Primary, Green Primary, or Blue Primary sliders to fine-tune these colors. Start with the Hue slider (which actually changes the color), then adjust the Saturation. (Negative values desaturate; positive values saturate.)

Camera Raw produces an image look based on camera profiles created by Adobe. Use the Camera Calibration tab to customize these profiles to your own look. You can save these settings as a preset and apply them at any time, or have them applied automatically by default on a camera-by-camera basis.

Figure 7-27

Figure 7-28

Save Settings

Subset: Camera Calibration	E
White Balance	Cancel
Daposure	Recovery
Fill Light	
Blacks	
Brightness	Contrast
Clarity	
Wibrance	
Saturation	
Parametric Curve	
Point Curve	
Sharpening	
Luminance Noise Reduction	
Color Noise Reduction	
Crayscale Conversion	
HSL Adjustments	
Spilt Toning	
Chromatic Aberration	
Lans Mognetting	
Apply auto tone adjustments	
Apply auto tone adjustments	
Apply auto prayacale mix	

Figure 7-30

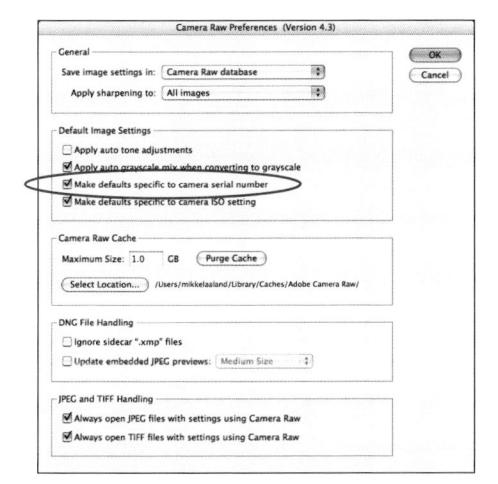

Figure 7-31

Check your adjustments visually or with the Color Sampler tool. Selecting and deselecting Camera Raw's Preview checkbox is helpful (Figure 7-29). When you are finished, save your settings as a preset.

Save as a User Preset

You can save these settings to use again later. Do this by selecting Save Settings from the Settings pop-up menu. This will bring up the dialog box shown in Figure 7-30. You'll probably want to save the only Camera Calibration settings (circled), which then creates a starting point from which you can adjust each image individually. (The easiest way to do this is to choose Camera Calibration from the Subset pop-up menu.) When you are finished, click Save. Now the preset will show up in the Apply Presets category in the Settings pop-up menu and in Bridge's contextual menu as well.

Save Default Develop Settings

You can also make your new calibration a default setting applied automatically to files from a specific camera. Do this by selecting Save New Camera Raw Defaults from Camera Raw's Settings pop-up menu. Then, in Camera Raw's Preferences, found by clicking on the Preferences icon in Camera Raw's toolbar, select Make defaults specific to camera serial number, circled in Figure 7-31.

NOTE Thomas Fors has created an awesome Photoshop script for automating much of the calibration process. His script, and a lot of supporting text, is available at http://fors.net/chromoholics/.

Advanced Tonal Control with Camera Raw and Photoshop

To illustrate this technique, I'm going to use the work of photographer and eminent digital photography educator Michael Reichmann. Michael took the shot in Figure 7-32 with a Canon EOS 1DS Mark II. As confirmed by Camera Raw's histogram, the camera captured details in both the highlight and shadow areas for a RAW image with superb dynamic range. However, to prepare this image for optimal viewing or printing, I'll need to selectively compress the dynamic range.

Simply using Camera Raw Basic tab controls doesn't do the trick, as you can see in Figure 7-33. Even though the background is better, detail is still lacking in the foreground. (Using the Point curve tone controls didn't help much either.)

To solve this problem, I'll present here what I did to Michael's image, step-by-step. I'll break the process into two main parts.

Some RAW images need more work than others to make them display properly on a typical monitor, or print correctly on a printer with limited dynamic range. Let's look at an advanced technique that comes in handy with images that contain extreme highlight and shadow tonal values.

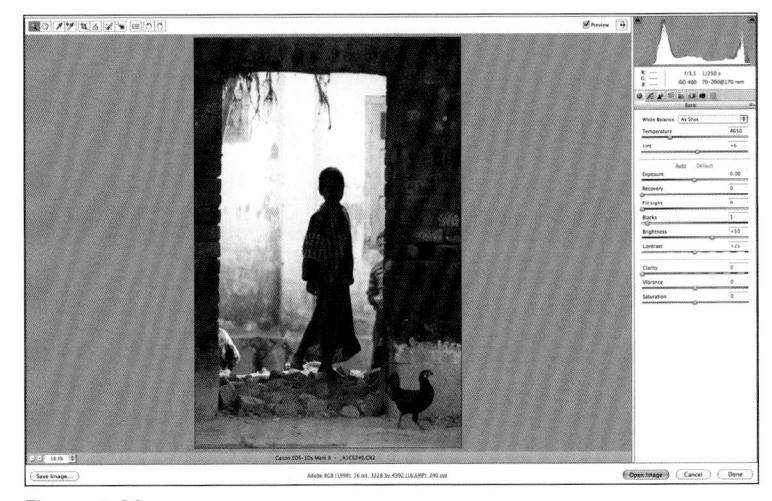

Figure 7-32

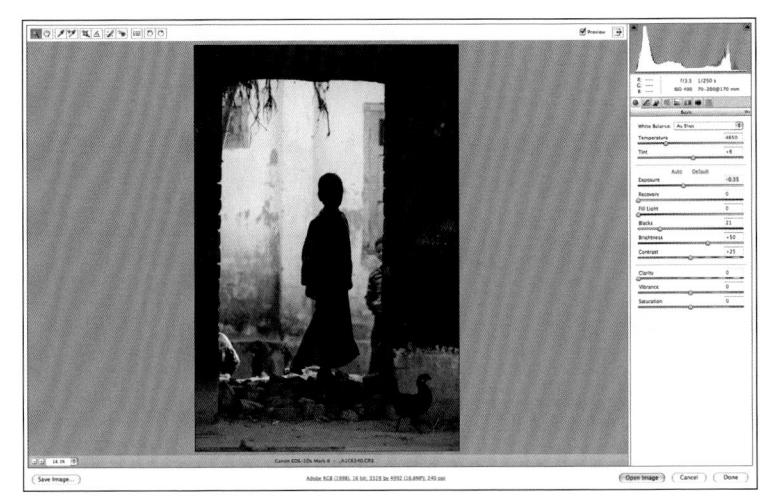

Figure 7-33

In this first part, I'll show you how to create multiple versions of the same RAW file as Smart Objects in Photoshop. Part Two shows a couple of ways to use Photoshop to selectively merge the different versions into one.

Part One: Creating Two Versions

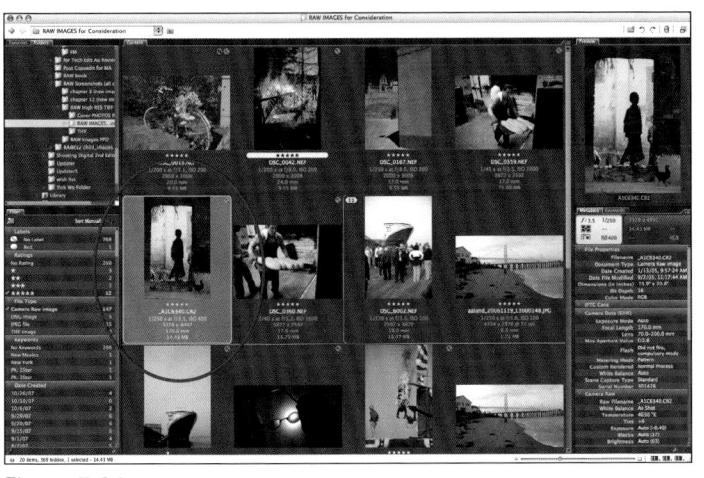

Figure 7-34

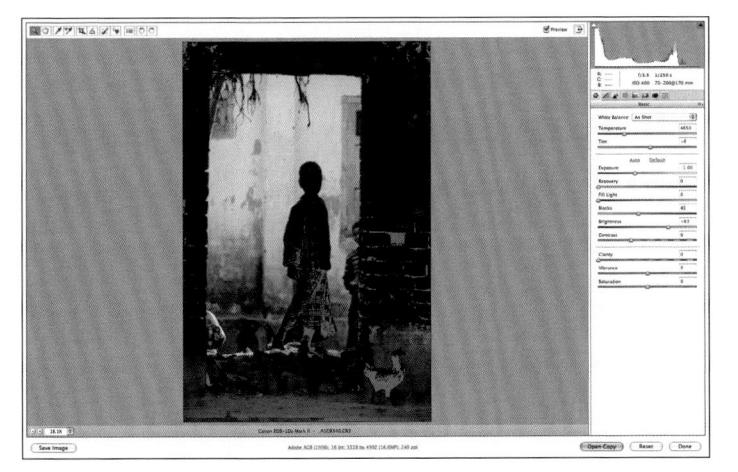

Figure 7-35

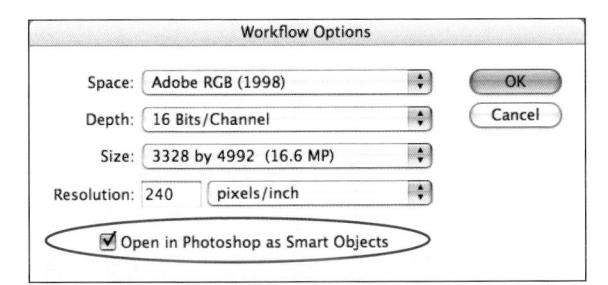

Figure 7-36

Here are the steps for this first part:

 Starting in Bridge, as shown in Figure 7-34, open the RAW file into Camera Raw (File→Open in Camera Raw).

- 2. In Camera Raw, use the Basic or Tone Curve controls to adjust for either the highlights or shadows. Don't try to compromise. Just make one or the other right. In Michael's image (Figure 7-35), the highlights in the background are now correct but, as indicated by the blue shadow clipping warning, the shadow areas in the foreground are lacking detail.
- 3. Select Camera Raw workflow preferences by clicking on the link at the bottom of the Camera Raw window. In the Workflow dialog box, select Open in Photoshop as Smart Objects (circled in Figure 7-36).

4. Select Open Object from the bottom right of the Camera Raw window. The RAW file, with your adjustments, will open in Photoshop as a Smart Object (as you can see in the History palette in Figure 7-37). It will retain its original characteristics and remain fully editable at any time in Camera Raw.

- 5. Back in Bridge, open the same RAW file again into Camera Raw. This time, adjust the exposure so the shadow areas are correct. Now Michael's background is blown out, as depicted by the red highlight warning in Figure 7-38. I quickly noticed that opening up the shadow areas revealed a lot of image noise. At this stage of the process, I ignored this obvious distraction, choosing to fix it later with Photoshop's Reduce Noise filter. (For more on this filter see Chapter 9.)
- 6. Open this version as a Smart Object in Photoshop. You'll now have two versions of the same image open in Photoshop as Smart Objects. Next you'll need to create a multi-layered document. With both images open in Photoshop, select a layer (it doesn't matter which one in the Layers palette of one of the images), hold the Shift key and drag the layer on top of the other image. The Layer Palette I created with Michael's image is shown in Figure 7-39. Note that both layers are Smart Objects, which means both are independently editable.

Figure 7-37

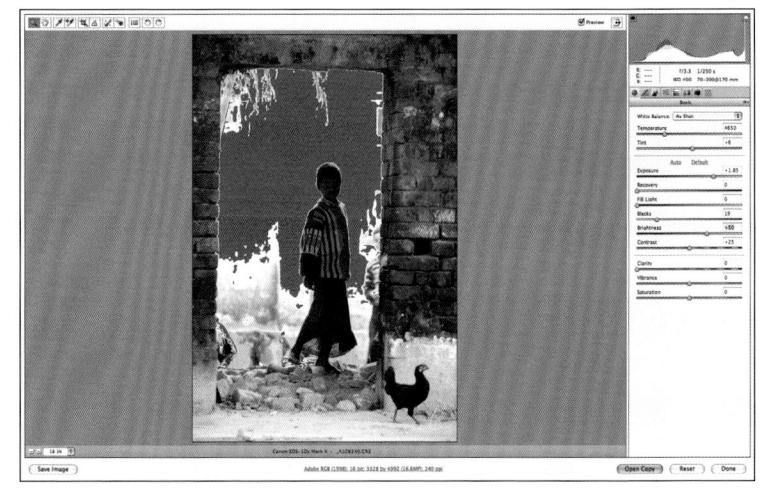

Figure 7-38

Figure 7-39

Figure 7-40

Figure 7-41

Figure 7-42

Now you are ready to blend the images, which I'll go into detail shortly.

Using Bridge's Place in Photoshop

You can also bring multiple versions of the same image into Photoshop as Smart Objects directly from Bridge by using Bridge's place command. The first time you use the Place command on your RAW file it won't open in Camera Raw, but you can always go back and perform your adjustments there later. The second time you use Place on the same RAW file, it will open in Camera Raw and you can make adjustments then or later.

To do this:

- Select File → Place In Photoshop from the Bridge menu, as in Figure 7-40.
- After the first version is automatically placed in Photoshop, go back to Bridge and repeat step one.
- 3. This time, when Camera Raw appears, make a tonal adjustment for either highlights or shadows and select OK when you are done. The second version will open in Photoshop and be pasted into the original one as a Smart Object, as shown in Figure 7-41. It'll have a large X across the image. Select the Commit button from the Options bar, circled in Figure 7-42.

4. In Photoshop's Layer palette, select base layer, which is the layer containing the first Smart Object you placed. Double-click on the icon and this will open up Camera Raw (see Figure 7-43). Choose an exposure value that complements your earlier correction. (If you adjusted for highlights earlier, adjust now for shadows.)

Next, you'll need to blend the layers together. I'll show you a couple ways to do this in the following section.

TIP As an alternative to the methods described here, try Dr. Brown's Place-A-Matic script (Figure 7-44). This free, downloadable script automatically places multiple versions of the same images directly from Adobe Bridge into a single Photoshop document as Smart Objects, which can then be edited for exposure differences in Camera Raw. You can place 8-bit or 16-bit Smart Objects. The script is available on the Adobe site and at http://www.russellbrown.com/tips_tech.html.

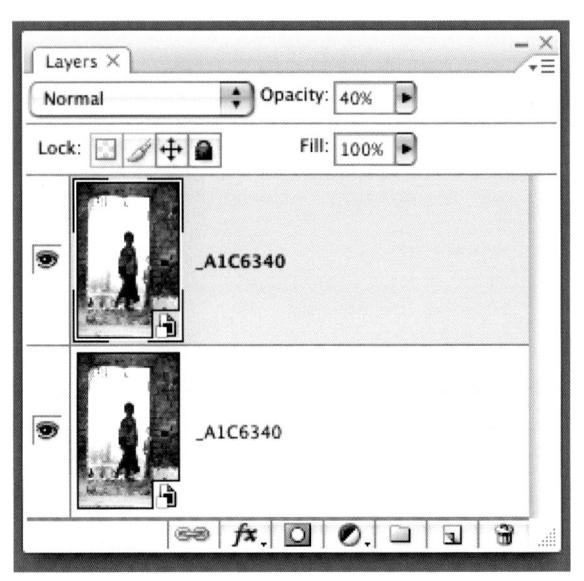

Figure 7-43

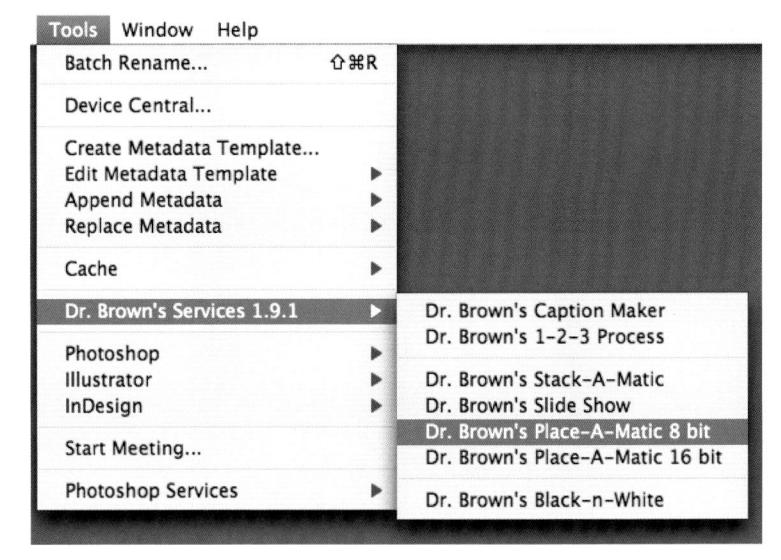

Figure 7-44

So far so good. Instead of trying to come up with a compromised exposure value, I was able to focus on specific areas of Michael's image and adjust the exposure without regard to other areas. Now comes the tricky part, blending the different versions into one.

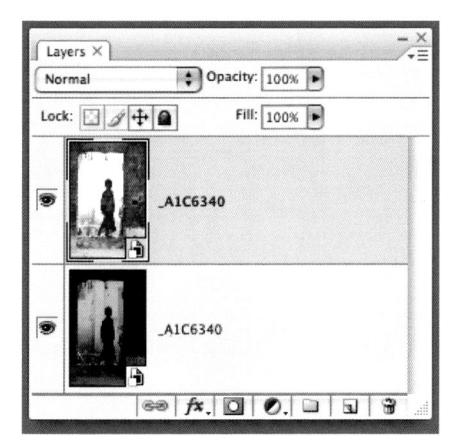

Figure 7-45

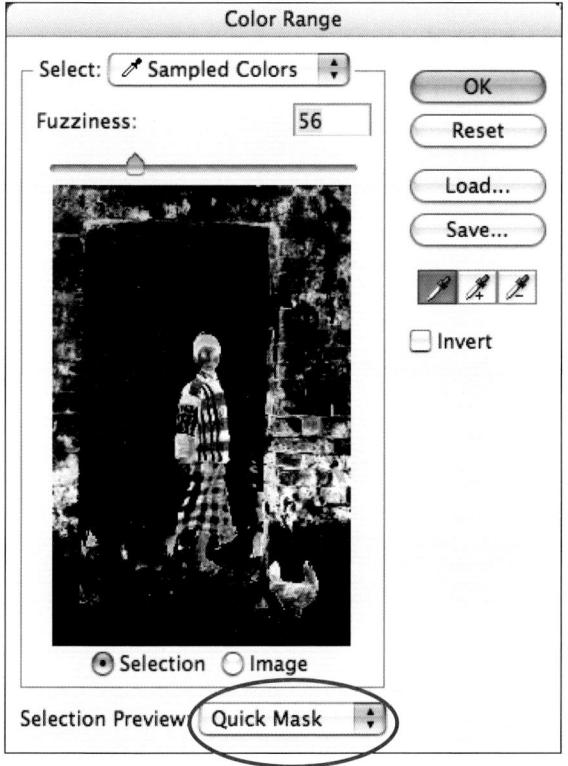

Figure 7-46

Part Two: Blending Two or More Copies in Photoshop

There are actually several ways to do this. I'll show you two variations, one based on using a layer mask, the other on using Layer Blending Options. (The layer mask technique is similar to the one I used at the end of the previous chapter.)

Blending with a Layer Mask

The goal is to leave the correct parts of one image and delete the others. To do this:

- 1. Select the layer you wish to mask, as I've done in Figure 7-45.
- 2. Use the Color Range selection tool to select the shadow areas your wish to keep intact. (Select→Color Range from the menu bar.) With some images, it's easier to select the highlight areas with the Color Range selection tool. Note how I chose Quick Mask (circled in Figure 7-46) as a Selection Preview in the Color Range dialog box. I find it makes it easier to see my selection, but experiment for yourself to see which option works best for you.

- 3. Turn your selection into a mask by clicking on the Create Layer Mask icon found at the bottom of the Layer palette (circled in Figure 7-47).
- 4. With the Layer Mask selected, use the Brush tool to add and subtract from the mask, revealing or hiding parts of the layer accordingly.

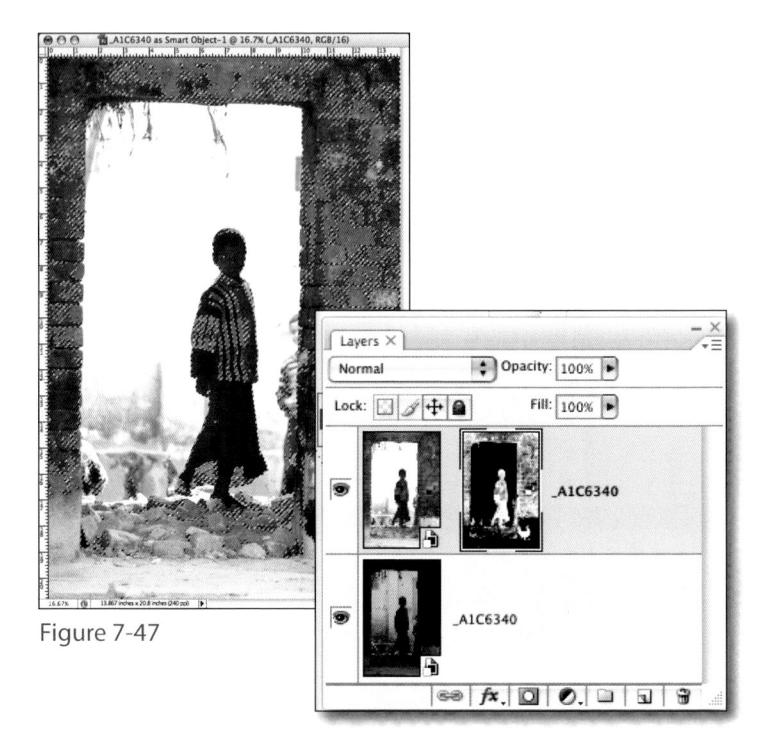

5. The final image is shown in Figure 7-48.

NOTE Using Masks is a subject unto itself. For more on this, I suggest you use the excellent Adobe Help tool found in the menu bar or check out Deke McClelland's Adobe Photoshop CS3 One-on-One (O'Reilly, 2007).

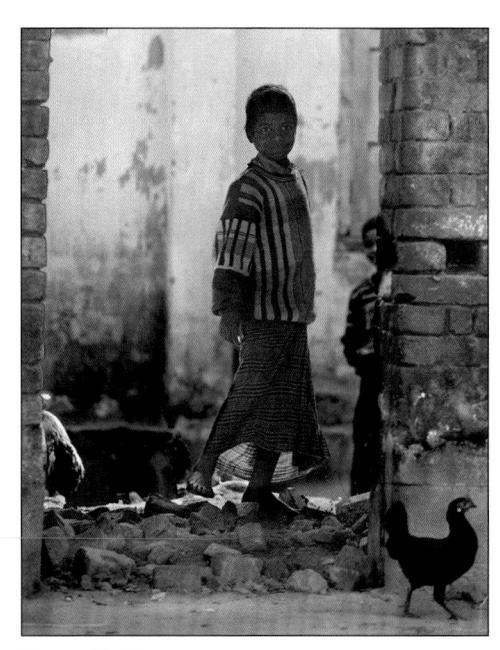

Figure 7-48

Figure 7-49

Figure 7-50

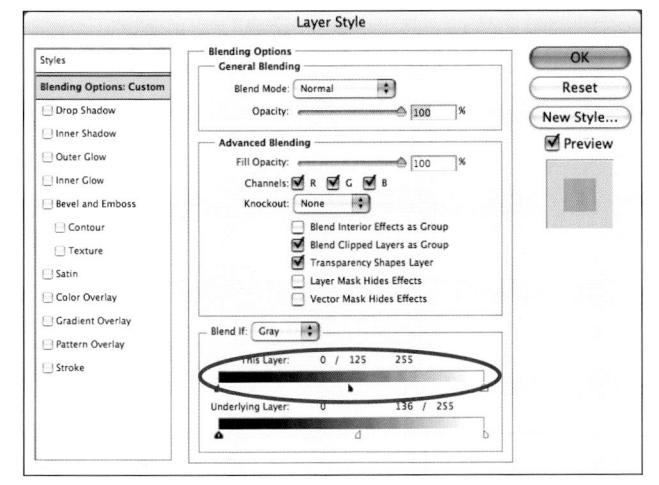

Figure 7-51

Using Photoshop's Blending Options

Using the Blending Options in Photoshop is fast and doesn't rely on masking techniques, but it doesn't work well on all images. (Case in point: it didn't work on Michael's image.) It can be used on Smart Object layers. To use it:

- After pasting or placing the duplicate layer, right-click on a layer thumbnail. Choose Blending Options (circled in Figure 7-49).
- 2. This brings up the Layer Style dialog box, shown in Figure 7-50.

3. Use the Blend If sliders at the bottom of the dialog box to control the relationship between layers. If you hold Option (Alt) while clicking anywhere on the This Layer slider (circled in Figure 7-51), it will automatically split the values. Try doing the same with the Underlying Layer slider. The result may be adequate. If not, tweak the sliders to get the blend just right.

Sharpening RAW

Almost every RAW file requires some degree of sharpening to counter the effect of blurring that occurs at some stage of image capture or image processing. This chapter will help you hone your sharpening skills—both with Camera Raw's new sharpening tools and Photoshop's Smart Sharpen filter—and teach you how to produce the best possible image.

Chapter Contents

RAW Sharpening 101

Sharpening with Adobe Camera Raw

Using Photoshop's Smart Sharpen

Sharpening High ISO Images with Reduce Noise

RAW Sharpening 101

The right amount of sharpening allows you to see all the detail in Figure 8-1.

However, in Figure 8-2, detail is actually lost from over-sharpening.

The goal of sharpening is to produce an image with crisp, clearly-defined edge detail, devoid of color fringing and extraneous noise. The challenge is to apply just the right amount of sharpening, without introducing distracting noise or artifacts to other areas.

Figure 8-3

Figure 8-4

When to Apply Sharpening

There is a lot of misunderstanding about when and how to apply sharpening. I find it useful to break sharpening down into three general categories, applied sequentially in the order listed here:

- Capture sharpening compensates for purposeful blurring at either the camera level or during raw conversion.
- Cosmetic sharpening is applied to a specific part of an image and not another, i.e., eyes, but not blemishes (Figure 8-3).
- Print or output sharpening is based on a specific size and the destination of an image.

Since this is a RAW-centric book, I'm going to emphasize capture sharpening, and just lightly touch the other two types of sharpening—which are huge subjects in and of themselves. (Applying correct output sharpening, for example, depends on a myriad of factors including the type of printer, ink, and media, not to mention image size.)

Capture sharpening is best understood by looking at an image with no sharpening applied. For example, look at the close-up in Figure 8-4 of the same image shown earlier. The photo was taken with a Fuji FinePix S3 Pro SLR using a high-end Nikon lens for optimal sharpness. It was shot at f/8 at 1/250th of a second and carefully focused. I used the Camera Raw sharpening slider to turn sharpening completely off, and the resulting image is not an accurate representation of the scene as I shot it. It also doesn't do the equipment I used justice. OK, so we agree this image requires sharpening, but what's the best way to do it?

Camera Raw, Smart Sharpen, or Other?

In the past, I recommended using Camera Raw sharpening (Figure 8-5) when speed was an issue, but now I highly recommend using the new and improved sharpen controls for most of your process sharpening needs. I say this knowing full well that you'll likely still need to use other sharpening methods to apply Cosmetic or Output sharpening at a later point.

I recommend using the Smart Sharpen feature in Photoshop (shown in Figure 8-6) when you have a problematic image to which Camera Raw sharpening doesn't do justice, or if you have the time and desire to perfect a particularly special image. The Smart Sharpen filter can also be used selectively for both Cosmetic and Output sharpening, and can be used on Smart Objects for non-destructive editing.

There are several other third-party sharpening options. My favorites include Nik Sharpener Pro, PhotoKit Sharpener, and FocalBlade. These products all streamline workflow by offering various sharpening presets appropriate to different stages of sharpening.

I can't end this discussion without bringing up Photoshop's Unsharp Mask filter (Figure 8-7), which has been part of Photoshop since Version 1. Some of you may have finally mastered this filter and find comfort in using the familiar. But I highly recommend trying some of the other options described above. Unsharp Mask relies on fairly old technology, now largely replaced by spaceage edge-detection methodology.

Figure 8-5

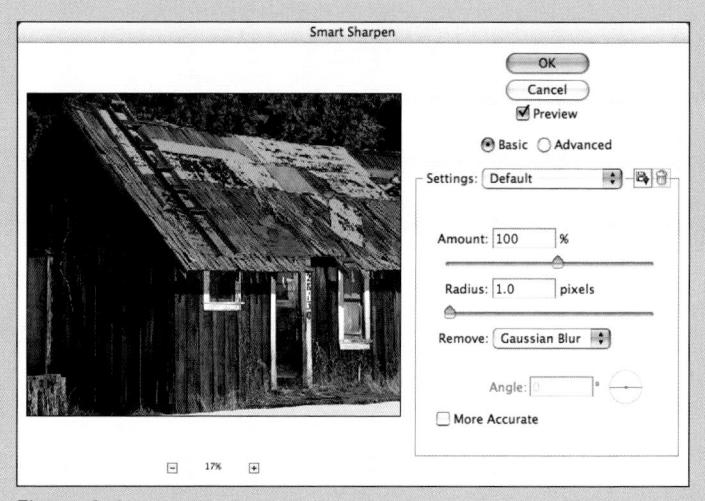

Figure 8-6

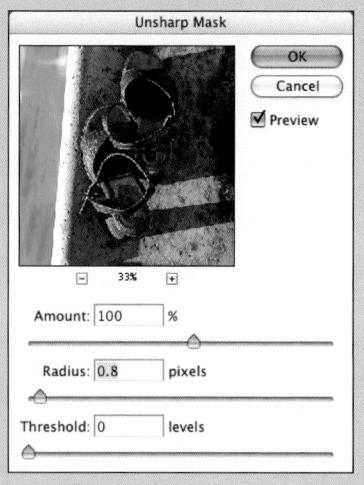

Figure 8-7

Camera Raw's four sharpening sliders, which are found in the Detail tab, offer sophisticated control. With just a basic understanding of what each slider does, you'll be able to produce images with crisp, clearly-defined edge detail without introducing distracting noise or artifacts to other areas of your image.

Sharpening with Adobe Camera Raw

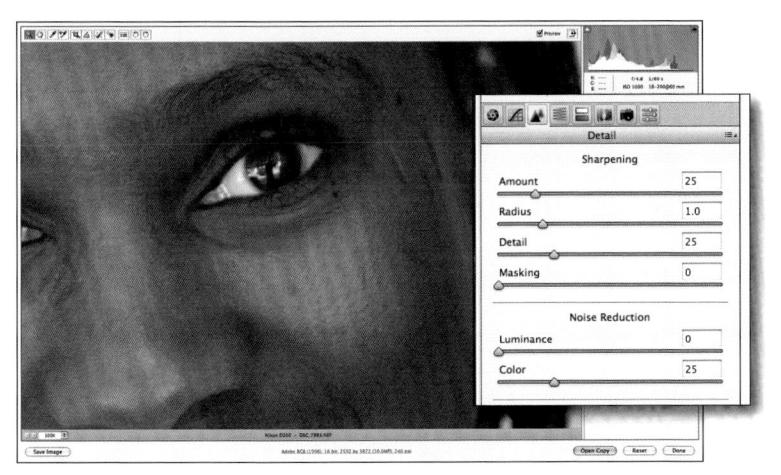

Figure 8-8

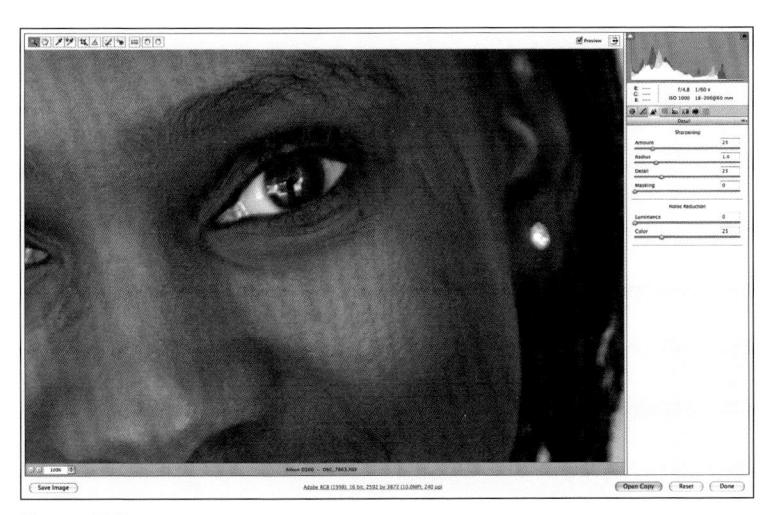

Figure 8-9

Camera Raw has significantly ramped up its sharpening control from previous versions. As you can see in Figure 8-8, instead of one slider, there are now four. For many, this added control will be welcome. For others, it may seem daunting. For those of you who don't want to spend a lot of time sharpening your images, I want to reassure you, Camera Raw's default settings are pretty darn good, especially if you are working with RAW files.

Sharpening Sliders

Fundamentally, image sharpening is really just an exaggeration of contrast along edges—places where light and dark pixels meet (Figure 8-9).

Camera Raw's Amount slider controls the intensity of the edge contrast; the Radius slider controls how wide the edge is; the Details slider determines exactly what is an edge; and the Masking slider gives you more control over where the effects of the first three sliders occur. Let me show you what I mean.

Amount Slider

The Amount slider controls the amount of contrast along the edges of an image on a scale from 0 to 150. In Figure 8-10, I bumped the Amount to 150 and kept the other default Sharpening settings. In Figure 8-11, I set the Amount slider to 0 and you can see the difference.

For RAW files, the default Amount setting is 25, a relative number based on the characteristics of your digital camera. (See the sidebar later in this chapter, "What's with the Number 25?") For other files, such as JPEGs and TIFFs, the Amount is set to 0, which means no extra sharpening is applied until you move the slider. Holding the Option (Alt) key while you slide the Exposure slider makes it easier to see the sharpening effect.

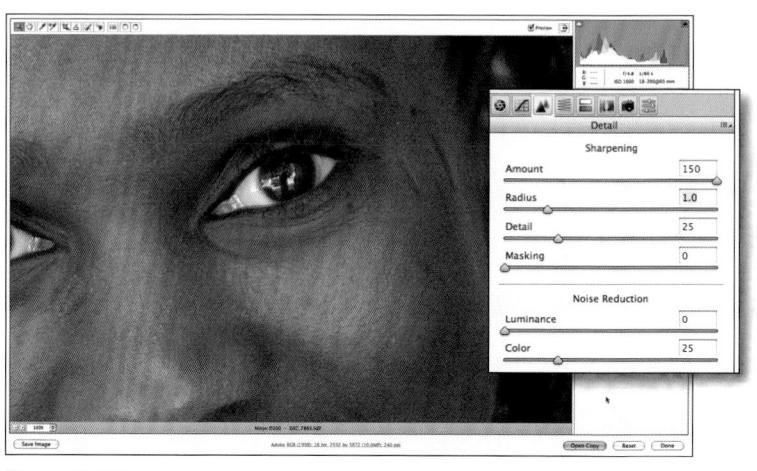

Figure 8-10

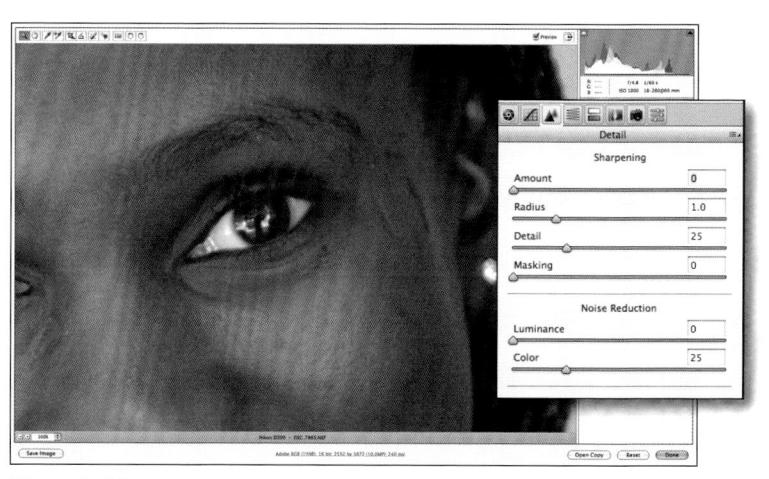

Figure 8-11

Radius Slider

The Radius slider controls how wide the edge is using values from .5 to 3.0. The greater the radius value, the larger the edge and the more obvious the sharpening. If you go too far with the Radius setting, you'll get an unpleasant halo effect. Again, the best way for me to illustrate this is by example. In Figure 8-12, I've boosted the Radius to 3 (maximum) and the Amount to 150 (maximum) and you can see that I clearly went way too far.

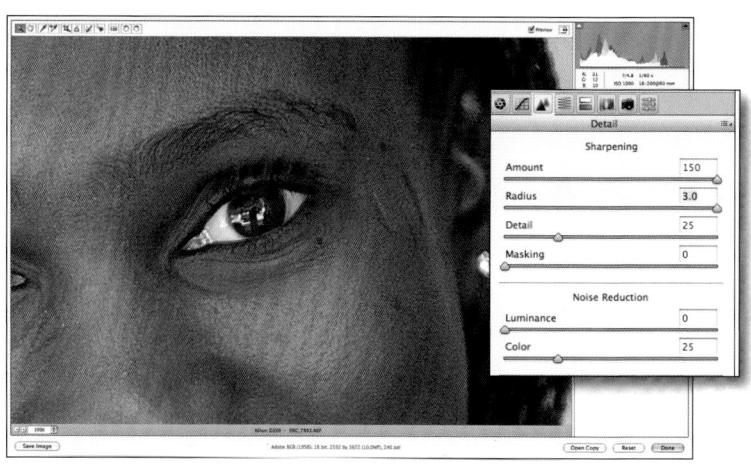

Figure 8-12

Figure 8-13

Figure 8-14

Figure 8-15

An even better way to show what this slider does is to hold the Alt (Option) key and then click on the slider. Figure 8-13 shows a Radius setting of .5 (minimum). You can see a faint outline, and few pixels are affected.

Figure 8-14 shows a Radius setting of 3 (maximum), and you can clearly see the pixels outlined that will be affected when I move the Amount slider.

For all types of image files, the default Radius setting is 1.0, and this is a good starting point. With JPEG, TIFF, and other non-RAW files, you'll have to move the Amount slider before you notice any sharpening.

Detail

The Detail slider works in a similar fashion to the Radius slider, but instead of working on a wide range of pixel values, it works on very fine detail. A setting of 100 (maximum) defines everything as an "edge" and increases contrast between all pixels equally. Lower values decrease the range and therefore the effect.

Again, looking at the extreme setting is helpful. Figure 8-15 shows an image with a Detail slider setting of 100. Holding the Option (Alt) key while moving this slider clearly outlines what areas are affected at this setting, as you can see in Figure 8-16.

Masking Slider

The Masking slider does just that: creates a mask that controls where sharpening is applied. This control is especially useful when you are working with portraits or other images that contain large areas of continuous tones that you want to remain smooth and unaffected by increases in contrast.

Again, let's see how it works by example. In Figure 8-17 (top), I set the Amount, Radius, and Detail sliders to their maximum. In other words, I've totally over-sharpened the image.

Next I'll move the Masking slider to its maximum. In Figure 8-17 (bottom), you can see how the sharpening (or contrast enhancement) is not apparent in the skin tones.

Holding the Option (Alt) key while clicking on the Masking slider reveals the actual mask. You can see in Figure 8-18, the black areas are those that are masked, or blocked.

Figure 8-16

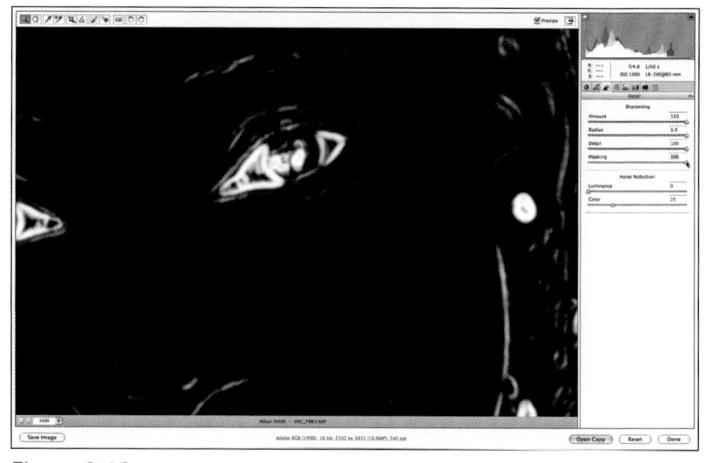

Figure 8-18

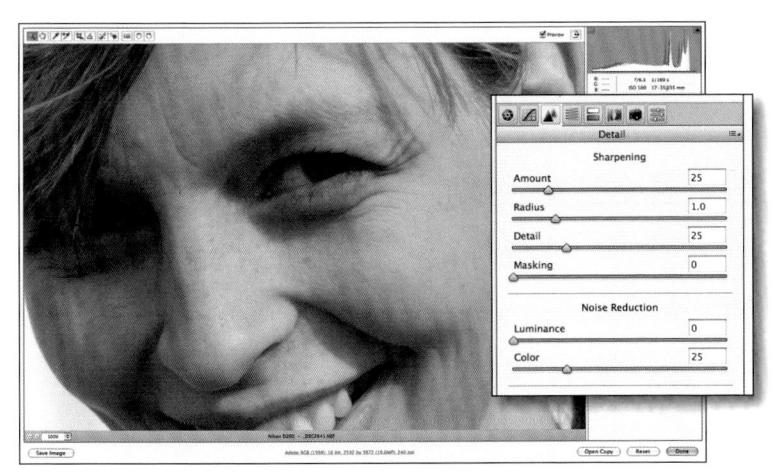

Figure 8-19

Zoom preview to 100% or larger to see the effects of the controls in this panel.

Figure 8-20

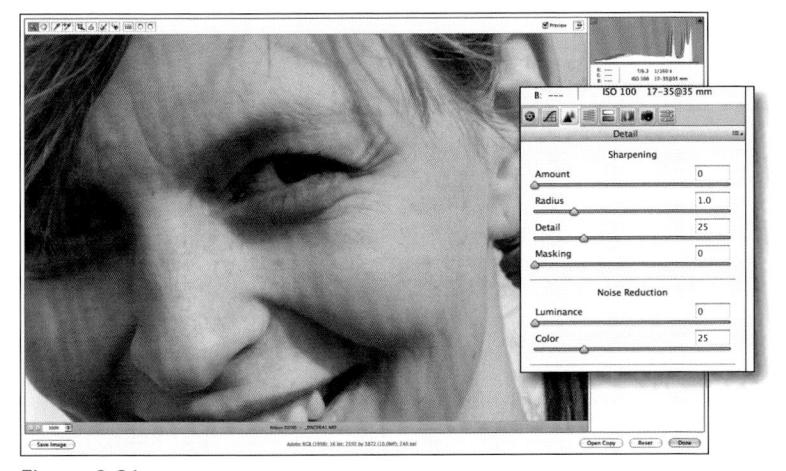

Figure 8-21

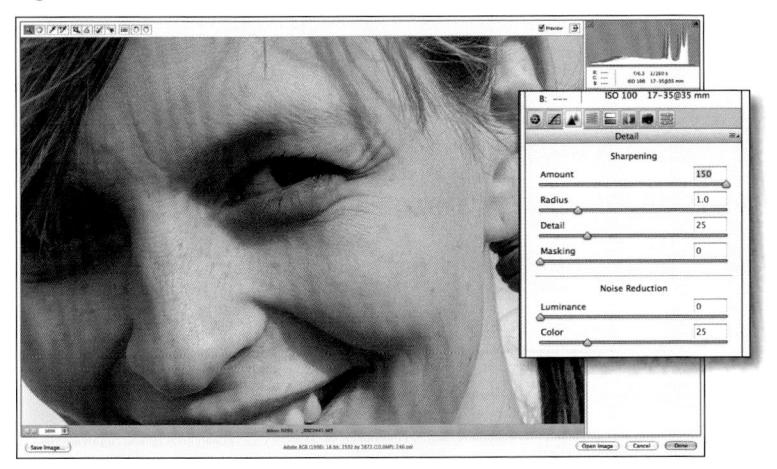

Figure 8-22

Sharpening Strategy

Just about every image will benefit from some sharpening. The default settings may be a good place to start, but if you are willing to take the time, you can certainly do better. Knowing that every image demands different settings, here is a general strategy to follow:

- Make your color and tonal adjustments first. (These are detailed in earlier chapters.)
- Select the Detail tab (enlarged in Figure 8-19).
- 3. If your image isn't enlarged at least 1:1 (100%), a warning message (shown in Figure 8-20) tells you to zoom the preview to 100% or higher to see the effects of the sharpening controls. Now pick an area that contains both detail and continuous tone (like an eye, hair, or tree branch against blue sky).
- 4. If you are working on a RAW file, the sharpening Amount setting is always 25 by default. I find it useful to start by sliding the slider to 0 and then examining the image to establish a baseline for my next adjustments (Figure 8-21). Keep this in mind: The effect of a 0 sharpening setting will vary from camera to camera. With some digital cameras, the effect is barely noticeable. With others, it'll appear extremely noticeable.
- 5. Next, move the Amount slider to 150, which is way off most of the time, as in Figure 8-22. Again, I go to the extreme to visually establish a range.

- 6. Through trial and error and going to extremes, I came up with reasonable Radius and Detail settings. I look for a balance between sharpness of the edges, with no noticeable noise added to the continuous tone areas. You can mitigate noise in the continuous tone areas with the Masking slider. Hold the Alt (Option) key when using the Radius, Detail, and Masking sliders. You'll get a better idea of what parts of the image are being affected. Figure 8-23 shows my final settings and Figure 8-24 shows the mask created with the masking slider.
- 7. The amount of sharpening you need depends on the final output. If you are sharpening for a screen, sharpen until it looks right. If you are sharpening to print later from Photoshop, you'll likely want to over-sharpen in order to compensate for paper/ink absorption. (Print-specific sharpening is a whole topic unto itself. There are so many variables to consider, including printer characteristics, print size, ink, paper, viewing distance, etc.)
- Finally, don't worry about getting it perfect (whatever that may be).
 Camera Raw uses a completely nondestructive process and you can go back at any time and start over.

It's useful to toggle between the default Sharpen settings and the new settings and compare. Camera Raw doesn't provide a before and after view, but you can select Camera Raw Defaults (or Image Settings) from the Settings menu, and then select Custom Settings from the Settings pop-up menu to view the changes. Figure 8-25

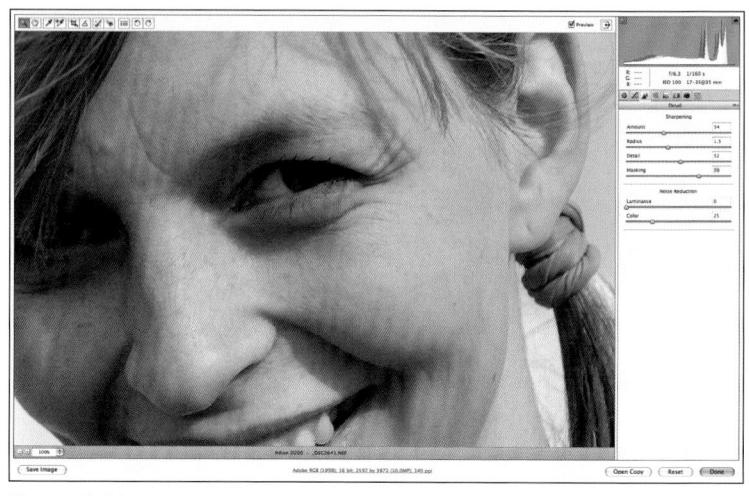

Figure 8-23

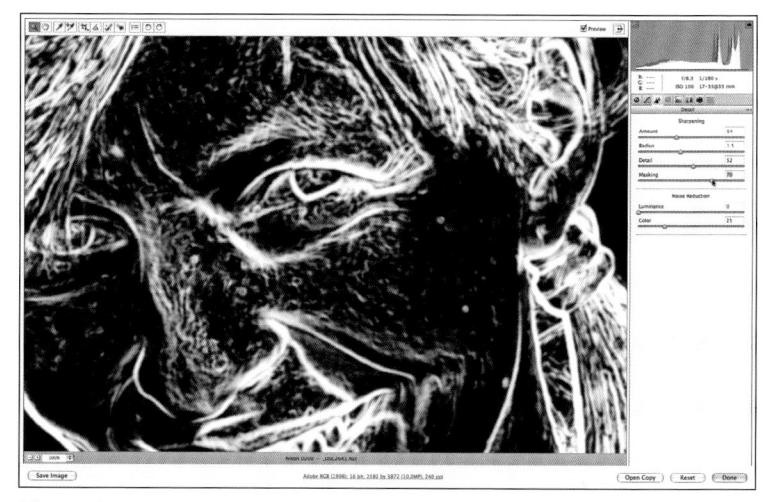

Figure 8-24

Figure 8-25

Figure 8-26

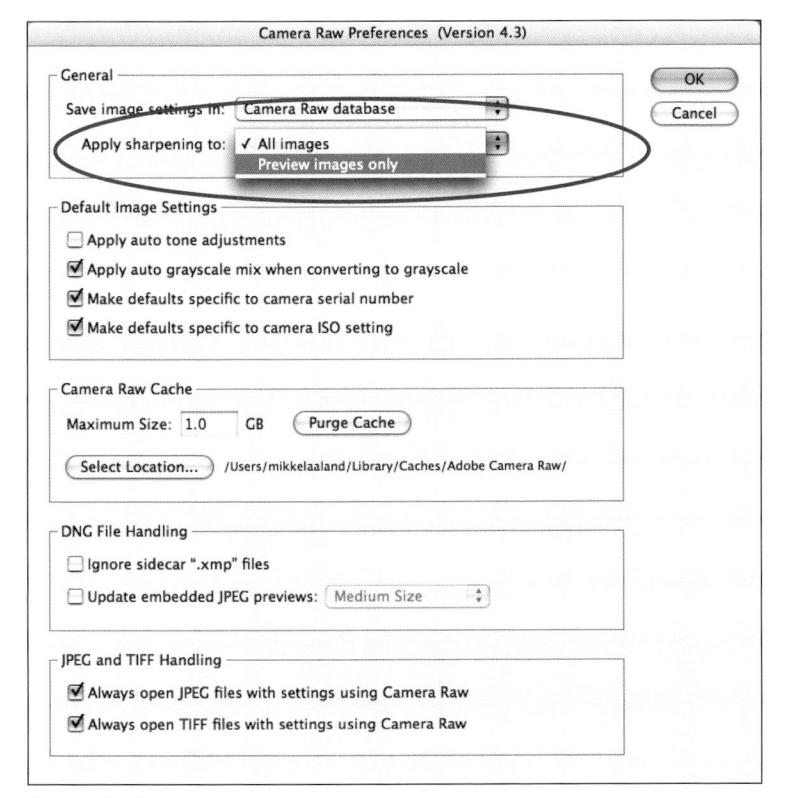

Figure 8-27

TIP Remember, when Preview (in the upper-right corner of the Camera Raw window) is deselected, you see a representation of your image that's determined by the Camera Raw settings that were applied when the file was first opened and before you changed anything. This means that if Sharpening is set to 25 at Camera Raw startup, when Preview is deselected, you are actually viewing your image with some sharpening applied.

Apply Sharpening to Preview Images Only

You can set Camera Raw to apply sharpening to the preview images only. However, when you open the image in Photoshop, the image will open with no sharpening applied. This allows you to see the effects of sharpening on your other Camera Raw adjustments.

To do this:

- Select Preferences from the toolbar (circled in Figure 8-26) or from Camera Raw Preferences in Bridge.
- Then select Apply sharpening to Preview images only (circled in Figure 8-27) from the Preferences dialog box.

What's With the Number 25?

When you open an unadjusted RAW file in Adobe Camera Raw, you'll notice the sharpening is set to 25 (Figure 8-28), regardless of which digital camera you use. Why this number, and what does it mean? You need to know how Camera Raw works. Every RAW file is subject to a demosaicking algorithm that includes purposeful blurring. This blurring helps prevent color fringing by slightly blending adjacent pixels. Every digital camera model requires a different amount of blurring. The exact amount depends on many factors, including the size and characteristics of the camera sensor. Smaller sensors with many pixels typically produce a lot of "noise" and require more blurring during the RAW conversion in order to prevent the halo effect.

Camera Raw uses information specific to a particular camera model to process a RAW file and determine how much blurring to apply. Since it knows how much blurring has been applied, it also knows how much sharpening is needed to compensate for that blurring. The number 25 represents the optimal sharpening strength for a particular camera. For example, 25 for a RAW file produced with the Sony 828, which uses a relatively small sensor, will represent more sharpening than, say, a 25 for a RAW file produced by Nikon D200 with its larger sensor (Figure 8-29).

Figure 8-28

Figure 8-29

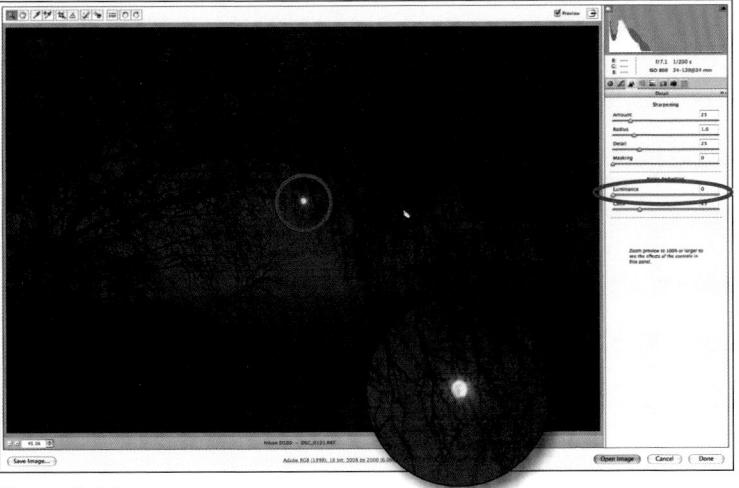

Figure 8-30

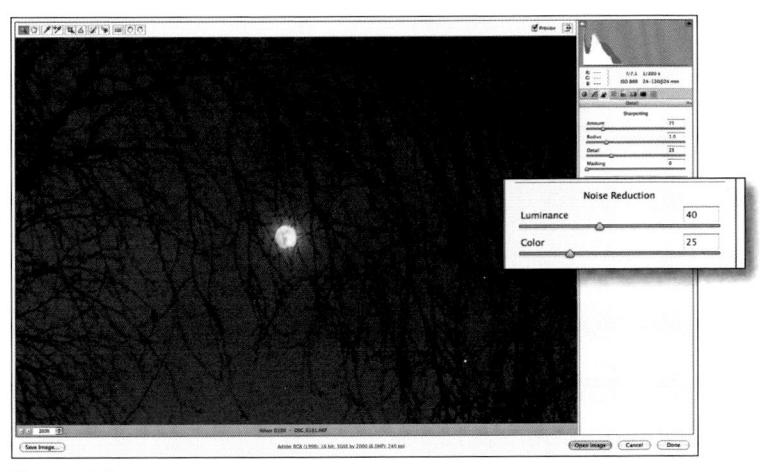

Figure 8-31

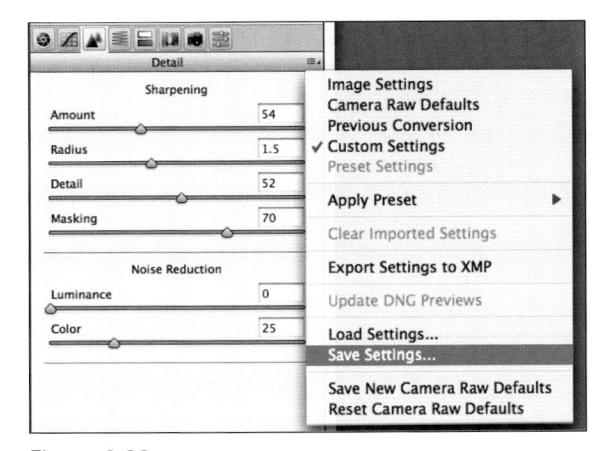

Figure 8-32

Fixing the Effects of Over-Sharpening

For some images, such as the moonscape shown in Figure 8-30, you can use Camera Raw's Luminance controls to diminish artifacts caused by over-sharpening, or, as in this case, a combination of sharpening and a high ISO of 800.

To do this:

- 1. Enlarge your image using magnification controls.
- 2. Select the Detail tab.
- 3. Find the optimal sharpening using the Sharpness sliders.
- 4. Increase the Luminance slider slowly, observing the effects. Stop when you achieve a balance between edge sharpness and diminished noise or artifacts in the continuous tone areas. In the example in Figure 8-31, a setting of 40 helped.

NOTE If you find Camera Raw's
Noise Reduction controls don't take
you far enough, or if your image
requires selective noise reduction,
open Photoshop and use its more
powerful, and feature-laden,
Reduce Noise filter instead. The
Reduce Noise filter can be used
non-destructively on Smart Objects.

Save Your Detail Tab Settings

To specifically save Sharpness, Luminance, and Color noise reduction settings:

1. Select Save Settings from the pop-up menu, as shown in Figure 8-32.

- In the Save Settings dialog window, shown in Figure 8-33, select Details from the Subset pop-up menu. (Or deselect all the settings except those you want to save.)
- Select Save. Name your setting and make sure it is saved in the default Settings folder. Otherwise, it won't show up in the Settings pop-up menu or in Bridge's Develop Settings menu.

Figure 8-33

"No Sharpen" Isn't Always Equal

I opened a NEF RAW file in Nikon Capture Editor and turned sharpening off by deselecting Unsharp Mask. Then I converted the NEF RAW file to a TIFF file and opened it in Photoshop. You can see the results in Figure 8-34.

Next, I took that same NEF RAW file and opened it in Camera Raw. I turned off sharpening and opened the image in Photoshop (Figure 8-35). When you compare the two images, you'll see that the one processed using the Nikon software is sharper than the one processed with Camera Raw, even though both had sharpening turned off in the RAW conversion. Why? Different applications process the same RAW data differently. In this case, I suspect that the Nikon software didn't apply as much softening to compensate for antialiasing, therefore resulting in a sharper image, even though sharpening was turned off.

Figure 8-34

Figure 8-35

It's called Smart Sharpen and it uses state-of-the-art edge detection algorithms and a sophisticated deconvolving method to remove blur. In plain language, deconvolving means reversing. It attempts to identify the root cause of the blur and "reverses" the effect. It also takes smarts to use Smart Sharpen properly.

Smart Sharpen OK Cancel Preview Basic Advanced Settings: Default Amount: 100 % Radius: 0.8 pixels Remove: Caussian Blur \$ Angle More Accurate

Figure 8-36

Figure 8-37

Using Photoshop's Smart Sharpen

Fast Sharpening or Quality Aharpening?

Smart Sharpen has two speeds: relatively fast, and slow. When you deselect More Accurate, circled in Figure 8-36, you are basically crippling some of Smart Sharpen's most compelling technology, but it really speeds things up. From a technical point of view, the results are on par with what you'd get if you used the good old fashioned Unsharp Mask, especially if you choose Gaussian blur as your Remove option.

With Advanced settings selected, you also gain control over highlight and shadow sharpening, which is something you don't get with Unsharp mask. It's your choice, but since I'm advocating Smart Sharpen for those special images—the ones that deserve a lot of your time and attention—I recommend using Smart Sharpen in More Accurate mode (Figure 8-37).

Even if you decide not to use More Accurate, all the following information on using the filter applies. Just keep in mind that the required Amount percentage values will need to be slightly higher if you turn More Accurate off.

OK, now let's throttle this baby to full power and see how to use it.

NOTE If you are working with multiple layers, be sure to make the layer you want active before selecting the Smart Sharpen filter.

Gaussian Blur or Lens Blur?

Several things cause image blur. It can be caused by a Gaussian blur applied during the assembly of the RAW data. Camera Raw and other RAW processing applications do this to some degree for every RAW file. It can also be caused by poor camera optics, or simply by poor focus, as in Figure 8-38. It can be caused by tiny micro-lenses placed over digital camera sensors to minimize aliasing and color fringing. It might be caused by a subject or camera moving while the image is captured, as shown in Figure 8-39. The more you know about the source of image blurring, the better your chances of effectively undoing or removing the blur. This is where the different choices in Smart Sharpen come in. Unfortunately, image blurs are often caused by a combination of factors, so fixing them is not always that simple. You may find that, for some of your RAW images, the Gaussian blur option (with More Accurate selected) is the way to go. (Gaussian blur also processes much faster than Lens blur.) Other images may benefit from the Lens blur option. You just have to experiment to get it right. Remember, once you have found the optimal choice, save your settings for future images that are taken under similar conditions with the same camera.

Figure 8-38

Figure 8-39
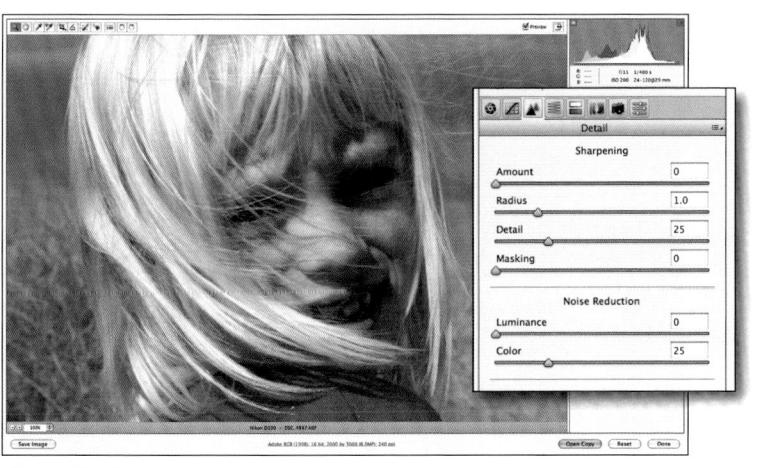

Figure 8-40

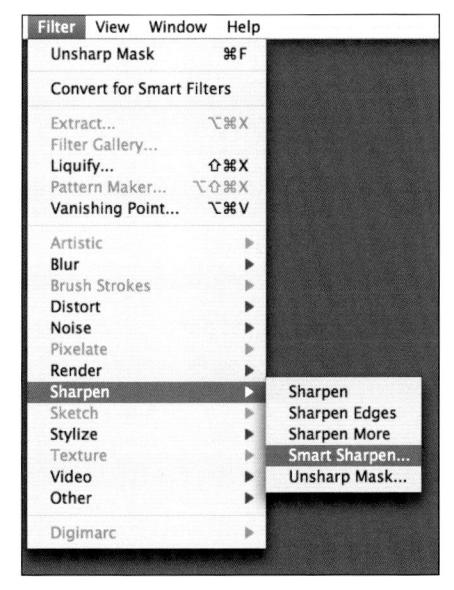

Figure 8-41

Figure 8-42

Selecting Proper Smart Sharpen Settings

Let's walk through how to use the filter:

- Use Camera Raw to process your RAW data. Be sure to turn off all sharpening by sliding the Camera Raw Amount slider to 0 (enlarged in Figure 8-40). Leave the Camera Raw Noise Reduction settings at Camera Raw defaults. For best results, keep your Depth set to 16 Bits/Channel.
- Click Open Image. (If you want to continue working non-destructively, go to Camera Raw's Workflow Options dialog box by clicking on the link at the bottom of the Camera Raw window. Select Open In Photoshop as Smart Objects. Select OK. Now Open Image becomes Open Object. Select it, and your image opens in Photoshop as a Smart Object. When you work with the Smart Sharpen filter, all your work is completely editable.
- 3. Select the Smart Sharpen filter (Filter→ Sharpen→Smart Sharpen) from the Photoshop menu bar (Figure 8-41). With the filter open, select More Accurate for optimal quality. When you select More Accurate, the intelligence of Smart Sharpen is ramped up. As the engineers who wrote the software code explained to me, "you go from the capabilities of a third grader to those of a college grad."
- 4. Next to Remove, choose between
 Gaussian Blur and Lens Blur (Figure
 8-42). (See the sidebar "Gaussian Blur
 or Lens Blur?") Motion Blur, which is
 another Remove option, should be used
 only when the blur is caused by camera
 or motion blur, and isn't relevant to our
 discussion. Enlarge your image using

the + and - controls at the bottom of the preview window (circled in Figure 8-43). Use your cursor—which turns into a Hand icon when placed over the preview window—to navigate to an area of your image that contains both edge detail and continuous tones.

5. Make your adjustments according to the characteristics and resolution of your image. Images with fine detail and average resolution generally take a Radius of approximately 0.9-2.0. Change the Radius value by sliding the slider or typing directly in the box. Higher-resolution images require higher Radius values. Your changes are reflected in the image preview window. You can compare the new values with the original unsharpened image by placing your mouse over the preview window and clicking and holding. As soon as you release the mouse, the preview changes to reflect the current settings.

NOTE Mac users: Don't forget to wait until the flashing bar at the bottom of the preview window (circled in Figure 8-44) disappears before deciding on the correct settings. (Window users should not experience a preview lag.)

6. Fine-tune the effect of the Radius settings with the Amount slider, circled in Figure 8-45. Start at 100% and gradually increase the strength by moving the slider to the right (or by typing in a higher value). It's useful to go too far, to a point where noise appears in the continuous tone areas, and then back off.

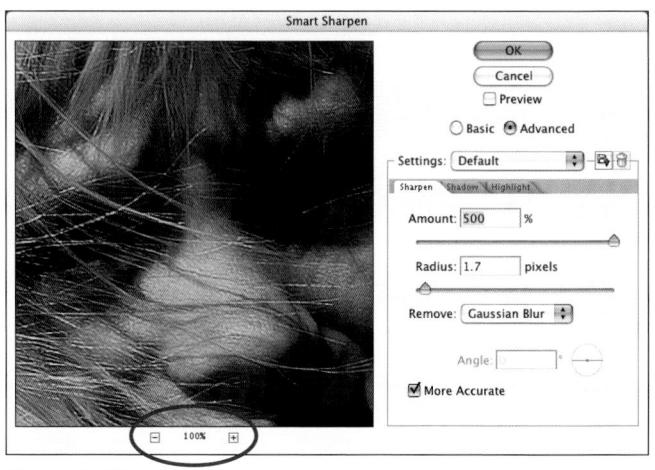

Figure 8-43

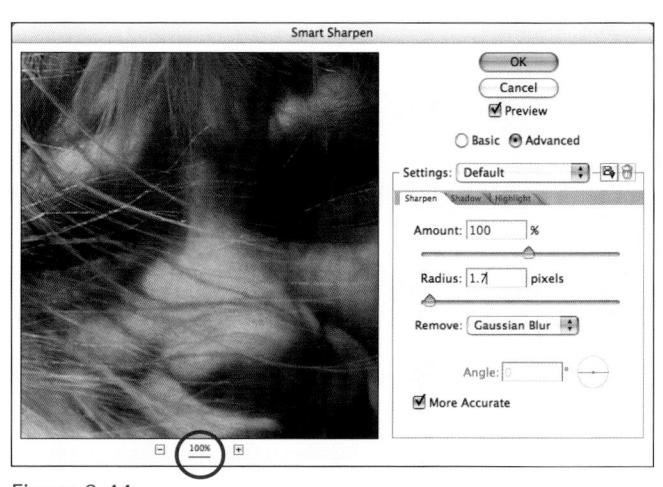

Figure 8-44

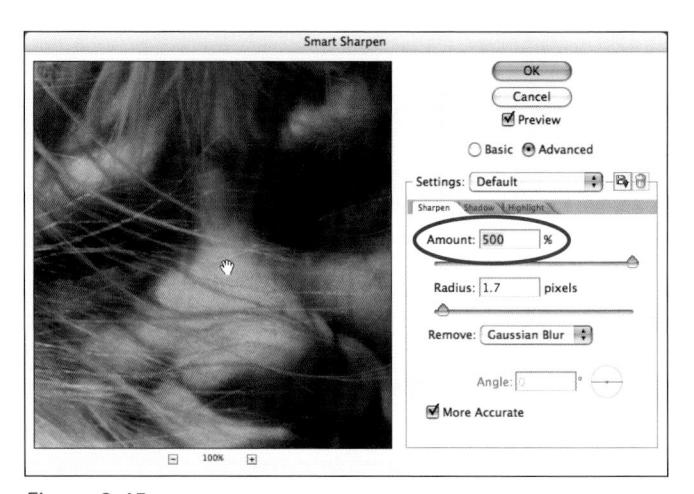

Figure 8-45

Figure 8-46

Figure 8-47

NOTE If you previously used the Smart Sharpen filter and increased the Highlight and Shadow Fade Amount from 0 to a higher value in the Advanced mode, beware! Values are sticky, meaning that whatever values you set last time will still apply the next time the filter is opened. If you increased the Fade Amount from 0 to a higher value, you may get unexpected results when you work in Sharpen mode. It's best to make sure the Fade Amount for both the Highlight and Shadow controls is set to 0—effectively turning these controls off—before working in Sharpen mode.

Advanced Smart Sharpen Settings

For the ultimate in control, select Advanced Settings, enlarged in Figure 8-46. When you do this, tabs containing the words Shadow and Highlight appear. With these controls, you can determine exactly how much sharpening is applied to areas of shadow and highlight. Commonly, these are areas that more readily exhibit sharpening artifacts.

The user controls for these Advanced Settings are a bit confusing, so bear with me as I walk you step-by-step through the process:

- 1. Start by using the Sharpen controls to get your edge details correct. You'll be working on removing the noise from shadows and highlight areas, so concentrate on edge detail and don't worry about the rest.
- 2. Select either the Shadow or Highlight tab, circled in Figure 8-47.
- Navigate to a part of your image that contains prominent shadows (or highlights, depending on which tab is selected).

- 4. Set the Fade Amount to 100%. As you can see in Figure 8-48, this lets you readily see the effects of the Radius and Tonal Width. You can always throttle the effects back later.
- 5. Pick a radius. This setting is determined by the nature of the shadow areas. Larger area details require a larger radius. Smaller details require a smaller radius. Throttle the Fade Amount back and forth from 0 to 100% to see the effects of different Radius settings (Figure 8-49).
- The Tonal Width controls the diffusion of the tonal width as set by the Radius.
 The higher percentages spread the tonal borders. Smaller percentages shrink the tonal borders.
- 7. If necessary, repeat the above steps, using Highlight controls.

Saving Smart Sharpen Settings

Once you come up with an optimal setting, you can save your settings and later apply them to similar images. To save a setting:

- Click the disk icon, located near the Settings pop-up window, and circled in Figure 8-50.
- In the resulting New Filter Settings dialog box, give your setting a descriptive name (Figure 8-51) and select OK. The next time you go to the Setting pop-up menu, your setting will appear.
- Save as many settings as you wish. To remove a setting, select it and click the trash icon. (It's next to the disk icon.)
- Share settings with others by making an Action, or sharing your entire Preset folder.

Figure 8-48

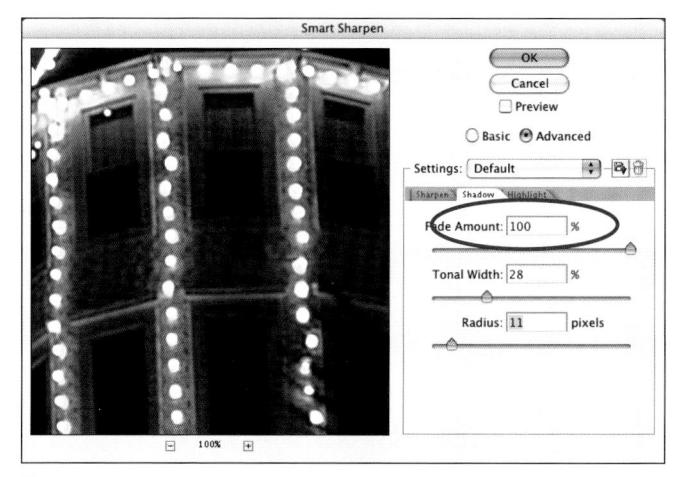

Figure 8-49

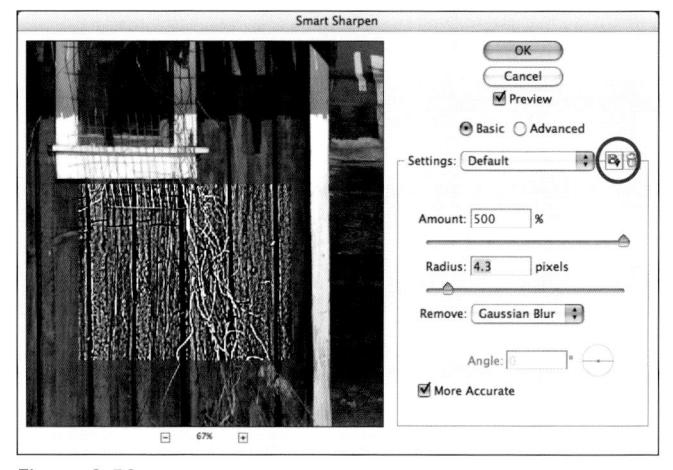

Figure 8-50

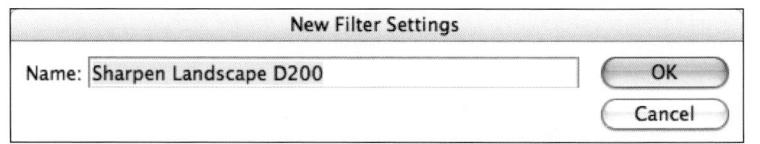

Figure 8-51

RAW images shot at a high ISO are problematic. Not only do they often need sharpening, but they also contain a lot of noise that is invariably boosted in the sharpening process.

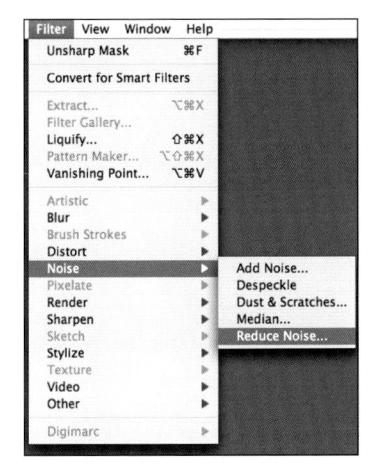

Figure 8-52

Figure 8-53

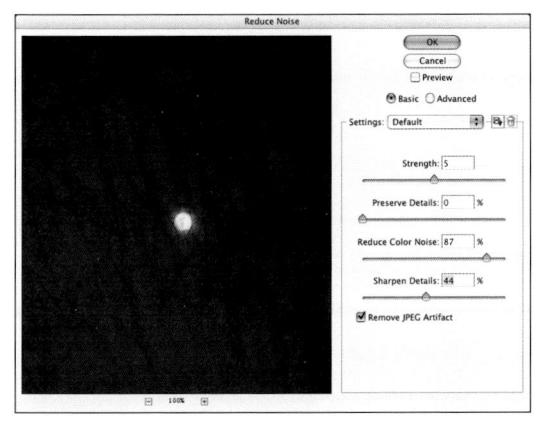

Figure 8-54

Sharpening High ISO Images with Reduce Noise

Reduce Noise is another filter in Photoshop that effectively sharpens images and removes noise from images shot with a high ISO (Figure 8-52). Like Smart Sharpen, it uses space-age inspired math to do the job. And, like Smart Sharpen, the intense math results in slow performance. Photoshop's Reduce Noise filter can also be used non-destructively on Smart Objects.

I go into great detail on using this filter in Chapter 9, but as you can see in the following before (Figure 8-53) and after (Figure 8-54) images, it is quite effective in sharpening as well as noise removal.

Although TIFF or PSD files converted from RAW don't usually contain JPEG artifacts, there are times when selecting this option helps. This is because some RAW data is actually compressed using a lossy, JPEG-like compression. With some digital cameras, this is a user option, but other times the compression is simply performed without the user's knowledge.

Reducing Noise, Correcting Chromatic Aberrations, and Controlling Vignetting

With varying degrees, all digital cameras produce images with electronic noise, chromatic aberrations, and vignetting. Electronic noise shows up as extraneous pixels sprinkled throughout an image. Chromatic aberrations appear in transitional tonal areas as colored halos, color banding, or purple fringing (especially around backlit edges). Vignetting—darkening around image edges—occurs with a filter-lenssensor mismatch. In this chapter, I'll cover how you can reduce the effects of these imperfections in your RAW files using either Adobe Camera Raw or Photoshop.

Chapter Contents

About Noise

Using Camera Raw to Reduce Noise

Using Photoshop's Reduce Noise Filter

About Chromatic Aberrations

Diminishing or Adding Vignetting

About Noise

Electronic noise is inherent to all RAW images, but its cause varies. It is more apparent in some images, and barely noticeable in others. Higher ISO values will enhance this effect, as will underexposure or long exposure. Process over-sharpening will also enhance electronic noise.

The noise in the detail of Figure 9-1 (enlarged to 400%) is a result of shooting at a high ISO setting. Mark Richards captured this rare shot of the inside of San Quentin for *People* magazine by boosting the sensitivity of his digital camera to 1600 ISO. He got the exposure settings he wanted, but obviously at a price in image quality.

On the other hand, the noise in the detail of Figure 9-2 (enlarged to 200%), taken at night at a normal ISO, is due to a relatively long exposure (1/3 second) and it's mostly apparent in the dark sky.

Of course, noise isn't necessarily bad.
As Luis Delgado Qualtrough, a fine art photographer puts it, "noise gives an image dimension—and authenticity." Luis came across the old painting in Figure 9-3 hanging on the wall in a very dark room at an old hacienda in Mexico. Setting his digital camera to 1600 ISO, Luis managed to get the shot without a tripod. Luis chose to leave the noise in the image, to emphasize the impressionist style of the painting. The final shot hangs in a Danish museum.

In any case, it's relatively easy to remove or reduce the effect of electronic noise and—this is key—maintain image detail. You can either do this in Camera Raw, or after you open your file in Photoshop with the Reduce Noise filter, which gives you much more options and frankly, in my opinion, better results. Your choice of which to use will depend on what your want: speed and efficient workflow, or more control.

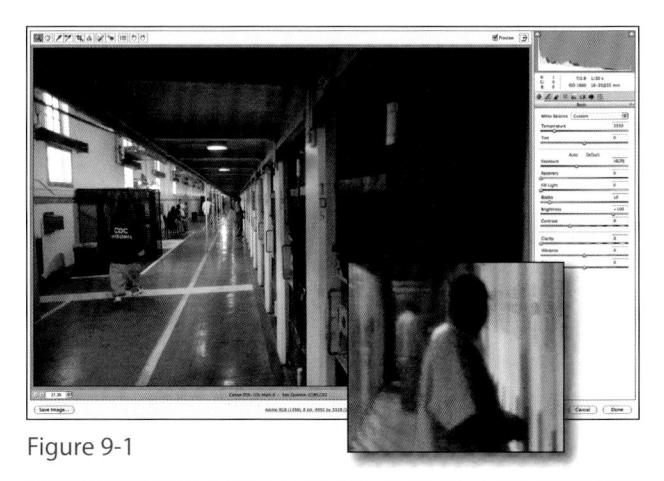

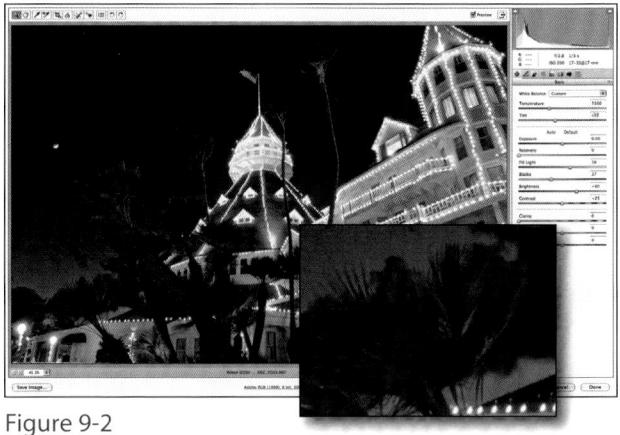

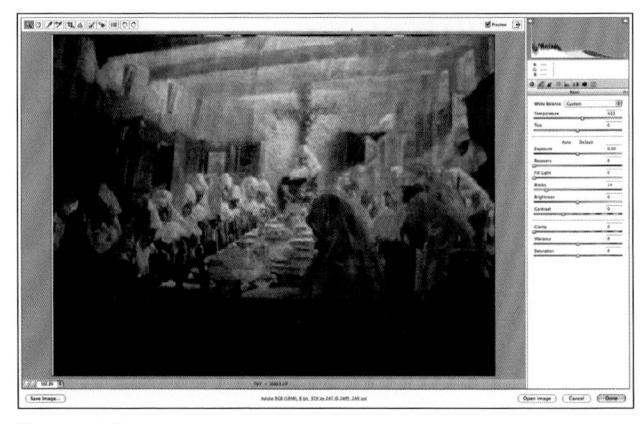

Figure 9-3

Adobe Camera Raw 4.2 and higher boasts stronger noise reduction controls than previous versions of Camera Raw. For many "noisy" images the more robust Camera Raw controls will be all you need. Later in the chapter, we'll get into using the even more powerful Photoshop Reduce Noise filter.

Figure 9-4

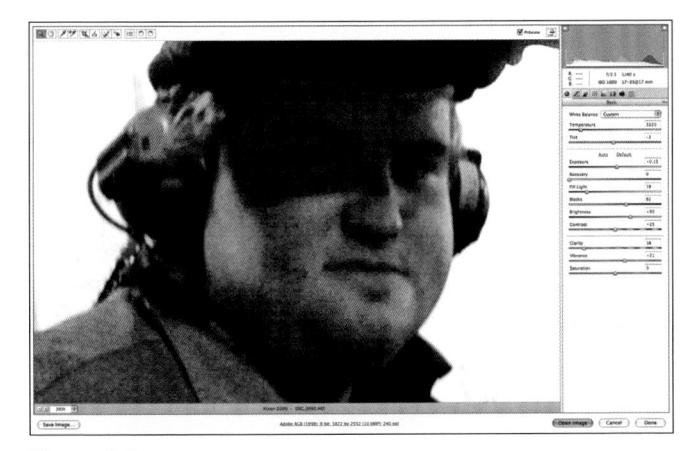

Figure 9-5

Figure 9-6

Using Camera Raw to Reduce Noise

Noise isn't always apparent when you examine an image at a low magnification, as you can see in Figure 9-4.

If you use Camera Raw's magnifying tools to enlarge your image after applying Camera Raw exposure and color controls (but before applying additional sharpening), the noise will become apparent, as you can see in Figure 9-5.

Pay particular attention to areas of continuous tone and shadow. Note the makeup of the noise. Does it look like a colored patchwork quilt? Or is the noise speckled and monochromatic? Some images actually contain a combination of chromatic (color) and luminance (monochromatic) noise. As you'll soon see, getting a handle on the type of noise will help determine which Camera Raw control—Luminance, Color, or both—will be more effective.

To begin the process:

 Select the Detail tab by clicking on the Detail icon (circled in Figure 9-6).
 If you are working with a RAW file, you'll notice right away the default Color setting is 25, while Luminance is set to 0 (circled in Figure 9-7). Unlike the Sharpness Amount setting, which is a relative value based on the type of camera you used, the Color setting is an absolute value. This value is applied generically, and while it may or may not be right for your camera or image, it's almost always a good starting point.

- 2. Enlarge your image preview to at least 100%, preferably higher. (A Zoom preview warning will appear below the Noise Reduction controls if you are below 100%.) Start by sliding the Color slider to the left, down to 0. Next, move the slider incrementally to the right, increasing the value, as shown in Figure 9-8. This affects the chromatic (color) noise and leaves details found in the Luminance (brightness) channel alone for the most part. If you go too far with the Color setting, you won't lose detail per se, but you'll compromise color accuracy. (For the long-exposure image shown here, a value of 50 is all it takes.) The chromatic noise is reduced without touching the Luminance slider.
- 3. If increasing the Color noise reduction value doesn't do the trick—as in the next example, Figure 9-9, using Mark Richard's San Quentin shot—set it to 0 and use Luminance.

Figure 9-7

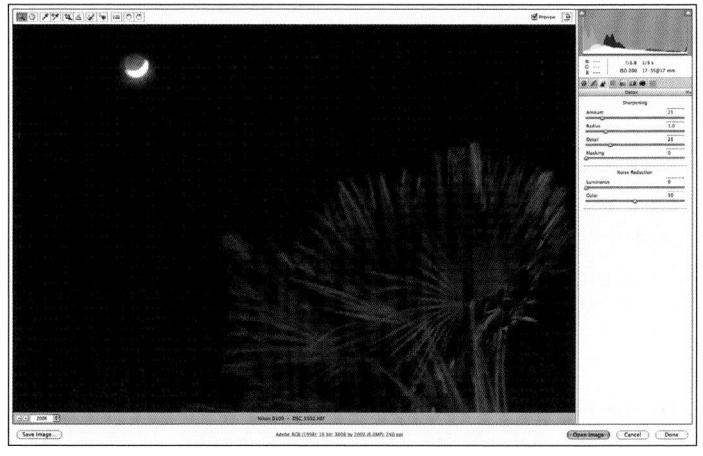

Figure 9-8

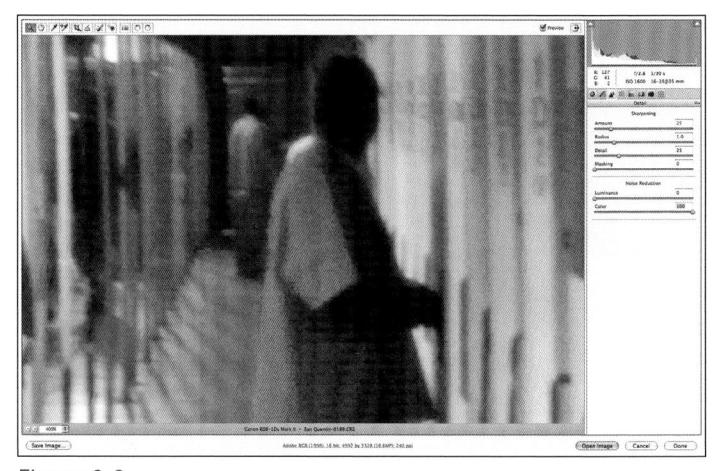

Figure 9-9

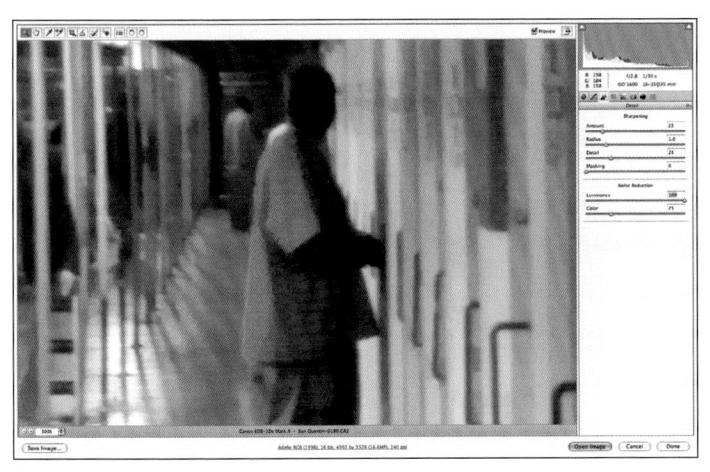

Figure 9-10

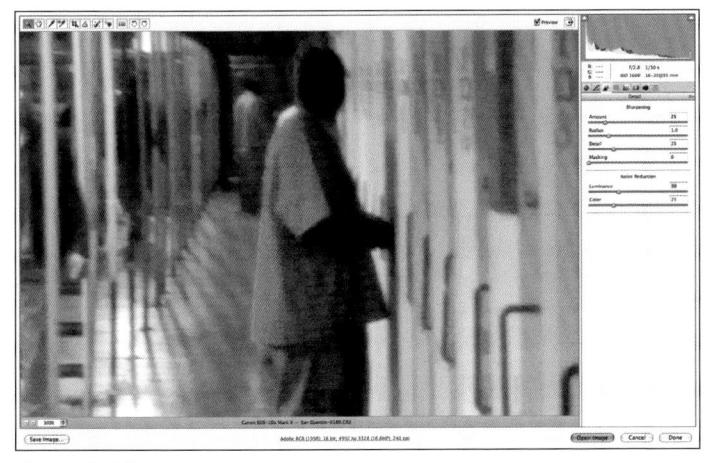

Figure 9-11

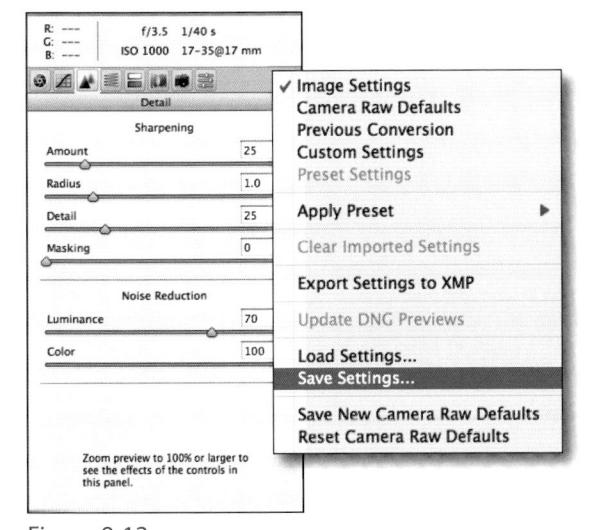

Figure 9-12

4. Go easy and increase the value incrementally. When working on the luminance channel, you can quickly compromise image detail. For the image in Figure 9-10, a Luminance value of 100 blurred it appreciably, as you can see.

5. Sometimes, a combination of Luminance and Color produces the best result. You'll have to experiment to get the correct combination, as the correct values vary from image to image. Remember, the trick is to reduce noise without losing too much image detail. For this image, a Luminance setting of 30 and a Color setting of 25 (Figure 9-11) worked best.

Saving Noise Reduction Settings in Camera Raw

Once you find an optimal setting for your camera, at a frequently used ISO, you can save specifically those settings and apply them to other similar images.

To do this:

1. Select Save Settings Subset from the pop-up menu, shown in Figure 9-12.

 In the Save Settings subset dialog window, select Details from the Subset pop-up menu, shown in Figure 9-13.
 Deselect Sharpening (or whichever settings you don't want to include) and the Details Subset becomes a Custom Subset.

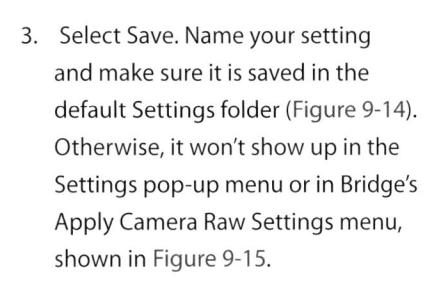

WARNING In Camera Raw, when you set your Noise Reduction settings to 0 in the Detail tab, don't be mislead. That 0 doesn't mean 0 noise reduction, just like 0 sharpening doesn't mean 0 sharpening (see Chapter 8). Behind the scenes, Camera Raw always applies some noise reduction. How much? Well, that depends on the version of Camera Raw. There have been many tweaks to the Noise Reduction "formula," and even though the 0 settings are very close between versions, there is a difference (which you may or may not notice).

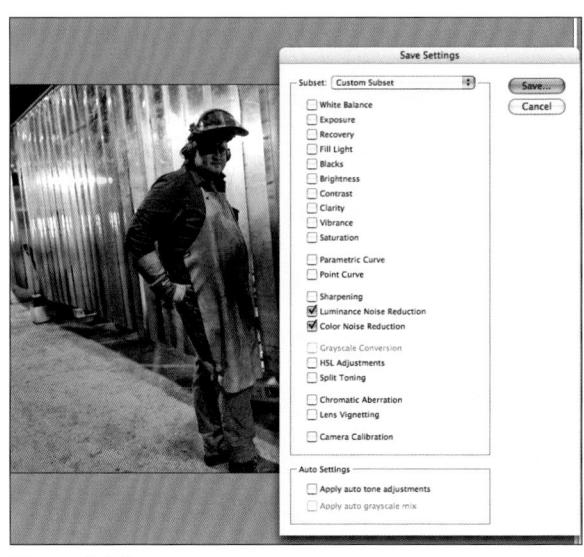

Figure 9-13

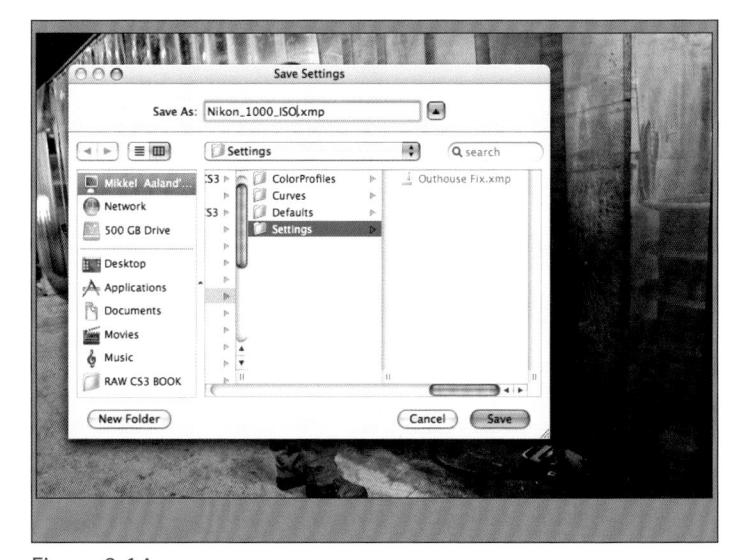

Figure 9-14

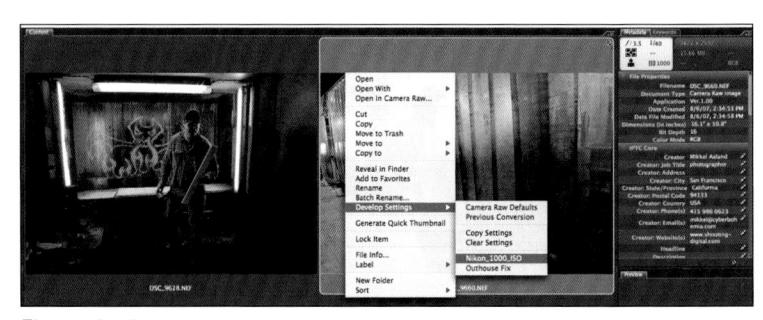

Figure 9-15

The Reduce Noise Filter is based on some fancy state-of-the-art software coding which produces better results than those you get from the Camera Raw controls. The downside to this "state-of-the-art" filter is that the user interface isn't very intuitive, and unless you are working on a very fast computer, the filter is slow.

Using Photoshop's Reduce Noise Filter

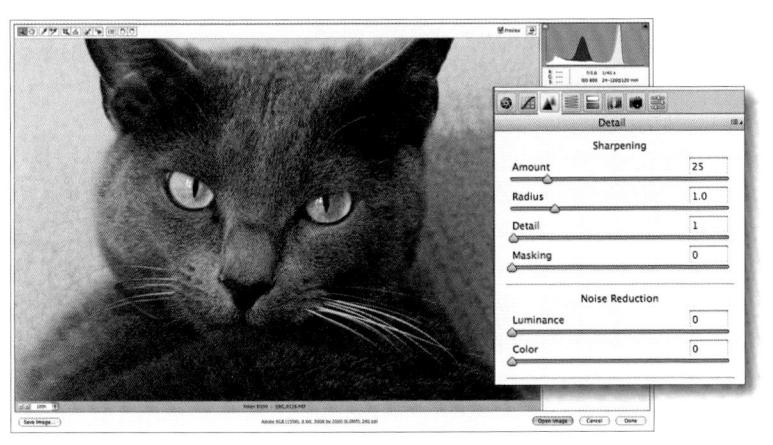

Figure 9-16

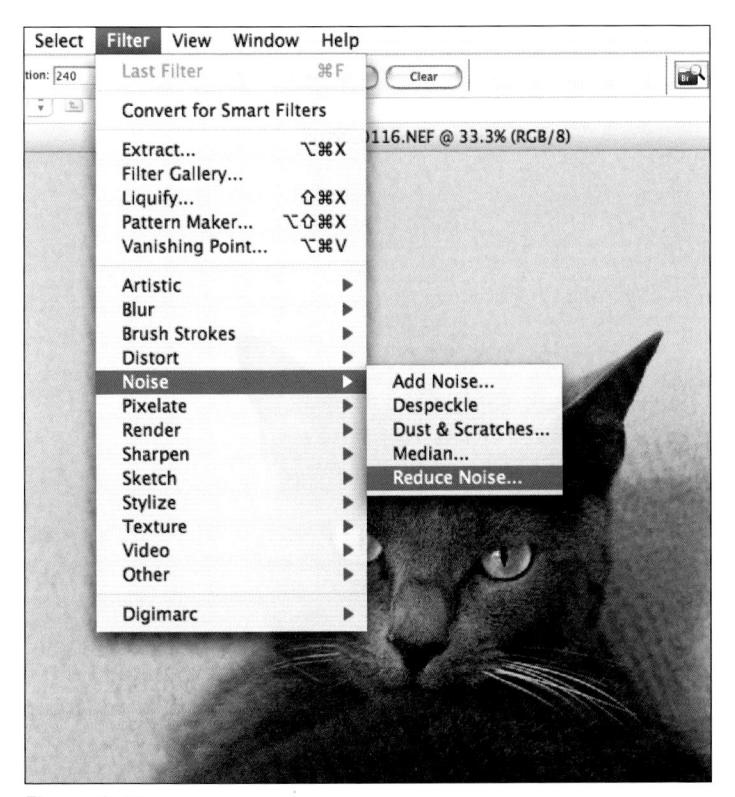

Figure 9-17

There are two modes to this filter: Basic and Advanced. I'll show you how to use both, although most users will find the Basic controls more than enough. Regardless of whether you use the Basic or Advanced settings, you'll need to run your RAW data through Camera Raw (Figure 9-16). Use Camera Raw to optimize your exposure and white balance settings, as explained in Chapter 6. I suggest you turn Color Noise Reduction to 0 and leave Luminance Smoothing at 0 as well. Generally, it's safe to leave your Sharpening settings at their default. The Reduce Noise filter works on 16-bit files, but performance is slowed.

Basic Settings for Photoshop's Reduce Noise Filter

Let's start with the basic settings:

- After preparing your RAW image in Camera Raw, select Open and bring it into Photoshop. If you want to work non-destructively in Photoshop, bring in the image as a Smart Object.
- Select Filter→Noise→Reduce Noise from Photoshop's main menu, shown in Figure 9-17.

3. Enlarge your preview to 100% or more. (Clicking on the percentage value at the bottom of the filter reverts it to 100%.) You can increase the efficiency of the filter by making a small selection before you open the Reduce Noise filter (Figure 9-18).

Determine your Reduce Noise filter settings, then select OK and close the filter. Undo the effect of your filter on your selection (#-Z or Ctrl-Z), then deselect your selection (#-D or Ctrl-D). Select Filter→Reduce Noise (#-F or Ctrl-F) from the menu bar. Your Reduce Noise settings will now apply to the entire image.

Figure 9-19 shows the default settings. These settings are a good place to start. (If you change these settings, the next time you open the filter, the new settings will replace the default ones.) If the default settings aren't satisfactory, I suggest taking the following steps.

4. Start by setting the Strength value to 0 (Figure 9-20). Slide the slider to the left, or enter the value in the box. This turns off luminance noise reduction, leaving you only with chromatic noise reduction. (Preserve Details, which is tied directly to the Strength value, will not be an option when Strength is set to 0.) Leave Sharpen Details set to 25% for now.

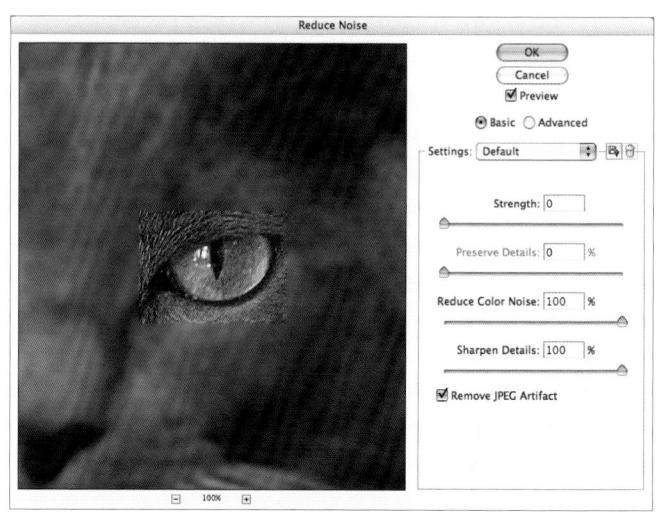

Figure 9-18

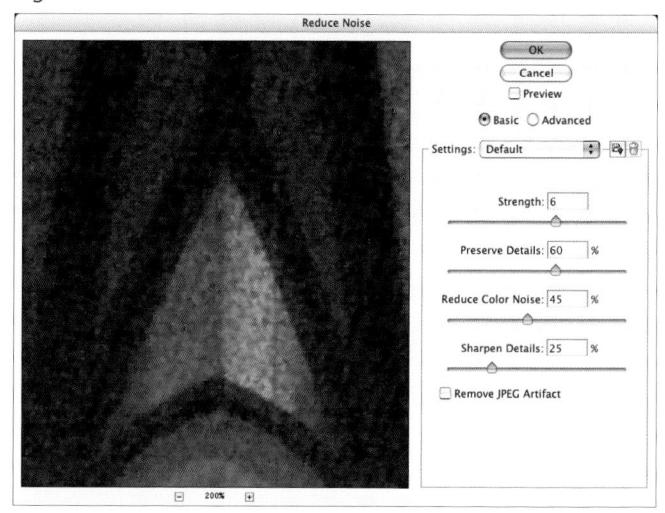

Figure 9-19

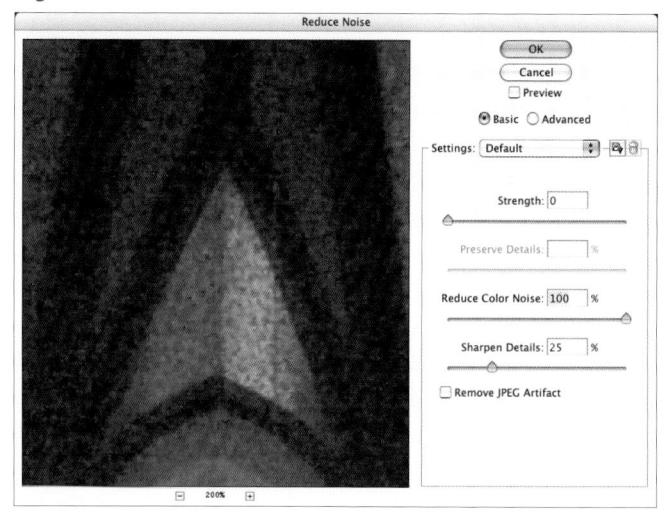

Figure 9-20

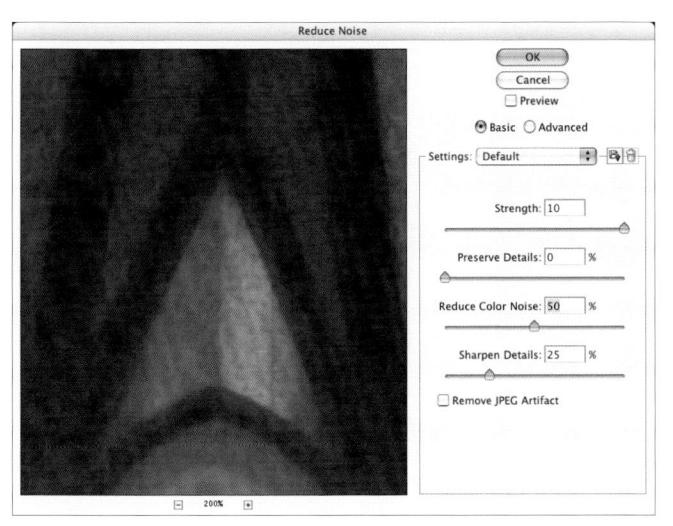

Figure 9-21

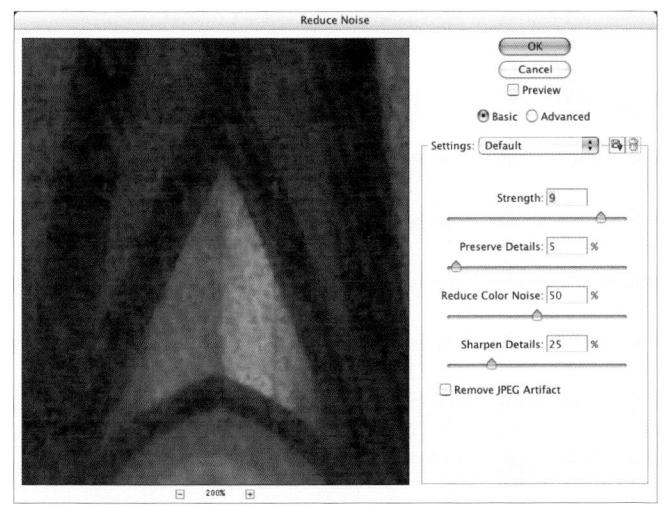

Figure 9-22

- 5. Experiment with different Reduce Color Noise values. Since this works only on the color channels, this should not affect details of your image, only its colors. With the example shown in Figure 9-21, nothing I did with Reduce Color Noise—even setting it to 100 percent—helped noticeably.
- 6. If Reduce Color Noise isn't enough, I suggest you set Strength, which works on the luminance (brightness) channel, to 10, its full value. Set Preserve Details to 0. The effect should be quite obvious, and image detail will surely suffer. (Mac users: withhold your judgment until the flashing bar below the percentage number stops signaling completion of processing. This can take some time, depending on the size of your image or your settings. It won't be an issue for most Window users.)
- 7. Now you have a choice: either dial the Strength value back or increase Preserve Details. These two settings are related. Preserve Details simply provides parameters for Strength to work within, telling it to ignore or preserve fine detail. After some experimentation, I came up with the proper combination of Strength and Preserve Detail to get what you see in Figure 9-22.
- 8. Try selecting Remove JPEG Artifact.
 Sometimes it helps, even when you are working with a RAW image that theoretically isn't compressed. RAW data can be saved with compression, and sometimes you just don't know whether it's been saved this way.

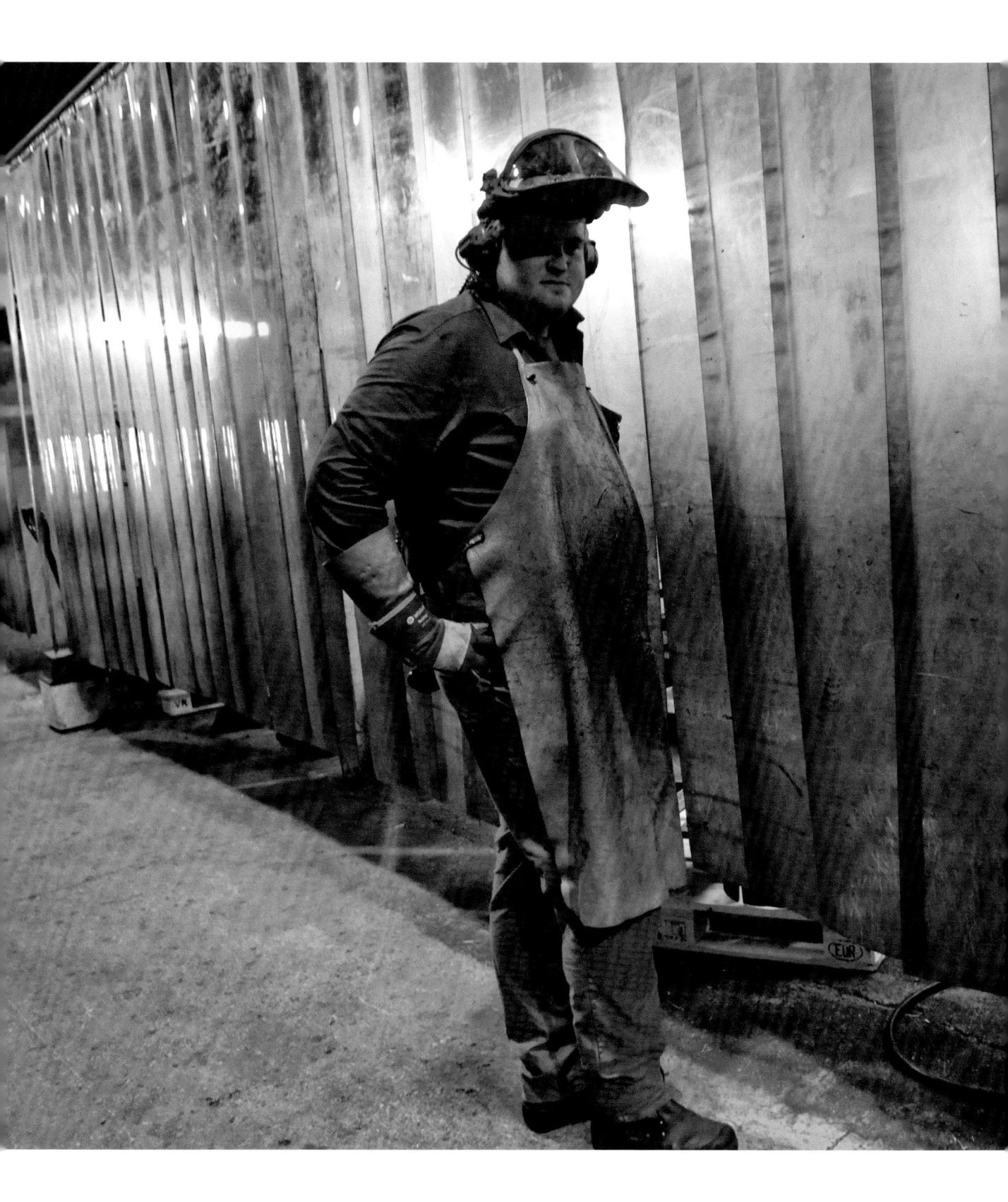

Working RAW

Actual files can be found at http://examples.oreilly.com/9780596510527/

The ability to boost sensor sensitively (ISO) on a frame-by-frame basis has fundamentally changed the way I shoot. In the past, I felt insecure unless I carried a huge arsenal of lighting equipment. Not now. Often I carry only a small on-camera strobe and a bounce reflector with me. Take this shot, for example. I was being escorted around the Ulefoss ironworks and my guide and I passed this wonderfully adorned painter in a dimly lit corridor. I wheeled around, set my ISO to 1000, captured the man's attention and easily got the shot before he continued on. Using the Reduce Noise controls, as described in this chapter, greatly diminished the high ISO-induced distractions.

Advanced Settings for Reduce Noise

When you select Advanced, a Per Channel tab appears, shown in Figure 9-23.

Using the Advanced Settings Per Channel option allows you to select individual channels based on the working color space and apply the Reduce Noise filter selectively. If you are working in RGB, for example, the red, green, and blue channels are available. If you are working in LAB, the Lightness, A, and B color channels are available (shown in Figure 9-24). Since electronic noise often appears in one channel more than another, this can be quite useful. For example, typically in the RGB color space, it's the blue channel that displays more noise, but not always. Using these settings, you can finetune your overall settings by boosting the noise reduction in a particular channel. You may find it useful to do all the adjusting in the individual channels. If you choose to do this, be sure to first adjust the Reduce Color Noise and Strength settings in the Overall menu to 0.

To use the Per Channel settings:

- 1. Select Advanced Settings.
- 2. Click on the Per Channel tab.
- Cycle through the red, green, and blue channels, observing the differences between them, as illustrated in Figure 9-25. You can magnify or reduce

Figure 9-23

Figure 9-24

Figure 9-25

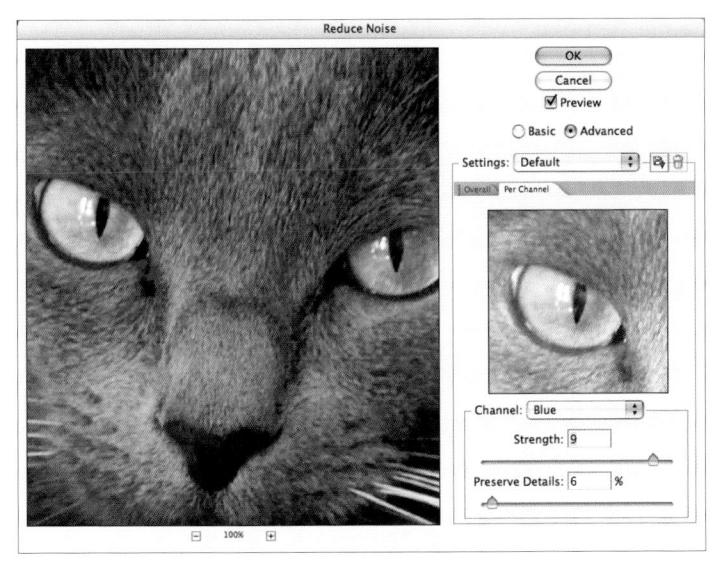

Figure 9-26

Figure 9-27

Flgure 9-28

the Color Channel grayscale display independently from the main color display window by holding your cursor over the grayscale display and Option-clicking (Alt-clicking) to reduce and #-clicking (Ctrl-clicking) to magnify. To reduce the display in both windows simultaneously, place your cursor over either display window, and use Option-Shift-click, (Alt-Shift-click); to magnify, use #-Shift-click (Ctrl-Shift-click). Hold the Shift key and drag to scroll both windows simultaneously.

- 4. Identify a channel that has noise, like the Blue channel in Figure 9-26.
- 5. Adjust the Strength slider until the noise is reduced satisfactorily.
- Adjust the Preserve Details slider accordingly.
- 7. To compare your changes with the original, place your cursor over either the color or the grayscale display, click, and hold. Both the color and grayscale displays will change. If this still doesn't remove all the noise, return to the Overall tab and make additional adjustments there.

Saving Noise Settings

When you find an optimal adjustment, you can save your settings to apply later to another similar image:

- 1. Select the Save icon (circled in Figure 9-27).
- 2. In the New Filter Settings dialog box (Figure 9-28), type in a descriptive name. The next time you open the filter, your new setting will appear in the Settings pop-up menu.

About Chromatic Aberrations

Figure 9-29 shows a shot taken by professional photographer Richard Morgenstein with a Canon 10D and a 14mm wide-angle lens. Although the chromatic aberrations are not visible at first glance, magnification will probably show some annoying anomalies in the edges of the chrome headlights.

Reducing Chromatic Aberrations with Camera Raw

To use Camera Raw to reduce chromatic aberrations in images such as this:

- Identify a likely area near the outer perimeter of a likely candidate. An example would be an image shot with a wide angle lens in bright lighting conditions with sharp edge detail.
- 2. Magnify the area using Camera Raw navigation tools. Select the Zoom tool and hold your cursor over the area you wish to magnify. Click and drag a rectangle around the area you wish to magnify, as enlarged in Figure 9-30, then release the mouse.
- 3. In the magnified image shown in Figure 9-31, you can clearly see the color fringing so typical of this type of chromatic aberration. (When light passes through glass, different color wavelengths are sometimes separated and shifted in focus ever so slightly. To visualize this, think of a common prism and the rainbow it produces. This shift

Chromatic aberrations show up as anomalous color shifts, mostly on the outer perimeter of images, in areas with distinct edge transitions. They are common when wide-angle lenses are used, but can appear with longer lenses as well. Both Camera Raw and Photoshop provide nearly identical ways to fix them.

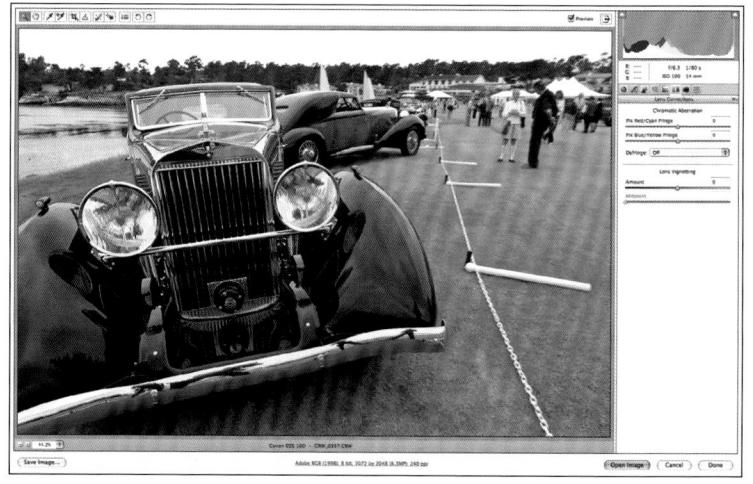

Figure 9-29

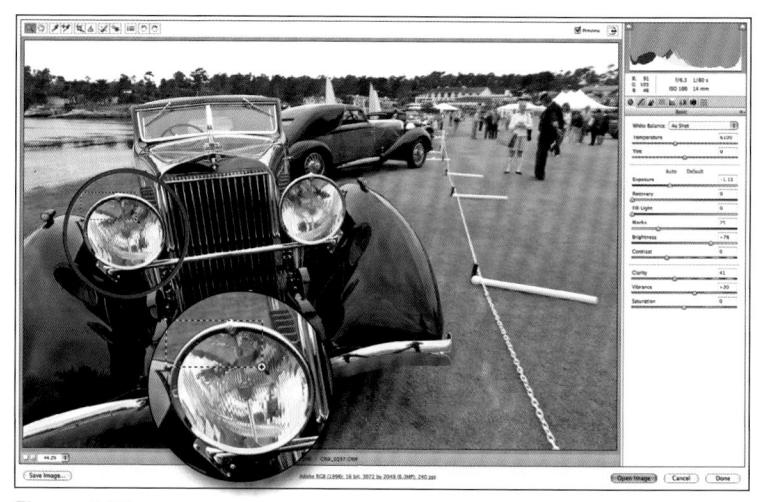

Figure 9-30

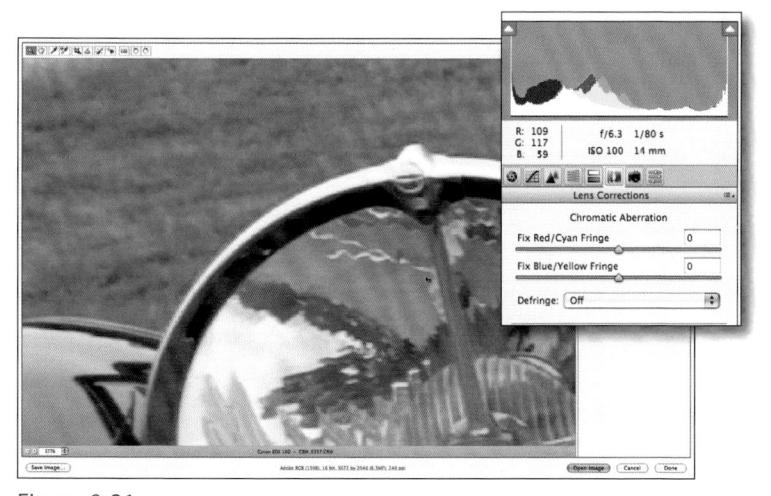

Figure 9-31

Figure 9-32

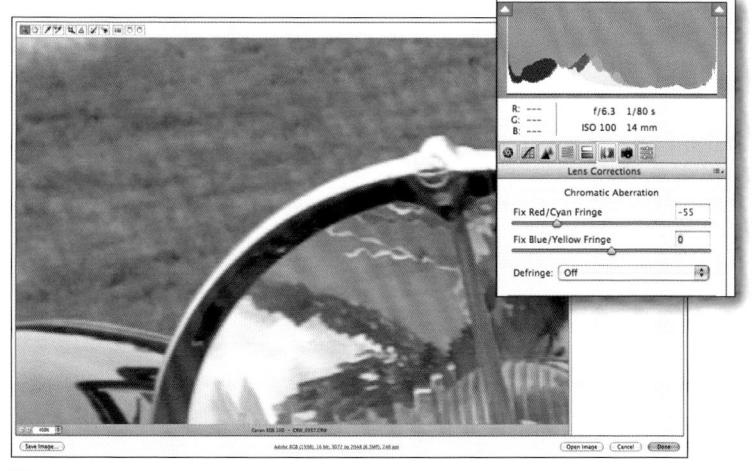

Figure 9-33

is recorded by the sensor and appears as a color fringe, such as the one shown in Figure 9-31.)

 Select the Lens Correction tab by clicking on its icon (circled in Figure 9-32). Under Chromatic Aberration, select the appropriate slider.

For this image, I chose Fix Red/Cyan Fringe and slid the slider to the left until I got what you see in Figure 9-33. Note I left the Defringe option set to Off. Highlight Edges or All Edges, the other Defringe options, slightly desaturate edges, which can help in some cases but may also result in thin gray lines.

It's very useful to understand how these controls actually work. When I first started using the Chromatic Aberration controls, I assumed they worked by simply looking for edges and removing or desaturating colors. But this isn't at all how they work, and I should have figured that out by simply watching the effect of moving the control sliders radically one way or another. Try that yourself on an image and you'll see what I mean.

You should notice a subtle distortion of your image, growing in intensity from the center of the image out to the edges.

In fact, the distortion is limited to select colors that are actually expanding or shrinking based on your settings (Figure 9-34). For example, if you chose Fix Red/Cyan Fringe, then either the red or cyan colors will be affected. If you chose Fix Blue/Yellow Fringe, only these colors will be affected. In the next section, I'll show more clearly what I'm talking about.

The key point here is that there are important practical implications. First, don't crop your image, apply Chromatic Aberration controls, and then expect good results. The color distortions are based on a lens model, and the minute you crop, you've changed that model. Second, don't expect this to work on other aberrations such as a dead pixel or a highlight blooming that appears in the dead center of an image. The effect is more powerful at the edges of your image, and diminishes as you move closer to the center. Finally, the results you get will vary depending on the lens you use.

Using Photoshop's Lens Correction Filter

Photoshop's Lens Correction filter offers an alternative environment to fix chromatic aberrations. To access the filter, select Filter Distort Lens Correction from the menu bar, as in Figure 9-35. The filter works non-destructively on Smart Objects.

There is little difference between the Chromatic Aberration controls in the Lens Correction filter and Camera Raw's controls. The Lens Correction filter, however, allows you to magnify your image to a larger percentage—1600 percent, compared to the 400 percent Camera Raw offers. It also does much more than just fix chromatic aberrations.

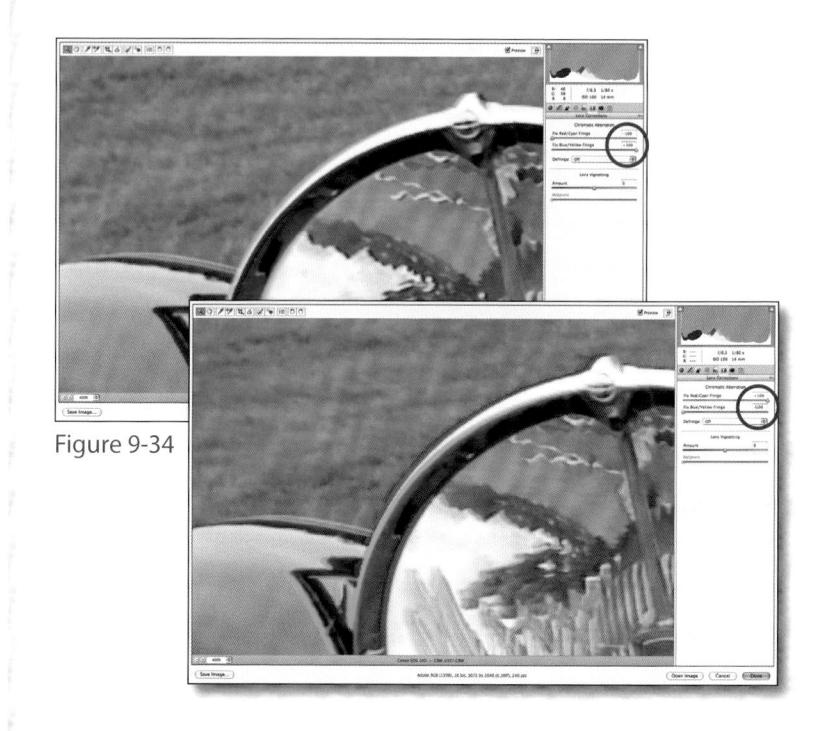

Figure 9-35

Figure 9-36

Figure 9-37

For example, the Remove Distortion slider, circled in Figure 9-36, is a nifty way to correct barreling and pin-cushioning effects produced by some lenses. As you'll see later in the chapter, you can use the filter to remove (or add) vignetting—just as you can in Camera Raw. The Transform commands open a lot creative options—all beyond the scope of this book. I really love how you can use the Edge setting to extend borders. The Lens Correction filter is a very useful member of Photoshop's native filter set.

To use the Chromatic Aberrations controls in the Lens Filter, simply refer to the previous section, "Reducing Chromatic Aberrations with Camera Raw." I suggest you deselect Show Grid, to get a clear view of your image. (The grid is handy when you use the Transform commands.)

I do, however, want to use the Lens Correction filter to illustrate better how the chromatic aberration controls work. I may be beating a dead horse, but sometimes it helps to understand how something works—and I've found so many people just don't get this one. Anyway, look at the image in Figure 9-37.

I used the Distortion controls to "correct" for—in this case, nonexistent—lens barreling. You can see how the image distorts inward. (Moving the Remove Distortion slider to the left corrects for pin-cushioning and distorts the image outward.) Well, imagine this same distortion specific to a select color instead of a global distortion. This is what happens when you use the chromatic aberration controls. The selected colors shrink or expand, incrementally, but enough to bring the colors back in line.

Edge Control

When you correct or otherwise distort an image your original image edges are distorted as well. You can extend the edges to their original perspective via the Edge pop-up menu (shown in Figure 9-38). You have three choices: Edge Extension, which interpolates and extends edges based on pixels in the original image (shown); Transparency, which makes the background transparent; and Background Color, which extends the edges with a color of your choice. You can also control the scale of the Edge control with the Scale slider.

Saving Lens Correction Settings

To save custom Lens Correction settings:

- 1. Select Save Settings from the pop-up menu (Figure 9-39).
- 2. Type in a descriptive name for your setting, as I've done in Figure 9-40.

 Load and apply your saved setting by selecting from the Settings popup menu. If it doesn't appear in the menu, select Load Settings from the pop-up menu next to the triangle and navigate to the appropriate location (Figure 9-41).

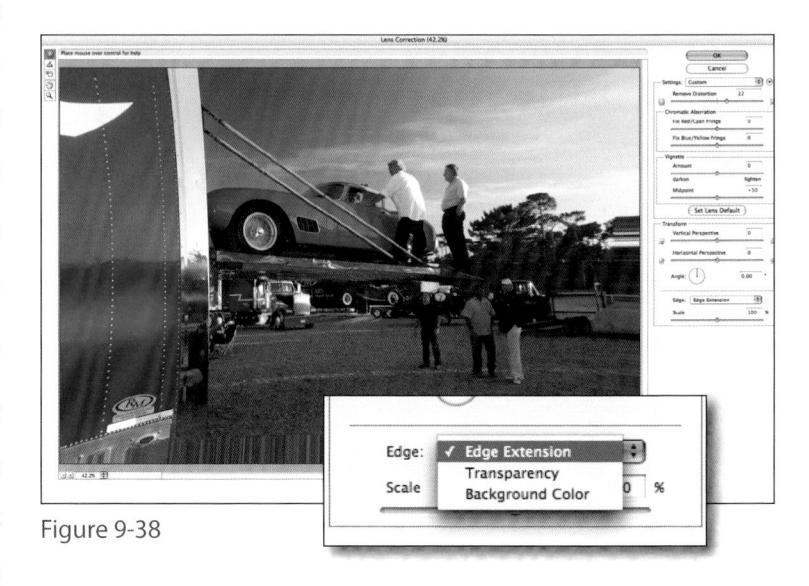

Figure 9-39

Figure 9-40

Figure 9-41

Vignetting (darkening at the corners of the frame) is one of the easiest things you can fix in Camera Raw. Conversely, you can also add a vignette to your image, which will draw attention a specific part of an image.

Diminishing or Adding Vignetting

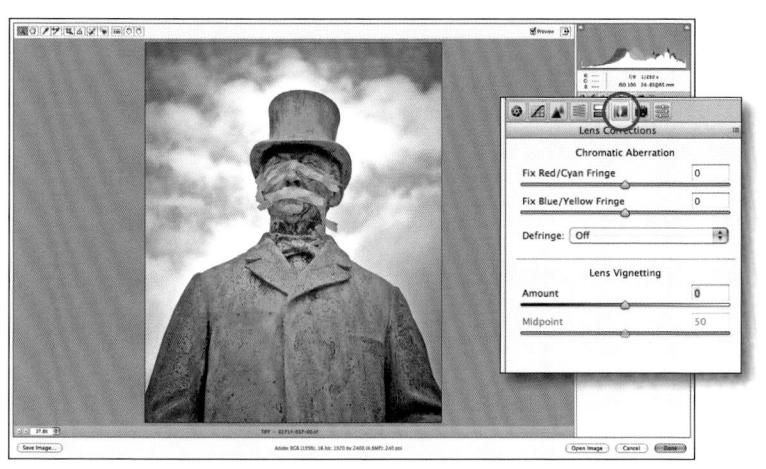

Figure 9-42

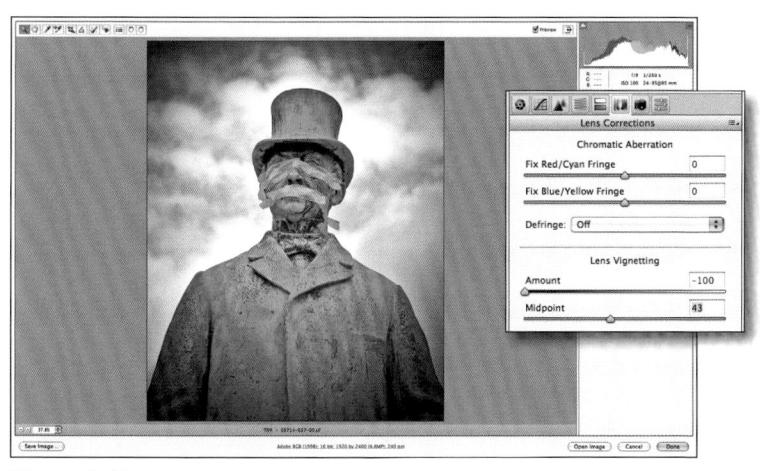

Figure 9-43

NOTE You can also use the Lens Correction filter found in Photoshop to create or diminish vignettes. The controls are the same as the ones in Camera Raw. If you are working on a Smart Object, the changes are non-destructive and can be edited at any time.

Vignetting can be caused by a mismatched filter/lens hood or a lens (e.g., using a filter on an ultra wide angle lens). It can also be caused by using wide angle lenses not optimized for digital capture (i.e., not optimized for even brightness across the frame).

To add or diminish a vignette:

- Select the Lens Corrections tab by clicking on the icon circled in Figure 9-42.
- 2. Adjust the Amount slider left or right. The edges will darken or lighten from a central radial point. In the case of Figure 9-43, photographer Luis Delgado Qualtrough actually darkened the edges of his image to bring more attention to his subject. (The image, by the way, was taken in Copenhagen with the Canon 5D and is part of his ongoing series, "Regarding the Hero and Antihero".)
- 3. Use the Midpoint slider to expand or decrease the range of the effect. You cannot, however, create multiple interest points. Adding a vignetting effect is therefore most effective when your image contains a single point of interest that you want to emphasize.

HUSHAVY | HUSHAVY |

Converting RAW to Black and White, Toning, and Special Effects

Like most photographers, I hold a special place in my heart for black and white photography. If you take away the red, greens, and blues and replace them with subtle shifts of luminance, you'll find form and shape are emphasized. A beautiful black and white image is a welcome respite to the eyes and mind in a world full of oversaturated and gaudy color.

In this chapter, I'll show you a couple ways to use Camera Raw and Photoshop to turn your RAW files into black and white images that rival—and even surpass—traditional film shooting and processing techniques. I'll also show you how to use Camera Raw's Split Toning sliders and how to push the boundaries with special effects.

Chapter Contents

Using Camera Raw's Grayscale Mix
Single Color Toning

Getting a Cross-Processing Look with Split Toning

Pushing the Boundaries with Special Effects

Advanced Localized Control

Using Camera Raw's Grayscale Mix

To start, you need a color image. From a quality point of view, it's preferable to work with a native RAW file like the one in Figure 10-1, but a JPEG, TIFF, or PSD file will do, as long as it is in color.

NOTE Many digital cameras now offer a Black and White option.
Camera Raw's Grayscale Mix control won't have any effect on these images, unless they are saved as RAW files, where the color data is always available. You can, however, tone these camera-generated grayscale JPEG or TIFF images using the Split Toning controls, found in the Split Toning tab.

Click the checkbox next to the words Convert to Grayscale (circled in Figure 10-2) in the HSL/Grayscale tab. Your image will appear unsaturated, but what you see is misleading. The underlying color data is still available, which means you can use Camera Raw's Grayscale Mix control to determine how each color is converted. If you save your image as a TIFF, JPEG, or PSD, all color data is eliminated, even though it is saved in Adobe RGB via the Workflow Options dialog box. If you save your converted image as a DNG file, the color is retained regardless of how you set your Workflow Options and can be retrieved, if necessary, in other programs such as Photoshop.

Camera Raw's new Grayscale Mix controls, found under the HSL/Grayscale tab, have revolutionized digital black and white conversion. Since using these controls, I've retired several of my more complex and time-consuming conversion techniques. Once you use the Grayscale Mix controls, you'll see what I mean.

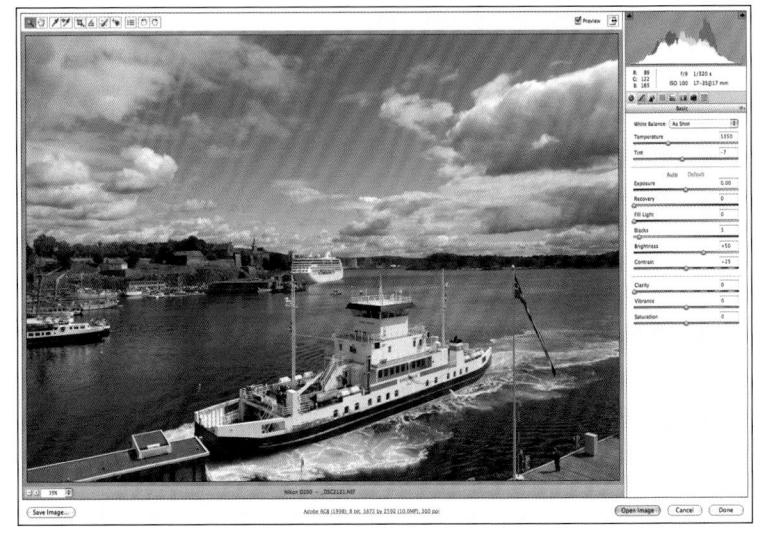

Figure 10-1

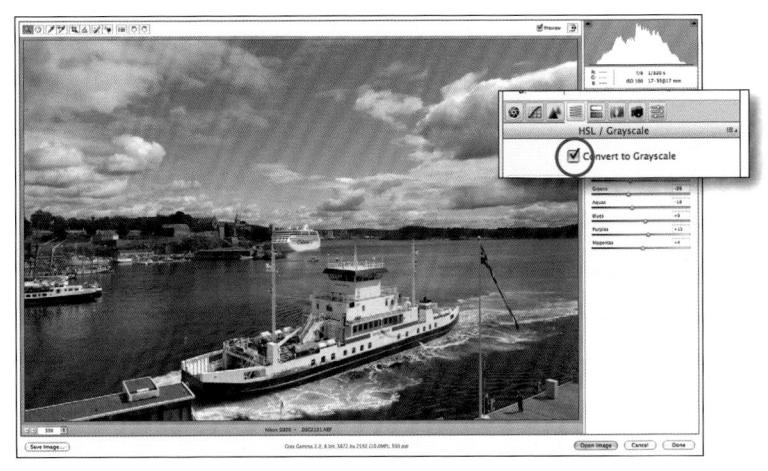

Figure 10-2

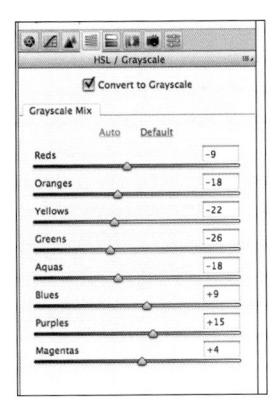

Figure 10-3

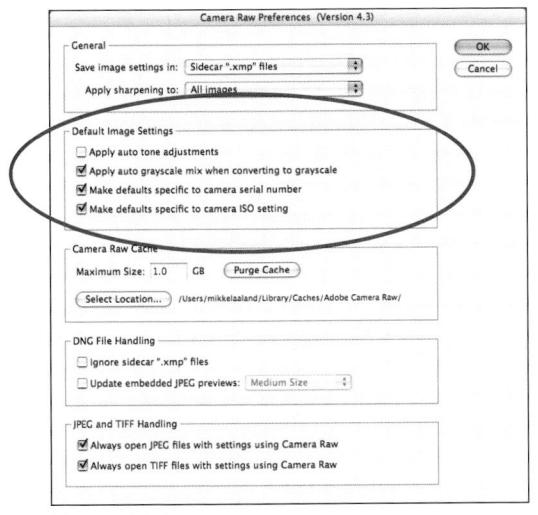

Figure 10-4

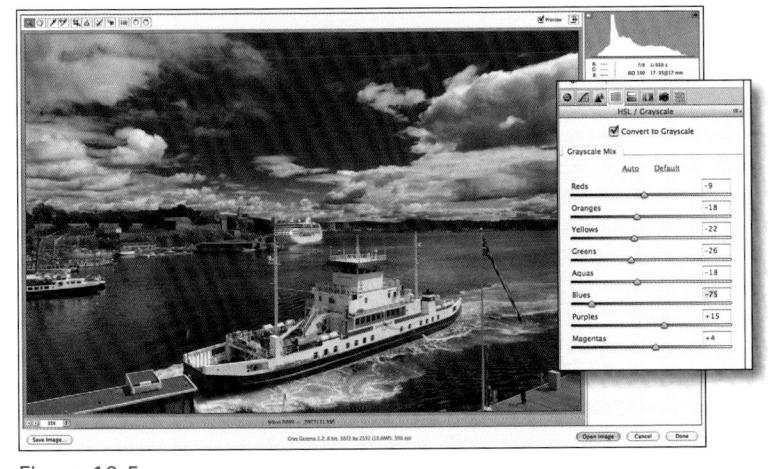

Figure 10-5

If you look closely at the Grayscale Mix sliders in Figure 10-3, you can see that they have not all moved the same amount. Camera Raw creates a "smart" custom auto mix (see the note below). Although this often produces pretty good results, I find it's mostly just a good starting point; often, I want to interpret the color conversion differently. I'll show you what I mean.

NOTE Camera Raw's Auto
Grayscale Mix takes into account
the fact that the human eye
perceives luminance values
differently based on color. For
example, we see blue as much
darker than green or red, even if it
shares the same physical brightness
values. If you don't want Camera
Raw to apply an auto grayscale mix
to your grayscale conversion, go
to Camera Raw's preferences and
deselect the appropriate Default
Image settings box, circled in
Figure 10-4.

Creating a Dramatic Sky

Let's say I want to make a blue sky appear darker. In Figure 10-5, I moved the Blue slider from +9 to -75. As you can see, my adjustments are immediately viewable.

What you may not notice at first is that the effect is global, which means that any blue found anywhere else in the image will become darker as well. For this image, that means the water becomes darker. At the end of the chapter, I'll show you a way to selectively alter colors, but it'll mean using layer masks in Photoshop.

Another Black and White Example

Here is a color image that I think really benefits from conversion to black and white and tweaking the Grayscale Mix sliders. Figure 10-6 shows the original in color. Notice how the colors are similar. Boring.

Figure 10-7 shows the image with Auto grayscale conversion in Camera Raw.

Again, the image is flat and lacking contrast between the hands and the shirt.

NOTE Camera Raw does its colorto-grayscale conversion in the LAB color space at 16-bits per pixel, rather than in RGB at 8-bits per pixel. This effectively reduces or eliminates banding (noticeable stripes) entirely, and subtle transitions between tonal values appear much smoother. (Wikipedia has a great article on the technical reasons why LAB color space is preferable: http:// en.wikipedia.org/wiki/Lab_color.)

Figure 10-8 shows the image after I adjusted the Grayscale Mix sliders. I changed the Red slider from –5 to +42 and the Orange slider from –15 to –44. There's much improvement, but work still needs to be done to make the image more interesting.

Finally, Figure 10-9 shows the image with adjustments made in the Basic tab. Much better.

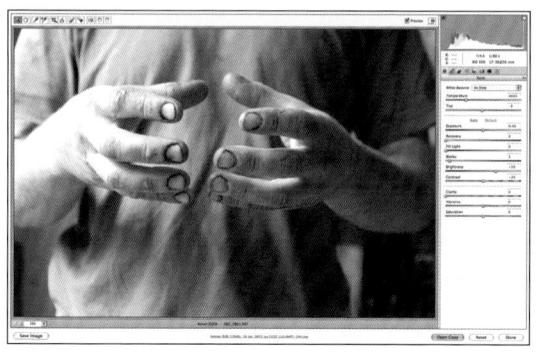

Figure 10-6

Figure 10-7

Figure 10-8

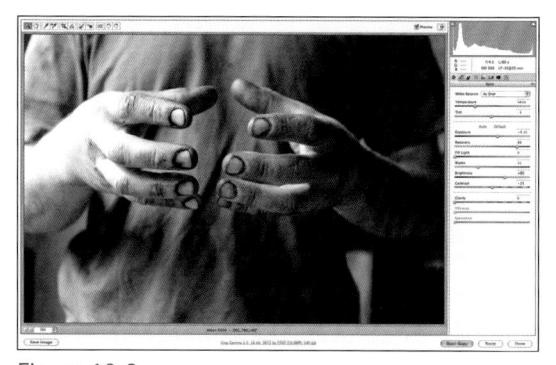

Figure 10-9

Figure 10-10

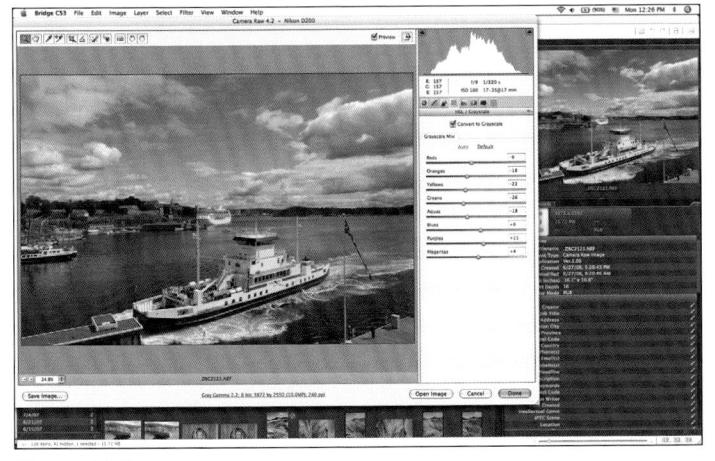

Figure 10-11

Using Before and After for Reference

Working on a color-by-color basis using the Grayscale Mix sliders on an image that has already been converted to black and white can be hit and miss unless you refer back to the underlying colors. If you started with a color version of your image in Camera Raw, you can do this by deselecting the Preview box in the upper-right corner of the Camera Raw window (circled in Figure 10-10). Select the Preview box to bring you back to the grayscale version.

Another way to maintain a color version for reference is to position your Camera Raw window in such a way that the preview box in Bridge is visible, as shown in Figure 10-11.

Figure 10-12
John McDermott took this shot with a Canon EOS 5D and set it to shoot black and white and save as a RAW file. On viewing for the first time in Bridge, the preview briefly reflected John's settings.

Figure 10-13
Bridge/Camera Raw
automatically created
its own preview and
all the in-camera black
and white settings were
ignored.

Beware: Camera Black and White Settings Ignored

Many digital SLRs, and some digital pointand-shoots, offer sophisticated control over the way black and white images are converted in the camera, as shown in Figures 10-12 and 10-13. If you are planning on using Camera Raw, don't spend a lot of time fiddling with these controls or any other camera-based special effects. The settings are often encrypted and unreadable by Camera Raw. On first view in Bridge, you might see a black and white thumbnail preview that appears to contain your camera settings. However, once Bridge/Camera Raw creates its own standard-sized preview, the original camera settings are not applied.

Imitating a Grainy Film Look

If you want to simulate the grainy black and white look of say, Tri-X film (remember film?), there are many ways to go:

- With your camera, increase the sensitivity of the sensor by boosting the ISO.
- In Camera Raw, increase the sharpening setting to its maximum. With your image open in Photoshop, take the effect further by using the Unsharp Mask filter (Filter

 Sharpen

 Unsharp Mask).
- In Photoshop, use the Add Noise filter
 (Filter→Noise→Add Noise).

Any of these methods, or a combination of them, will produce an effect that approximates the grainy look associated with many black and white films.

For the image shown in Figure 10-14, taken with a Leica D-Lux-3, I used a combination of shooting and processing techniques.

First, I shot the image at 400 ISO, which increased the noise. Then I did the following to the RAW file in Camera Raw:

- I selected the HSL/Grayscale tab and checked the Convert to Grayscale box. I started with the Auto settings, as you can see in Figure 10-15.
- I then slid the Red slider to +31 and the
 Orange slider to +59. This increased the
 noise in specific colors and, for this image,
 gave me the look I wanted (shown in
 Figure 10-16). For images shot with other
 digital cameras, moving other color sliders
 might do the trick.

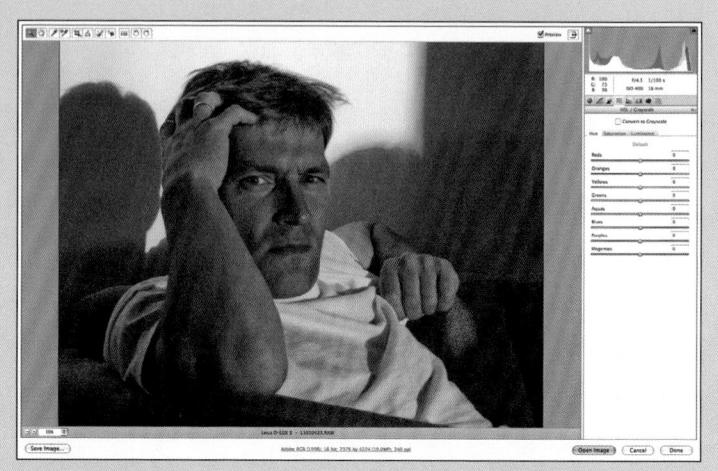

Figure 10-14

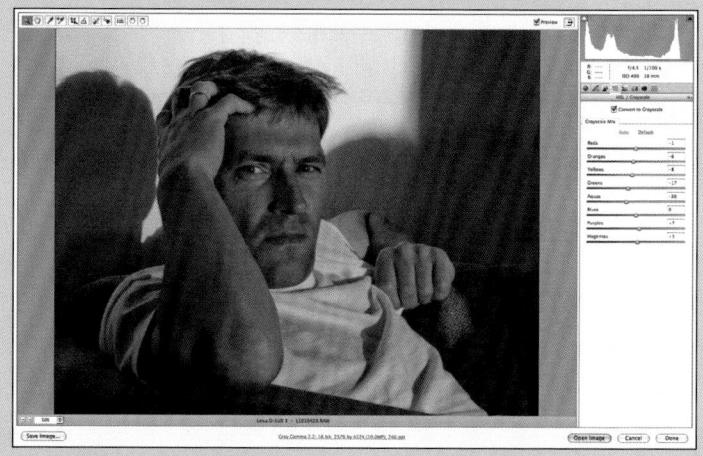

Figure 10-15

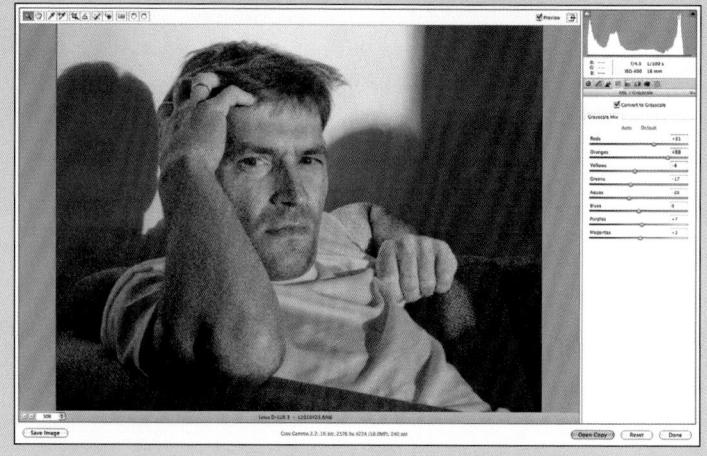

Figure 10-16

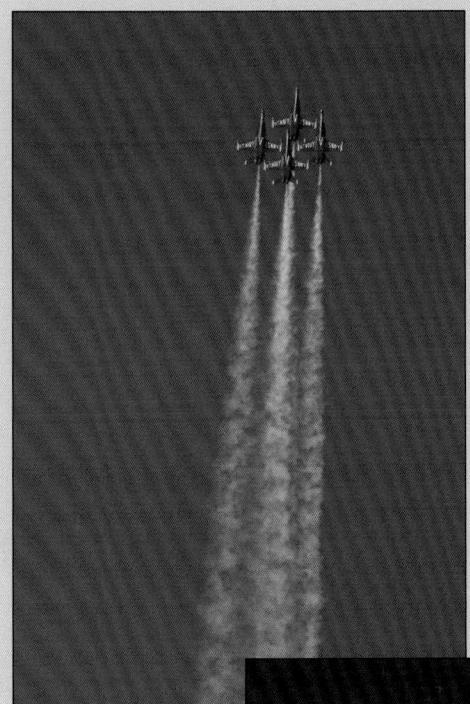

Figure 10-17

Figure 10-18

Shooting Considerations for Black and White Images

Some shots work better in black and white than others. There are no hard-and-fast rules. If you are trying to create a particular mood or evoke a certain era in time, for example, rendering the final image in black and white is appropriate. However, a black and white image can be plain boring if there is neither good composition nor compelling content.

For example, John McDermott's vertical shot of the Blue Angels preforming over the San Francisco Bay, shown here in both color (Figure 10-17) and black and white (Figure 10-18), works very well either way because of the dramatic lighting and striking composition.

Of course, content and composition aren't all that go into making a good black and white image. You need a range of tonal values, and that's where proper exposure comes in. Most digital cameras aren't capable of giving you a black and white preview. You can, if you want, tape a sheet of dark green acetate or cellophane over your LCD to get an approximate sense of grayscale. You can also employ the old-fashioned method of previsualizing in black and white with your mind's eye. After all, most of the greatest black and white images of all time were taken using a color viewfinder and this method.

Single Color Toning

Adding a color tint to a photo has long historical precedent in traditional photography. Who can forget the smell of the chemicals we used to create Sepia-colored prints? Anyway, it's a lot easier with Camera Raw!

Using White Balance Tint Control

One of the easiest ways to create a color tint from a color image is to simply change the White Balance slider control, found in the Basic tab. Moving the Tint slider to the left shifts the colors to green (Figure 10-19), while sliding them to the right shifts the colors to magenta (Figure 10-20). This method definitely works better on some images than others; it all depends on the colors of the image. It won't work at all if you have completely desaturated your color image or converted it to grayscale. You can control the amount of tint with the Basic tab's Saturation slider.

Using Split Toning to Create Single Color Tone

You can use the Split Toning tab to create a uniform tint to your image. (In the next section, I'll show you how to create a cross-processing look, one which distributes the tint to shadows and highlights differently.)

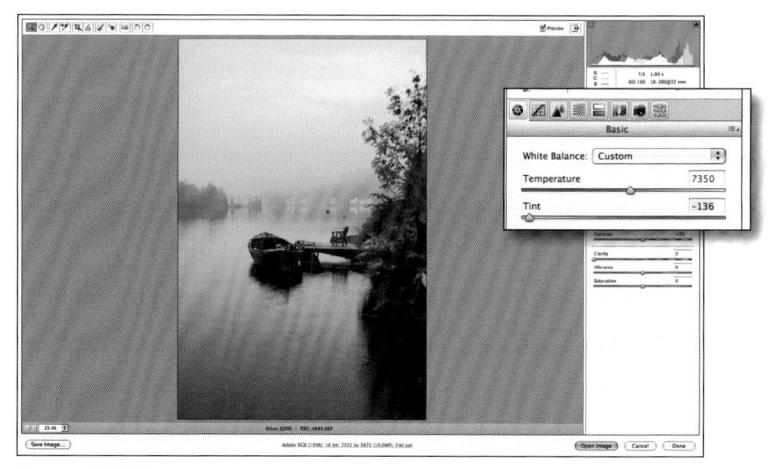

Figure 10-19

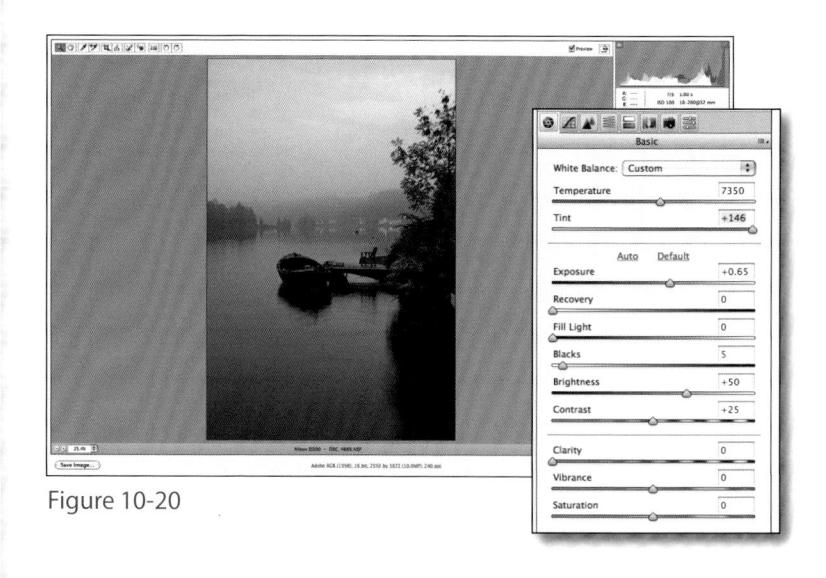

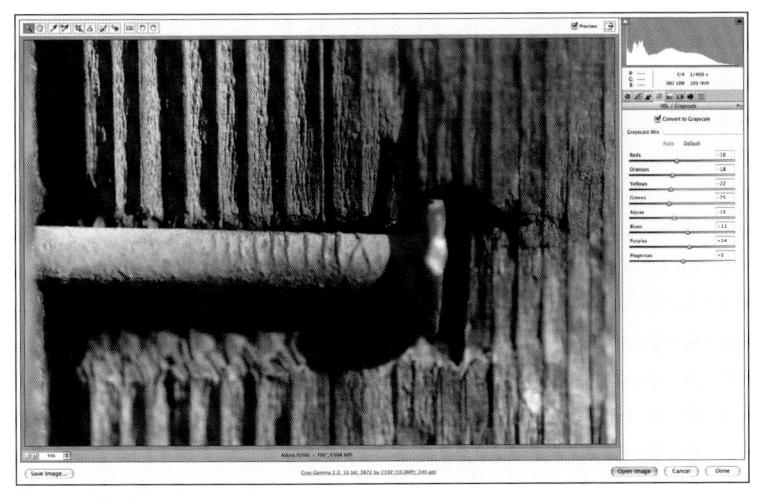

Figure 10-21

Figure 10-23

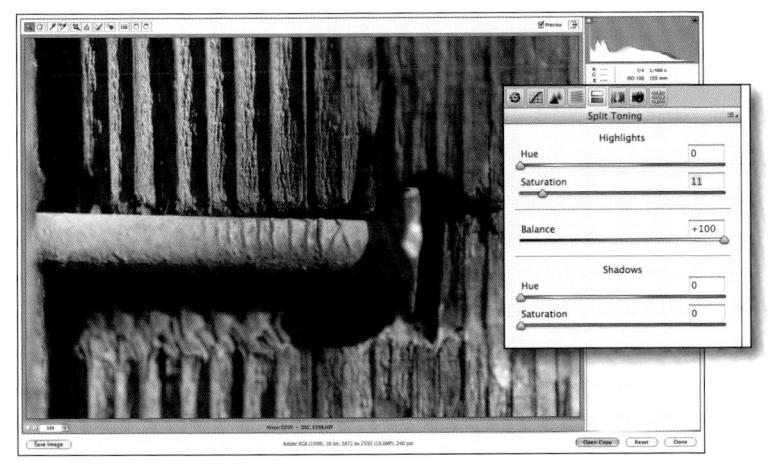

Figure 10-24

Here's how:

 Convert your image to grayscale in the HSL/Grayscale tab (Figure 10-21).
 Adjust the Grayscale Mix as needed. (You can always do this later, after applying a tone.)

- 2. Go to the Split Toning tab (Figure 10-22)
- 3. Move the Balance slider all the way to the right, to +100, as I've done in Figure 10-23. (This effectively pushes the tint values to highlights only and not shadows.)
- 4. Move the Saturation slider to a desired level.
- 5. Slide the Hue slider until you get the tint you want. Hold the Option (Alt) key while you do this to preview the actual tint color (Figure 10-24). You can control the intensity of the tint with the Saturation slider.

NOTE The sliders in Camera Raw's Camera Calibration tab can also be used to tint an image, but it's more hit-and-miss so I generally don't use it for a single-toned look.

Getting A Cross-Processing Look with Split Toning

Let's start with the photo shown in Figure 10-25. I'll convert it to grayscale (right) and experiment with the Split Toning pane controls until I get the cross-processing look I'm after. The basic theory is this: You can control the tint and the saturation of the tint applied to the highlight areas of an image separately from those applied to the shadow areas. The Balance slider in the middle controls the range of each. You'll understand the Balance slider better after I show you some examples.

Getting it Right

First I'm going to show you how I got the cross-processing look I want, and then I'll show you how the Balance slider works by going to the extremes. To get what you see in Figure 10-26, I did the following:

- Adjusted the Highlight Hue slider until I got the aqua tint you see in the horses and clouds (the highlights).
 You can hold the Option (Alt) key while you adjust the slider to more easily determine the color tint. This temporarily pumps the saturation to 100%.
- Adjusted the Shadows Hue slider until I got the magenta tint in the ground and mountains.
- Increased the Saturation settings for both the Highlight and Shadows controls to a desired level.

Cross-processing was a popular technique in the film world where film was deliberately processed incorrectly. The results were unpredictable, but often included interesting unnatural colors and high contrast. You can simulate this popular technique with Camera Raw's Split Toning tab controls.

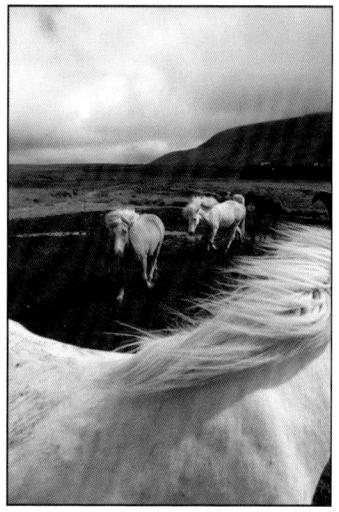

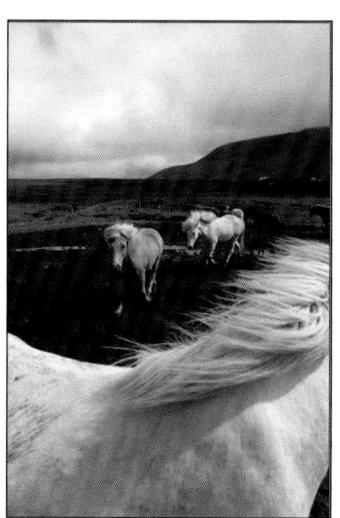

Figure 10-25

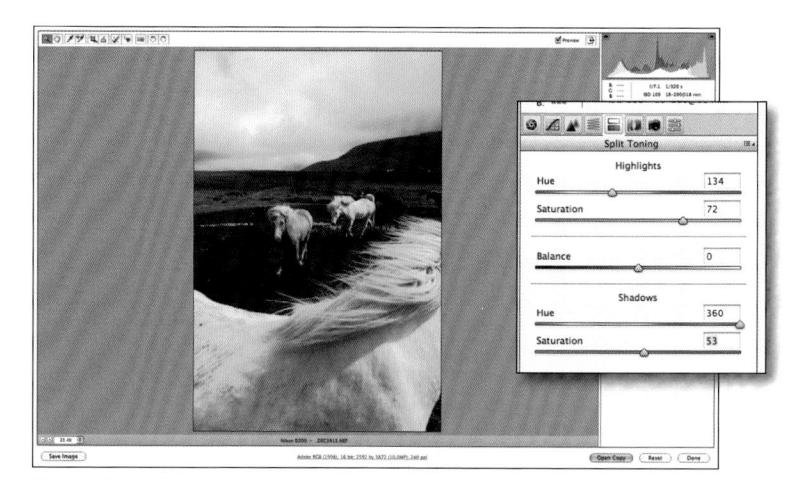

Figure 10-26
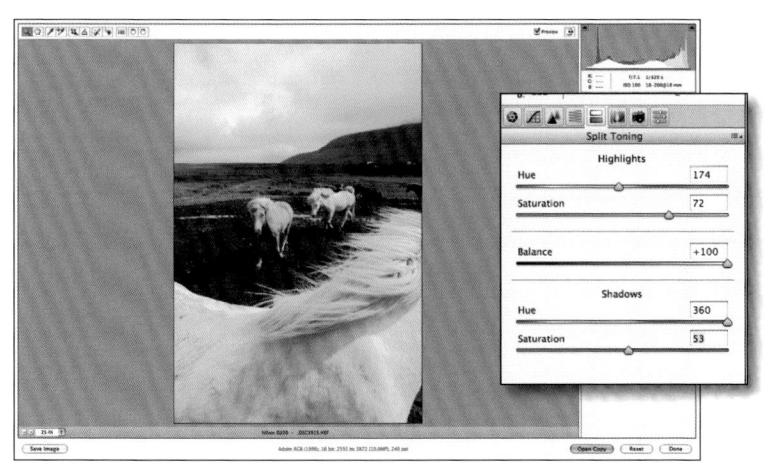

Figure 10-27

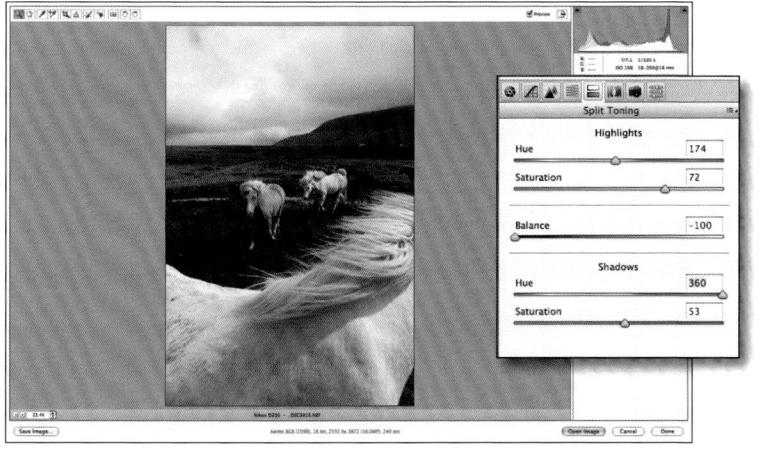

Figure 10-28

Going to the Extreme

Just so you can see how the Balance slider works, I'm going to crank up my Balance to +100. In Figure 10-27, you see that the aqua tint, which before was specific only to the highlight area, has spread into the shadows as well. If I slide the slider toward negative values, less and less of the aqua tint will apply to the shadow areas.

In Figure 10-28, I cranked the Balance slider the other way, to -100. As you can see, the magenta has spread from the shadow areas into the highlights. Again, if I pull the slider the other way, toward the positive values, less and less of the magenta will spill over into the highlights.

NOTE The Photoshop component of CS3 has also ramped up its grayscale conversion capabilities with advanced Black and White adjustments (Image→Adjustments →Black and White, or, better yet, as a non-destructive Layer adjustment). The Photoshop Black and White conversion doesn't offer as many color choices as Camera Raw's Grayscale Mixer, but there are several useful presets including Infrared. Color Tints can also be done via the Black and White dialog window.

Pushing the Boundaries with Special Effects

Let's work our way down through the tabs in Camera Raw to see which controls are useful for producing special effects.

Changing White Balance for Effect

If you shoot and save RAW files, the simple act of changing the White Balance setting in Camera Raw's Basic tab can produce unexpected, and often interesting, results on your RAW image. This is all I did to produce the effect shown in Figure 10-29. I tried all the various white balance settings, but settled on the Tungsten setting (circled).

Maximize Fill Light and Black Settings

Another simple but guaranteed way to produce a special effect is to crank up both the Fill Light and Black sliders in the Basic tab to 100 (circled). This is what I did to produce the effect in Figure 10-30.

When you use the various controls in Camera Raw, you can create harmonious, realistic photos, or you can push the boundaries and create wild, unrealistic effects, all at a flick of a slider. The possibilities are nearly limitless.

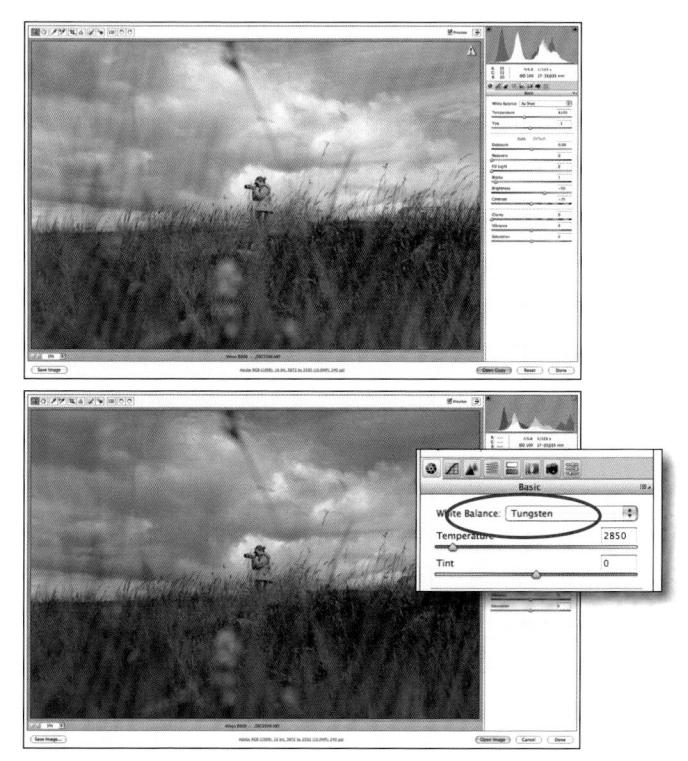

Figure 10-29

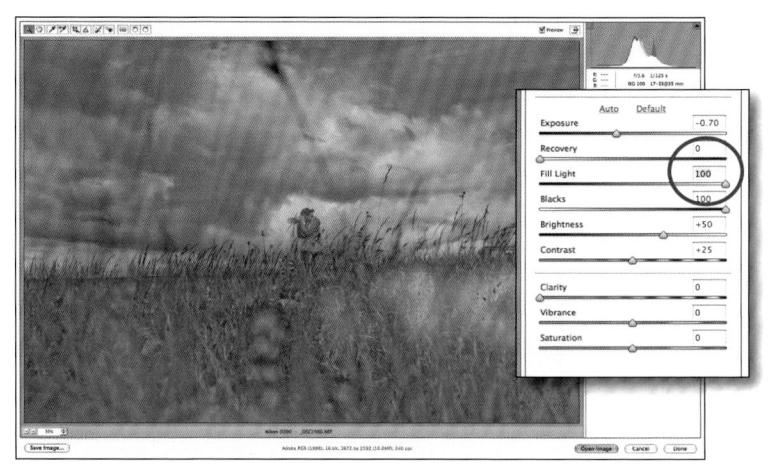

Figure 10-30

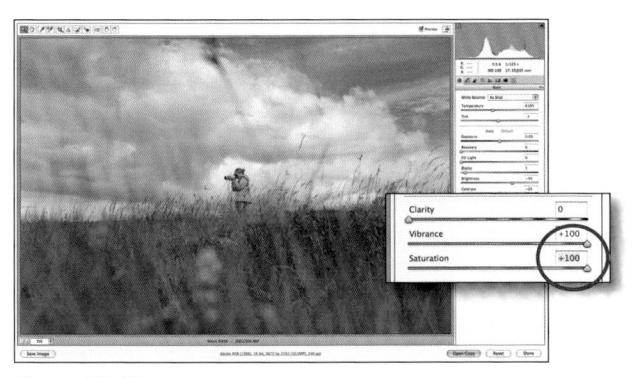

Figure 10-31

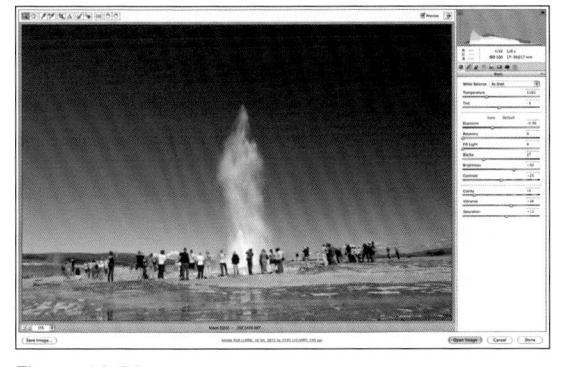

Figure 10-32

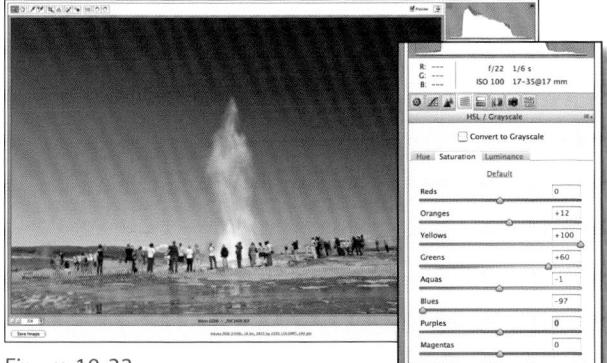

Figure 10-33

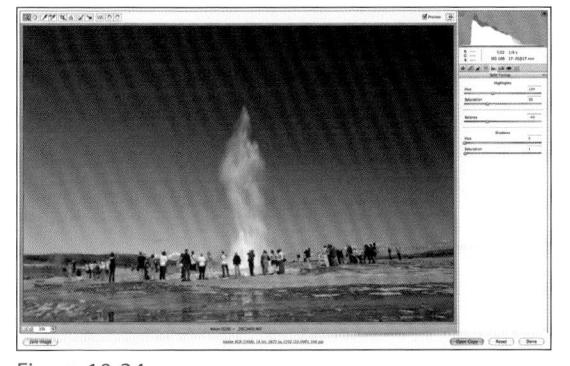

Figure 10-34

Use Both Saturation and Vibrance

The Saturation and Vibrance sliders in the Basic tab both boost color saturation but they do it in different ways. (I discussed their practical use in Chapter 6.) Boosting both of them to their maximum settings with a color image will definitely produce an interesting, and sometimes pleasant, effect, as in the case of Figure 10-31.

Selectively Desaturate Colors (and More)

Special effects can be easily achieved by desaturating selective colors. For this example, I used a combination of controls found under the HSL/Grayscale and Split Toning tabs.

Here is what I did, step-by-step:

- Adjusted the Exposure setting. In the case of Figure 10-32, I adjusted only the Black slider in the Basic pane to give the photo more contrast.
- 2. Selected the HSL/Grayscale tab and desaturated the blue sky. I also boosted the saturation of the foreground colors, as shown in Figure 10-33.
- 3. Selected the Split Toning tab. First I boosted the Highlight's Saturation slider to 30. Then I adjusted the Hue slider to 134, which gave the entire image a slight aqua tint, mostly in the highlights (water spout).
- 4. The aqua tone spilled beyond the highlights, so I adjusted the Split Toning Balance slider to –40, so that the color tint applied only to the brightest highlights. The final image is shown in Figure 10-34.

Advanced Localized Control

Here is a fairly straightforward way to use Photoshop, Bridge, and Camera Raw to create a black and white image and apply localized control. (You can also use the method to fine-tune split toning effects.)

Improving a Portrait Shot

I'll use the portrait in Figure 10-35—shot by *Popular Science* photographer John Carnett—of Burt Rutan, the aerospace designer, as an example. When I adjusted Camera Raw's Grayscale Mix red slider to bring out the logo on the shirt, the rest of the image looked like it was shot with infrared film. I needed to apply the red adjustment locally.

- Starting in Bridge, open the RAW file into Camera Raw (File→Open in Camera Raw). Make sure Bridge is host. In Camera Raw, use the HSL/Grayscale Mix tab to convert your file to black and white. I suggest for this version you use Auto.
- 2. Open the Workflow preferences by clicking on the link at the bottom of the window (Figure 10-36). In the Workflow dialog box, select Open in Photoshop as Smart Objects.
- Select Open Object from the bottom right of the Camera Raw window. The RAW file, with your adjustments, will open in Photoshop as a Smart Object, retaining its original characteristics and remaining fully editable in Camera Raw.

The methods I've shown you so far apply a global effect over the entire image. For some images this is fine, but for others, it's helpful to paint the effects into specific areas. This takes time, and requires more advanced Photoshop skills. But the tradeoff in time is more than made up for in the control you gain.

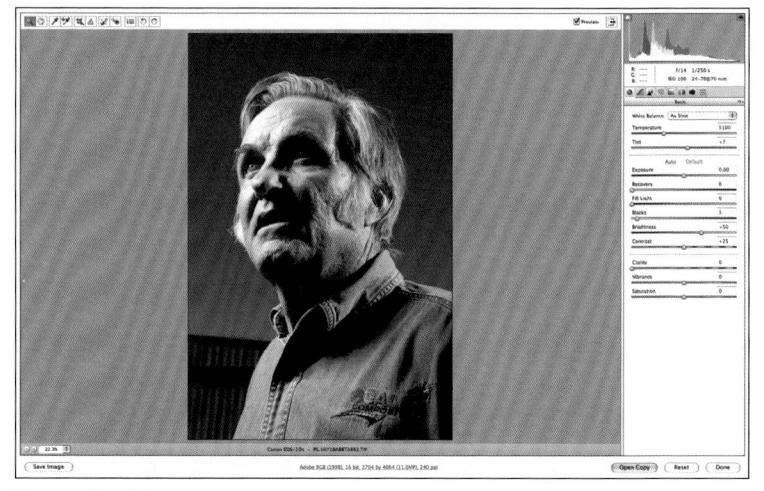

Figure 10-35

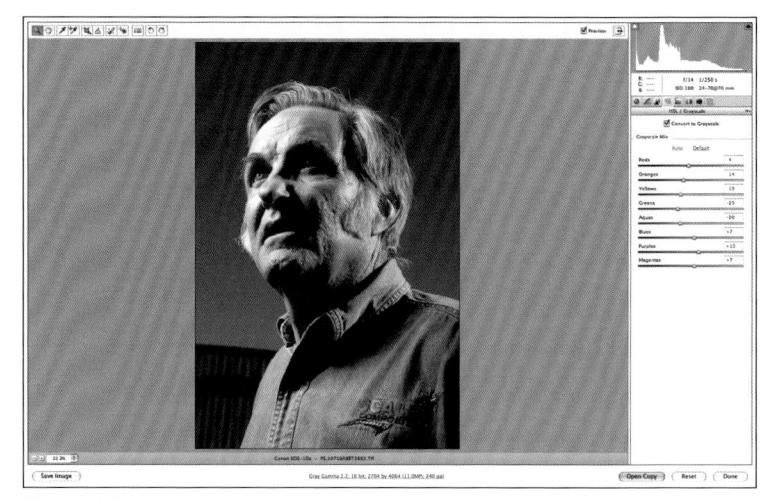

Figure 10-36

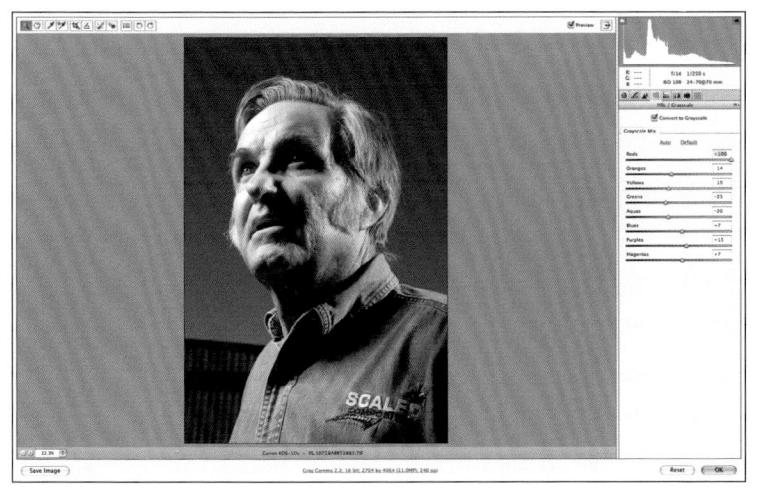

Figure 10-37

Figure 10-38

Figure 10-39

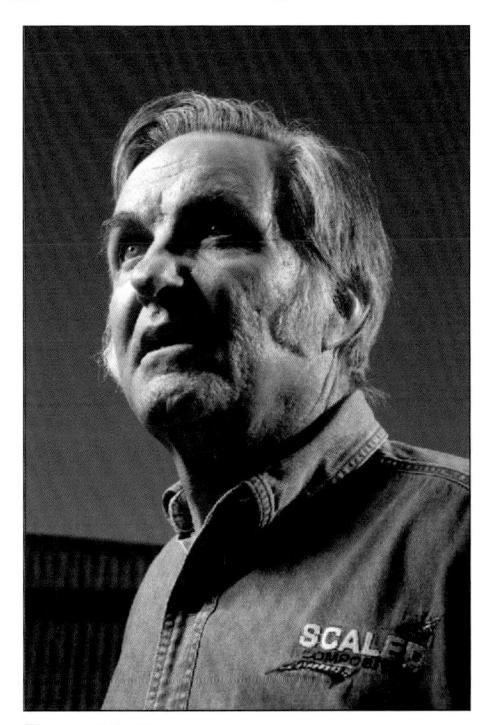

Figure 10-40

- 4. After the first version is placed in Photoshop, go back to Bridge, select the same file, and then choose File→Place→In Photoshop from the Bridge menu. This time, when Camera Raw appears, make another Grayscale Mix adjustment and click OK when you are done. In Figure 10-37, I used the Grayscale Mix controls to bring out the red logo and wording on the shirt. As you can see, this wasn't good for the skin tones.
- 5. The second version will open in Photoshop and be pasted into the original one as a Smart Object. It'll have a large X across the image. Select the Commit button from the Options bar.
- 6. Select the top layer and then click the Layer Mask icon at the bottom of the layer palette (circled in Figure 10-38).

 Next, select the Brush tool from the toolbar. Make sure the foreground swatch at the bottom of the tool bar is set to black. (The keystroke X will switch the background and foreground colors alternately.

 Keyboard command "D" will make sure default colors are selected.)
- 7. With the Brush tool and an appropriate-size brush, "paint" or mask out unwanted adjustments, as I've done in Figure 10--39. (Use the bracket keys to increase or decrease the size of the brush.
- Note in the final version (Figure 10-40), the logo on Burt's shirt, originally in Red, is now readable and his face is properly lit.

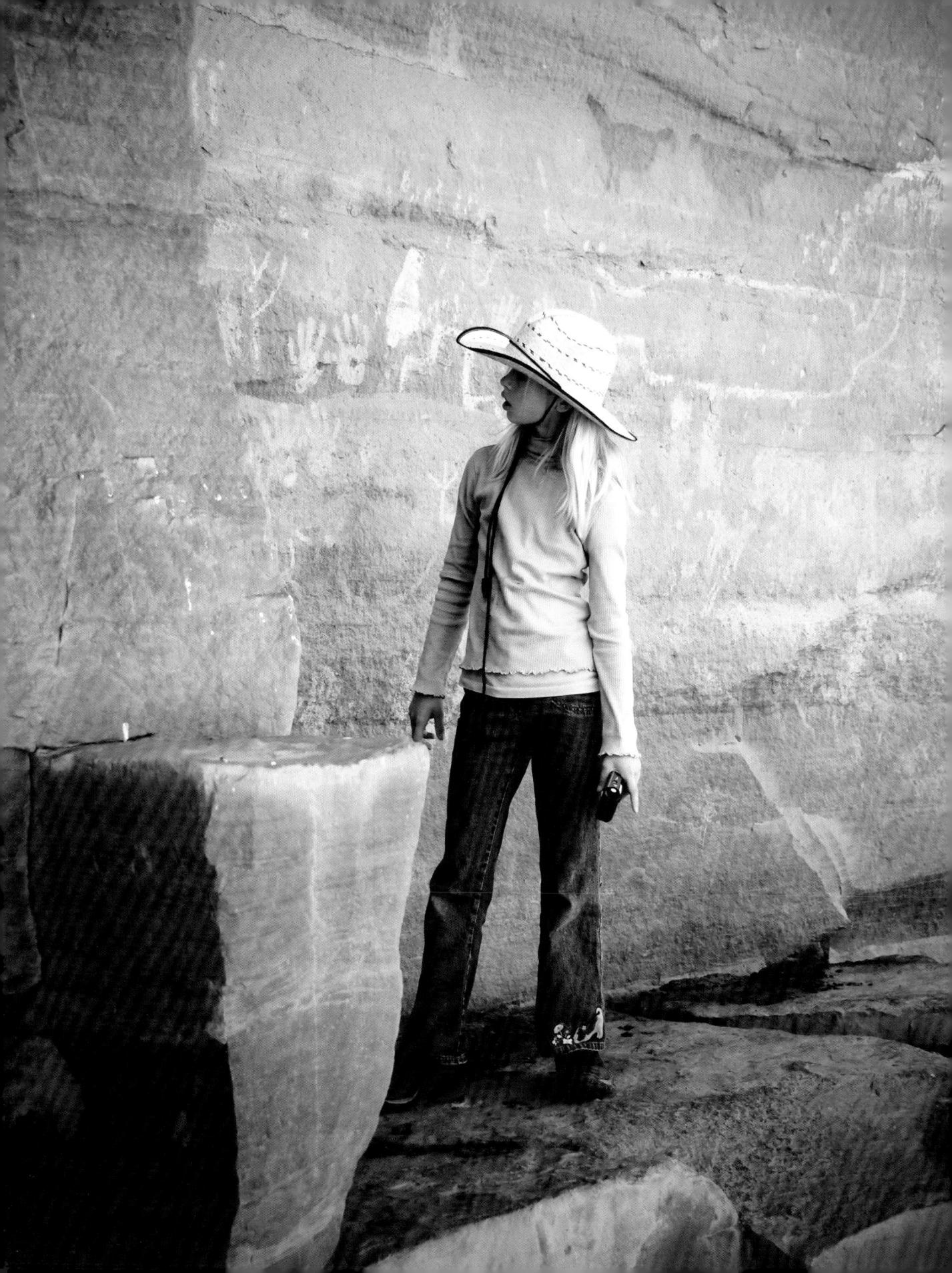

Archiving and Working with DNG

DNG stands for digital negative, and it's Adobe's answer to the confusing world of multiple RAW data file types. By converting and saving your proprietary RAW data file into the DNG format, you can archive your precious photographs, accompanying metadata, and processing adjustments in an open format that is more likely to be compatible with future software applications. You also have the option of packing your original RAW file into a DNG file, thereby increasing the odds that your image will be preserved intact for future viewing. This chapter will show you how to save and archive DNG files using either Camera Raw or the free standalone, Adobe DNG Converter.

Chapter Contents

Archive Strategy: Hedging Your Bets
Saving DNG Files
Converting to DNG with Camera Raw
Using Adobe DNG Converter

Archive Strategy: Hedging Your Bets

Will the RAW data files produced by your digital camera today be decipherable 5–10 years from now? No one knows for sure. One thing is certain: you need an archive strategy that takes multiple scenarios into account.

Proprietary RAW files often contain encrypted data, which is potentially readable only by proprietary software. Camera companies argue they need encrypted and copyrighted data to maintain a competitive advantage, but what happens when no one dares (or bothers) to support these numerous formats? It's the photographer with thousands of unreadable files who potentially suffers.

What about the long-term reliability of Adobe's DNG format (Figure 11-1)? Are you taking a chance converting and saving your proprietary RAW files in that format? Again, the honest answer is yes. Your images are not set in stone and there is no guarantee DNG will be supported in the future.

There isn't anything particularly complicated or proprietary about the DNG format. Thomas Knoll, its creator, based DNG on the venerable and widely supported TIFF file format. Since it is an open format—publicly documented—anyone with coding skills can use or write to it with ease, without paying royalties.

When faced with an unknown future, I can see no reason why you shouldn't hedge your bets and save both the original RAW file and a DNG file separately. Assuming that DNG is the best hope of ensuring future accessibility to our images, let's move on to creating and saving DNG files (Figure 11-2).

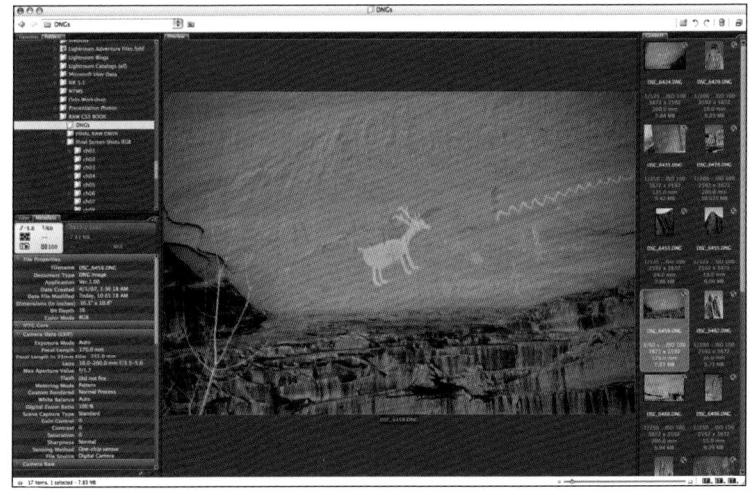

Figure 11-1

Figure 11-2

NOTE If you want to be more efficient, you can embed an exact copy of your original RAW file into the DNG file and trash the original, but that means you are assuming there will always be software capable of extracting the original file from the DNG.

In this section, I'll discuss some of the variables you'll need to consider when you're working with DNG files.

Version 4.2 Thomas Knoll, Sandy Alves, Julie Meridian, Kevin Connor, Gwyn Weisberg, David Howe, Jackie Lincoln-Owyang, Adam Jerugim, Heather Dolan, Rod Golden, Marc Pawliger, Tom Pinkerton, Dan Gerber, Melissa Gaul, Elena Murphy, Peter Crandall, Melissa Tamura, Addy Roff, George Jardine, Brian Sonet, T. Scot Nozawa, Pallavi Samapika-Mishra, Gina Terada, Karen Tenenbaum Schneider, Cari Gushiken, Yoko Nakagawa, Yukie Takahashi, Bryan O'Neil Hughes. © 2007 Adobe Systems Incorporated. All rights reserved. Adobe and the Adobe logo are either registered trademarks or trademarks of Adobe Systems Incorporated in the United States and/or other countries.

14.

Figure 11-3

Figure 11-4

Saving DNG Files

There are several ways to convert your RAW files to the DNG format. With CS3, you can use Bridge's Photo Downloader or Camera Raw. You can also download the free, standalone Adobe DNG Converter application (Figure 11-3), which can be more time-efficient for converting existing folders of RAW files compared to using Camera Raw. (However, with Camera Raw you can also save TIFFs, PSDs, or JPEGs as DNGs, in addition to RAW files.)

Regardless of which method you use—Photo Downloader, Camera Raw, or the DNG Converter—you can choose whether to embed the original RAW file into the DNG file. This will more than double your file size, but it's a handy way to keep all the original data and the DNG file in one place. (At this time, you'll need the Adobe DNG Converter to extract the original RAW files. More on that later.)

NOTE When you create a DNG file, Camera Raw process settings and other metadata is written directly to the DNG file, where it remains intact until updated. Figure 11-4 shows a DNG file opened in a text editor. The Camera Raw settings are clearly part of the header information. No separate sidecar files are required, and this is a definite advantage—there is no chance of separating or losing the sidecar data, as is the case with using propriety RAW files.

When to Convert to DNG?

At what point in the workflow should you convert your RAW files to DNG? On import, with Photo Downloader, and before you do anything to the original RAW file? Or later, after you've used Camera Raw to tweak white balance, exposure, etc.? There is no simple answer. It depends on what you are doing. Let's look at some different approaches.

Converting One File at a Time

If you are working with one portfolio quality image at a time, or just a few, it really doesn't matter when you convert (Figure 11-5). It's a matter of personal preference. You can convert your original RAW file into a DNG without applying any Camera Raw settings, then work on the DNG file and apply custom Camera Raw settings later. You can also open the original RAW file in Camera Raw, apply custom settings, and then save the file as a DNG. Your Camera Raw settings are written into the DNG file and—as long as you select Done in Camera Raw when you are finished—a sidecar file will be created for the original RAW file.

Converting Large Numbers of Images at Once If you are working with an entire photo shoot of native RAW files, as in Figure 11-6, I'll show you three workflow scenarios. The good thing about Scenario 1 and Scenario 2 is much of the heavy lifting is done outside of the Photoshop/ Bridge/Camera Raw environment, thereby freeing up the applications for other purposes. The good thing about Scenario 3 is that you end up with a native RAW file whose Camera Raw settings match those of the converted DNG file.

Figure 11-5

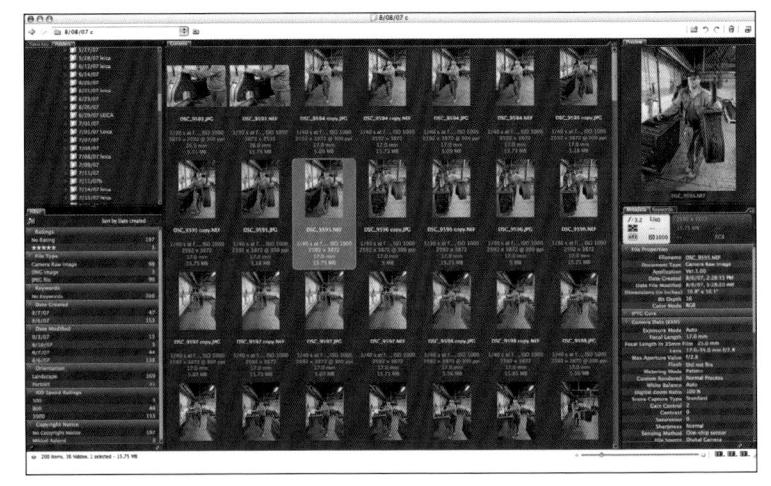

Figure 11-6

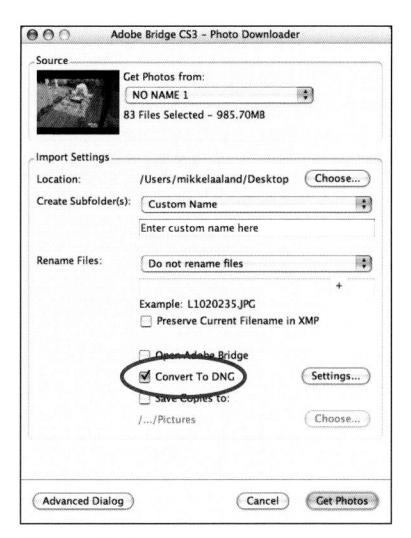

Figure 11-7

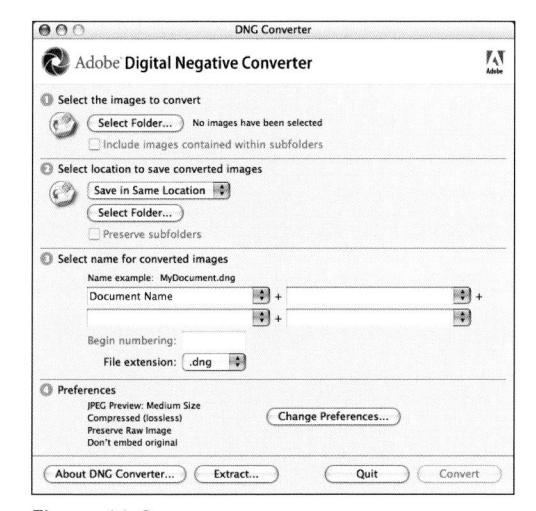

Figure 11-8

Figure 11-9

Scenario 1

- Use the Adobe Photo Downloader to download RAW files directly from your digital camera. From Bridge, select File→Get Photos from Camera. (The Downloader is featured in Chapter 2.)
- Select Convert To DNG from the Photo Downloader dialog window (Figure 11-7). Click Settings to open a DNG Conversion Settings dialog box with options similar to those I discussed for Camera Raw in Chapter 2.
- Select Done. The download and DNG conversion will occur in the background while Bridge, Camera Raw, and Photoshop remain operable.

Scenario 2

- Open the Adobe DNG Converter (Figure 11-8) and batch process a selected folder of RAW files into DNG. (I'll show you specifically how to use the DNG Converter later in the chapter.) The conversion process may take some time, depending on your DNG Converter settings. If you choose to embed the original RAW file or use full-sized previews, it can take longer. Processing is done outside the Bridge, Adobe Camera Raw, and Photoshop environments, and documented with a window such as the one shown in Figure 11-9.
- Open the DNG files in Camera Raw and apply the necessary settings, i.e., White Balance, Exposure, etc..
- Select Done. Photoshop will be inoperable until the updating process is complete, but you'll still be able to use Bridge.

Working RAW

Actual files found at

http://examples.oreilly.com/9780596510527/

Svein Narum is one of an increasingly rare breed of artist who makes all his ingredients by hand. In this shot, he is mixing the the basic ingredients required to make potter's clay. This shot was originally in color. All the colors are so similar that the image lacks contrast and punch. I converted the RAW file to Grayscale and used Camera Raw's Grayscale Mix controls to get what you see here. When you download the RAW, file you'll see my settings.

Scenario 3

- Download RAW files from your digital camera.
- 2. Apply custom Camera Raw settings to the native RAW files via Bridge, or open the images in Camera Raw and globally apply the settings, as shown in Figure 11-10.
- After you are finished applying custom settings to your native RAW file, you have two choices. In either case, you'll end up with custom settings attached via XMP sidecars to your native RAW file:
- In Camera Raw, click Save Images from the lower left corner of the dialog box (Figure 11-11), and use the resulting Save Options dialog box (shown in Figure 11-12) to convert your files into DNG. (I'll give you detailed instructions on how to do this in the next section.)
 Be sure to select Done when exiting Camera Raw. Otherwise, your current custom settings won't be saved along with the native RAW file.
- Or, select Done and exit Camera Raw.
 Use the Adobe DNG Converter to batch process the tweaked RAW files into the DNG format. The converter will automatically apply the Camera Raw settings saved as XMP sidecars.

If Camera Raw converts while hosted by Photoshop, and you click Done, the dialog box shown in Figure 11-13 appears in the Photoshop environment and remains until the conversions are done. Even though Photoshop is inoperable while the conversion is taking place, you'll still be able to work in Bridge.

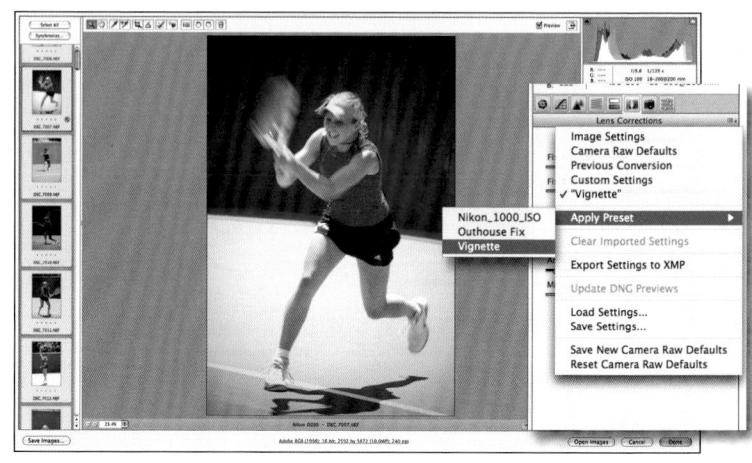

Figure 11-10

Figure 11-11

Figure 11-12

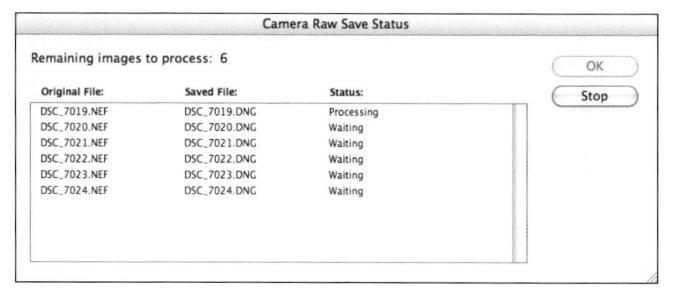

Figure 11-13

Regardless of whether you are working on one image or a series of several images, here is the basic step-by-step process for using Camera Raw to convert your RAW files into the DNG format. I'll get more specific about converting multiple files later in this section.

Converting to DNG with Camera Raw

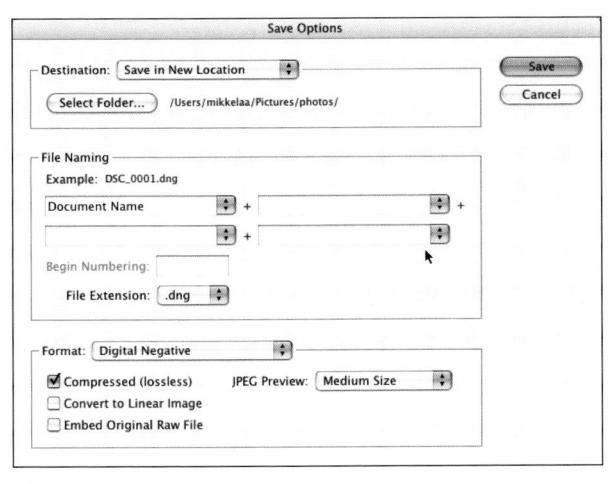

Figure 11-14

Figure 11-15

Figure 11-16

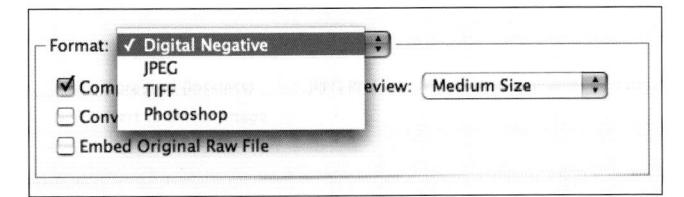

Figure 11-17

To convert:

- Open your native RAW file or files in Camera Raw. It doesn't matter if Camera Raw is hosted by Photoshop or Bridge.
- Use Camera Raw to adjust or tweak your images. (If your images need no adjustment, you can obviously skip this step.)
- 3. Chose Save Images from the bottom left of the Camera Raw dialog box. The Save Options dialog box, shown in Figure 11-14, appears. (In the future, you can skip this dialog box by holding the Option (Alt) key when you select Save Images.

Choose a Destination from the pop-up menu shown in Figure 11-15. You can select Save in New Location or Save in Same Location. If you choose Save in New Location you can select a separate destination for your converted images.

Choose a File Naming protocol. As you can see in Figure 11-16, the choices here are similar to those you get with the Batch Rename command.

From the Save Options dialog box, you can also save your RAW file into other file formats such as JPEG, TIFF, or PSD, by selecting from the Format pop-up menu, shown in Figure 11-17. You can select and save only one file format at a time. If you want to save multiple file formats. you'll need to refer to Chapter 12.

When you choose a Format, an appropriate extension is selected. The file extension for DNG is .dng, obviously. (Uppercase is also an option.) As you can see in Figure 11-18, there are a few other options here:

- Select Compressed (lossless) and your DNG file will be about a 1/3 smaller than the original RAW file with no tradeoff in quality or flexibility. It does, however, slow the conversion process considerably.
- Select Convert to Linear Image and your file will be more than three times the size of the original RAW file. Since it is separated into separate red, green, and blue channels, you've essentially lost many of the advantages of saving RAW data. Adobe claims that in some instances, saving a demosaiced file can improve compatibility, particularly if the camera sensor contains an unusual mosaic pattern that all converters do not support.
- Select Embed Original Raw File if you want an exact copy of the original RAW file stored within the DNG file. This will create a file about 2/3 larger than the original RAW file. At this time, you'll need the Adobe DNG converter to retrieve the stored file from the DNG file.

When you select Save, you return to the Camera Raw workspace and you'll get a save status message at the bottom of the window (enlarged in Figure 11-19). It may take some time, depending on the number of files you are converting and the options you choose.

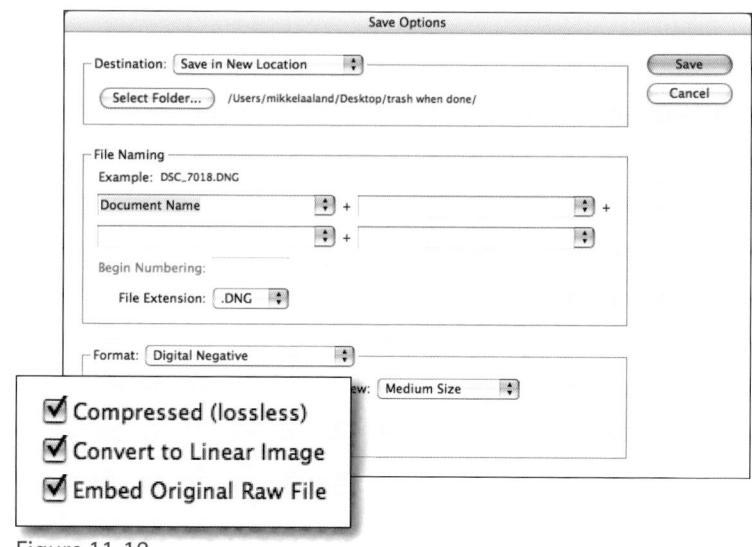

Figure 11-18

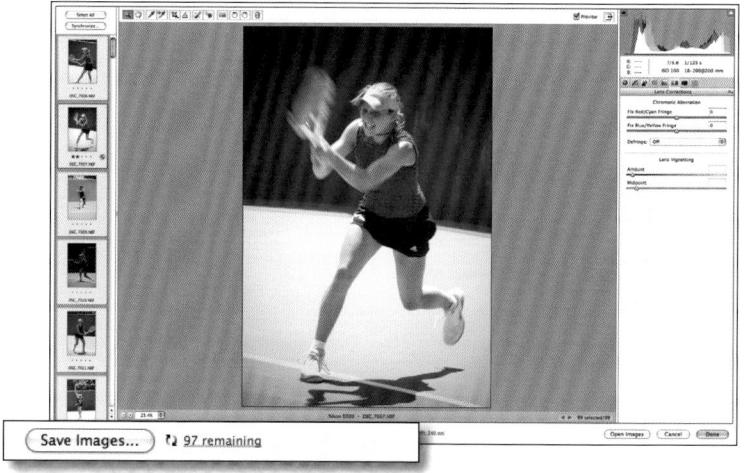

Figure 11-19

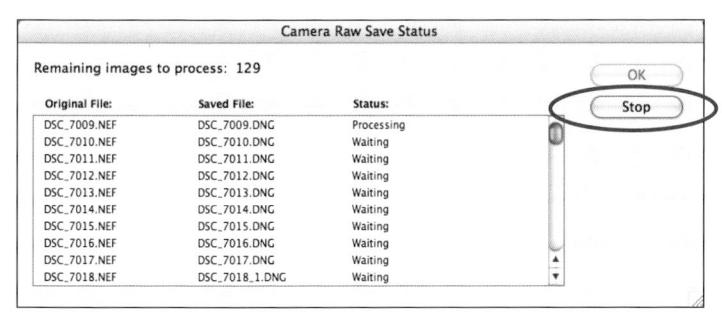

Figure 11-20

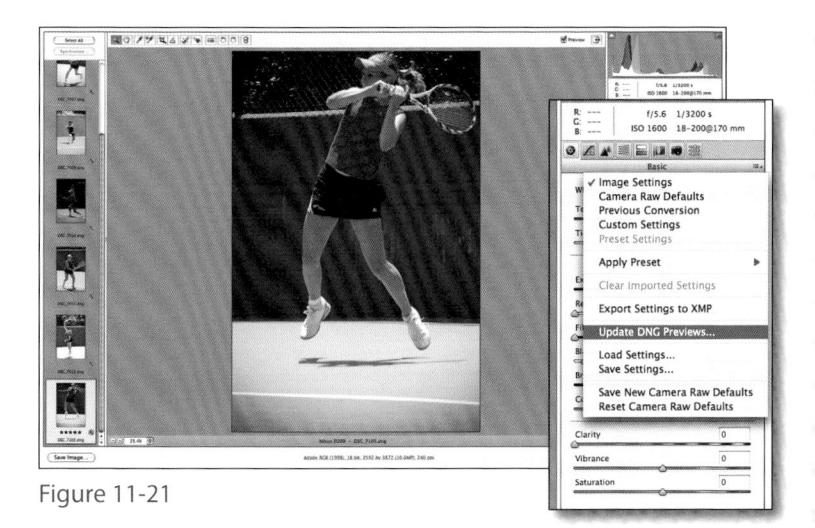

If you click on the Save Status link, you'll get a full dialog box like the one shown in Figure 11-20. When Camera Raw is hosted by Photoshop, and you select Done or Cancel while the process is occurring and you try and work in Photoshop, you'll get the dialog box again. You won't be able to use any Photoshop controls while the dialog box is present, but Bridge will still be fully operable. You can cancel the process at any time by clicking Stop (circled) from the Camera Raw Save Status dialog box.

Updating DNG Files

After you create a DNG file, you can work on the file in Camera Raw, just as you would a native RAW file. When you are finished adjusting exposure, applying sharpening, etc., select Done in Camera Raw. If you haven't changed your Camera Raw preference to update previews, the update process should be very quick. Camera Raw simply changes the metadata to reflect your changes. If you change your preference to update the preview image, it'll take longer, because Camera Raw must rewrite the entire file.

You'll see a difference in the embedded preview only if you use other applications such as Microsoft Media Expression or Photo Mechanic. Camera Raw creates its own previews on the fly. If you have multiple images open in Camera Raw, you can selectively apply the update preview image command to one or more images. To do this:

- Select the image or images you wish to update.
- Select Update DNG Previews from the drop-down menu, as shown in Figure 11-21.

 Wait as Camera Raw updates the settings, showing the status window in Figure 11-22. The time it takes to update will depend on how many images you selected and the size of the preview.

DNG File Handling Preferences in Camera Raw

You can control how Camera Raw handles DNG files in the Preferences dialog box under DNG File Handling, shown in detail in Figure 11-23.

Select Ignore sidecar ".xmp" files if you are working with legacy DNG files created with older versions of Photoshop/Camera Raw. These earlier versions created DNG files with sidecar files. This can potentially cause problems if sidecars with the same file name are available for both the DNG and original RAW file. Selecting Ignore sidecar ".xmp" files is a good idea because it prevents Camera Raw from using the wrong sidecar.

If you choose Update embedded JPEG previews, you are offered a choice of Medium Size (default) or Full Size (circled). These previews are not used when you open a DNG file in Camera Raw, but are used by cataloging programs such as Microsoft Expression Media (Figure 11-24).

Essentially, when you save a full resolution file, you create a very useful "soft proof" that reflects your Camera Raw adjustments. This proof is always part of the DNG file and can also be printed with very good results. (At this time, the full resolution preview isn't read by all third-party applications. This will change as DNG becomes more widely supported.)

Figure 11-22

Figure 11-23

Figure 11-24

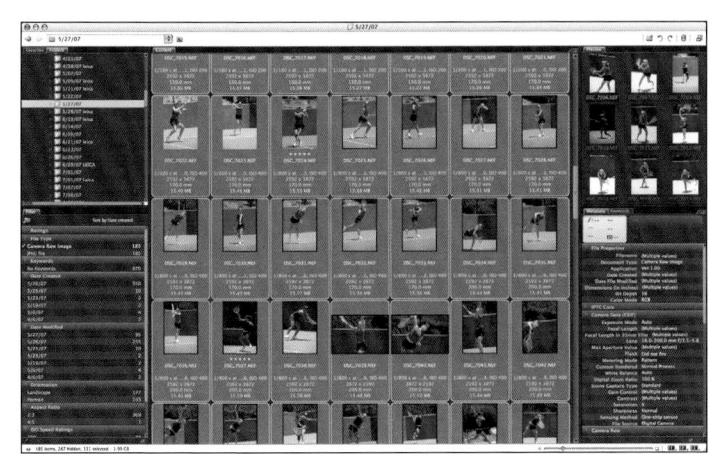

Figure 11-25

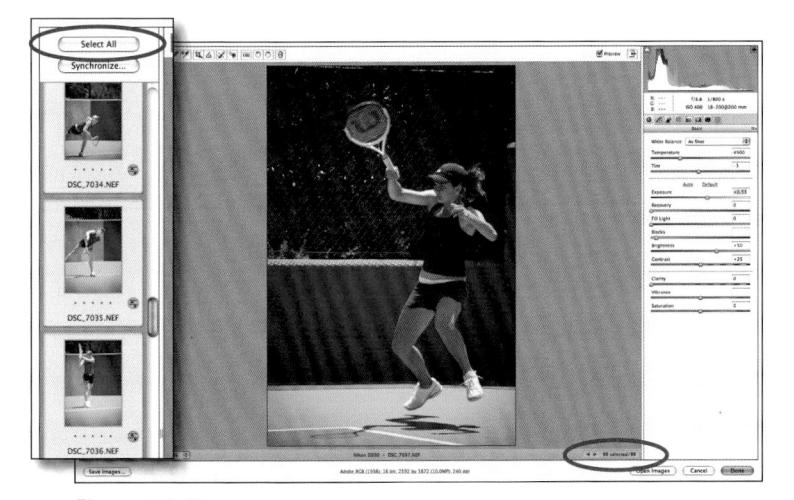

Figure 11-26

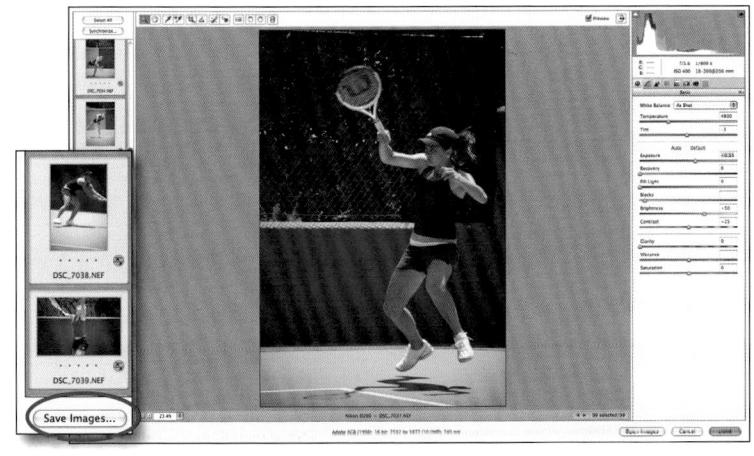

Figure 11-27

Converting Multiple Files with Camera Raw

If you want to convert a folder of images to the DNG format using Camera Raw, this what you should do:

- 1. Open Bridge.
- 2. Navigate to the folder containing the images you wish to convert to DNG. (You can also open files via Photoshop's Open command, but it's so much easier to do it from within Bridge.) Select the image files you wish to convert (Figure 11-25).
- Open the selection with Camera Raw (File→Open in Camera Raw).
- In Camera Raw, click Select All from the top left of the work area (circled in Figure 11-26).
- 5. The number of selected images should be noted on the lower right side of the Camera Raw dialog box (circled, lower right). Apply any necessary Camera Raw settings that you want to apply to all the RAW files. (White Balance, Exposure, Sharpening, etc.)
- Select Save Images from the lower left of the Camera Raw dialog box (circled in Figure 11-27).
- 7. Set the Save Options Format options to Digital Negative and select the appropriate settings. (In the future, you can bypass this dialog box by holding the Option (Alt) key when you select Save.)
- 8. Select Save from the Save Options dialog box. A save status link appears at the bottom left of the Camera Raw window. Click on it at any time and select Stop from the status dialog box to stop the process.

Using Adobe DNG Converter

Download the Adobe DNG Converter (Figure 11-28) from www.adobe.com/products/dng. It's free.

After you download the DNG Converter and open the standalone application, depending on the version you are using, you'll get a window that looks something like Figure 11-29.

At this point you should:

- Click Select Folder to navigate to the images you want to convert.
 You can only select an entire folder (with subfolders if you want) and not individual files.
- Select a location for the converted images. If you are archiving your images, you may want to choose Save in New Folder or Select Folder and save the DNG files in an offsite location.
- Select names for the converted images. You can leave the fields blank if you wish, and the original file names or numbers will be used and appended with the .dng extension.

You can use the Adobe DNG Converter to convert single RAW files or entire folders full of RAW files. At this time, you will need the DNG Converter to extract original RAW files from a DNG, regardless of whether you used Camera Raw or the DNG Converter to embed them in the DNG file.

Figure 11-28

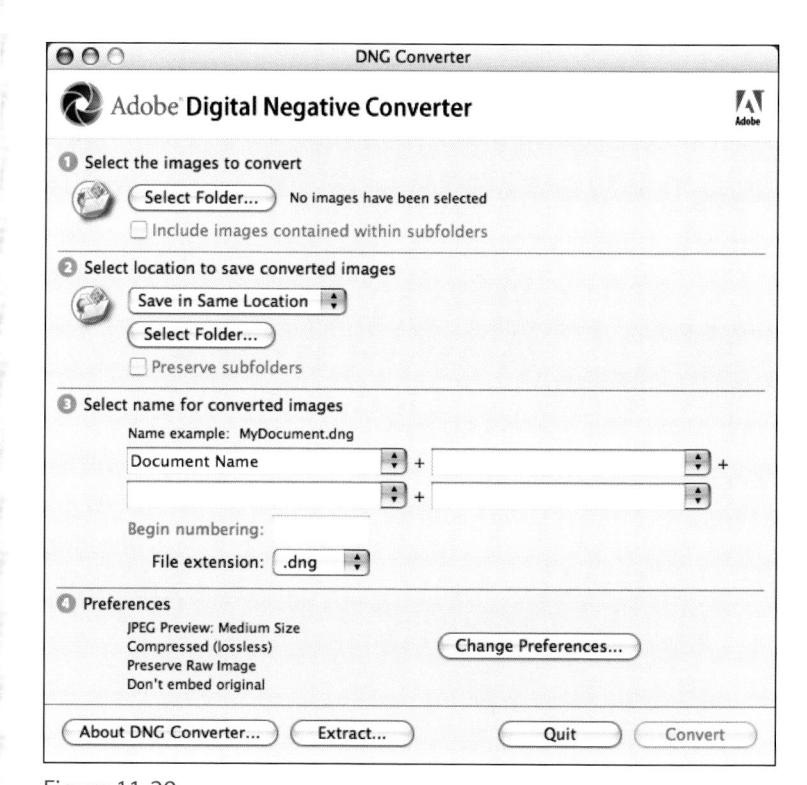

Figure 11-29

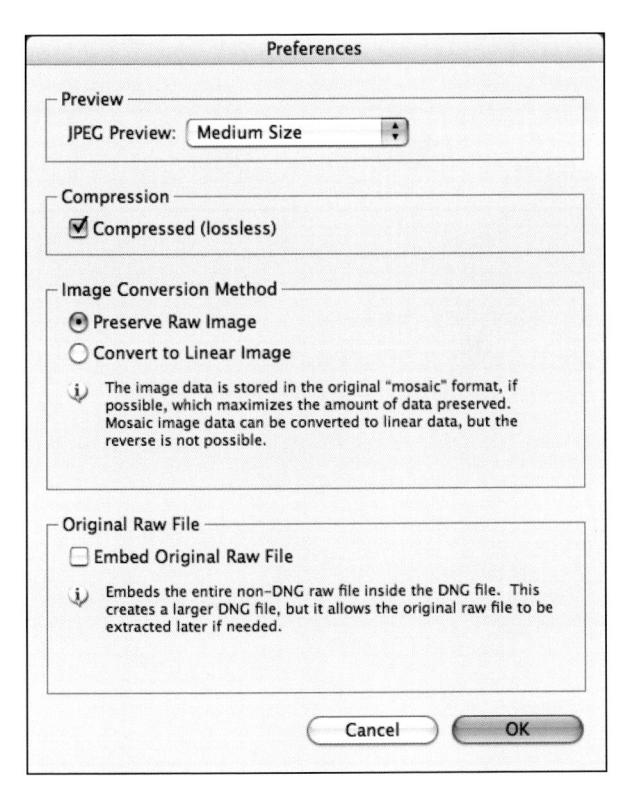

Figure 11-30

Figure 11-31

NOTE This chapter dealt primarily with RAW to DNG file conversion. JPEGs and TIFF files can also be converted to the DNG format. (JPEGs are converted to a lossless file format.) By converting to the DNG format, you get all the advantages of non-destructive editing in Camera Raw, as well as a single container containing your source file, rendering instructions, image management metadata, and a full-size preview.

- 4. Select Change Preferences and this dialog box appears. Figure 11-30 These are similar options to the ones in the Camera Raw Save Options dialog box I discussed earlier.
- 5. Select OK to take you back to the main window.
- Select Convert to start the conversion process. The amount of time it will take depends on the number of images and the various Preferences you've selected. Processing is done independently of Photoshop, Bridge, or Camera Raw.

Using the DNG Converter to Extract Original RAW Data

If you have chosen to embed an original RAW file with your DNG file, your only option (at this time) for extracting the file is to use the Adobe DNG Converter.

To extract a RAW file from a DNG file:

- 1. Open the Adobe DNG Converter.
- Select Extract from the bottom of the dialog box. The Extract Originals dialog box (Figure 11-31) will appear.

Select the location of the folder with the DNG file containing the embedded original and select a location to save the extracted original. The extraction is very quick. While the original RAW data is now available as a separate file, it is not accompanied by a sidecar containing any Camera Raw settings you may have applied to the DNG file. When you open the original RAW file in Camera Raw, it'll open with the default Camera Raw settings.

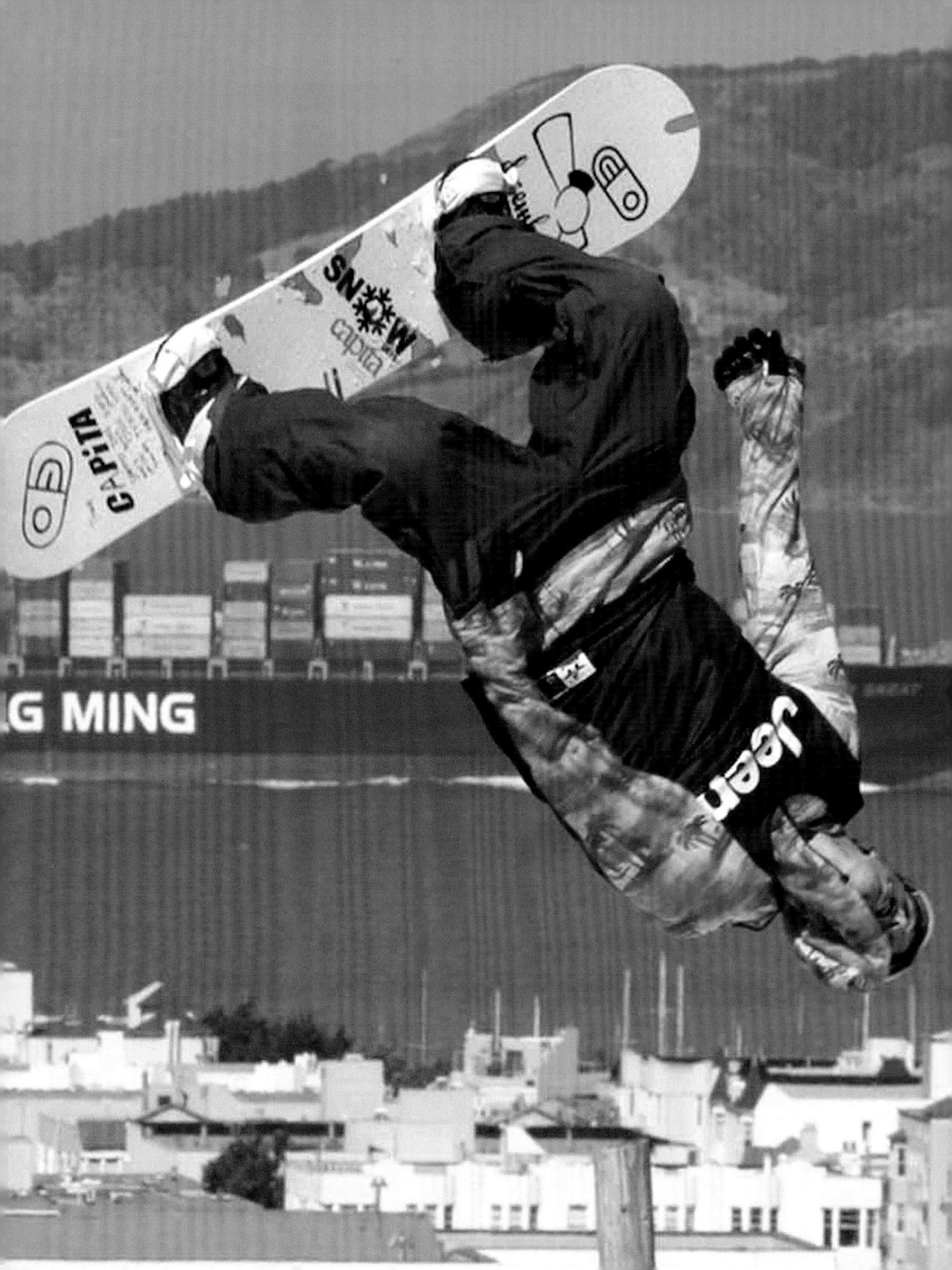

Converting and Delivering RAW

You'll rarely share your RAW files, just as you rarely shared your negatives in traditional photography. In this chapter, I'll show you how to use several of Photoshop CS3's automated tools and features to easily convert one—or several hundred—RAW file(s) into a form ready for delivery.

Not surprisingly, there are many ways to use Photoshop CS3 and its three distinct environments—Bridge, Camera Raw, and Photoshop—to help you convert and deliver your RAW images. While there is no single, one-click process that will take you everywhere you want to go, there are several automated commands, which, when used on top of each other, should do the trick.

Chapter Contents

Using Bridge + Image Processor to Convert RAW Files

Applying Custom Camera Raw Settings to Multiple Images

Using Camera Raw's Save Command

Automating Contact Sheets, Picture Package & Web Photo Gallery

Using Batch and Actions

Writing Custom Scripts

Using Bridge with Image Processor to Convert RAW Files

You can launch Image Processor from either Bridge or Photoshop. In Bridge, select Tools→Photoshop→Image Processor; in Photoshop, choose File→Scripts→Image Processor. Either method will bring up the screen you see in Figure 12-1, albeit with slight variations in the user interface.

TIP You can also use one of the other Photoshop CS3 automated processes and quickly turn the TIFF or PSD files into a printable—or electronically delivered—contact sheet, picture package, or web photo gallery, ready for sharing. I'll get into this subject a bit later in the chapter.

To illustrate how Image Processor works, I'll turn to the work of photographer Maggie Hallahan. I'll demonstrate her process using a shoot she did for Corbis, her stock photo agency. The event she photographed was a mid-October ski jump in the middle of crowded San Francisco, featuring trucked-in snow and world-class ski jumpers.

The easiest way to convert RAW files into a more readily shared file format is to use Bridge's Image Processor which produces up to three versions of your RAW file: a JPEG, a TIFF, or a PSD, any of which can be sent by email, posted on an FTP site, burned to a CD, or incorporated into a printed or electronic contact sheet.

	Image P	rocessor				
Process files from Bridge only (1) Open first image to apply settings Select location to save processed images						
						(E)
9	Select Folderkkelaaland/Pictures					
File T	ype					
	Save as JPEG	Resize to Fit				
	Quality: 9	W: 500 px				
	✓ Convert Profile to sRGB	H: 1000 px				
	Save as PSD	Resize to Fit				
	✓ Maximize Compatibility	W: px				
		H: px				
	Save as TIFF	Resize to Fit				
	LZW Compression	W: px				
		Н: рх				
Prefer	ences					
Ru	n Action: Default Actions	test 1	*			
Copyr	ight Info:					
☐ Inc	lude ICC Profile					

Figure 12-1

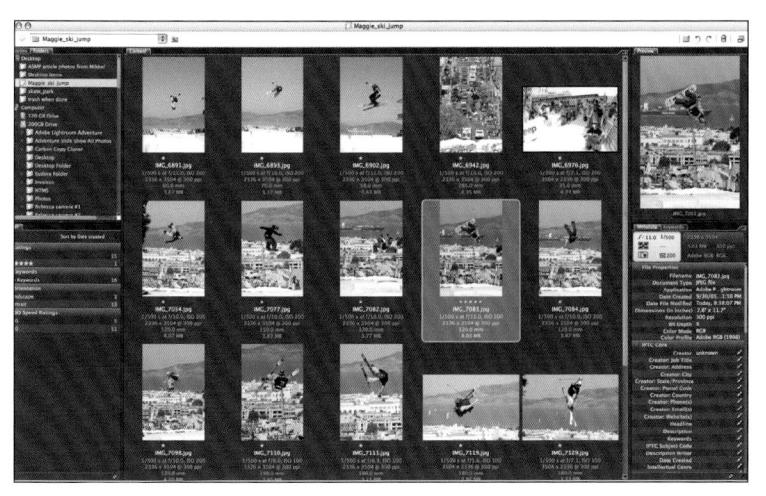

Figure 12-2

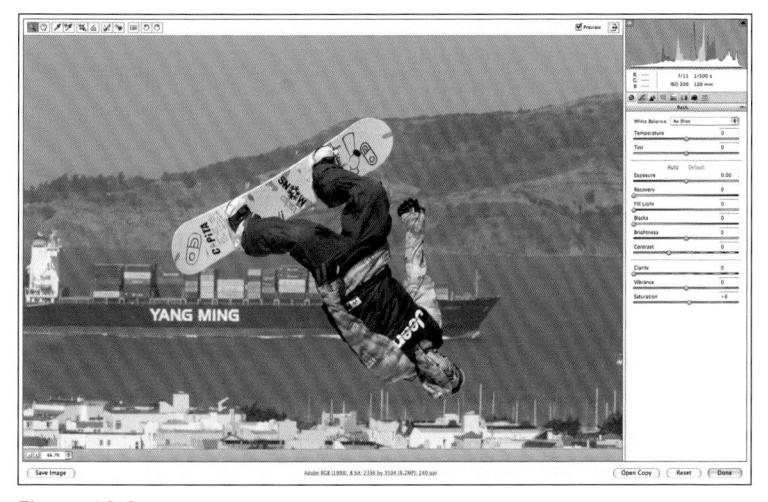

Figure 12-3

Figure 12-4

Maggie always begins her process by downloading the files from her camera with a FireWire card reader onto her portable's internal hard drive. Back in her studio, she puts all the images from a shoot into one folder and backs up the images on an external drive. She then uses Bridge to edit and sort the RAW files (see Chapter 3). She also adds copyright information and other metadata, such as a description of the contents of the shoot (using Bridge's Metadata panel), and a custom metadata template. Maggie ends up with a Bridge window that looks something like the one shown in Figure 12-2. Let's follow what Maggie does next step-by-step:

- 1. Open a representative image in Camera Raw and process it to get a look you like. In Maggie's case (Figure 12-3), for the ski jump images, there wasn't much to do. She increased saturation slightly, but left most everything else alone. She set the Space to Adobe RGB (1998) and Depth to 8 Bits/Channel, because that's what the client required.
- Create a custom setting with a specific name. Maggie named hers ski_jump. (From the Settings menu, revealed by clicking the icon circled in Figure 12-4, select Save Settings, select subsettings, Save, and type in a descriptor.) Select Done
- 3. Back in Bridge, select all the images you wish to deliver. (Edit→Select All, or use the keyboard shortcut #-A or Ctrl-A). Maggie then applies the custom Camera Raw setting to all the images. (Edit→Develop Settings→Setting of Choice.) For more on this, and how to create a custom setting, see the next section.

 Once the processing is complete, Maggie is ready for the easy part, using Image Processor. Open Image Processor (Tools→Photoshop→Image Processor), as shown in Figure 12-5.

5. Set the settings as shown in Figure 12-6.

Here are more details on the various Image Processor options:

- Select the Images to Process If
 you are working from within Bridge,
 "Process files from Bridge only"
 (Figure 12-7) is your only choice.
 (From Photoshop, you can use Image
 Processor on open images or navigate
 to a particular folder.)
- Open first image to apply settings If you select this option, you can adjust the setting in the first image to your satisfaction and then apply the same settings to the remaining images.
 Maggie didn't do this because she had already applied a Camera Raw setting to all her RAW files before selecting Image Processor, which, in my opinion, is a better way to go.

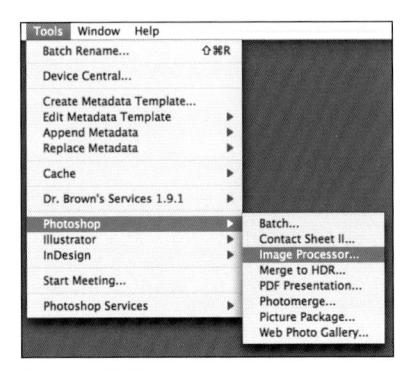

Figure 12-5

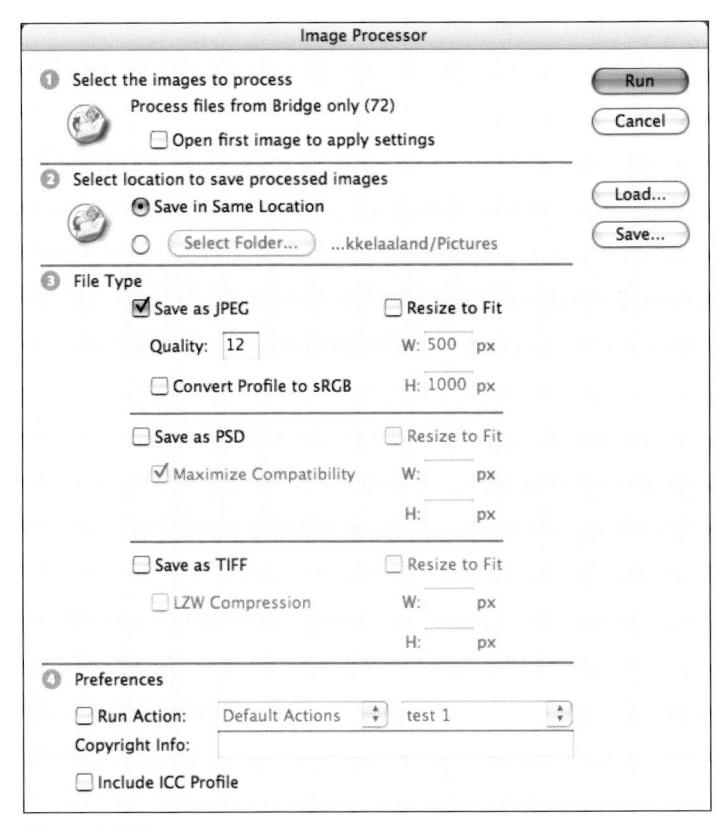

Figure 12-6

Figure 12-8

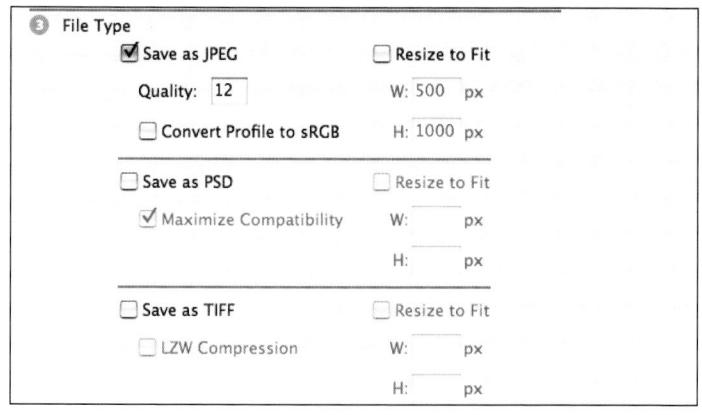

Figure 12-9

Figure 12-10

Figure 12-11

Figure 12-12

- Select thesave location for processed images. You can process the same file multiple times to the same destination by choosing the option shown in Figure 12-8.
 A subfolder is created for each file type.
- In the File Type area, you have the following choices.
 - Save as JPEG Saves images in JPEG format within a folder called JPEG (Figure 12-9).
 - Quality Sets the JPEG image quality between 0 and 12. (Maggie always chooses 12 for maximum quality.)
 - Resize to Fit Resizes the image to fit within the dimensions you enter in the Width and Height fields (Figure 12-10). The image retains its original proportions. (This is great if you want to quickly convert a series of images to a specific size. You can also set your size in Camera Raw, which, in some cases, may produce better results.)
 - Convert Profile To sRGB Converts the color profile to sRGB (Figure 12-11). Again, you can choose a color space in Camera Raw. Make sure that Include ICC Profile is selected if you want to save the profile with the image.
 - Save as PSD Saves images in Photoshop format within a folder called PSD in the destination folder (Figure 12-12).
 - Maximize Compatibility This option is not relevant to RAW files. However, if selected, it saves a composite version of a layered image within the target file for compatibility with applications that can't read layered images, increasing file size significantly.

Dr. Brown's 1-2-3 Process

Image Processor is great, and it ships with CS3, but there is another image processor that you can download for free which provides even more options and might be be more useful. It's called Dr. Brown's 1-2-3 Process (Figure 12-13), and It's provided as a public service by Adobe's Russell Brown, who actually came up with original Image Processor. It's available at www.russell-brown.com/tips_tech.html. Follow the download installation guide.

Dr. Brown's 1-2-3 Process works in fundamentally the same way as Image Processor. However, there are several more options, which I'll outline here.

- If you select Save in sub-folder (Figure 12-14), each file format is placed in separate folders, with names of your choice.
- Not only can you choose the PSD, TIFF, JPEG formats, but GIF as well. GIF is a web-friendly file format that converts images to 256 or fewer colors (Figure 12-15).
- 3. With Dr. Brown's 1-2-3 Process, you can select and apply a Photoshop Action on a file-format-by-file-format basis (Figure 12-16), rather than applying globally to all.

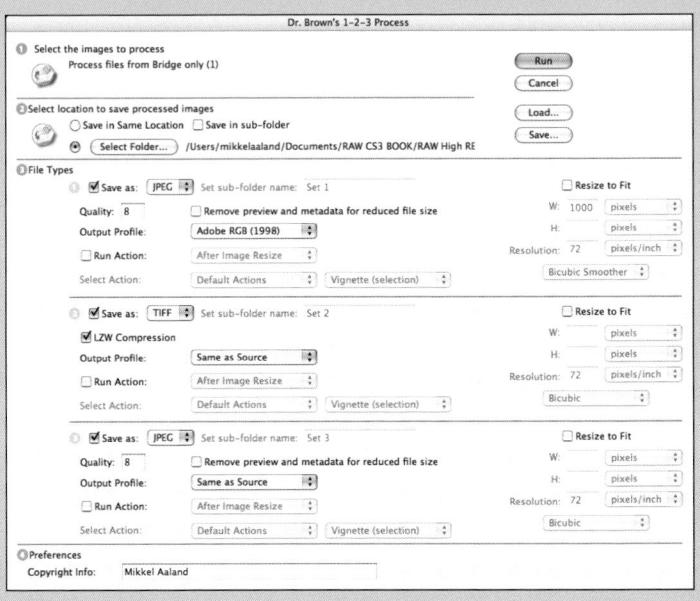

Figure 12-13

Figure 12-14

Figure 12-15

Figure 12-16

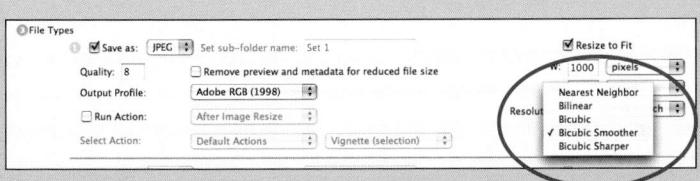

Figure 12-17

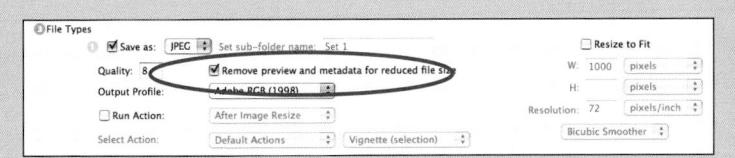

Figure 12-18

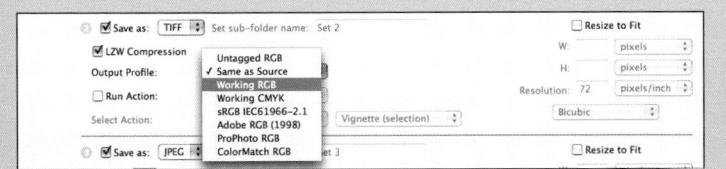

Figure 12-19

- 4. If you select Resize to Fit (Figure 12-17), not only will you be able to resize up or down to a specific size and resolution, but you can also choose the method of interpolation. Frankly, I find this one of the most compelling reasons to take the time to download and load the new image processor. Now when you resize up, for example, and choose Bicubic Smoother, you will get a better result than if you had simply used Bicubic. If you resize down, choose Bicubic Sharper for better results. Again, you can make resampling choices on a file-format-by-file-format basis.
- 5. If you select JPEG as one of your file format choices, not only will be you be able to choose the Quality amount (and therefore the file size), but if you select "Remove preview and metadata for reduced file size," you'll get just that: an even more reduced file size (Figure 12-18).
- 6. Under Output Profile, you can choose a color space (Figure 12-19)! This is another compelling reason to use Dr. Brown's script. You can do this on a file format by file format basis, and choose from ProRGB, Adobe RGB, sRGB, and more.

- Save As TIFF Saves images in TIFF format within a folder called TIFF in the destination folder (Figure 12-20).
- LZW Compression Saves the TIFF file using the LZW compression scheme, which is lossless.
- The Preferences section of the screen contains the following items:
 - Run Action (Enlarged in Figure 12-21)
 Checking this box runs a Photoshop action loaded in the Actions palette.
 You can, for example, run an action that applies specific sharpening to an image based on output. However, keep in mind that the sharpening occurs before any resizing, making it useful only if you don't apply any resizing using Image Processor. (If you resize with Camera Raw, it won't matter.) I'll cover creating and using actions later in the chapter.
 - Copyright Info Includes any text you enter in the IPTC copyright metadata for the file. Remember, text you include here overwrites the copyright metadata in the original file, which is why Maggie left it blank.
 - Include ICC Profile Checking this box embeds the color profile with the saved files.

When you've made all your selections, click Run. Image Processor converts and processes multiple files, using the original RAW data for each conversion. The amount of time it takes depends on several variables, including processor speed, number of files, and how many file formats are selected. The final images are neatly organized in appropriate folders, as you can see in Figure 12-22.

Figure 12-20

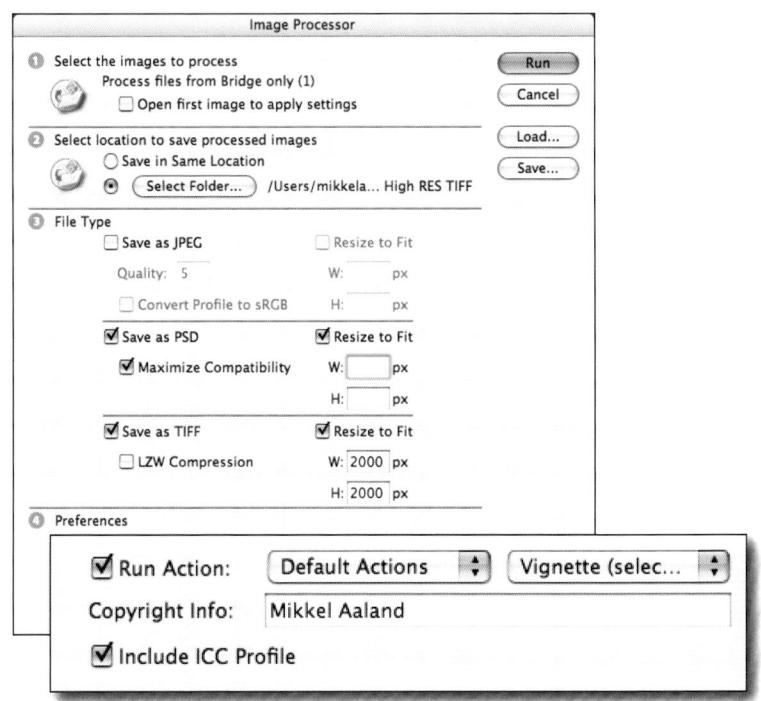

Figure 12-21

Figure 12-22

With multiple RAW images that require similar adjustments, you can apply a custom setting to them all at once. Knowing how to do this quickly and efficiently is critical, especially if you don't want to spend your day in front of a computer screen. In this section, I'll cover using Camera Raw to accomplish this task.

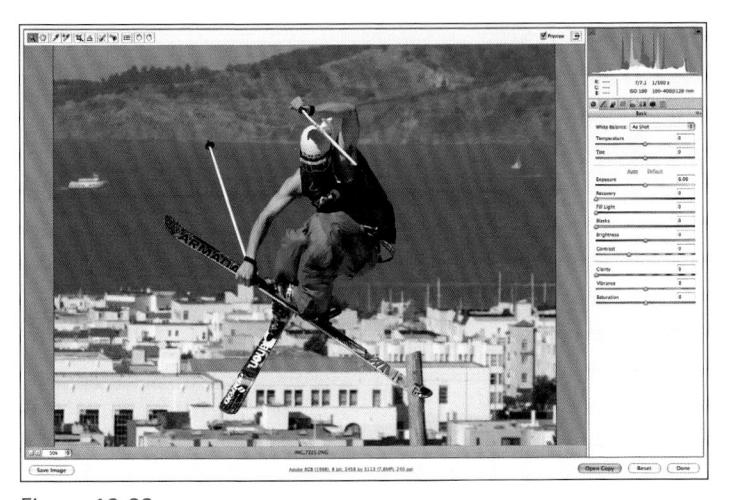

Figure 12-23

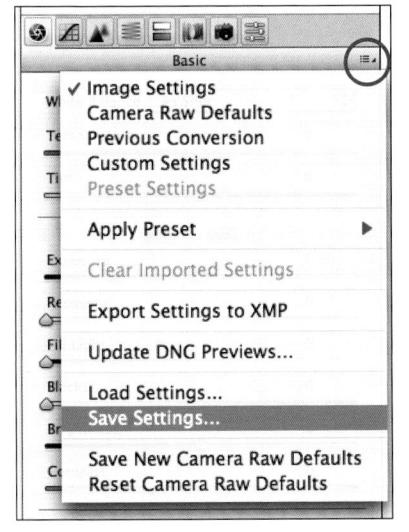

Figure 12-24

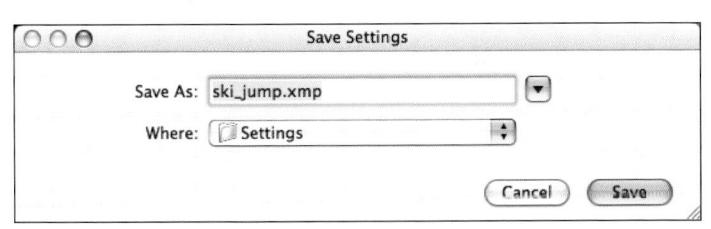

Figure 12-25

Applying Custom Settings to Multiple RAW Images

To apply Camera Raw settings to multiple images in Bridge at once:

- Select one key image that represents the majority of the images you are working with. In this example, Maggie Hallahan selected the shot of Olympic skier Jonny Moseley flying above San Francisco with crossed skis.
- 2. Open the image in Camera Raw, as shown in Figure 12-23.
- Optimize the image using Camera Raw color, exposure, and sharpening settings. (For more on this, see Chapters 5 through 8.)
- Select Save Settings from the Settings menu, shown in Figure 12-24. (I circled the tiny Settings icon so you can see where to click to get the menu.)
- 5. Choose a Subset, select Save, name your preset in the Save Settings dialog, and select a destination (Figure 12-25). It's best to keep it in the default Settings folder—otherwise, the setting may not show up in Camera Raw's Settings pop-up menu, which means you'll have to manually navigate to it via the Camera Raw Load Settings option. (It might not show up as an option in Bridge either.) Select Save.

- 6. In Bridge, select the images to which you wish to apply the custom settings.
 Right-click the selection and choose
 Develop Settings, and select the preset of choice. (In this case, Maggie chose ski_jump, as shown in in Figure 12-28.) Select Previous Conversion or Camera Raw Defaults if these are more appropriate. (You can also apply Camera Raw settings from the menu bar by choosing Edit→Develop Settings.)
- 7. You'll notice the thumbnails change, reflecting the new settings. A small icon with two triangles will appear at the bottom right of the thumbnail to indicate Camera Raw settings have been applied.

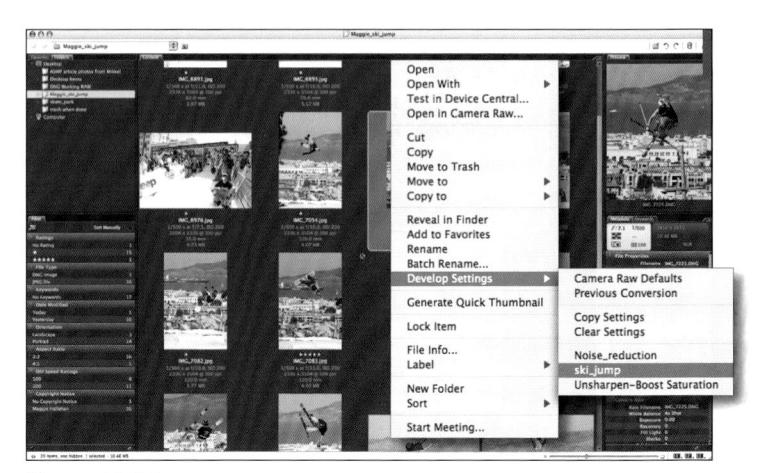

Figure 12-26

Save Settings Subset

You can create custom Camera Raw settings that contain selective Camera Raw adjustments. For example, you can selectively apply settings from Basic tab controls, but not settings from the other tabs. To do this:

- Select Save Settings from the Settings pop-up menu, as shown in Figure 12-27.
- 2. The choices in Figure 12–28 appear. You can deselect the ones you don't want applied.
- You can also choose from several pop-up presets (enlarged detail).

When you select Save, you'll get the Save Settings dialog box, where you can name the setting and select a destination. Again, it's best to keep settings in the default Settings folder. If you don't, the settings may not show up where you want them to.

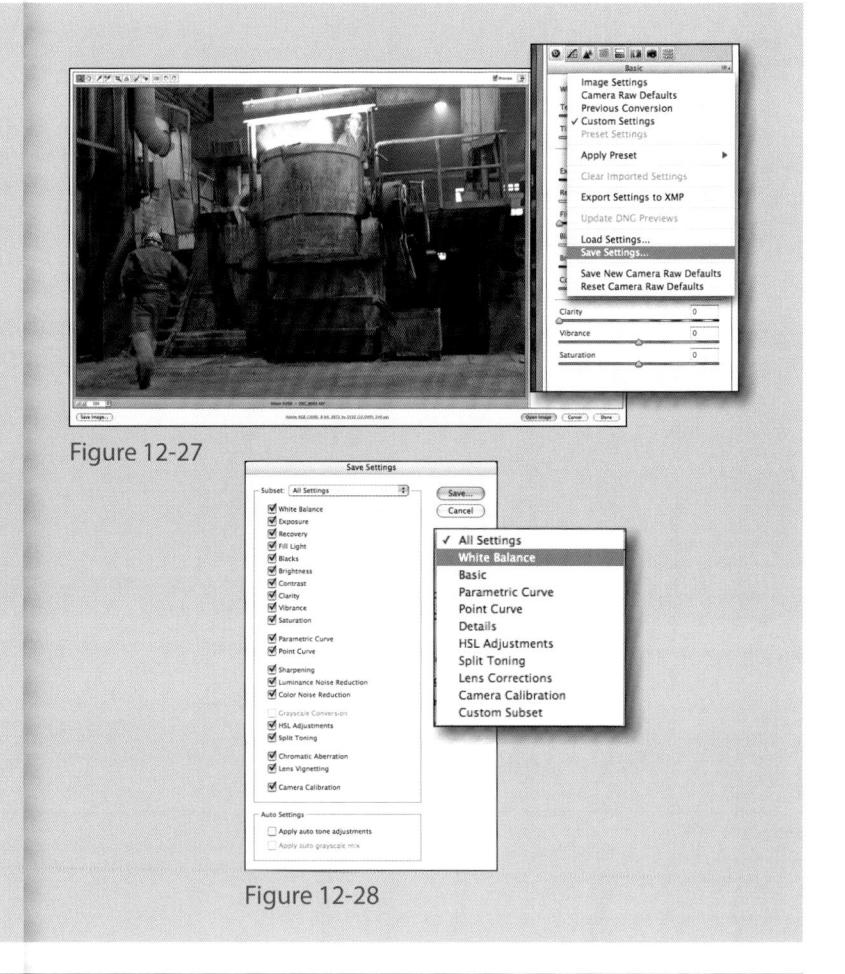

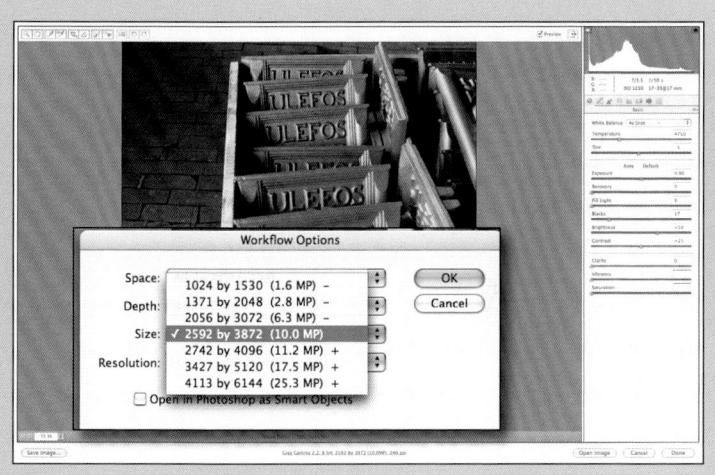

Figure 12-29

Bicubic Sharper (best for reduction)

Where Should You Resize?

Many digital cameras produce images with pixels to spare, and there are many times when sizing down is necessary. On the other hand, there are times when you want more pixels and you want to sample up. Camera Raw offers preset Size options (enlarged in Figure 12-29), both to sample up and to sample down. Then again, you can also resize in Photoshop via the Image Size dialog box (Image→Image Size). Where is the best place to resize? This is what I suggest:

- Resize in Camera Raw when speed and workflow are an issue. The quality is good, but you don't have as many size options as you would in Photoshop, and the options you have depend on the pixel dimensions of the original shot.
- Resize in Photoshop when you need specific sizes not offered by Camera Raw, or if you want more control over the way resizing occurs. Not only does Photoshop provide a choice of interpolation methods (Bicubic, Bicubic Smoother, etc., as you can see in Figure 12-33), but you can also easily create an action or script to sample up or down in increments and add a slight sharpening at each step—the method acknowledged by many professionals as the best. (New Bicubic choices make incremental sharpening less desirable-Bicubic Sharper when sampling down, and Bicubic Smoother when sampling up—but I have no hard evidence to support this.) Third-party tools, like Genuine Fractals, are also available.

Using Camera Raw's Save Image

Let's see how:

- 1. Open one or several images in Camera Raw. Using #-R (Ctrl-R) to open the files will ensure Camera Raw is hosted by Bridge, which is what you want. That way, Camera Raw can run the conversion in the background while you maintain use of both Photoshop and Bridge. When you try to open 10 or more images, you get the polite reminder shown in Figure 12-31. Select OK.
- In Camera Raw, click on Select All (circled at the top left in Figure 12-32). Now all the thumbnails on the left are selected and the image browser on the lower right will reflect the total number of images.
- 3. Select "Save Images..." from the lower left of the Camera Raw dialog box. The Save File dialog box, shown in Figure 12-33, appears. Here you can choose a destination for your converted images, custom file names, and format: TIFF, PSD, JPEG, or DNG. (I covered DNG in the previous chapter.) Each format offers different save options.

You can also convert multiple or single images to another file format directly from within Camera Raw. Using Camera Raw this way over Image Processor gives you more renaming options—however, unlike Image Processor, Camera Raw converts to only one file format at a time.

Figure 12-31

Figure 12-32

	Save (Options		
Destination: Save in New L	 ncel			
File Naming Example: DSC_0077.JPG				
Document Name	* +		 +	
	+	- 2	•	
Begin Numbering: File Extension: JPG	•			
(V-				
	•			
Format: JPEC Quality: 8 High	*			

Figure 12-33

Figure 12-34

Figure 12-35

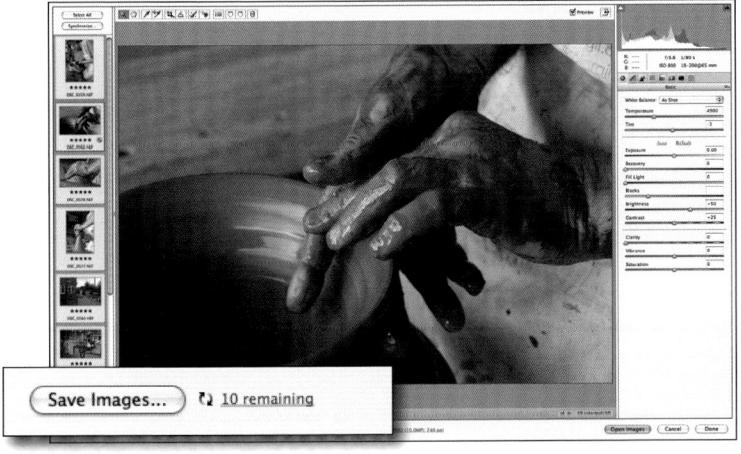

Figure 12-36

- JPEG, shown in Figure 12-34, offers different quality settings.
- TIFF offers three types of Compression settings: None, LZW (which is lossless), and ZIP, which is also lossless and offers better compression, but is slower and potentially problematic when opening in other applications.

- The Photoshop format (circled in Figure 12-35) is the only format that offers to "Preserve Cropped Pixels." If you don't select it, cropped pixels are discarded in the conversion. This is an option only if you have used Camera Raw's crop tool. This creates a PSD file without a background layer, in which the canvas size is larger than the document size, in order to hold the extra data.
- 4. After selecting a file format (you can choose only one at a time), select Save. You'll get a link at the bottom left of the Camera Raw window, such as the one shown in Figure 12-36. (Click on the link to open the Camera Raw Save Status dialog box, where you can cancel the operation by selecting Stop.) You are now free to select Done and return to Bridge, or you can select Open Image(s) and have your images open in Photoshop.

Working RAW

This is the Bulgarian tennis star Tanya Raykova, spread out on the tennis court with an ice pack on her leg. Download the RAW file from the O'Reilly site and use the Adobe Camera Raw HSL controls. The green background provides a readymade canvas to easily observe how the Hue, Saturate, and Luminance controls work.

Archiving the Camera RAW Database

Camera Raw settings are saved as individual XMP sidecar files, like the ones listed in Figure 12-37 (except DNGs), or in a central Adobe Camera Raw Database like, those shown in Figure 12-38.

You choose which location by setting Camera Raw Preferences (Figure 12-39), accessed either through Bridge or in Camera Raw. Knowing where this data is saved is especially important when you go to archive your RAW files on an external hard drive or removable media. If your settings are saved as XMP sidecar files, it's very straightforward: simply transfer and backup the XMP files along with the original RAW files. They'll share the same file name, albeit with a different extension. If the settings are saved in a Camera Raw database, it's more problematic. For single or multiple images that are open in Camera Raw, selecting Export Settings to XMP from the Settings menu (Figure 12-40) will generate XMP sidecar files if there aren't any.

Short of that, you'll need to locate the Camera Raw database on your hard drive and archive it as well. (On Windows, it's in the Application Data folder as Document and Settings/user name/ Application Data/ Adobe/Camera Raw. On Mac OS it's in the user's Preferences folder as Users/user name/Library/Preferences.) Of course, all this is an argument for using the DNG file format, which saves the Camera Raw settings together with the image data in one file. (I covered DNG in Chapter 11.)

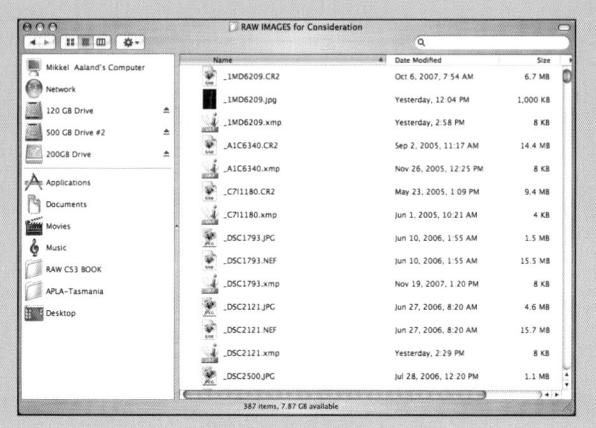

Figure 12-37

Figure 12-38

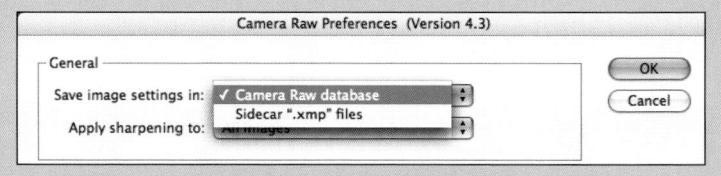

Figure 12-39

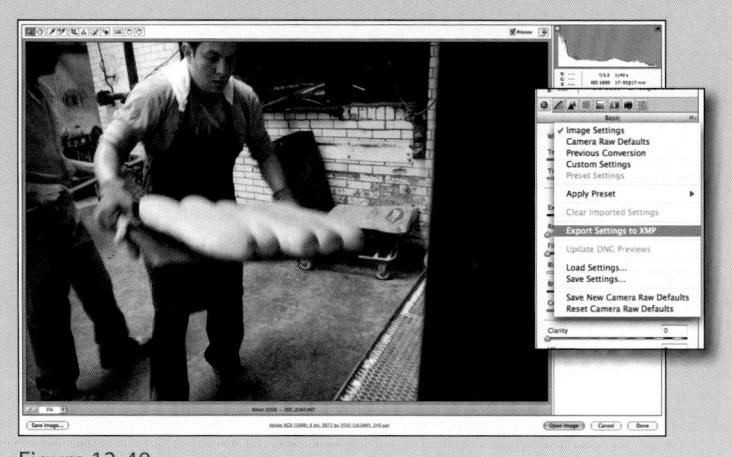

Figure 12-40

In this section, I'll show you how to use automated techniques to make a printable contact sheet, a PDF file containing an emailable version of your contact sheet, and a Picture Package. Finally, I'll show you how to create a Web Photo Gallery that's ready for posting on the Web.

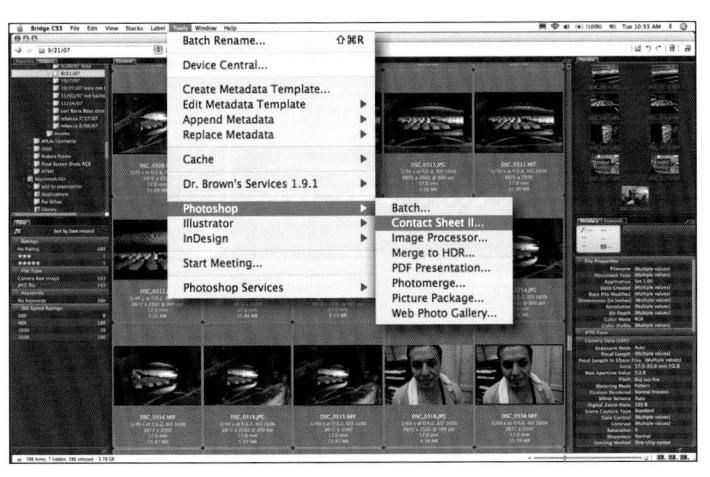

Figure 12-41

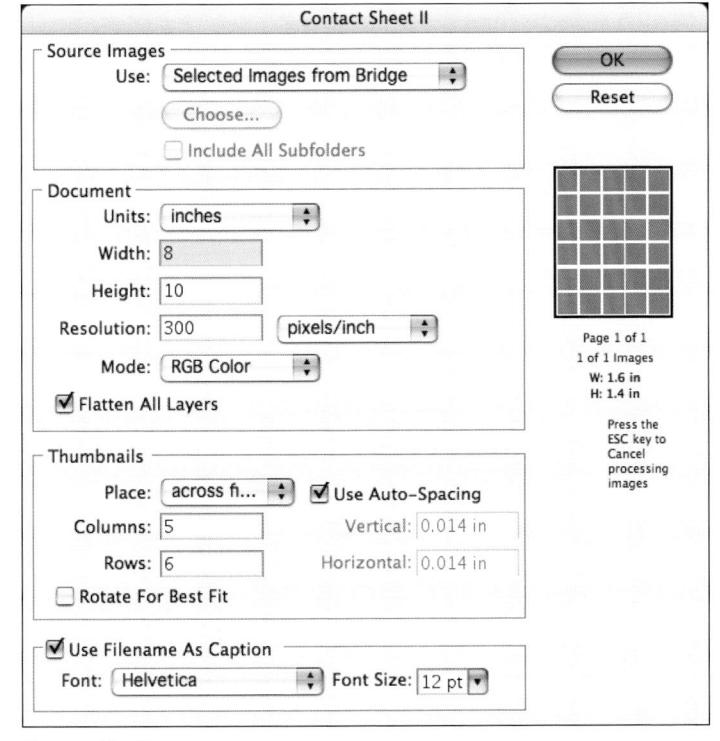

Figure 12-42

Automating Contact Sheets, Packages, and Web Galleries

You can use these automation commands directly on a RAW file, or, if you've converted your RAW files into TIFFs or PSDs, you can apply them directly to these files. If you apply the automation commands to JPEG conversions, quality will suffer. All the automation commands are available via Photoshop, but I suggest using them directly from Bridge, as shown in Figure 12-41. This way, you'll have direct access to images displayed in Bridge. (Using Bridge as a source is not possible when you start from Photoshop.)

Creating a Printable Contact Sheet

We'll start by creating a simple printable contact sheet:

- Select your RAW, PSD, or TIFF files in Bridge.
- 2. SelectTools→Photoshop→Contact Sheet II from the Bridge menu bar.
- Select your Source Images
 (Selected Images from Bridge)
 from the Contact Sheet II dialog
 box, shown in Figure 12-42.
 Determine the size of your
 document and the resolution. If
 you want, select Use Filename as
 Caption, so the person viewing
 your work can reference their
 image choices. Click OK.

Converting the Contact Sheet to PDF

Once you've created it, you can print your contact sheet. But if you want to share it electronically via email, I suggest converting the sheet into a PDF file. A PDF file can contain multiple sheets at a reasonable file size. It's best to do this from within Photoshop, after you have created your contact sheet.

To convert to PDF:

- From within Photoshop, after
 Contact Sheet II has finished
 creating the contact sheets, select
 File→Automate→PDF Presentation, as
 in Figure 12-43.
- 2. Select Add Open Files, Multi-Page Document, and then Save.
- When the Save Adobe PDF dialog box appears (Figure 12-44), make the appropriate selections. For example, if you want the optimal email size, select Smallest File Size from the Adobe PDF Preset pop-up menu.
- You can also restrict viewing and printing by selecting the Security tab (Figure 12-45) and selecting the appropriate boxes.

Creating a Picture Package

Photoshop's Picture Package is a tool for automatically creating a variety of layouts with your images that otherwise would be very time-consuming.

To create packages:

 Select your RAW, PSD, or TIFF files in Bridge.

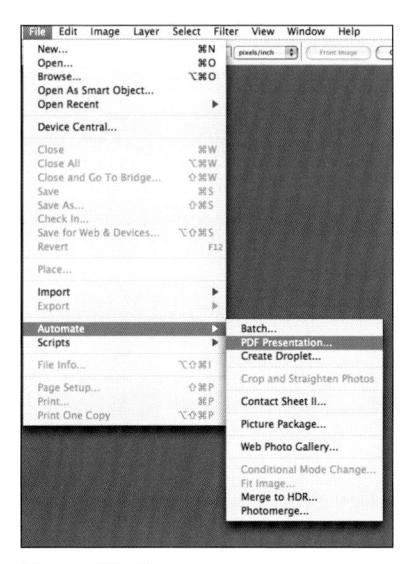

Figure 12-43

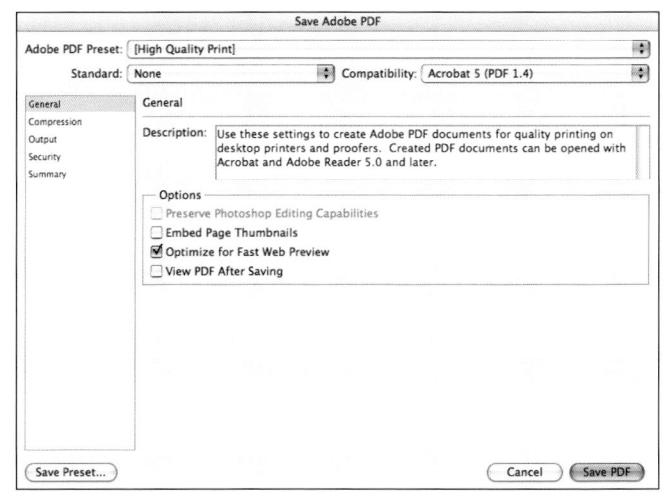

Figure 12-44

Figure 12-45

Figure 12-46

Figure 12-47

Figure 12-48

- Select Tools→Photoshop→Picture
 Package from the Bridge menu bar.
- 3. Select your Source Images (Selected Images from Bridge) from the Picture Package dialog box (Figure 12-46).

 Determine page size, layout, resolution, and mode. You can then add labels and custom text. Picture Package offers many options, including the ability to include a variety of different images on the same page. (For more on this, refer to Adobe's online help.) Click OK.

Creating a Web Photo Gallery

With the Web Photo Gallery command, it's easy to convert a selection of RAW images into an interactive online gallery. Photoshop creates both thumbnail and full-size images, as well as the HTML pages and navigable links. To use the Web Photo Gallery command:

- 1. From within Bridge, select the images you wish to share.
- Select Tools→Photoshop→Web Photo Gallery from the Bridge menu bar, as shown in Figure 12-47. This will launch Photoshop if it isn't already open.
- 3. Select your Source Images (Selected Images from Bridge) and a destination from the Web Photo Gallery dialog box, shown in Figure 12-48. Choose an appropriate style and enter descriptive text. Be sure Web Photo Gallery is set to include a filename under each image, so those who view your work can reference their choices. Click OK. (For more on creating galleries and posting your content on the web, I suggest you refer to Adobe's online help.)

Using Batch and Actions

If you want to apply an existing action to a batch, start by evoking the Batch tool from Bridge. Select Tools→Photoshop→Batch from the Bridge menu bar, as shown in Figure 12-49.

This opens the Batch dialog box in Photoshop (Figure 12-50). Here you can select any preexisting action you have loaded.

Most of the time, you'll want to create a specific action for a specific batch of images. For example, I'm going to resample up a group of portraits to a specific size not available in Camera Raw. Because the final destination is a high-quality printer, I'm going to resample up in increments and add a sharpening step after each resize. (Image Processor adds a sharpen Action before resizing, which isn't very useful.)

Photoshop power users have long used actions—playable recordings of a series of commands and tasks—to automate their work. The Batch Command is used to apply the action to an entire folder or selection of images and can easily be used to convert your RAW images into a form ready for sharing.

Figure 12-49

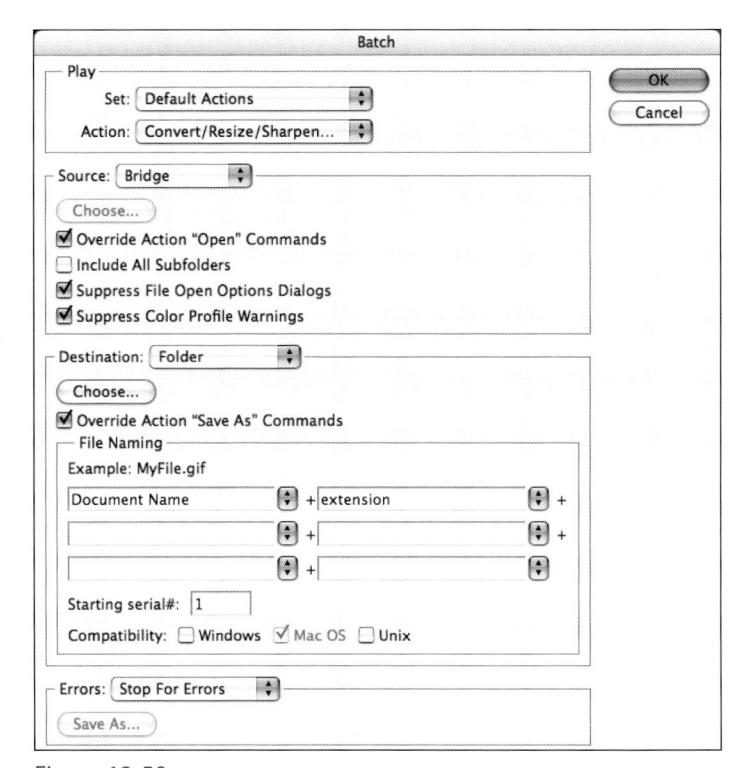

Figure 12-50

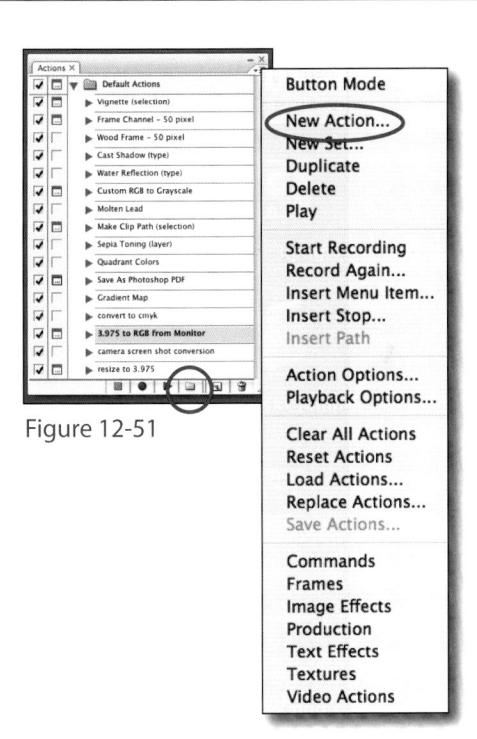

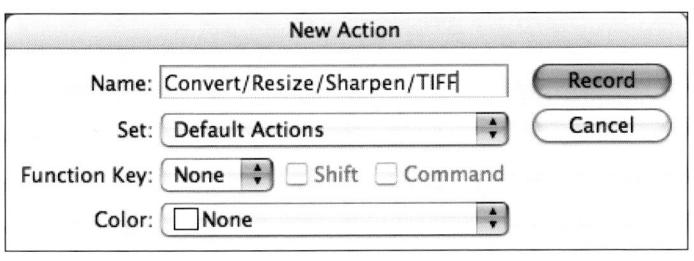

Figure 12-52

Figure 12-53

Let's start by creating the action in Photoshop, and use Bridge to apply a Batch/Action to a group of selected RAW files. From Photoshop:

- Open the Actions palette by choosing Window→Actions.
- 2. In the Actions palette, either click the New Action button, or choose New Action from the Actions palette flyout menu (Both options are circled in in Figure 12-51).

- Name your Action. In Figure 12-52, you can see I've named mine Convert/ Resize/Sharpen/TIFF.
- 4. Click Record.
- Open a RAW file using the Photoshop File→Open menu (Figure 12-53). It'll open in Camera Raw. (It doesn't matter which image you use. We're only interested in capturing the Camera Raw settings.)
- 6. In Camera Raw, select the appropriate workflow settings. (I've selected Adobe RGB and 8 Bits/Channel. I kept the size at its original camera setting.)

- 7. In the Settings pop-up menu, select either Image Settings or Camera Raw Default. Be sure to make the right choice. If you know Camera Raw Default is the way you want to go, fine. However, if you are working with RAW files that have been previously edited in Camera Raw with custom settings, you'll want to select Image Settings. This way, the settings particular to each image, from the Camera Raw database or sidecar XMP files, are applied when you batch process (Figure 12-54).
- 8. Select Open and wait until the RAW file is open in Photoshop.
- Select File→Image Size from Photoshop's main menu. The dialog box in Figure 12-55 opens.

10. My final size is 20 inches by 30 inches, but I'm going to resample up in approximately 50% increments. First, I'll enter 12 inches in the Width box. As long as Constrain Proportions (circled in Figure 12-56) is selected, the Height is automatically set to 18.048. I'll also change my resample method from Bicubic to Bicubic Smoother. If you resample down, I recommend using Bicubic Sharper.

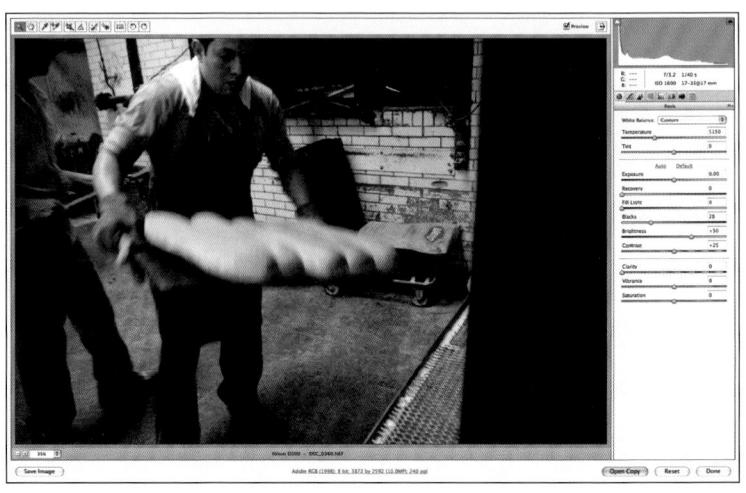

Figure 12-54

Figure 12-55

		Image Size	
Pixel Dime	ensions: 35	.7M (was 17.2M)	ОК
Width:	2880	pixels 🗘 🗇	Cancel
Height:	4332	pixels 🗘 🕽	Auto
Documen	t Size:]
Width:	12	inches 🗘 🗇	
Height:	18.048	inches	
Resolution:	240	pixels/inch 💠	

Figure 12-56

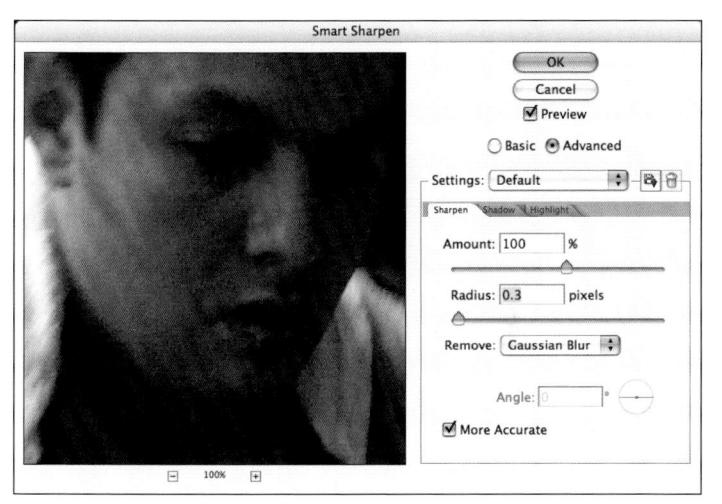

Figure 12-57

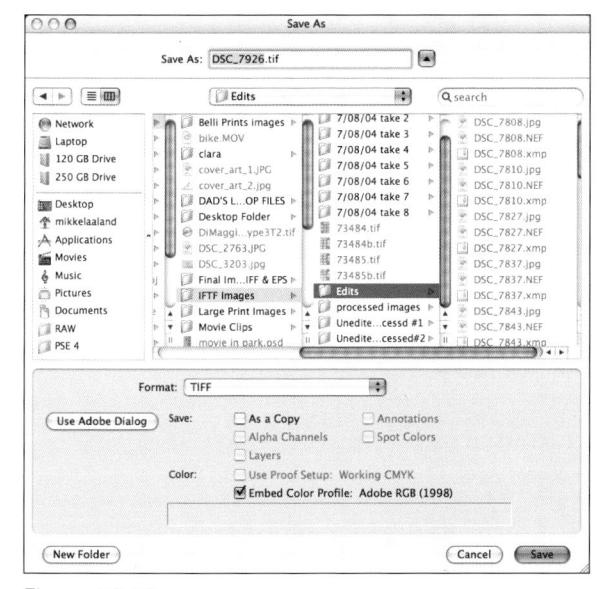

Figure 12-58

Figure 12-59

- 11. Select OK. Next, in Photoshop, I'll use the Smart Sharpen filter to apply a slight sharpening, as shown in Figure 12-57. Then I'll open Resize again and resample up to 20 inches x 30.083 inches. Again, in Photoshop, I'll apply a slightly higher Smart Sharpen Radius setting, because my file is now a little larger. I know this is sounding slow and tedious, but because I'm recording all my steps, I'll have to do it only once.
- 12. When you're done resizing (or whatever your action is), select Save As from Photoshop's main menu, and the dialog box in Figure 12-58 opens. It's not critical to change either the destination or file name. As you'll see later, when we get to the part about using Batch, you'll override this step anyway and keep the original file names intact. You'll choose a destination in the Batch options. The important thing here is to select your file format of choice and whether to embed a color profile. Click Save.
- 13. In Photoshop, close your image and stop recording. To stop recording, either click the Stop button, choose Stop Recording from the Actions palette menu, or press the Esc key.

Now, let's go to Bridge and apply this Action to a batch of images, using the Batch command.

- 1. Select the RAW files you wish to process.
- Select Tools→Photoshop→Batch (Figure 12-59).

- 3. The Batch window, shown in Figure 12-60, opens. I've listed the settings that are critical for this work below.
- Select OK. Depending on the complexity of the Action, the number of RAW files, and the speed of your computer, you may very well take the opportunity to go out and have lunch.

Figure 12-60

Play Select correct Set and Action.

Source Bridge

Override Action "Open" Commands This ensures your Bridge files open, not the file named in the action.

Suppress File Open Options Dialogs This prevents the Camera Raw dialog box from opening for each RAW file being processed.

Suppress Color Profile Warnings If you don't select this option, you'll have to manually close the color profile warning for every image.

Destination Choose a Destination for the final images. Then select "Override Action' Save As' Commands." This will apply the Save As file format choice, but keep the original file names or names chosen with File Naming options.

File Naming Change your document name and add sequencing information here, if you want.

Errors Stopping for errors is generally recommended. However, if you are confident the process works, and want to avoid a possible delay, select Log Errors to File. The process will continue, even if a minor glitch occurs.

Scripts, like actions, allow you to automate common tasks, but are much more powerful. Instead of recording and playing back a linear sequence of events, you can build in "if this then that" logic. Scripts can be written in JavaScript (Mac and Windows), Visual Basic (Windows-only), or AppleScript (Mac-only).

Scripts 4 ▶ 88 ≣ □ ♦-Network 120 GB Drive 500 GB Drive #2 _ 200GB Drive Applications Documents Movies & Music RAW CS3 BOOK Event Scripts Only APLA-Tasmania Desktop Layer Comps To Files.jsx Layer Comps To PDF.jsx Laver Comps To WPG.isx 19 items, 7.77 GB available

Figure 12-61

Figure 12-62

Writing Custom Scripts

Image Processor, which I discussed earlier in this chapter, is a JavaScript. So is Get Photos from Camera, which I discussed in Chapter 2. Figure 12-61 shows a folder full of scripts that I use occasionally. Scripts are good, and many people enjoy writing their own and sharing them via the Web for free—or for a nominal charge. I have friends who do that—but I don't.

This is what I suggest. If you are like me, periodically check the Adobe web site (Figure 12-62) for scripts that sound interesting (www.adobe. com/cfusion/exchange/). Follow the instructions for loading them. Try them out. See if they work. (I've downloaded a few dogs.) If you want to write your own, refer to the Adobe online help. Me, I'm tired of spending so much time in front of a computer. I'm done. I'm going out and shooting some photos!

Index

A	Advanced
ACDSee asset management	
	Amount s archiving da aspect rat (Br author ma automatic Bridge 2 Photosh contac JPEG f Merge pictur PSD fi TIFF fi
See Photo Downloader Adobe Photoshop CS3 One-on-One, 144 Adobe RGB color space, 97, 113, 227 Adobe web site, scripts, 245	Web P auto tone 90 keyboar Auto Whit

```
d Dialog (Photo
ownloader), 24–25
sharpening slider, 152
Camera Raw
tabases, 236
tio, filtering content
ridge), 32
etadata, 25
on commands
237-239
nop
ct sheets, 222, 237
files, 237
e to HDR, 135
re packages, 222, 238–239
les, 222, 237
les, 222, 237
hoto Gallery, 222, 239
adjustments, 45-46,
-91, 96
d commands, 131
te Balance camera
tting, 12
```

background brightness (Bridge), 36 Balance slider, 197-198 Basic tab (Camera Raw), 73 auto tone adjustments, 90-91 keyboard commands, 131 Tone Curves, 139 keyboard commands, 131 Parametric and Point, 126 batch files RapidFixer, editing in 85 renaming, 54, 80 Photoshop, applying actions, 240-244 Bicubic Smoother (Dr. Brown's 1-2-3 Process), 227 black and white images camera settings, 193 shooting RAW, 12 conversion before and after references, 193 Camera Raw, 190-192 Photoshop, 199 grainy simulation, 194

shooting guidelines, 195

B

Blacks slider, 23, 72, 102, 109, 200	opening, 60	color space, 96, 97, 111
Blending Options (Photoshop), 145	profiles, 136–137	Adobe RGB, 227
Bridge	saving	camera settings, 11
display performance, 36-38	custom presets, 93–94	ProRGB, 227
Favorites panel, 31	default settings, restoring, 120	sRGB, 225, 227
versus File Browser, 28	files, 77	color targets
hosting Camera Raw, Photoshop	undoing operations, 76, 120	gray cards, 14–15
versus Bridge, 37, 41, 103	updating, 58	GretagMacbeth test chart, 14
opening, 18, 28	version checking, 58-59	X-rite ColorChecker target, 14–15
Camera Raw, 60	camera settings	compression types, 228, 233
photos/files in, 21	black and white, 193	Contact Sheets, 47
panels, viewing, 29	encrypted data, 206	automation commands, 222, 237
rotating images, 30	shooting RAW	Content panel (Bridge), 30
undoing operations, 76	color bias compensation, 15	background brightness, 36
workspaces	color space, 11	Contrast slider, 109
customizing, 40	controlling interpretation, 3	copyright
default, 29	exposure, 10, 13	filtering content in Bridge, 32
Filmstrip, Horizontal/Vertical, 39	file format, 10	information, 228
Brightness slider, 109	ISO, 10	metadata, 25, 81
Brown, Russell, 142, 226	sharpening, 11	Cosmetic sharpening, 149
	white balance, 9, 11	Creative Suite, 28
C	Canto Cumulus asset management	Crop tool, 65-67
cache (Bridge)	program, 55	cross-processing simulation, 198–199
preferences, exporting image	Capture sharpening, 149	
files, 38	Carnett, John, 202	D
purging, 38, 46	Chromatic Aberration	The DAM Book: Digital Asset Manage-
Camera Calibration tab (Camera	Camera Raw, 182–184	ment for Photographers, 55
Raw), 75, 94	Photoshop, 184–186	depth, color data, 60
camera profiles, 136–137	Clarity slider, 110, 116–117	Detail sharpening slider, 153-154,
saving presets, 137	clipping information	160
tints, 197	color channels, 72	Detail tab (Camera Raw), 74
Camera Raw	Shadow/Highlight warnings, 71–72	Noise Reduction, 171–174
auto settings	Clone tool, 68–69	digital camera settings. See camera
converting RAW data, 4	color bias compensation, 15	settings, shooting RAW
displaying JPEGs, 4	color labeling images, 49–50	Digital Negative format. See DNG
Database, 236	ColorMatch RGB color space, 97	Display Calibrator Assistant, 123
hosting, Photoshop versus Bridge,	Color Range selection tool	Distortion controls (Photoshop), 185
37, 41, 103	(Photoshop), 143	
installing, 59	Color Sampler tool, 64, 98, 99	

DNG Converter	LCD preview, 13	Н
versus Camera Raw and Photo	Over/Under exposure, 13	Hallahan, Maggie, 221, 229
Downloader, 207	RapidFixer, 85	Hand tool, 63
converting files to DNG, 209,	Extensis Portfolio asset management	HDR Conversion (Photoshop), 135
218–219	program, 55	Heal tool, 68–69, 84
extracting RAW data, 219	Eye-One Display 2, 123	Highlight clipping warnings, 71–72,
Preferences, 219		95
DNG (Digital Negative) files	F	Highlight Hue slider, 198
converting to	Favorites panel (Bridge), 31	histograms, 13, 72, 99, 100–101
advantages/disadvantages, 208	File Browser <i>versus</i> Bridge, 28	hosting Camera Raw, Photoshop
with Camera Raw, 212–216, 232	file formats, camera settings, 10	-
with DNG Converter, 209,	File menu (Photo Downloader), Get	versus Bridge, 37, 41, 103
218–219	Photos from Camera, 19, 25	Horizontal Filmstrip workspace, 39
JPEG or RAW file while	files, naming/renaming, 54–55	HSL/Grayscale tab (Camera Raw), 74,
downloading, 21	Bridge, 80	132–134
long-term reliability, 206	Fill Flash, 23	Grayscale Mix, 190–192 before and after references, 193
with Photo Downloader, 209	Fill Light slider, 109, 200	
single/multiple files, 208	Filmstrip workspaces, Horizontal and	grainy black and white
downloading, Photo Downloader	Vertical, 39–40	simulation, 194 special effects, 201
versus DNG Converter versus	Filter panel (Bridge), 31–32	Hue slider, 132, 133, 197
Camera Raw, 207	slideshows, 36	nue siluer, 132, 133, 197
embedding RAW data in, 207	FocalBlade, 150	1
metadata, 207	Folders panel (Bridge), 31	
updating, 215–216	Fors, Thomas, 137	ICC profiles, 228
Dr. Brown's 1-2-3 Process, 226–227		Image Backdrop slider (Bridge), 36
	G	Image Processor
E	Genuine Fractals,	converting RAW files, 224–225
Edge controls (Photoshop), 186	Get Photos from Camera, File menu	Preferences, 228
8 Bits/Channel depth, 60	(Photo Downloader), 19, 25	Image Size dialog box (Photoshop),
encrypted data, 206	GIF files, 226	231
Evening, Martin, 123	gray cards, 14–15	import settings, Get Photos from,
EXIF data, 34	grayscale conversion, Black and	File menu (Photo
image editing, 48	White adjustments	Downloader), 19
retaining, 55	(Photoshop), 199	IPTC data, 34
ExpoDisc Digital White	Grayscale Mix, 190–192. See	ISO settings, 10
Balance filter, 12	also grayscale conversion	filtering content in Bridge, 32
exposure settings, 10, 13, 45–46	before and after references, 193	frame-by-frame selection, 179
Camera Raw, 72, 102, 108, 115	grainy black and white	
special effects, 201	simulation, 194	
cameras	GretagMacbeth color chart,	
histograms, 13	14, 43, 107	

14, 43, 107

J	Lens Corrections, 75	presets, 25
JPEG files	Chromatic Aberration	thumbnails, 30
automatic commands, 237	Camera Raw, 184–185	XMP data, 34, 54
camera profiles, 136	Photoshop, 184186	DNG files, 207
converting files to DNG, 21	vignettes, 187	Microsoft Expression Media asset
criteria for shooting, 5–7	Levels adjustment layers	management program, 55
displaying with Camera Raw auto	(Photoshop), 121	monitor calibration, 123
settings, 4	Linear Point tone curve preset, 128	Morgenstein, Richard, 119, 182
versus RAW, 5–7	Look-In window (Bridge), 31	
RAW+JPEG camera settings	lossless compression, 228, 233	N
color space, 11	Loupe tools (Bridge), 32-33, 47-48	naming/renaming folders/files/
sharpening, 11	Luminance slider, 132, 133, 134,	photos, 20
saving	159–160	Bridge, 54–55, 80
Camera Raw, 232	LZW compression, 228, 233	custom file naming, 54
Dr. Brown's 1-2-3 Process,		navigation (Camera Raw), 62–63
226–227	M	negatives of digital images. See RAW
Image Processor, 225	masking in Photoshop, 122	Nikon Capture Editor, 160
XMP data, 21	Layer Mask, 143–144	Nik Sharpener Pro, 150
Avii data, 21	Quick Mask, 143	Noise Reduction
K	Unsharp Mask filter, 116, 150	Camera Raw, 74, 87, 171–173
	grainy black and white simula-	versus Photoshop, 159
keyboard commands, Basic and Tone	tion, 194	saving settings, 160, 173-174
Curve tabs (Camera Raw), 131	Masking sharpening slider, 154	overview, 170
Keywords panel (Bridge), 35	McClelland, Deke, 144	Photoshop
adding metadata, 34, 50	McDermott, John, 189, 195	Add Noise filter, 194
filtering content, 32	Medium Contrast Point tone curve	Advanced settings, 180–181
Knoll, Thomas, 57, 206	preset, 127	Basic settings, 175–177
Krogh, Peter, 54, 55, 130	Merge to HDR (High Dynamic	Reduce Noise, 167
L	Range), Photoshop, 135	
	metadata	0
labeling images, 49–50	adding in Photo Downloader, 25	1-2-3 Process. <i>See</i> Dr. Brown's 1-2-3
Layer Blending Options	Bridge, 33–34	Process
(Photoshop), 145	copyright, 81	onion skinning stacks, 53
Layer Mask (Photoshop), 143–144	EXIF data, 34, 48, 55	Open in Photoshop as Smart Objects
Layer Style dialog box	filtering content, 32	option (Camera Raw), 61
(Photoshop), 145	image editing, 48	orientation of images, 30, 70
LCD preview, 13	IPTC data, 34	Output sharpening, 149
	Keywords panel, 34, 35	Over/Under exposure, 13
	metadata templates, 33–35	- 1. 5., 5.1.45. 5.,p35416/15

P	Point tone curves, 127–130	Q
Parametric curves, 73 Parametric tone curve, 126–127 PDF files, converting contact sheet to, 238 Photo Downloader Advanced Dialog accessing, 24 adding metadata, 25 selecting images, 24 versus Camera Raw and DNG Converter, 207 launching, 18–19 photos/files backing up automatically, 21 converting JPEG or RAW to DNG, 21, 209 downloading, 19, 25 naming folders, 20 opening in Bridge, 21 preserving filenames in XMP, 21 renaming files, 20–21 selecting photos, 24 photo galleries. See Web Photo Gallery PhotoKit Sharpener, 150 Photoshop hosting Camera Raw, Photoshop versus Bridge, 37, 41, 103 opening Camera Raw, 60 Bridge, 28 Photoshop CS3 for Digital Photographers, 123 picture packages, automation commands, 222, 238–239 Place-A-Matic script, 142 Place command (Bridge), 141–142 point curves, 73	Preferences Bridge Cache, 38 launching Photo Downloader, 18 Playback/Stacks, 53 Thumbnails, Details, image information, 30 Thumbnails, Details, metadata, 48 Thumbnails, Quick Thumbnails, Quick Thumbnails, 37 Camera Raw Apply Auto Tone Adjustments, 91 Apply sharpening to preview images only, 157 Defaults, 45–46 DNG File Handling, 216 location for saving settings, 236 versions, 59 DNG Converter, 219 Image Processor, 228 Presets tab (Camera Raw), 76 Preview Camera Raw, 71 Bridge, 32–33 background brightness, 36 Print sharpening, 149 ProPhoto RGB color space, 97, 113 ProRGB color space, 227 PSD file format automation commands, 222, 237 camera profiles, 136 saving Camera Raw, 232 Dr. Brown's 1-2-3 Process, 226 Image Processor, 225	Qualtrough, Luis Delgado, 169, 170, 187 Quick Mask (Photoshop), 143 R Radius sharpening slider, 152–153 RapidFixer, 85 rating images, 49, 83–84 RAW files Batch commands, 242–244 camera profiles, 136 camera settings. See camera settings, shooting RAW conversion software improvements, 4 conversion with Camera Raw auto settings, 4 Image Processor, 222–225, 228 converting to DNG files, 21 advantages/disadvantages, 208 with Camera Raw, 207, 212–216 with DNG Converter, 209, 218–219 long-term reliability, 206 versus Photo Downloader and DNG Converter, 207 with Photo Downloader, 209 single/multiple files, 208 criteria for shooting, 5–7 embedding data in DNG files, 207 extracting RAW data with DNG Converter, 219 versus JPEG, 5–7 rationale for use, 2–4, 94 settings multiple, Bridge, 229–230 saving, 236 thumbnail status icons, 48 XMP data, 21
		AIVIP adla, ZI

RAW+JPEG, camera settings, 11	sharpening	Smart Sharpen filter (Photoshop),
Recovery slider, 23, 72, 108	Camera Raw, 148	150, 161
Red Eye Removal tool, 70	Amount slider, 152	Gaussian or Lens Blur, 162, 163–166
Reduce Noise filter (Photoshop), 167	applying to preview images, 157	Split points, Parametric tone
Advanced settings, 180–181	Detail slider, 153–154, 160	curve, 126
Basic settings, 175–177	FocalBlade, 150	Split Toning
versus Camera Raw's Noise	Masking slider, 154	Camera Raw, 75
Reduction, 159, 167	Nik Sharpener Pro, 150	cross-processing simulation,
Reichmann, Michael, 125, 138	i~versus~i Nikon Capture	198–199
Remove Distortion slider	Editor, 160	single color tone, 196–197
(Photoshop), 185	over-sharpening fixes, 159	special effects, 201
renaming folders/files/photos.	PhotoKit Sharpener, 150	sRGB color space, 97, 111, 225, 227
See naming/renaming	Radius slider, 152–153	stacks (Bridge)
Retouch tool, 68–69, 84	saving settings, 160	collapsing, 52
applying to multiple images, 70	sliders, 72, 151	creating, 51
Richards, Mark, 170	strategies, 155–156	expanding, 52
rotating images, 30	25 setting, 157, 158	onion skinning, 53
Camera Raw, 70	when to use, 149	playback frame rate, 53
5	camera settings, 11	promoting images to top, 52
S	Photoshop	scrubbing thumbnails, 53
Saturation, 92, 110, 118–119, 132, 133,	Smart Sharpen filter, 150, 161–167	Story, Derrick, 110–112
134, 197, 201	Unsharp Mask filter, 150	Straighten tool, 67–68
Save New Camera Raw Defaults, 92	Shooting Digital, 13	Strong Contrast Point tone curve
saving custom presets, 93–94	16 Bits/Channel depth, 60	preset, 128
scripts, 245	sizing/resizing images	Sundberg, Martin, 66, 79, 80
scrubbers, 131	Camera Raw, 231	Synchronize feature, 84
Settings menu (Camera Raw)	Dr. Brown's 1-2-3 Process, 227	_
Apply presets, 94	Image Processor, 225	T
Defaults, 120	Photoshop, 231	Temperature slider, 106
Reset Camera Raw Defaults, 76	slideshows, 35–36	thumbnails (Bridge)
Save New Camera Raw	Smart Objects (Photoshop)	auto tone adjustments, 91
Defaults, 92	Open in Photoshop as Smart	display performance, 36–37
saving	Objects option (Camera	enlarging, 53
custom presets, 93–94	Raw), 61	metadata, 30
subsets, 230	multiple versions of images,	Preferences, Details, 30
Shadow clipping warning, 71–72, 95	139–143	Preferences, Quick Thumbnails, 37
Shadows Hue slider, 198	portrait improvements, 202–203	purging cache, 38
,	Reduce Noise filter, 159, 167	sizing, 30
		sorting, 31
		sorting/viewing, 84
		status icons, 48

TIFF file format, 5 automation commands, 222, 237 camera profiles, 136 saving Camera Raw, 232	V Vertical Filmstrip workspace, 39–40 Vibrance slider, 110, 118–119, 201 vignettes, 23, 187	X XMP metadata, 34, 54, 84 XMP sidecar files, 236 X-rite ColorChecker target, 14–15
Camera Raw, 232 Dr. Brown's 1-2-3 Process, 226 Image Processor, 226, 228 Tint slider, 106–108, 196 tone controls, 108–114 Split Toning cross-processing simulation, 198–199 single color tone, 196–197 special effects, 201 Tone Curve tab (Camera Raw), 73	Web Photo Gallery, 47 automation commands, 222, 239 wedding photography, 7 white balance, 9, 43 Camera Raw, 64, 99, 106 menu options, 104 presets, 105 special effects, 200 Temperature options, 106 Tint options, 106, 196 camera settings, shooting RAW, 11–12	Z ZIP compression, 233 Zoom tool, 62–63
Unsharpen-Boost Saturation setting, 81 Unsharp Mask filter (Photoshop), 116, 150 grainy black and white simulation, 194 User Interface Brightness slider (Bridge), 36	ExpoDisc Digital White Balance filter, 12 GretagMacbeth chart, 107 white points, 108 Workflow Options dialog box (Camera Raw) Depth, 60 Open in Photoshop as Smart Objects option, 61, 77, 139–142 Resolution, 61 Size, images, 61 Space (color), 60, 96, 97	

Where innovation, creativity, and technology converge.

There's a revolution in how the world engages ideas and information. As our culture becomes more visual and information-rich, anyone can create and share effective, interactive, and extraordinary visual and aural communications. Through our books, videos, Web sites and newsletters, O'Reilly spreads the knowledge of the creative innovators at the heart of this revolution, helping you to put their knowledge and ideas to work in your projects.

To find out more, visit us at digitalmedia.oreilly.com

Capture. Design. Build. Edit. Play.

digitalmedia.oreilly.com

Try the online edition free for 45 days

Transform your RAW images into works of art

O'REILLY®

Mikkel Aaland

Keeping your competitive edge depends on having access to information and learning tools on the latest creative design, photography and web applications—but that's a lot easier said than done! How do you keep up in a way that works for you?

Safari offers a fully searchable library of highly acclaimed books and instructional videos on the applications you use everyday. Best-selling authors offer thousands of how-to's, sharing what really works, and showing you how to avoid what doesn't. And with new content added as soon as it's published, you can be sure the information is the most current and relevant to the job at hand.

To try out Safari and the online edition of the above title FREE for 45 days, go to www.oreilly.com/go/safarienabled and enter the coupon code XXXXXXX.

To see the complete Safari Library visit: safari.oreilly.com